IMPRESSIONS OF
UKIYO-E

Authors: Dora Amsden
 Woldemar von Seidlitz

Translation: Marlena Metcalf

Layout:
Baseline Co. Ltd.
127-129A Nguyen Hue
Fiditourist 3rd Floor
District 1, Ho Chi Minh City
Vietnam

ISBN: 978-1-84484-470-8

Printed in Korea

IMPRESSIONS OF
UKIYO-E

CONTENTS

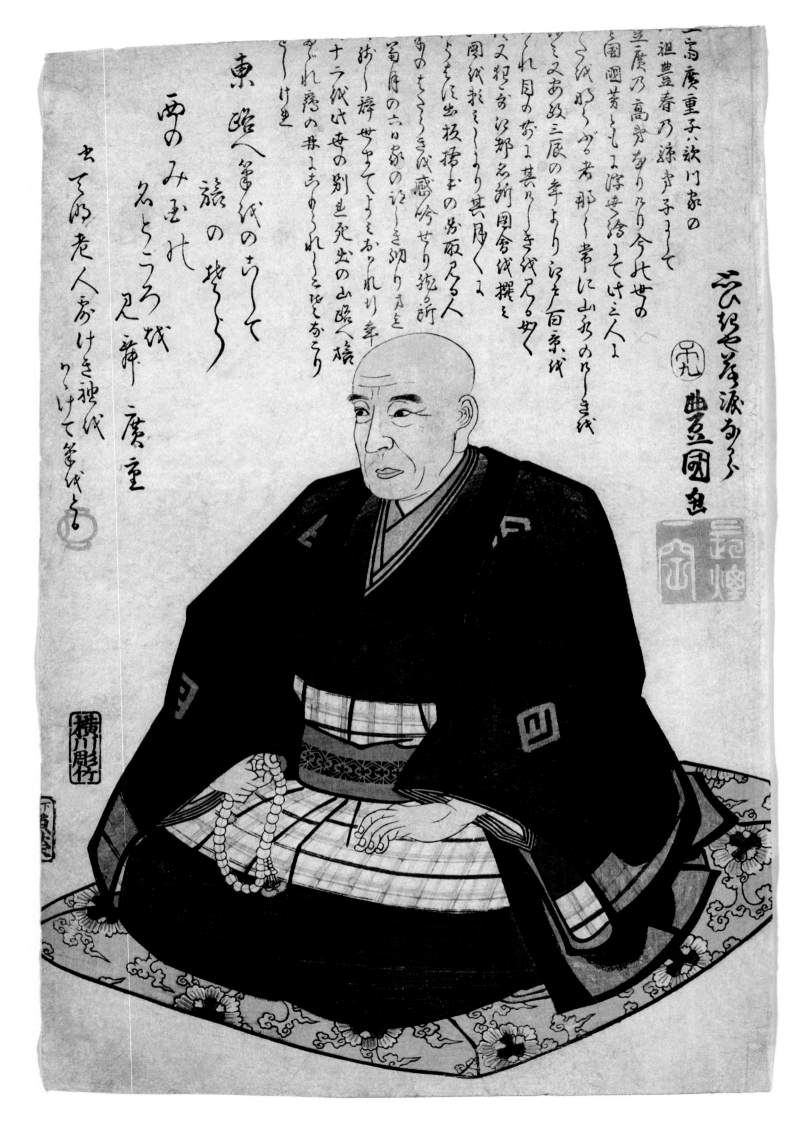

THE RISE OF UKIYO-E – THE FLOATING WORLD

The Art of Ukiyo-e is a "spiritual rendering of the realism and naturalness of the daily life, intercourse with nature, and imaginings, of a lively impressionable race, in the full tide of a passionate craving for art." This characterisation of Jarves sums up forcibly the motive of the masters of Ukiyo-e, the Popular School of Japanese Art, so poetically interpreted as "The Floating World".

To the Passionate Pilgrim and devotee of nature and art who has visited the enchanted Orient, it is unnecessary to prepare the way for the proper understanding of Ukiyo-e. This joyous idealist trusts less to dogma than to impressions. "I know nothing of Art, but I know what I like," is the language of sincerity, sincerity which does not take a stand upon creed or tradition, nor upon cut and dried principles and conventions. It is truly said that "they alone can pretend to fathom the depth of feeling and beauty in an alien art, who resolutely determine to scrutinise it from the point of view of an inhabitant of the place of its birth."

To the born cosmopolite who assimilates alien ideas by instinct or the gauging power of his sub-conscious intelligence the feat is easy, but to the less intuitively gifted, it is necessary to serve a novitiate, in order to appreciate "a wholly recalcitrant element like Japanese Art, which at once demands attention, and defies judgment upon accepted theories". These sketches are not an individual expression, but an endeavour to give in condensed form the opinions of those qualified by study and research to speak with authority upon the form of Japanese Art, which in its most concrete development the Ukiyo-e print is claiming the attention of the art world.

The development of colour printing is, however, only the objective symbol of Ukiyo-e, for, as our Western oracle Professor Fenollosa said: "The true history of Ukiyo-e, although including prints as one of its most fascinating diversions, is not a history of the technical art of printing, rather an aesthetic history of a peculiar kind of design."

The temptation to make use of one more quotation in concluding these introductory remarks is irresistible, for in it Walter Pater sets his seal upon art as a legitimate pursuit, no matter what form it takes, though irreconcilable with preconceived ideas and traditions. "The legitimate contention is not of one age or school of art against another, but of all successive schools alike, against the stupidity which is dead to the substance, and the vulgarity which is dead to form."

Utagawa Kunisada,
Memorial Portrait of Hiroshige, 1858.
Colour woodblock print, 35.5 x 23.4 cm.
Leeds Art Gallery, Leeds.

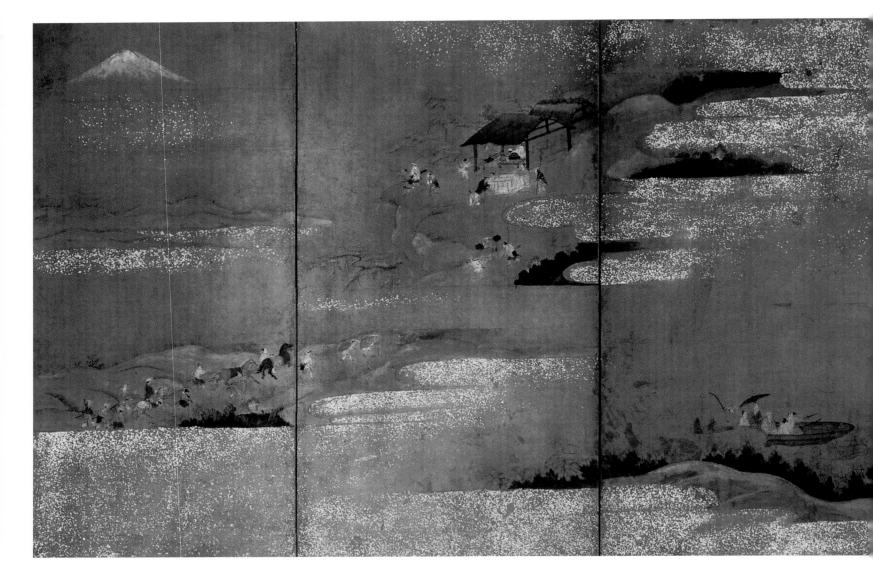

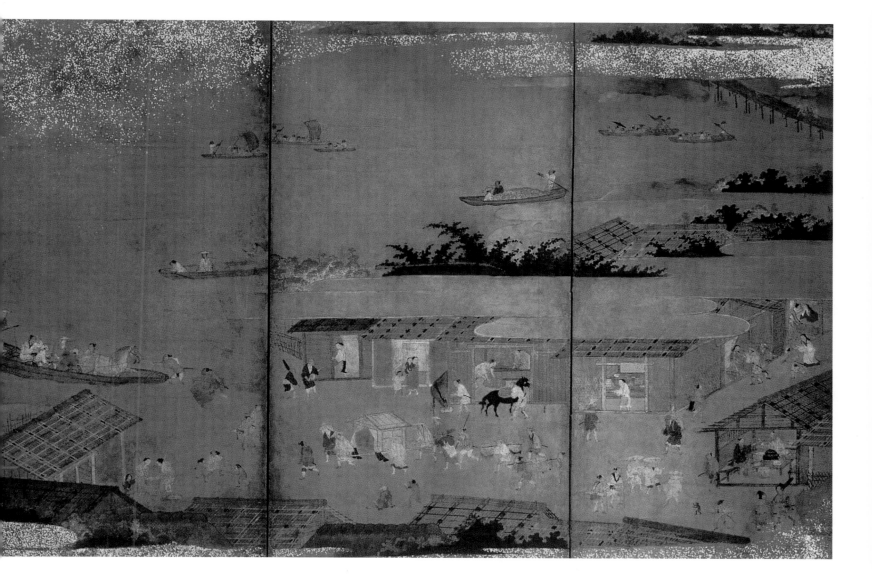

Tosa School,
View of Mount Fuji (Fujimizu),
Muromachi period, 16th century.
Six-panel folding screen "Wind wal" (byōbu),
88.4 x 269.2 cm.
Private collection, deposit in the Tokyo National
Museum, Tokyo.

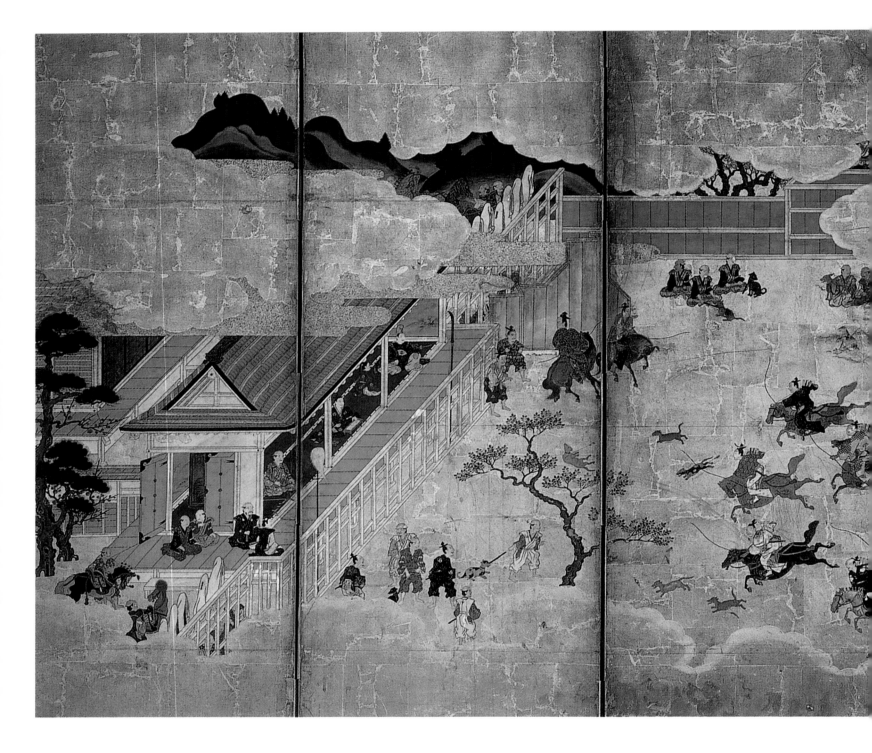

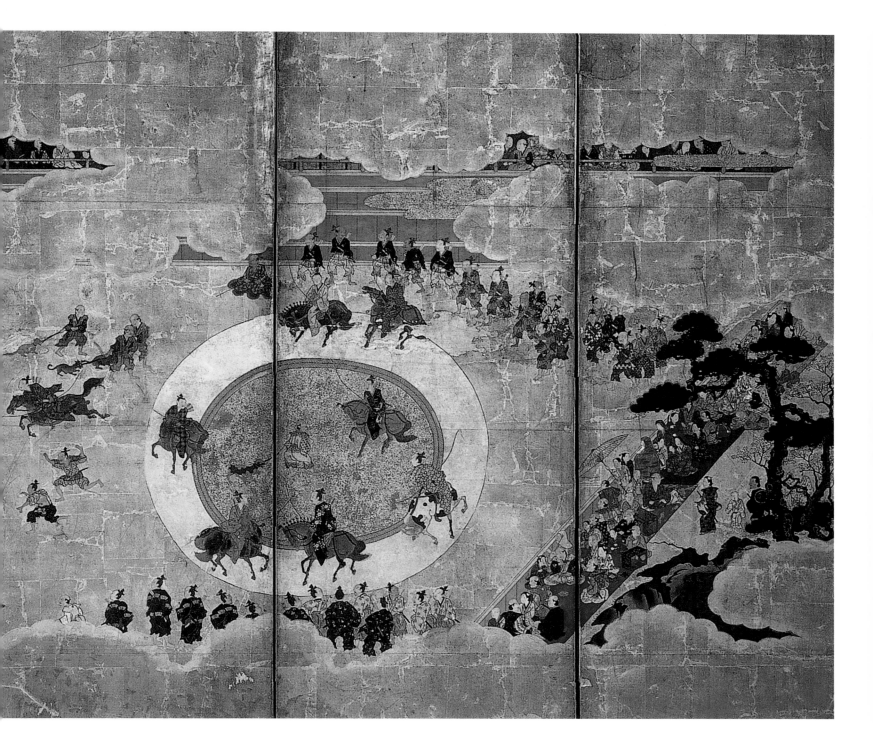

Kanō School,
Dog Chase (Inuoumono),
Edo period, c. 1640-1650.
Folding screen "Wind wall" (byōbu), 121 x 280 cm.
Ink and colour on golden leaves.
Private collection.

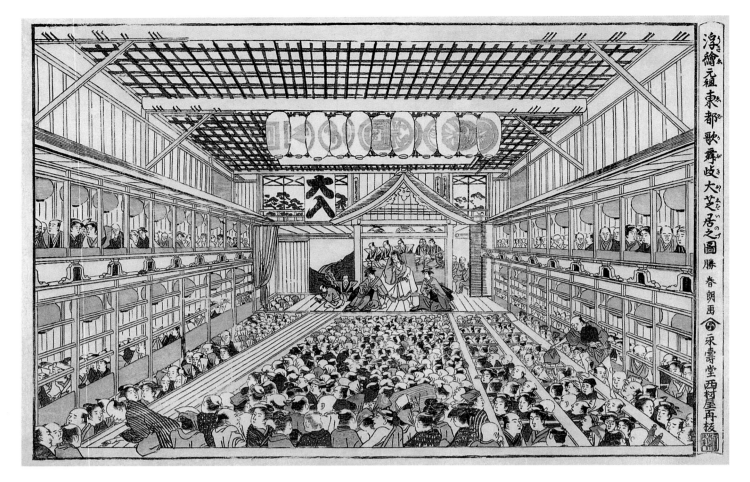

As the Popular School (Ukiyo-e) was the outcome of over a thousand years of growth, it is necessary to glance back along the centuries in order to understand and follow the processes of its development.

Though the origin of painting in Japan is shrouded in obscurity, and veiled in tradition, there is no doubt that China and Korea were the direct sources from which it derived its art; whilst more indirectly she was influenced by Persia and India – the sacred font of oriental art – as

of religion, which have always gone hand in hand.

In China, the Ming dynasty gave birth to an original style, which for centuries dominated the art of Japan; the sweeping calligraphic strokes of Hokusai mark the sway of hereditary influence, and his wood-cutters, trained to follow the graceful, fluent lines of his purely Japanese work, were staggered by his sudden flights into angular realism.

The Chinese and Buddhist schools of art dated from the sixth

century, and in Japan the Emperor Heizei founded an imperial academy in 808. This academy, and the school of *Yamato-e* (paintings derived from ancient Japanese art, as opposed to the Chinese art influence), founded by Fujiwara Motomitsu in the eleventh century, led up to the celebrated school of Tosa, which with Kanō, its august and aristocratic rival, held undisputed supremacy for centuries, until challenged by plebeian Ukiyo-e, the school of the common people of Japan.

Utagawa Toyokuni,
View of a Kabuki Theatre, c. 1800.
Colour woodblock print, 37.7 x 74.7 cm.
The British Museum, London.

Anonymous, style of Tomonobu,
Korean Acrobats on Horseback, 1683.
Monochrome woodblock print, 38 x 25.5 cm.
Victoria & Albert Museum, London.

Katsushika Hokusai,
*Kabuki Theatre at Edo Viewed
from an Original Perspective*, c. 1788-1789.
Colour woodblock print, 26.3 x 39.3 cm.
The British Museum, London.

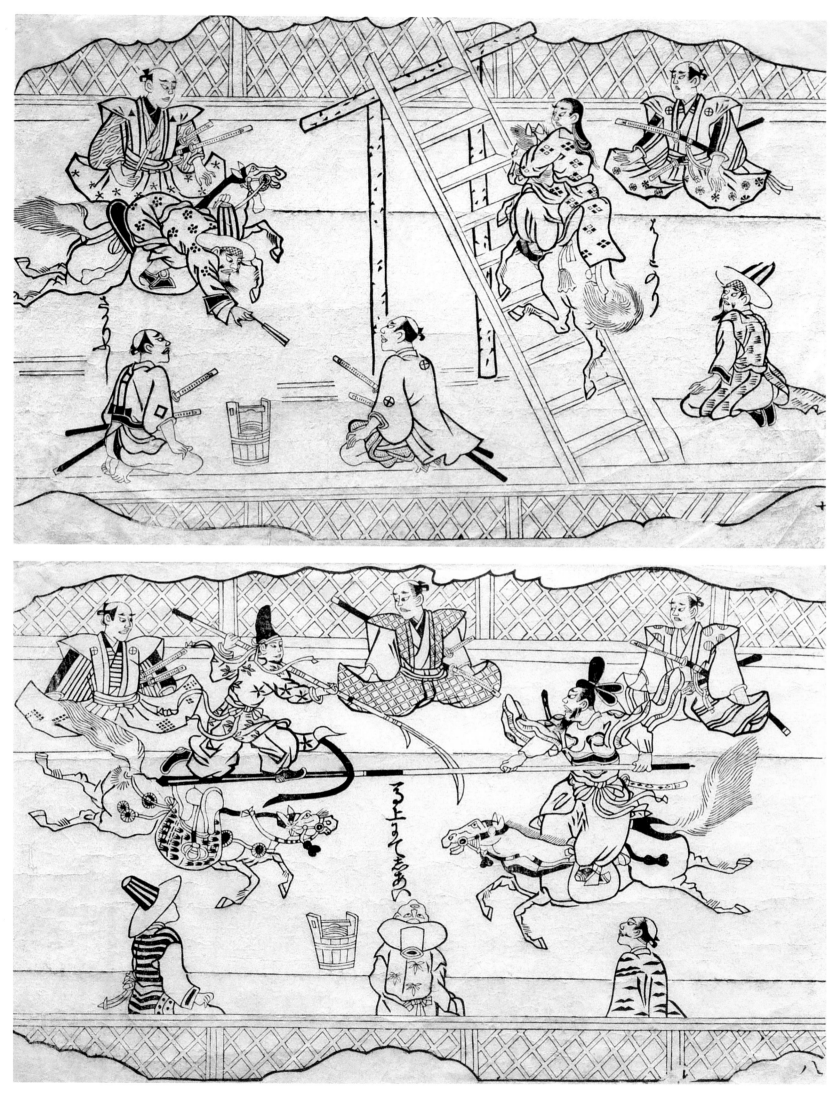

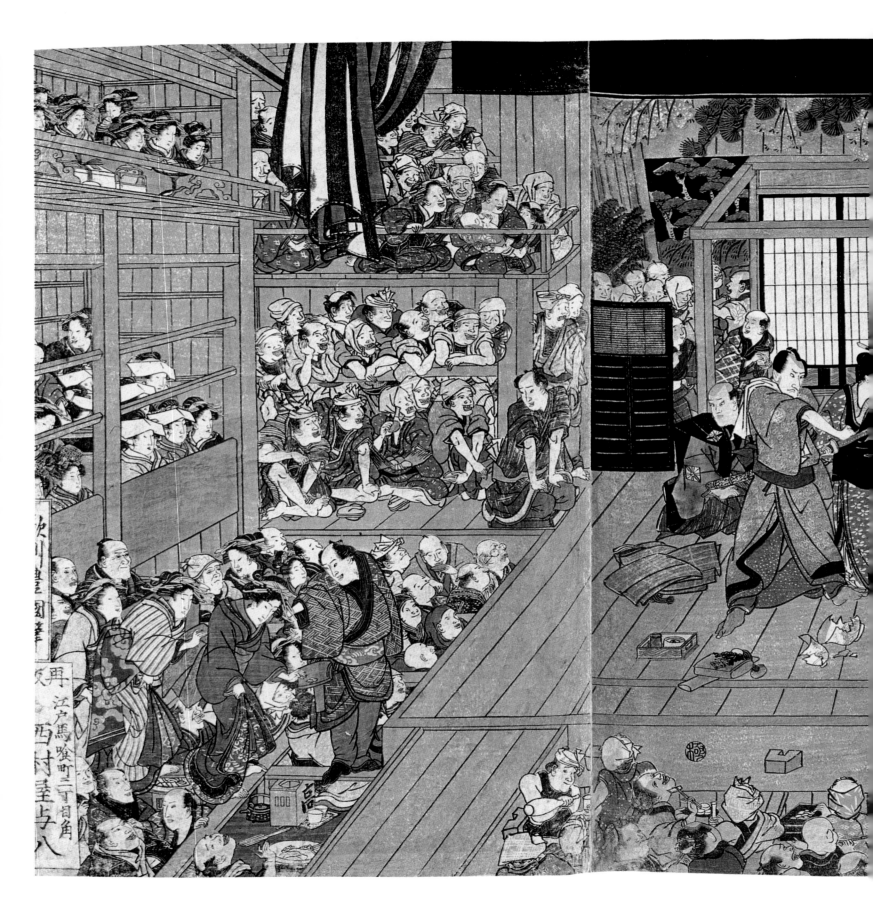

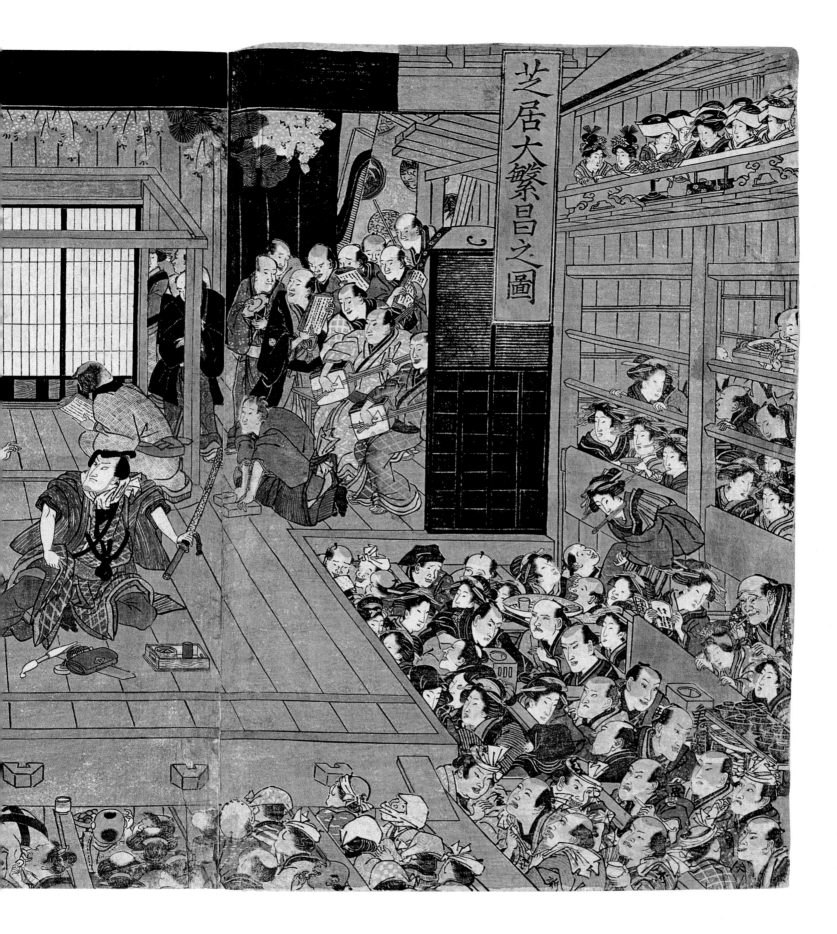

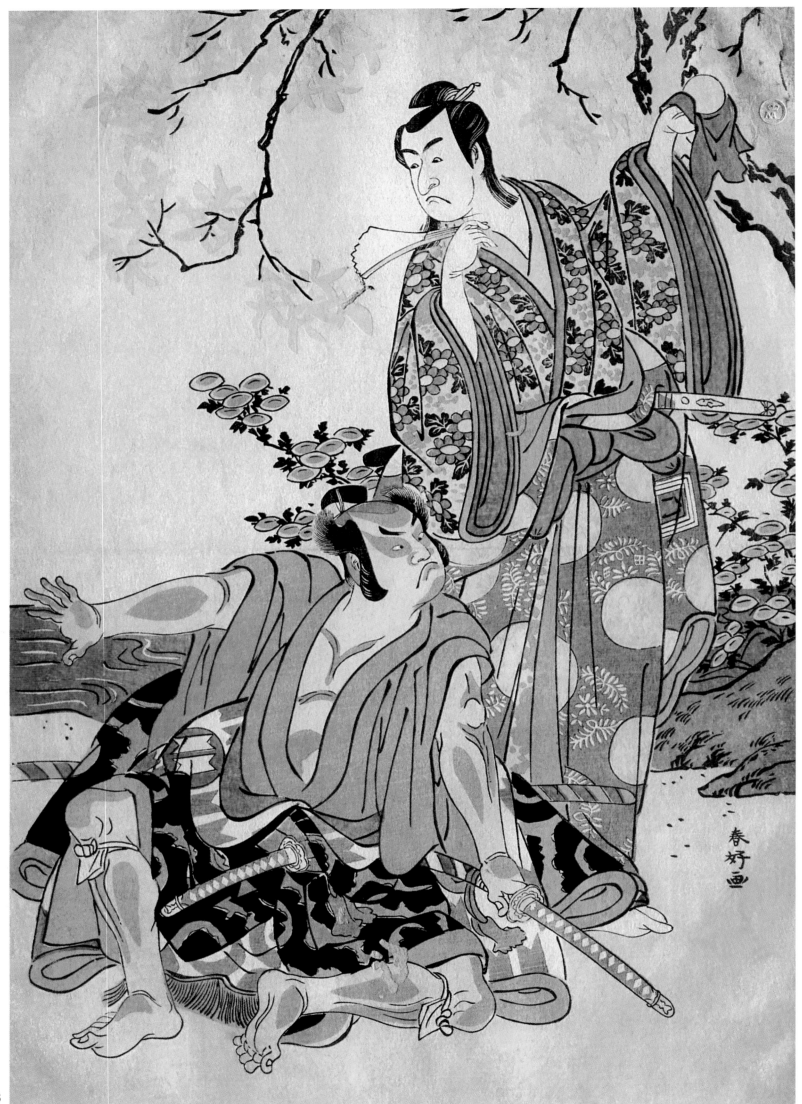

16

The school of Tosa has been characterised as the manifestation of ardent faith, through the purity of an ethereal style. Tosa represented the taste of the court of Kyoto, and was relegated to the service of the aristocracy; it reflected the esoteric mystery of Shinto and the hallowed entourage of the divinely descended Emperor. The ceremonial of the court, its *fêtes* and religious solemnities – dances attended by *daimios* (feudal lords), in robes of state falling in full harmonious folds – were depicted with consummate elegance and delicacy of touch, which betrayed familiarity with the occult methods of Persian miniature painting. The Tosa artists used very fine, pointed brushes, and set off the brilliance of their colouring with resplendent backgrounds in gold leaf, and it is to Tosa we owe the intricate designs, almost microscopic in detail, which are to be seen upon the most beautiful specimens of

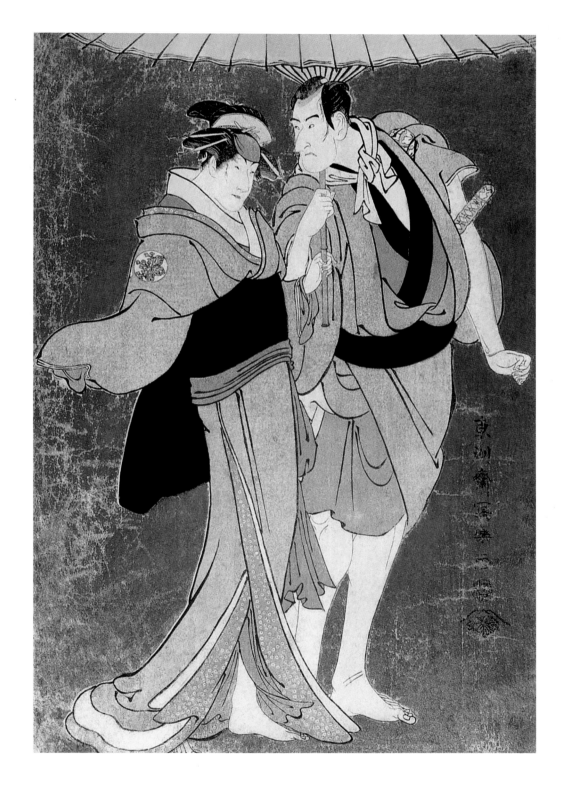

Katsukawa Shunkō,
*The Kabuki Actors Ichikawa Monnosuke II
and Sakata Hangoro III*, mid-1780s.
Colour woodblock print, 34 x 22.5 cm.
Victoria & Albert Museum, London.

Tōshūsai Sharaku,
*The Actors Ichikawa Komazo in the Role of Chubei with
Nakayama Tomisaburo in the Role of Umegawa*, 1794.
Brocade print, 38 x 25.5 cm.
Tokyo National Museum, Tokyo.

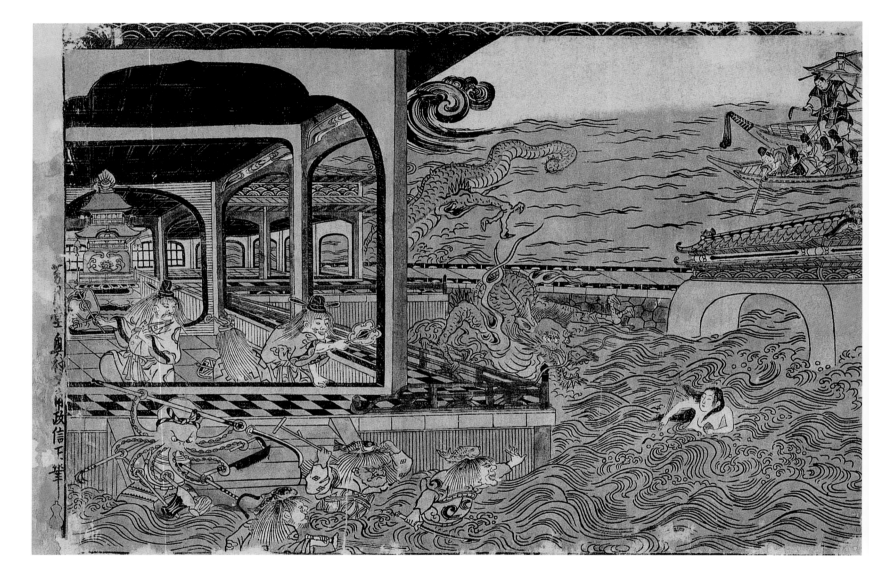

Okumura Masanobu,
Dragon Palace under the Sea,
Edo period, 1740s.
Woodblock print (urushi-e); ink on paper with
hand-applied colour and nikawa, 29.4 x 43.7 cm.
Museum of Fine Arts, gift of William Sturgis
Bilegow, Boston.

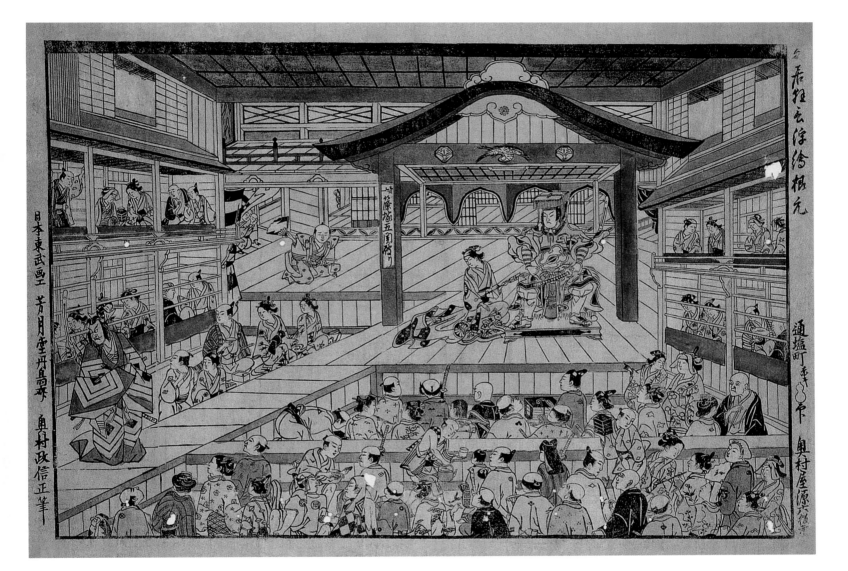

Okumura Masanobu,
Perspective Image of a Theatre Stage, 1743.
Woodblock print (beni-e), ink on paper, with
hand-applied colour, 32.5 x 46.1 cm.
Ostasiatische Kunstsammlung, Museum für
Asiatische Kunst, Staatliche Museen zu Berlin, Berlin.

gold lacquer work; and screens, which for richness have never been surpassed.

Japanese Art was ever dominated by the priestly hierarchy, and also by temporal rulers, and of this the school of Tosa was a noted example, as it received its tide from the painter-prince, Tsunetaka, who, besides being the originator of an artistic centre, held the position of vice-governor of the province of Tosa. From its incipience, Tosa owed its prestige to the Emperor and his nobles, as later Kanō became the official school of the usurping Shoguns. Thus the religious, political and artistic histories of Japan were ever closely allied. The Tosa style was combated by the influx of Chinese influence, culminating in the fourteenth century, in the rival school of Kanō.

The school of Kanō owed its origin to China. At the close of the fourteenth century the Chinese

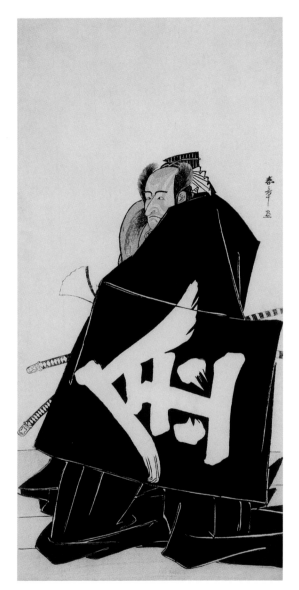

Buddhist priest, Josetsu, left his own country for Japan, and bringing with him Chinese tradition, he founded a new dynasty whose descendants still represent the most illustrious school of painting in Japan. The Kanō school to this day continues to be the stronghold of classicism, which in Japan signifies principally adherence to Chinese models, a traditional technique, and avoidance of subjects which represent every-day life. The Chinese calligraphic stroke lay at the root of the technique of Kanō, and the Japanese brush owed its facility elementarily to the art of writing. Dexterous handling of the brush is necessary to produce these bold, incisive strokes, and the signs of the alphabet require little expansion to resolve themselves into draped forms, and as easily they can be decomposed into their abstract element.

The early artists of Kanō reduced painting to an academic

Katsukawa Shunshō,
The Actor Ichikawa Danjūrō V as Sakata Hyōgonosuke
Kintoki, in the Play Raikō's Four Intrepid Retainers in the
Costume of the Night Watch (Shitennō Tonoi no
Kisewata), 1781.
Colour woodblock print, hosoban, 32 x 14.9 cm.
The Art Institute of Chicago, Chicago.

Torii Kiyohiro,
Nakamura Tomijūrō
in the Role of Musume Yokobue, 1753.
Limited colour woodblock print, 43.5 x 29.3 cm.
Chiba Art Museum, Chiba.

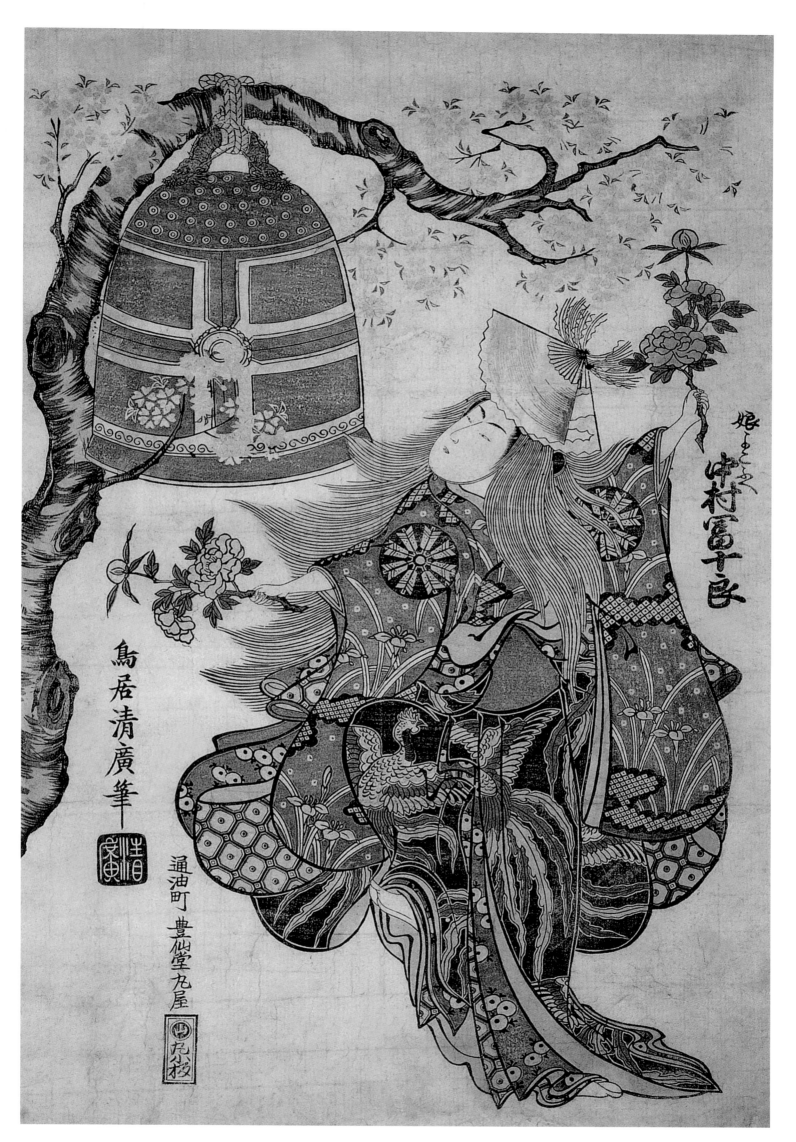

娘 中村富十郎

鳥居清廣筆

通油町 豊仙堂丸屋

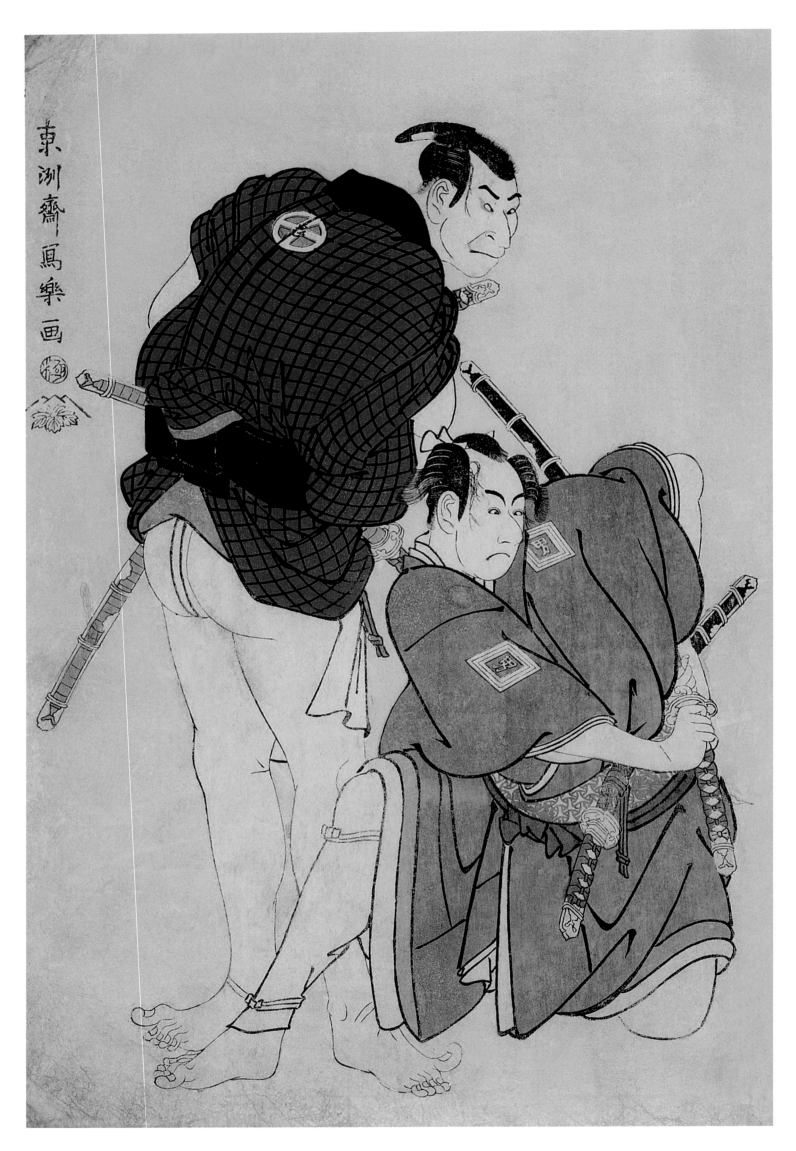

art, and destroyed naturalism, until the genius of Okumura Masanobu, who gave his name to the school, and still more, that of his son, Kanō Motonobu, the real "Kanō," grafted on to Chinese models, and monotony of monochrome, a warmth of colour and harmony of design which regenerated and revivified the whole system. Kanō yielded to Chinese influence, Tosa combated it, and strove for a purely national art, Ukiyo-e bridged the chasm, and became the exponent of both schools, bringing about an expansion in art which could never have been realised by these aristocratic rivals. The vigour and force of the conquering Shoguns led Kanō, while the lustre of Tosa was an emanation from the sanctified and veiled Emperor.

The favourite subjects of the Kanō painters were chiefly Chinese saints and philosophers, mythological and legendary heroes, represented in various

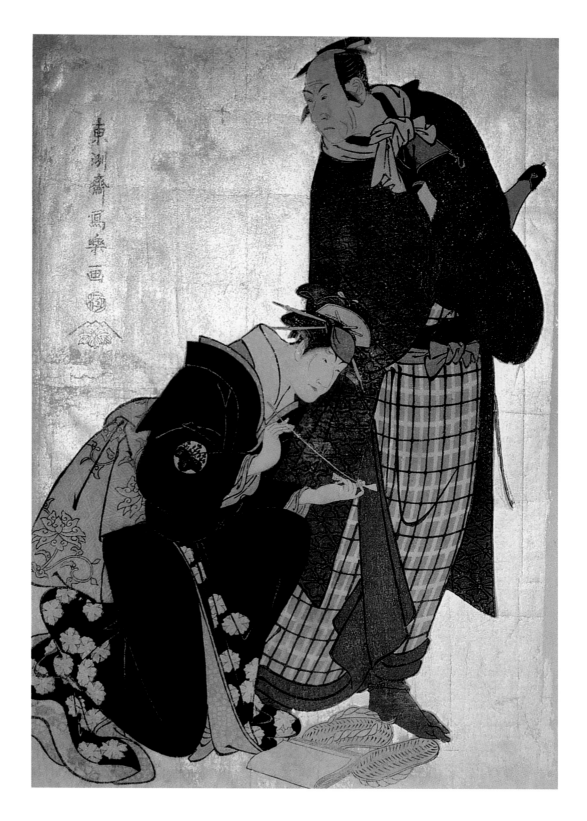

Tōshūsai Sharaku,
The Actors Ichikawa Omezō in the Role of Tomita Heitarō and
Ōtani Oniji III in the Role of Kawashima Jubugorō, 1794.
Colour woodblock print, 38.8 x 25.8 cm.
Honolulu Academy of Arts, Honolulu.

Tōshūsai Sharaku,
The Actors Matsumoto Kōshirō IV and Nakayama Tomisaburō, 1794.
Colour woodblock print, 36.2 x 24.7 cm.
Baur Collection, Geneva.

attitudes with backgrounds of conventional clouds and mists, interspersed with symbolic emblems. Many of the Kanō saints and heroes bear a striking resemblance to mediaeval subjects, as they are often represented rising from billowy cloud masses, robed in ethereal draperies, and with heads encircled by the nimbus.

Beneath the brush of Kanō Motonobu, formal classicism melted. In this new movement, says Kakuzo Okakura: "Art fled from man to nature, and in the purity of ink landscapes, in the graceful spray of bamboos and pines, sought and found her asylum."

Space will not permit a glance at the personnel of the many schools of Japanese Art. A lengthy catalogue alone would be required to enumerate the masters who inaugurated schools, for if an artist developed exceptional talent in Japan, he immediately founded

an individual school, and it was incumbent upon his descendants for generations to adhere rigidly to the principles he had inculcated, so becoming slaves to traditional methods.

During the anarchy of the fourteenth century art stagnated in Japan, but a revival, corresponding with the European Renaissance, followed. The fifteenth century in Japan, as in Europe, was essentially the age of revival. Anderson epitomises in one pregnant phrase this working power: "All ages of healthy human prosperity are more or less revivals. A little study would probably show that the Ptolemaic era in Egypt was a renaissance of the Theban age, in architecture as in other respects, while the golden period of Augustus in Rome was largely a Greek revival." There seems to have been a reciprocal action in Japanese Art. Tosa, famed for delicacy of touch, minutiae of detail and brilliance of

colour, yielded to the black and white, vigorous force of Kanō. Kanō again was modified by the glowing colouring introduced by Kanō Masanobu and Kanō Motonobu. Later we see the varied palette of Miyagawa Chōshun efface the monochromic simplicity of Moronobu, the ringleader of the printers of Ukiyo-e.

The leading light in art in the beginning of the fifteenth century was Cho Densu (also called Minchō, 1352-1431), the Fra Angelico of Japan, who, as a simple monk, serving in a Kyoto temple, must in a trance of religious and artistic ecstasy have beheld a spectrum of fadeless dyes, so wondrous were the colours he lavished upon the draperies of his saints and sages. The splendour of this beatific vision has never faded, for the masters who followed in the footsteps of the inspired monk reverently preserved the secret of these precious shades until at last,

Furuyama Moromasa,
The Actor Ichikawa Danjūrō II
as Kamakura no Gongorō, 1736.
Ink and colours on silk, 61 x 29 cm.
The Art Institute of Chicago, Chicago.

Katsushika Hokusai,
Shirabyōshi, Heian Court Performer, c. 1820.
Colours on silk, 98 x 41.9 cm.
The Hokusai Museum, Obuse.

Tōshūsai Sharaku,
The Actor Nakamura Nakazo II as Prince Koretaka Disguised as the Farmer Tsuchizo in the Play
Intercalary Year Praise of a Famous Poem, c. 1795.
Colour woodblock print, ōban, 31.7 x 21.7 cm.
The Art Institute of Chicago, Chicago.

Utagawa Toyokuni,
The Actor Nakamura Nakazō II as the Matsuō maru, 1796.
Colour woodblock print, 37.8 x 25.5 cm.
Honolulu Academy of Arts, Honolulu.

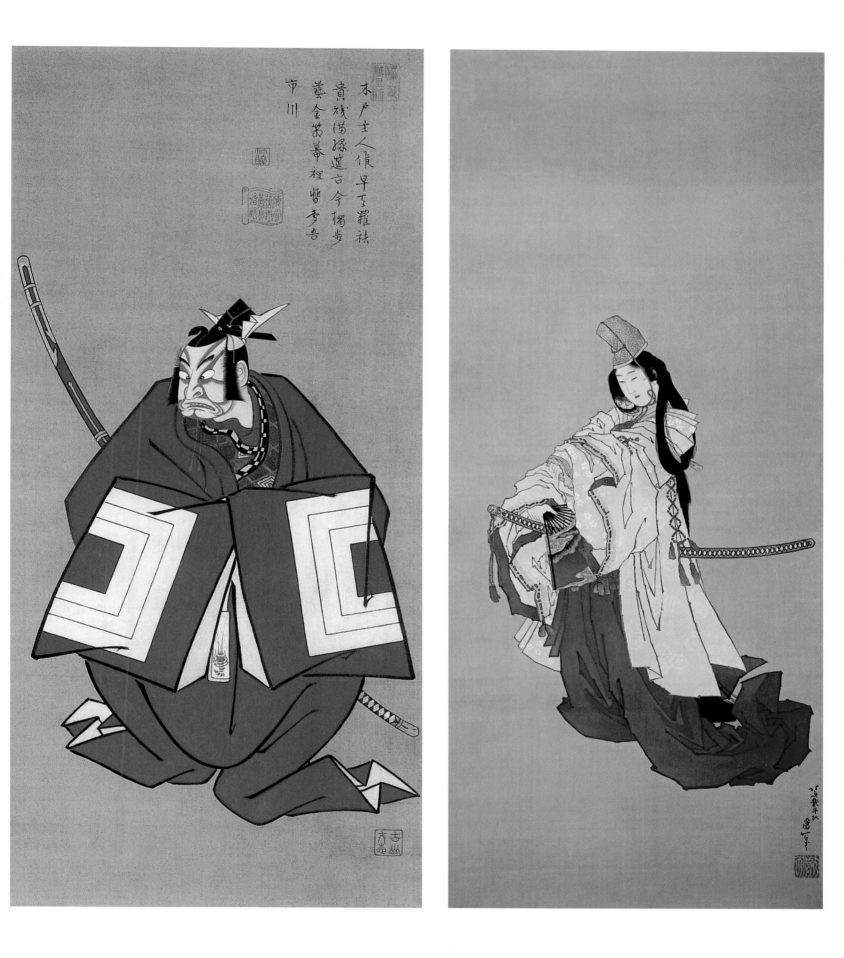

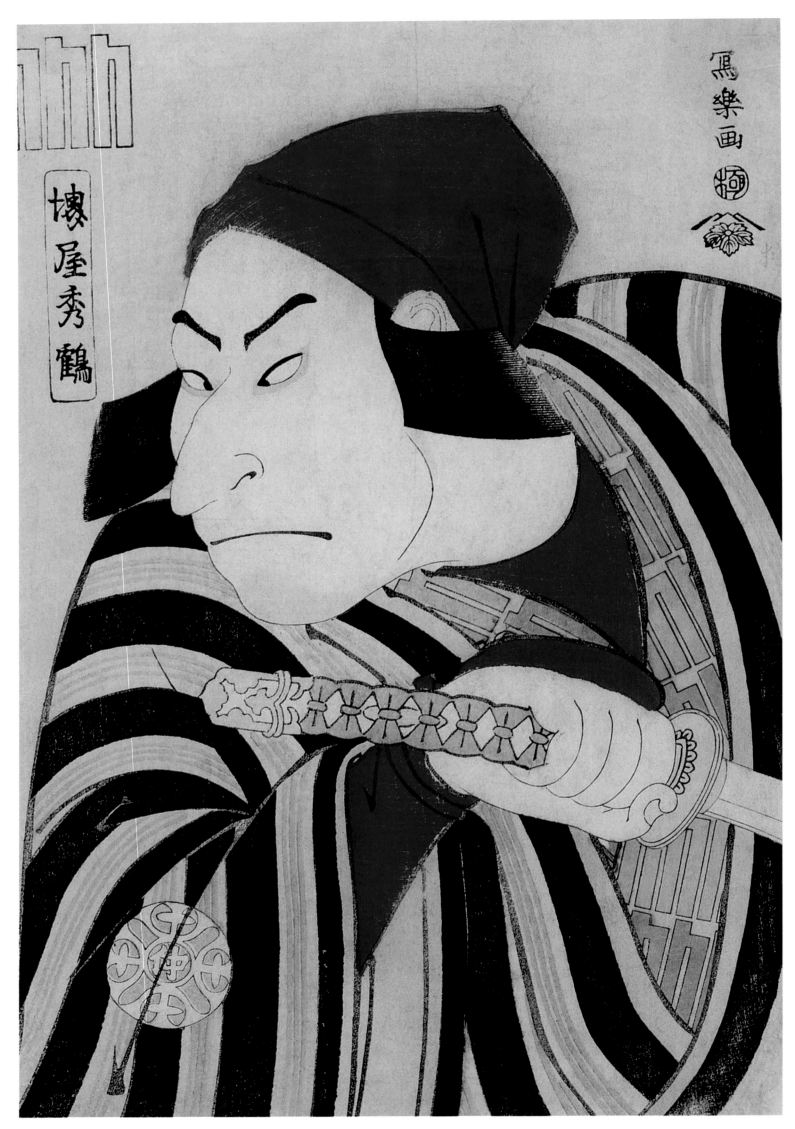

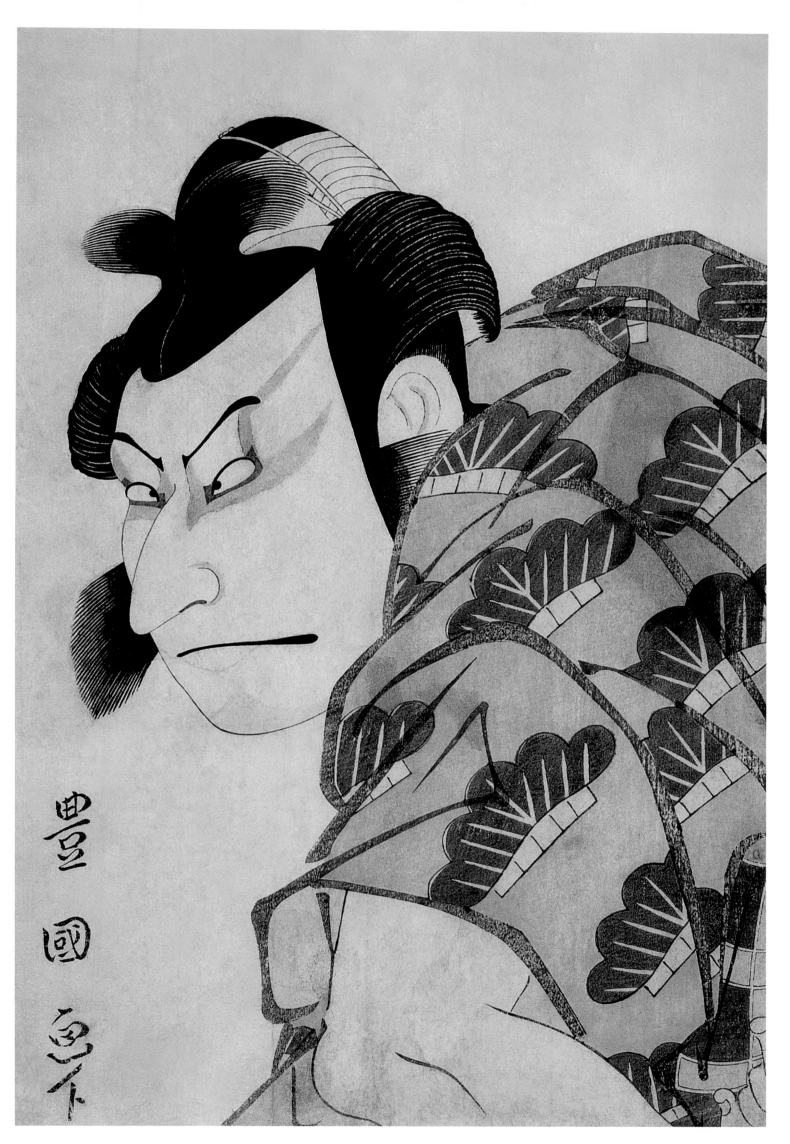

27

in the form of the Ukiyo-e print, they were broadcast and revolutionised the colour sense of the art world.

It has been remarked that Japanese Art of the nineteenth century is often nothing but a reproduction of the works of the ancient great masters, and the methods and mannerisms of the fifteenth century artists simply served as examples for later students. The glory of the fifteenth century was increased by Tosa Mitsunobu, and above all by the two great Kanō artists, Kanō Masanobu and his son, Kanō Motonobu, who received the title of "Hogen," and is referred to as "Ko Hogen," or the ancient Hogen, of whom it has been remarked: "He filled the air with luminous beams."

By the close of the fifteenth century the principles of art in Japan became definitely fixed, as, almost contemporaneously, Giotto established a canon of art in

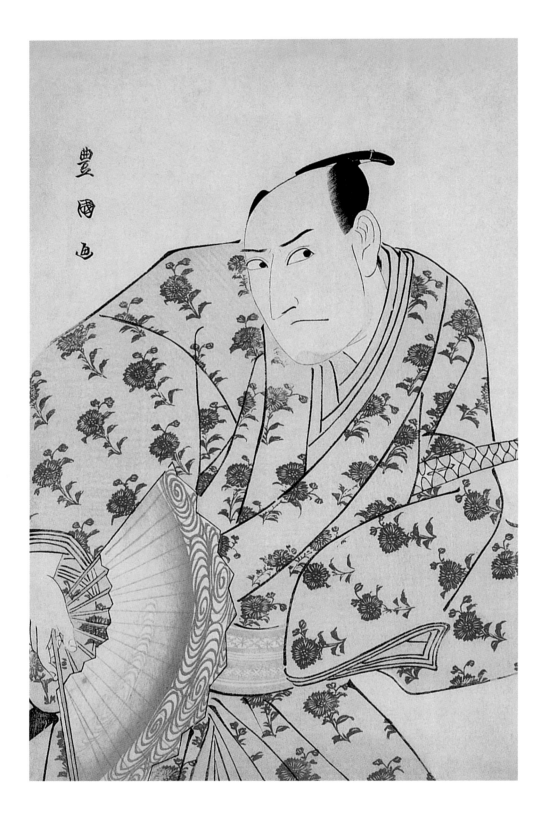

Utagawa Toyokuni,
The Actor Sawamura Sōjūrō III, c. 1782-1785.
Colour woodblock print, 37.8 x 25.4 cm.
The Howard Mansfield Collection, The Metropolitan
Museum of Art, New York.

Florence, which he in turn had received from the Attic Greeks, through Cimabue, and which was condensed by Ruskin into a grammar of art, under the term "Laws of Fésole".

The two great schools, Tosa and Kanō, flourished independently until the middle of the eighteenth century, when the genius of the popular artists, forming the school of Ukiyo-e, gradually fused the traditions of Tosa and Kanō, absorbing the methods of these rival schools which, differing in technique and motive, were united in their proud disdain of the new art which dared to represent the manners and customs of the common people. Suzuki Harunobu and Katsushika Hokusai, Torii Kiyonaga and Utagawa Hiroshige were the crowning glory of all the schools – the artists whose genius told the story of their country, day by day, weaving a century of history into one living encyclopaedia, sumptuous in form, kaleidoscopic in colour.

Ukiyo-e prepared Japan for intercourse with other nations by developing in the common people an interest in other countries, in science and foreign culture, and by promoting the desire to travel, through the means of illustrated books of varied scenes. To Ukiyo-e, the Japanese owed the gradual expansion of international consciousness, which culminated in the revolution of 1868 – a revolution, the most astonishing in history, accomplished as if by miracle; but the esoteric germ of this seemingly spontaneous growth of Meiji lay in the atelier of the artists of Ukiyo-e.

To trace the evolution of the Popular School in its development through nearly three centuries is a lengthy study, of deep interest. The mists of uncertainty gather about the lives of many apostles of Ukiyo-e, from the originator, Iwasa Matahei, to Utagawa Hiroshige, one of the latest disciples, whose changes of style and diversity of signature have given rise to the supposition that as many as three artists are entitled to the name. These mists of tradition cannot be altogether dispersed by such indefatigable students as Louis Gonse, Professor Fenollosa, Edmond de Goncourt, W. Anderson, John S. Happer and many others, but by their aid the methods of Oriental Art are clarified and explained.

Iwasa Matabei, the date of whose birth is given as 1578, is considered to be the originator of the Popular School. The spontaneous growth of great movements and the mystery of the source of genius are illustrated in the career of Matabei. His environment fitted him to follow in the footsteps of his master, Tosa Mitsunobu. Yet the city of Kyoto, veiled in mystic sanctity, where religion and princely patronage held art in conventional shackles,

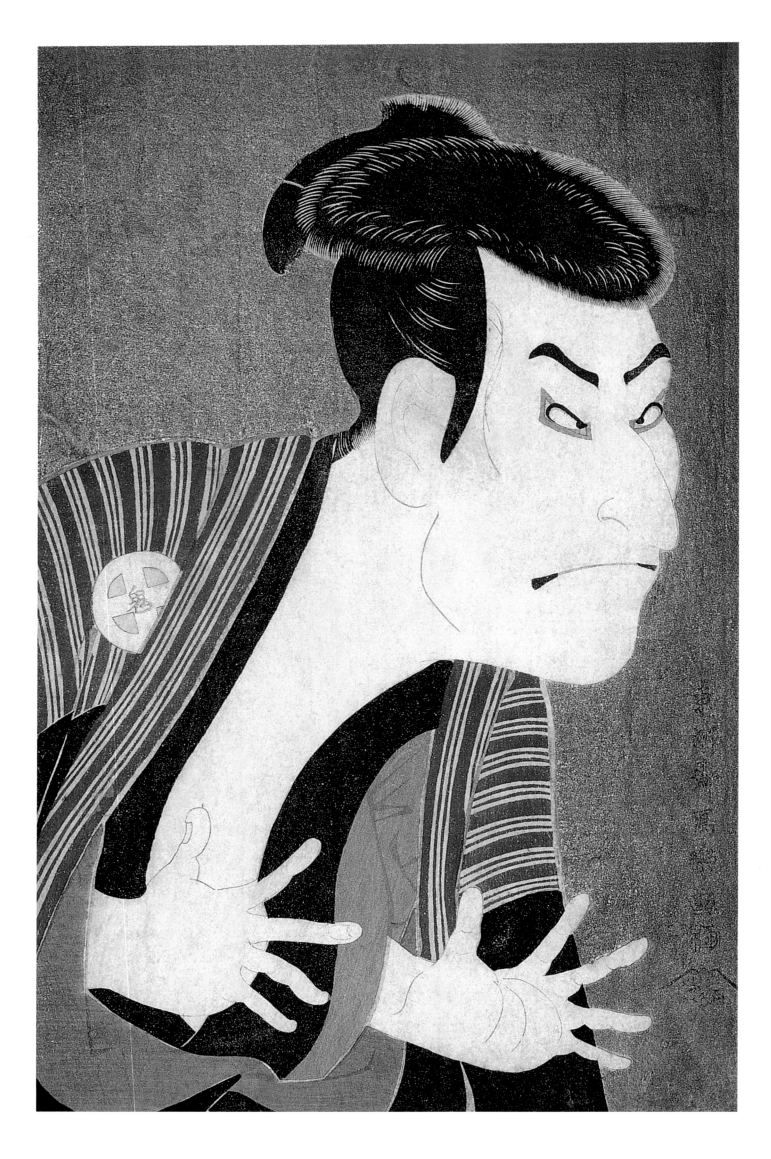

gave birth to the leader of the Popular School. Still, was not Kyoto, the sacred heart of Japan, a fit cradle for Ukiyo-e, the life and soul of the Japanese people?

Matabei and his followers entered into the spirit of the Japanese temperament, and from the Popular School sprang liberty and a novelty of horizon. The aristocratic schools had confined themselves to representations of princely pageantry, to portraiture, and to ideal pictures of mythical personages, saints and sages. The tradition of China showed in all their landscapes, which reflected ethereal vistas classically rendered, of an alien land. Therefore Matabei was contemptuously disowned by Tosa for depicting scenes from the life of his countrymen, yet the technique of Kanō and Tosa were the birthright of the artists of Ukiyo-e, an inalienable inheritance in form, into which they breathed the spirit of life, thus

Tōshūsai Sharaku,
The Actor Ōtani Oniji III as the yakko Edobei, 1794.
Brocade print, 36.8 x 23.6 cm.
Tokyo National Museum, Tokyo.

Utagawa Kunimasa,
The Actor Ichikawa Omezō
as the Kudō Suketsune, 1803-1804.
Colour woodblock print, 36.9 x 25.6 cm.
Honolulu Academy of Arts, Honolulu.

Utagawa Kuniyoshi,
The 'Chushingura' (The Story of the Forty-Seven Ronin -
Masterless Samurai); A Scene from Act II when the Ronin
Attack Moronao's Castle, c. 1854.
Colour woodblock print.
Maidstone Museum & Bentlif Art Gallery,
Maidstone.

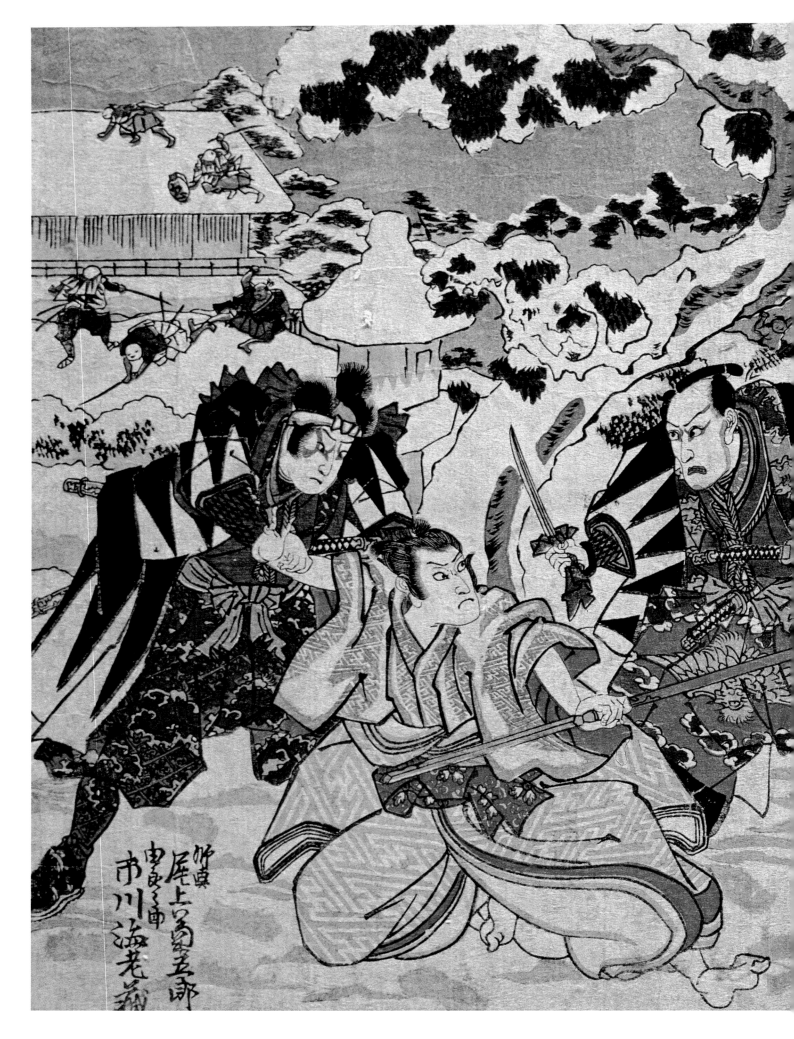

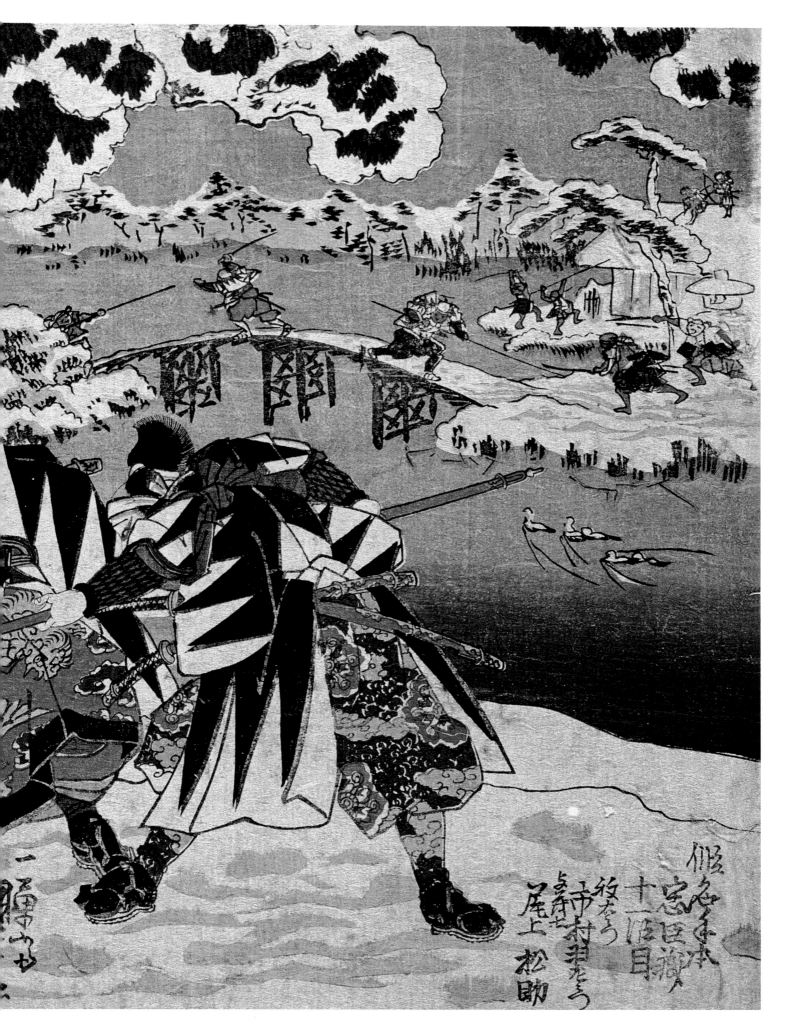

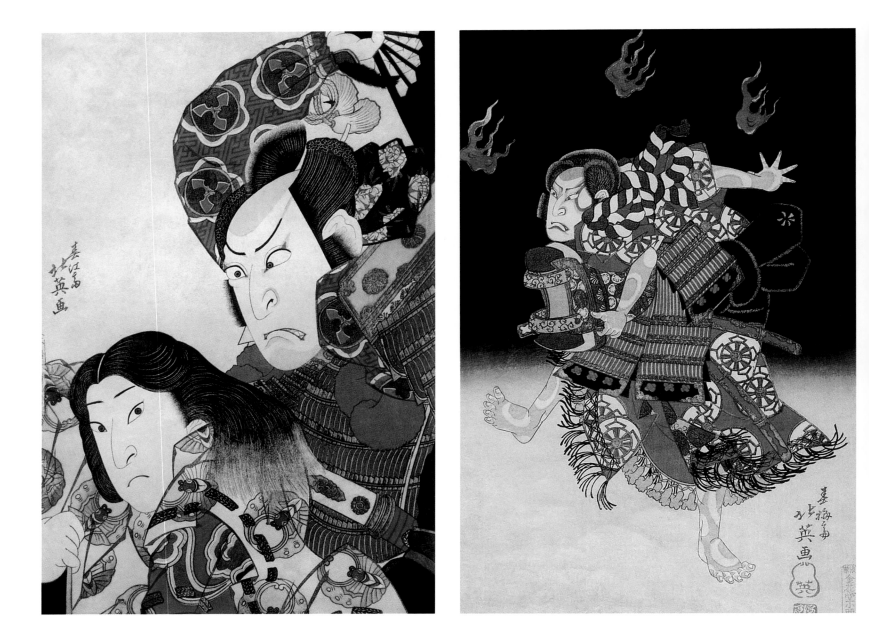

revivifying an art grown cold and academic, and frosted with tradition. The colouring of Kanō had faded, tending continually toward monochrome, but the Ukiyo-e painters restored the use of gorgeous pigments, preserving the glory of Kanō Yeitoku, the court painter to Hideyoshi.

In the middle of the seventeenth century appeared Hishikawa Moronobu, considered by many to be the real founder of Ukiyo-e. His genius welded with the new motif the use of the block for printing, an innovation which led to the most characteristic development in Ukiyo-e art. This art of printing, which originated in China and Korea, had, until the beginning of the seventeenth century, been confined solely to the service of religion for the reproduction of texts and images, but Moronobu conceived the idea of using the form of printed book illustration, just coming into vogue, as a channel to set forth

the life of the people. Besides painting and illustrating books, he began printing single sheets, occasionally adding to the printed outlines dashes of colour from the brush, principally in orange and green. These sheets, the precursors of the Ukiyo-e prints, superseded the *Otsu-e* – impressionistic hand-paintings, drafted hastily for rapid circulation. The *Otsu-e* were sometimes richly illuminated, the largest surfaces in the costumes being filled in with a ground of black lacquer, and ornamented with layers of gold leaf attached by varnish.

Moronobu acquired his technique from both Tosa and Kanō, but was originally a designer for the rich brocades and tissues woven in Kyoto. He added to this art that of embroidery, and leaving Kyoto, took up this branch at the rival city Edo, where all the arts and crafts were developing under the fostering care of the Tokugawa Shoguns, the dynasty

with which Ukiyo-e art is practically coextensive. It was he who designed for his countrywomen their luxurious trailing robes, with enormous sleeves, richly embroidered – gorgeous and stately garments which he loved to reproduce on paper, with marvellous powers of sweeping line. As in all fashions of dress, in time the graceful lines became exaggerated until, in the beginning of the nineteenth century, they overstepped the limits of beauty, and approached the realm of caricature. Today, in the modern poster, we see perpetuated the degenerate offspring of the genius of Moronobu, of whom it is remarked that his enlarged compositions have the plasticity of bas-reliefs.

An artist who greatly influenced Moronobu was Kanō Tanyu of the School of Kanō, whose masterpiece may be seen at the great temple in Kyoto – four

Shumbaisai Hokuei,
The Kabuki Actors Utaemon III and Iwai Shijaku I, 1832.
Colour woodblock print, 38 x 25.5 cm.
Victoria & Albert Museum, London.

Shumbaisai Hokuei,
The Actor Nakamura Shikan II as Tadanobu, 1835.
Colour woodblock print, 36.4 x 24.4 cm.
Victoria & Albert Museum, London.

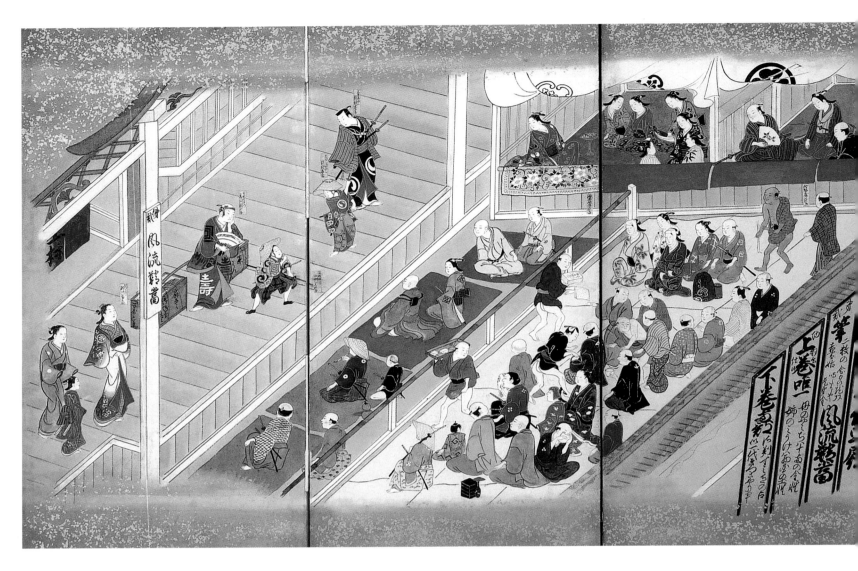

painted panels of lions of indescribable majesty. Under Tanyu's direction the task of reproducing the old masterpieces was undertaken. The artists of Ukiyo-e were always ready to profit by the teaching of all the schools; therefore, to properly follow the methods of the Popular School, we must study the work of the old masters and the subjects from which they derived their inspiration.

In this brief *résumé* we cannot follow the fluctuations of Japanese Art through the centuries. During long periods of conflict and bloody internecine strife, art languished; when peace reigned, then in the seclusion of their *yashikis* these fierce and princely warriors threw down their arms and surrendered themselves to the service of beauty and of art. Nor had the dainty inmates of their castles

languished idly during these stirring times. Often they defended their honour and their homes against treacherous neighbours. It was a Japanese woman who led her conquering countrymen into Korea. In the arts of peace the cultured women of Japan kept pace with their lovers and husbands. A woman revised and enlarged the alphabet, and some of the most beautiful classic poems are

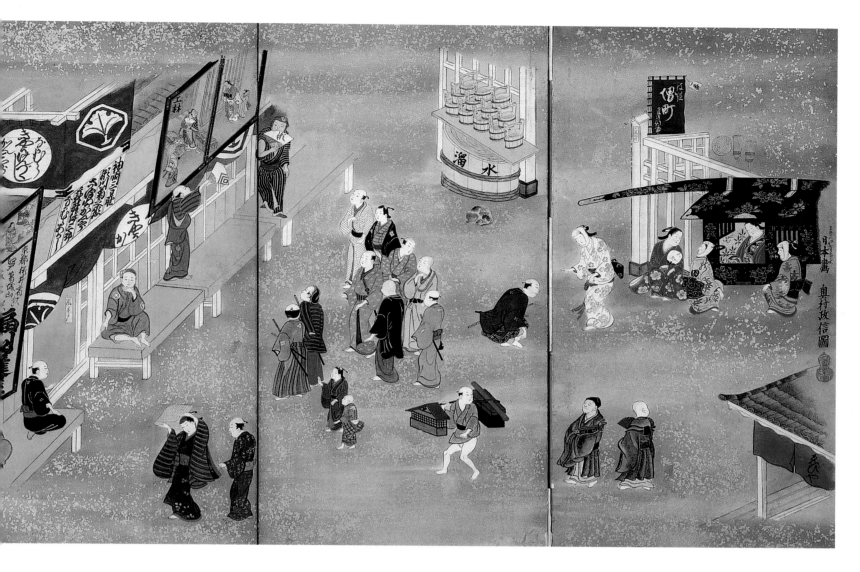

ascribed to them. Well might the Japanese fight fiercely for his altar and home, with the thought of the flower-soft hands that were waiting to strip him of his armour and stifle with caresses the recollection of past conflict. The early history of Japan suggests a comparison with ancient Greece, and the Japanese poets might have encapsulated their country, as did Byron the land of his adoption:

"The isles of Greece, the isles of Greece!
Where burning Sappho loved and sung,
Where grew the arts of war and peace –
Where Delos rose, and Phoebus sprung!"

Happily Japan, unlike Greece, withstood the enervating influences of luxury and the passionate adoration of beauty. Princes laboured alike with chisel and with brush, and the loftiest rulers disdained not the tools of the artisan. Art Industrial kissed Grand

Art, which remained virile beneath the sturdy benediction. Therefore Japan lives, unlike Greece, whose beauty in decay called forth that saddest of dirges, ending,

"'Tis Greece,
but living Greece no more."

In Japan, art lightens the burden of labour, utility and beauty go hand in hand, and the essential and the real reach upward, and touch the beautiful and the ideal.

Okuruma Masanobu,
Scene from the Nakamura Theatre, 1721.

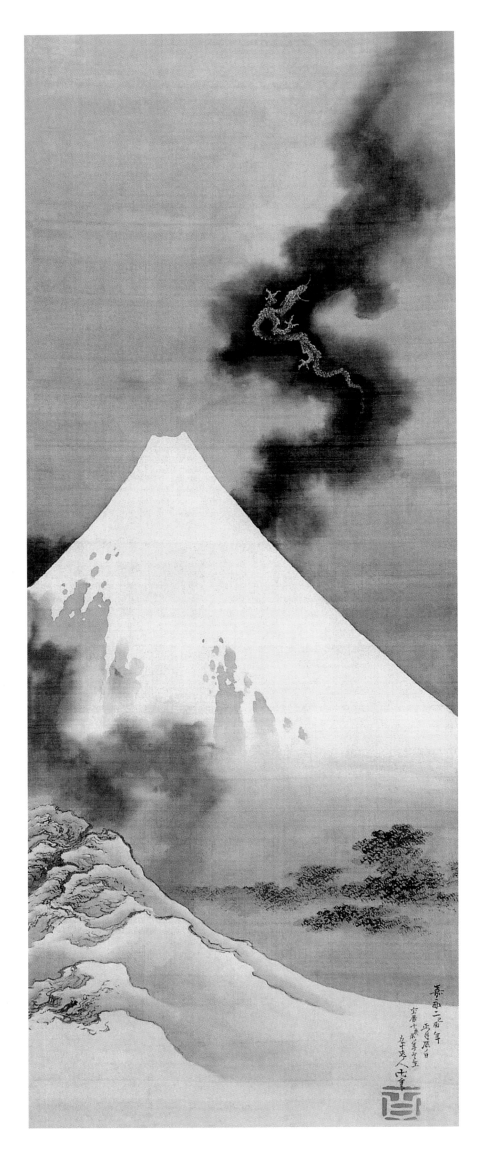

GENROKU.
THE GOLDEN ERA OF ROMANCE AND ART

The era of Genroku ("Original happiness"), from 1688 to 1703, was that period of incomparable glory which the Japanese revere – as the French do the time of Louis XIV. Peace had long reigned and art flourished under the fostering care of the Tokugawa Shoguns.

Then lived the great worker in lacquer, Ogata Korin, pupil of Sotatsu Tawaraya, the flower painter, both unrivalled artists who had absorbed the secrets of both Kanō and Tosa. Hanabusa Itcho, the grand colourist, flourished, and Ogata Kenzan, brother of Korin, the "Exponent in pottery decoration of the Korin School."

Edo (now Tokyo), the new capital of the usurping Tokugawas, now became the Mecca of genius, rivalling the ancient metropolis Kyoto, for the great Shoguns encouraged art in all forms, not disdaining to enrol themselves as pupils to the masters in painting and lacquer.

The greatest ruler became one of the greatest artists, even assuming the art title of Sendai Shogun. In this age the height of perfection was reached in metal work, both chased and cast.

"The sword is the soul of the Samurai," says the old Japanese motto, therefore its decoration and adornment was a sacred service to which genius delighted to dedicate itself. In Japan the greatest artists were sometimes carvers and painters and workers in metals in one, and suggest comparison with the European masters of two centuries earlier. Did not Botticelli take his name from the goldsmith for whom he worked, and Leonardo da Vinci began his art life by "twisting metal screens for the tombs of the Medici"?

Also in Japan, as in Europe, the genius of the nation was consecrated to the dead. More than half of Michelangelo's life was devoted to the decoration of tombs, and the shrines of the Shoguns are the greatest art monuments in Japan. Preoccupation with graves perhaps enabled the Japanese to face death so readily, even embracing it upon the slightest pretext.

Genroku was the acme of the age of chivalry. Its tales of deadly duels and fierce vendettas are the delight of the nation. The history of the forty-seven Ronin equals any mediaeval tale of bloodthirsty vengeance and feudal devotion. This Japanese vendetta of the seventeenth century is still re-enacted upon the stage, and remains the most popular drama of the day, and the actor designers of Torii delighted in it as a subject for illustration. A brief outline of the story may be of interest and serve to recall its charming interpretation by Mitford.

The cause of this famous drama of vendetta was the avarice of Kira Kozuke-no-Suke Yoshinaka, a courtier of the

Katsushika Hokusai,
Dragon Flying over Mount Fuji, 1849.
Hanging scroll, ink with light colour on silk,
95.8 x 36.2 cm.
The Hokusai Museum, Obuse.

Shogun at Edo. This pompous official was detailed to receive two provincial noblemen at his castle and instruct them in court etiquette. Asano Naganori Takumi-no-Kami and Kamei Sama had been assigned the onerous task of entertaining the Emperor's envoy from Kyoto. In return for this tutelage they duly sent many gifts to Kira, but not costly enough to gratify the rapacity of the minister, who day by day became more insufferably arrogant, not having been "sufficiently insulted".

Then a counsellor of one of these great lords, Kamei, being wise in his generation, and fearing for his master's safety, rode at midnight to the castle of the greedy official, leaving a present or bribe of a thousand pieces of silver. This generous donation had the desired effect.

"You have come early to court, my lord," was the suave welcome the unconscious nobleman received the next morning. "I shall have the honour of calling your attention to several points of etiquette today." The next moment the countenance of Kira clouded, and, turning haughtily toward his other pupil from whom no largesse had been received, he cried, "Here, my lord of Takumi, be so good as to tie for me the ribbon of my sock," adding under his breath, "boor of the provinces".

"Stop, my lord!" cried Asano Naganori Takumi-no-Kami, and, drawing his dirk, he flung it at the insolent nobleman's head. Then a great tumult arose. His court cap had saved Kira from death, and he fled from the spot, whilst Asano was arrested, and to divert the disgrace of being beheaded, hastily performed *seppuku*; his goods and castle were confiscated and his retainers became Ronin (literally "Wave Men"), cast adrift to follow their fortunes, roving at will.

The vendetta, sworn to and carried out by these forty-seven faithful servants, is the sequel of the story. Oishi Kuranosuke Yoshio, the chief of the Ronin, planned the scheme of revenge. To put Kira off his guard, the band dispersed, many of them under the disguise of workmen taking service in the *yashiki* of their enemy in order to become familiar with the interior of the fortification.

Meanwhile Oishi, to further mislead his enemies, plunged into a life of wild dissipation, until Kira, hearing of his excesses, relaxed his own vigilance, only keeping half the guard he had at first appointed. The wife and friends of Oishi were greatly grieved at his loose conduct, for he took nobody into his confidence. Even a man from Satsuma, seeing him lying drunk in the open street, dared to kick his body, muttering, "Faithless beast, thou givest thyself up to

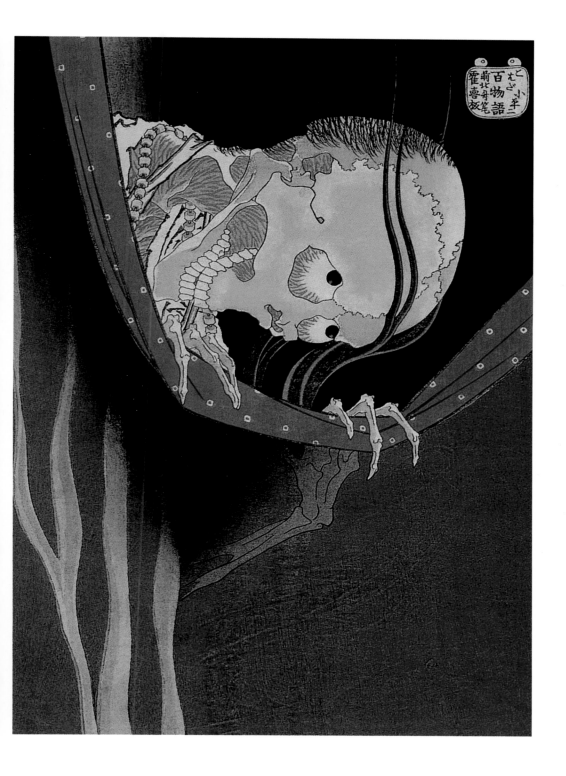

women and wine, thou art unworthy of the name of a Samurai."

But Oishi endured the arrogant remarks, biding his time, and at last, in the winter of the following year, when the ground was white with snow, the carefully planned assault was successfully attempted. The castle of Kira was taken, but what was the consternation of the brave Ronin, when, after a prolonged search, they failed to discover their victim! In despair, they were about to despatch themselves, in accordance with their severe code of honour, when Oishi, pushing aside a hanging picture, discovered a secret courtyard. There, hidden behind some sacks of charcoal, they found their enemy, and dragged him out, trembling with cold and terror, clad in his costly night robe of embroidered white satin. Then humbly kneeling, Oishi thus addressed him: "My lord, we

Katsushika Hokusai,
Phantom of Kohada Koheiji,
from the series *One Hundred Ghost Stories*, 1831.
Colour woodblock print, 25.8 x 18.5 cm.
Musée Guimet, Paris.

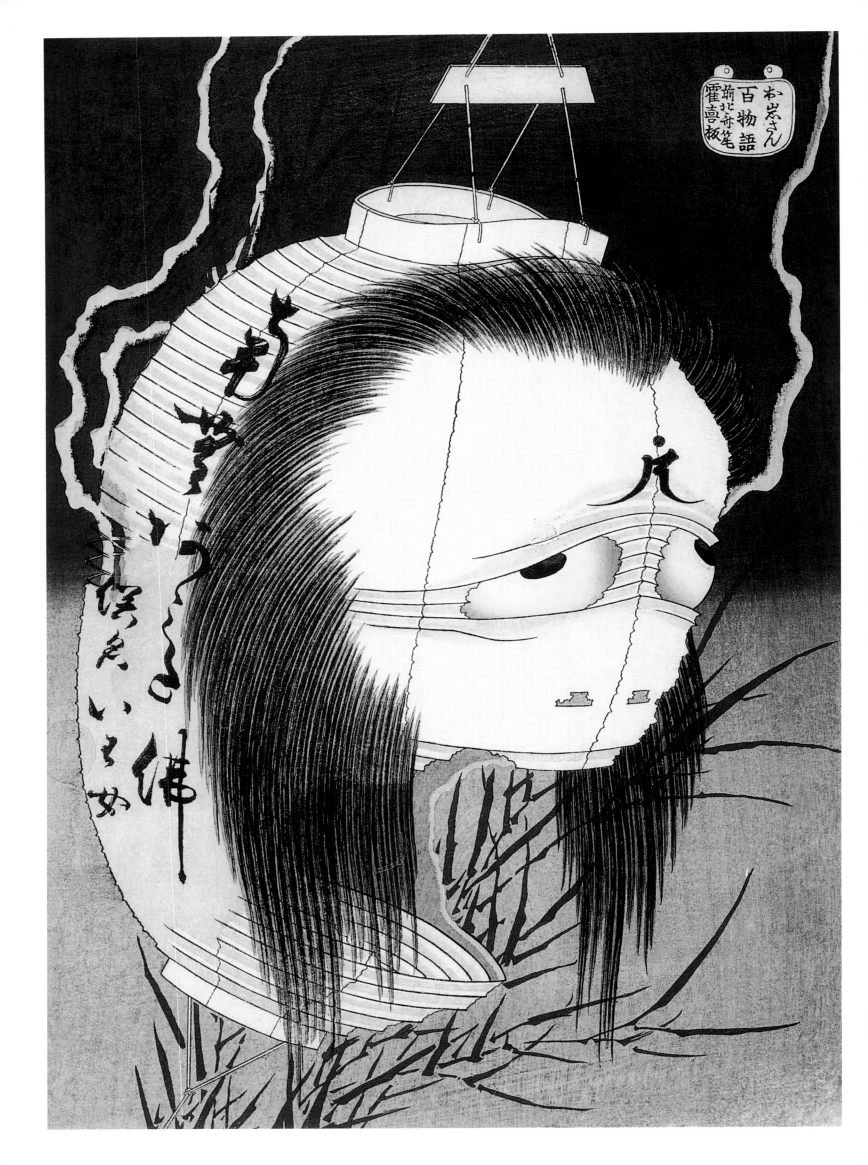

beseech you to perform *seppuku*. I shall have the honour to act as your lordship's second, and when, with all humility, I shall have received your lordship's head, it is my intention to lay it as an offering upon the grave of our master, Asano Naganori Takumi-no-Kami." Unfortunately, the carefully planned programme of the Ronin failed to recommend itself to Kira, and he declined their polite invitation to disembowel himself, whereupon Oishi at one stroke cut off the craven head, with the blade used by his master in taking his own life.

So in solemn procession the forty-seven Ronin, bearing their enemy's head, approached the Temple of Sengakuji, where they were met by the abbot of the monastery, who led them to their master's tomb. There, after washing in water, they laid it, thus accomplishing the vendetta; then, praying for decent burial and for masses, they took their own lives.

Thus ended the tragic story, and visitors to the temple are still shown the receipt given by the retainers of the son of Kira for the head of their lord's father, returned to them by the priest of Sengakuji. Surely it is one of the weirdest relics to take in one's hand, this memorandum, its simple wording adding to its horror:

Item – One head.
Item – One paper parcel, and then the signatures of the two retainers beneath.

Another manuscript is also shown in which the Ronin addressed their departed lord, laying it upon his tomb. It is translated thus by Mitford:

"The fifteenth year of Genroku, the twelfth month, and fifteenth day. We have come this day to do homage here, forty-seven men in all, from Oishi Kuranosuke Yoshio, down to the foot soldier, Terasaka Kichiyemon, all cheerfully about to lay down our lives on your behalf. We reverently announce this to the honoured spirit of our dead master. On the fourteenth day of the third month of last year our honoured master was pleased to attack Kira Kozuke-no-Suke Yoshinaka, for what reason we know not. Our honoured master put an end to his own life, but Kira lived. Although we fear that after the decree issued by the Government, this plot of ours will be displeasing to our master, still we who have eaten of your food could not without blushing repeat the verse. 'Thou shalt not live under the same heaven nor tread the same earth with the enemy of thy father or lord,' nor could we have dared to leave hell and present ourselves before you in paradise, unless we had carried out the vengeance which you began. Every day that we waited seemed as three autumns to us.

Katsushika Hokusai,
Oiwa's Spectre,
from the series *One Hundred Ghost Stories*, 1831.
Hand-coloured woodblock print, 26.2 x 18.7 cm.
Musée Guimet, Paris.

Verily we have trodden the snow for one day, nay for two days, and have tasted food but once. The old and decrepit, the sick and ailing, have come forth gladly to lay down their lives. Having taken counsel together last night, we have escorted my lord, Kira, hither to your tomb. This dirk by which our honoured lord set great store last year, and entrusted to our care, we now bring back. If your noble spirit be now present before this tomb, we pray you as a sign to take the dirk, and striking the head of your enemy with it a second time to dispel your hatred forever. This is the respectful statement of forty-seven men."

There were forty-seven Ronin. Why, then, do forty-eight tomb-stones stand beneath the cedars at Sengakuji? Truly the answer has caused tears to fall from the eyes of many a visiting pilgrim, for the forty-eighth tomb holds the body of the Satsuma man, who in an

agony of grief and remorse ended his life, and was buried beside the hero, whose body he had scornfully trampled upon in the streets of sacred Kyoto.

This history of the forty-seven Ronin is an epitome of Japanese ethics, for in it is exemplified their feudal devotion, their severe code of honour, their distorted vision of duty and fealty to a superior, justifying the most lawless acts. Thus the conduct of Oishi Kuranosuke during his wild year of reckless abandonment, in which he threw off all moral restraint in order to deceive his enemy, breaking the heart of his faithful and devoted wife, was considered by his countrymen meritorious and a proof of his devotion. The Ukiyo-e artists, who loved to take for models the beautiful denizens of the "Underworld," chose this obsession of Oishi as the subject for many of their illustrations, so that at a first glance the series might almost be mistaken for

scenes from the life of the Yoshiwara.

Here and there, however, we come across the Ronin engaged in terrific conflict with Kira Kozuke-no-Suke Yoshinaka's retainers. Cruel and bloodthirsty are the blades of their relentless katanas, which once unsheathed must be slaked in human blood, and their garments, slashed into stiletto-like points of inky blackness, forming a *cheveaux de frise* round their fierce faces, seem to scintillate with the spirit of vendetta.

In examining the sets of impressions, illustrating the popular story, it is hard to give preference to any special artist: to choose between the Utamaro-like violets and greens of Yeisen; the rich dark tints and fine backgrounds of Kunisada; the delicately massed detail of Toyokuni, unlike the usual boldness of his style, and the varied sword-play of the versatile

Torii Kiyomasu I,
Ichikawa Danjūrō I as Soga Gorō, 1697.
Hand-coloured woodblock print, 54.7 x 32 cm.
Tokyo National Museum, Tokyo.

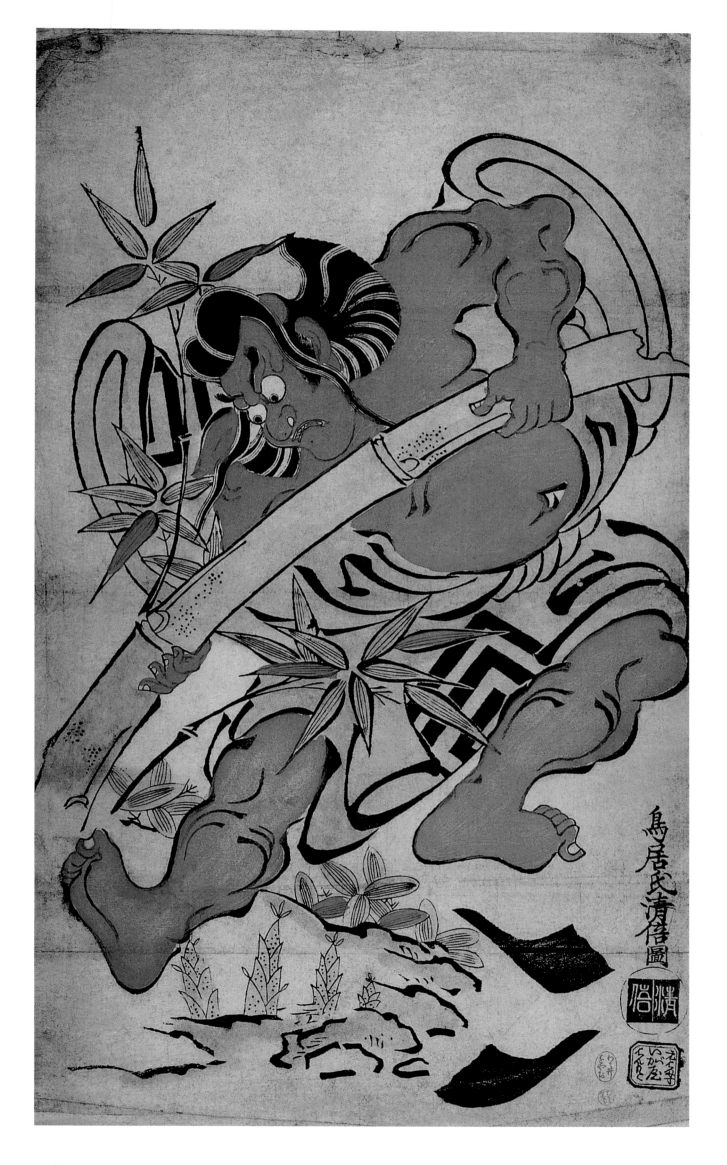

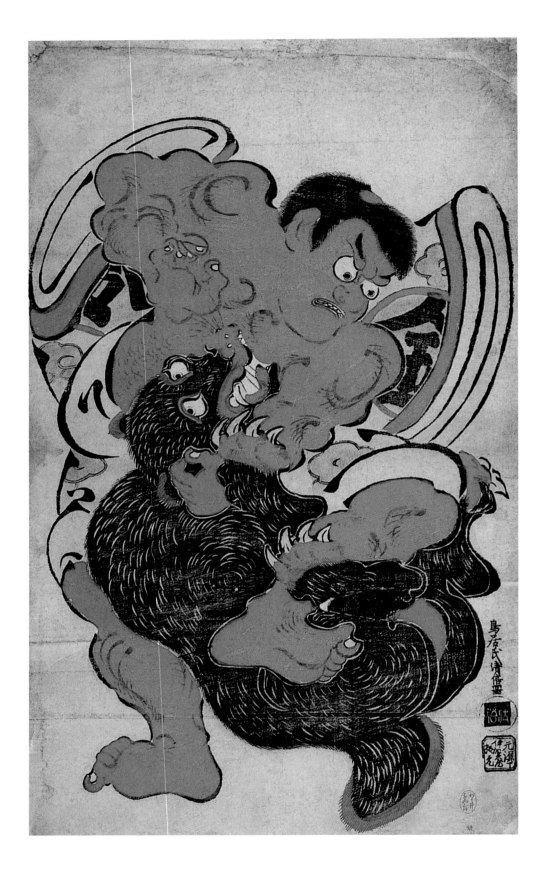

Hiroshige, set in a frosted, snowy landscape. Hokusai, who abjured theatrical subjects after breaking away from the tutelage of Shunshō, published a series of prints illustrating the famous vendetta, but as his great-grandfather had been a retainer of Kira Kozuke-no-Suke Yoshinaka, losing his life during the midnight attack, the story formed part of his ancestral history. The series is signed Kako, and the sweeping lines and contours of the female figures show the Kiyonaga influence. Yellow preponderates, outlining the buildings and long interior vistas, and the impressions are framed with a singular convention of Hokusai at that period, drifting cloud effects in delicate pink. Utamaro also illustrated the story, substituting 'for the Ronin the forms of women, a favourite conceit of the artist of beauty.

This digression in favour of the masters of the Popular School

Torii Kiyomasu I,
Kintoki and the Bear, c. 1700.
Hand-coloured woodblock print, 55.2 x 32.1 cm.
Honolulu Academy of Arts, gift of James A.
Michener, Honolulu.

has carried us over a hundred years, and we must return to the close of the seventeenth century. Moronobu illustrated the carnival of Genroku, but toward the end of the century, under the domination of a Shogun who combined the qualities of extravagance and profligacy with the delirious superstition of Louis XI, a period of unbridled license set in. The military men, who were the nation's models, forgot their fine traditions and fell from their estate, so that the latter manners and customs of Genroku became a by-word. Then followed a puritanical reaction. Under the eighth Shogun, the knights were restricted from attending the theatre, just coming into favour, and the looser haunts of pleasure were strictly under ban. The Ukiyo-e print, being the medium for illustrating these joys and pleasures, forbidden to the great, but still indulged in by the people, was strictly condemned,

and to this day the aristocracy of Japan accord but grudging and unwilling recognition to the merits of the masters of Ukiyo-e, the old caste prejudice still blinding their artistic sense.

At this stage Ukiyo-e broke into rival schools, the founders of both belonging to the academy of Hishikawa Moronobu. The leader of the first, the school of painting, was Miyagawa Chōshun, who in order to preserve aristocratic patronage and praise, eschewed the use of the printing-block, still taking his subjects from the "floating world," and so being in one sense at unity with the other branch, that of printing founded by Torii Kiyonobu, the first master of the great Torii School. As the print artists are our subject matter we cannot follow the other branch of Ukiyo-e, founded by Miyagawa Chōshun, but leaving the atelier of the painters, we must devote ourselves to the fortunes of the Torii School, the

laboratory of the Ukiyo-e print, working parallel with the pictorial school for the first half of the eighteenth century.

The first sheets of Torii Kiyonobu (about 1710) were printed in ink from a single block. Part of the edition would be issued in this uncoloured form, the rest being coloured by hand. The colours most used were olive and orange, these prints being called *Tan-e,* whilst those in ink were named *Sumi-e. Urushi-e* (lacquer pictures), was the generic term for hand-painted prints. *Beni-e* (literally red pictures) followed the *Urushi-e.* They were printed in two tones, rose and pale green, enforced by black, a harmony exquisite in delicacy. The use of the multiple colour blocks gave rise to the title *Nishiki-e,* or brocade paintings. The national mania for the stage induced Kiyonobu and his followers to take for their subjects popular actors, and the theatrical

poster may be said to date from the decade following Genroku.

Later in the century the process of colour-printing by the substitution of blocks for flat colours was gradually evolved, and to no special artist or engraver can the credit be given, for all contributed to its development, though the genius of Suzuki Harunobu drew to a focus in 1765 the achievements of his brother artists, and it was he who solved the problem of uniting the skill of the engraver with the full palette of Miyagawa Chōshun and his follower Miyagawa Shunsui, thus uniting the two branches of Ukiyo-e art.

The Popular School, however, is bound up with print development. Japanese book illustration and single-sheet printing revolutionised the world's art. The great connoisseurs of colour tell us that nowhere else is anything like it, so rich and so full, that a print comes to have every quality of a complete painting.

The other leaders of the Torii School were Torii Kiyomasu and Okumura Masanobu, namesake of the great founder of Kanō, who must not be confused with the later artist of the same name, belonging to the school of Kitao. Masanobu deserves special mention, for his style being chiefly pictorial, and his subjects not confined to the stage, he formed a link between the painters' atelier and his own. He realised that book prints rather than actor prints ought to be the most potent force of Ukiyo-e.

Nishimura Shigenaga followed in the footsteps of Masanobu, but his fame is eclipsed by that of his great pupil Suzuki Harunobu, whose genius was displayed not only by the introduction of new colours upon the printing-block, but by his schemes of arrangement, juxtaposition of shades, and marvellous handling

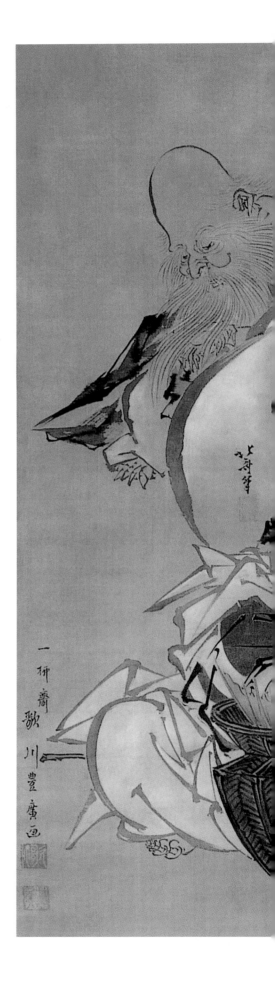

Katsushika Hokusai,
Seven Gods of Good Fortune, 1810.
Ink, colours and gold on silk, 67.5 x 82.5 cm.
Museo d'Arte Orientale Edoardo Chiossone, Genoa.

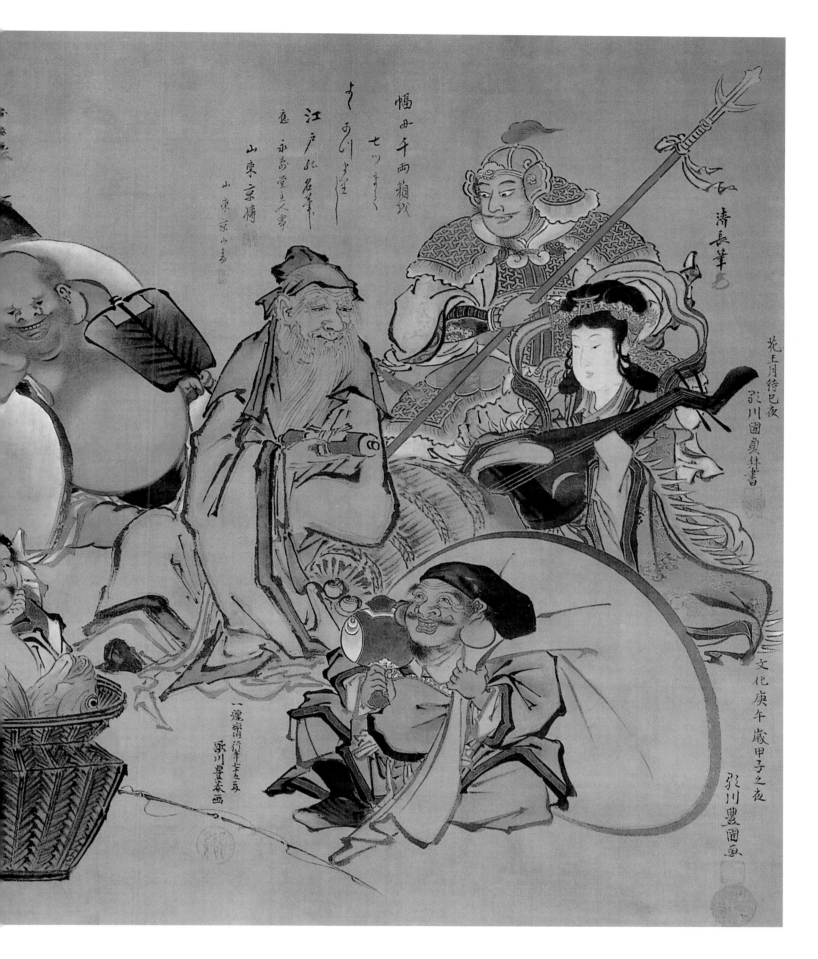

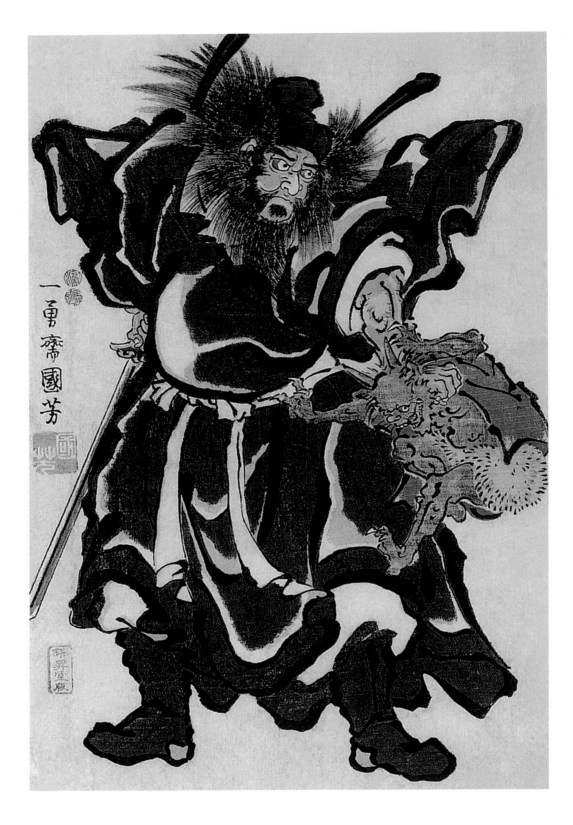

of the areas between the printed outlines. This restriction of measured spaces does not cramp the painter's individuality and sweep of brush; rather, they set him free to concentrate his genius upon blended harmonies, and interwoven schemes of colour, and to surrender himself to the intoxication of the palette.

Harunobu revolutionised the status of the Popular School, pronouncing this dictum, "Though I am a worker in prints I shall hereafter style myself 'Yamato Yeishi'", the title assumed by the ancient court painters. A national painter he declared himself, let him deny who dare, working through the new medium of the despised and ostracised Ukiyo-e print from which he determined to remove the stigma of vulgarity.

Now we see a strange transposition in the aims of the popular artists. Harunobu, though a pupil of Shigenaga, the printer, took for his models the subjects of the painter Shunsui, successor to Miyagawa Chōshun, and by rejecting stage motives discarded the Torii tradition. From Shunsui, Harunobu borrowed the ineffable grace and refinement which breathe from the forms of his women, from the painter he stole colour harmonies and designs with landscape backgrounds, which the Torii School had hitherto ignored.

The introduction of genre painting, though attributed by Walter Pater to Giorgione, applies equally to the work of Harunobu and his follower Isoda Koryūsai. "He is the inventor of genre, of those easily movable pictures which serve neither for uses of devotion nor of allegorical or historical teaching: little groups of real men and women, amid congruous furniture or landscape, morsels of actual life, conversation or music or play, refined upon and idealised till they come to seem like glimpses of life from afar. People may move those spaces of cunningly blended colour readily and take them with them where they go, like a poem in manuscript, or a musical instrument, to be used at will as a means of self-education, stimulus or solace, coming like an animated presence into one's cabinet, and like persons live with us for a day or a lifetime." Must not such an influence have descended upon Whistler when, saturated with the atmosphere of Hiroshige, he imagined that most beautiful of his "Nocturnes" described by Theodore Child as "a vision in form and colour, in luminous air, a Japanese fancy realised on the banks of the grey Thames"?

Utagawa Kuniyoshi,
Zhong Gui, 1847-1852.
Colour woodblock print, 35.4 x 23.5 cm.
Musée Guimet, Paris.

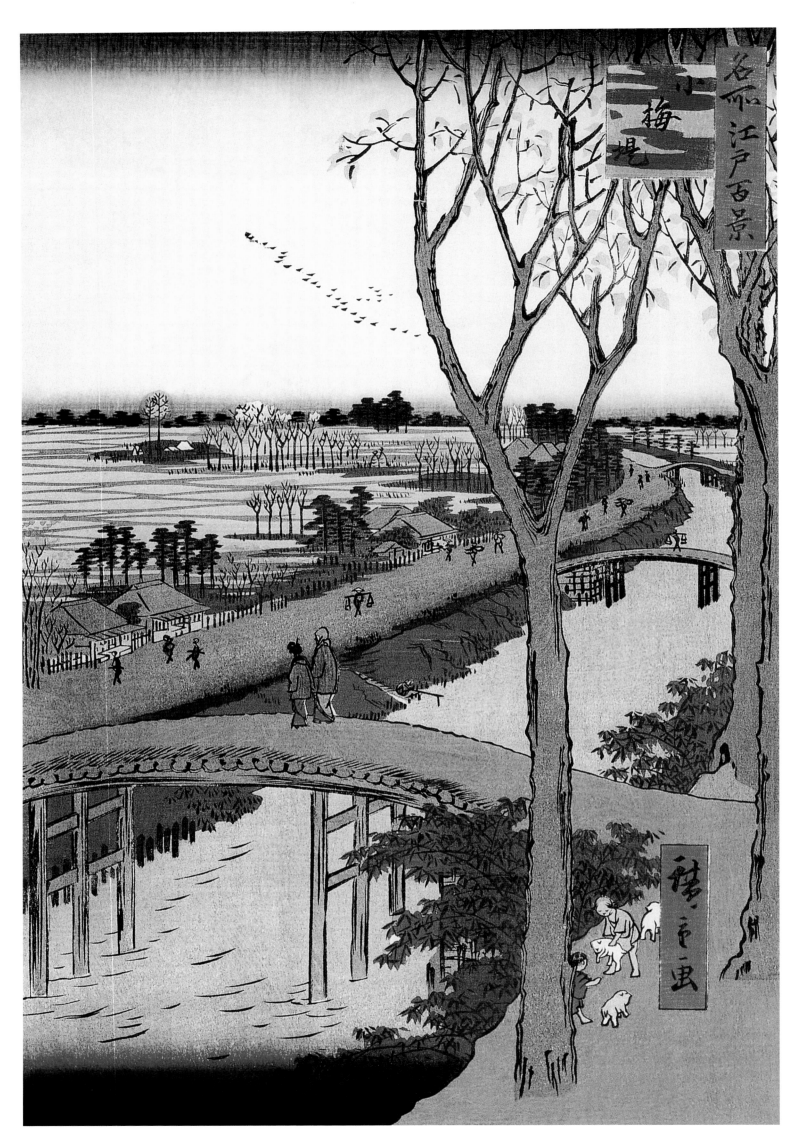

THE SCHOOL OF TORII.
THE PRINTERS' BRANCH OF UKIYO-E

The Torii School was pre-eminently the exponent of drama. It was bound up with stage development and ministered to the emotional temperament of the nation; leading in what may be considered a national obsession, a mania for actors and actor-prints.

A fascinating subject is this century of dramatic evolution fostered by the printers' branch of the Popular School. Actors had been consigned, in dark feudal days, to the lowest rung in the ladder of caste, ranking next to the outcast *(Eta)*, as in early English days the strolling player was associated with tinkers and other vagrant populations.

The *No Kagura* and lyric drama – suggesting the mediaeval- and passion-plays of Europe – prefigured modern drama in Japan, but the immediate precursor of the present theatre was the Puppet Show, a Japanese apotheosis of European marionette performances. It is interesting to note that Toyokuni carried further than any one the power of

mimetic art, and with whose theatrical scenes we are most familiar. He began his career as a maker of dolls, and these puppets were eagerly sought after as works of art.

If the aphorism "not to go to the theatre is like making one's toilet without a mirror," be true, then the Japanese are justified in their national passion for the stage, which overshadows the love of any other amusement. Taking the phrase literally, it was to the actors, and the printers who broadcast their pictures, that the people owed the aesthetic wonders of their costume. The designers were also artists, as instanced by Hishikawa Moronobu, the Kyoto designer and Edo embroiderer, the printer and painter, illustrator of books and originator of Ukiyo-e.

Enthusiasm for the portraits of actors, fostered by the Torii printers from the foundation of the school by Kiyonobu, in about 1710, hastened no doubt the development of colour-printing. As early as Genroku, the portrait of

Danjūrō the second of the great dynasty of actors, who by their genius helped to brighten the fortunes of the playhouse, was sold for five Yen cash, in the streets of the capital.

The combined genius of the artists, engravers and printers of Ukiyo-e evolved and perfected the use of the multiple colour-blocks. Toward the middle of the century, under the waning powers of Torii Kiyomitsu, successor to Kiyonobu, the school seemed to be sinking into oblivion, for Harunobu, its rightful exponent, filled with visions of ethereal refinement, scorned the theatrical arena. When most needed, however, a prophet arose in the person of Shunshō, the painter, the pupil of Shunsui and master of Hokusai, thus completing the transformation begun by Harunobu. The great scions of the rival branches of Ukiyo-e, printing and painting, stepped into each other's places and bridged the chasm, which threatened the unity of the Popular School.

Utagawa Hiroshige,
The Koume Embankment, February 1857.
Colour woodblock print, 36 x 24 cm.
Brooklyn Museum of Art, New York.

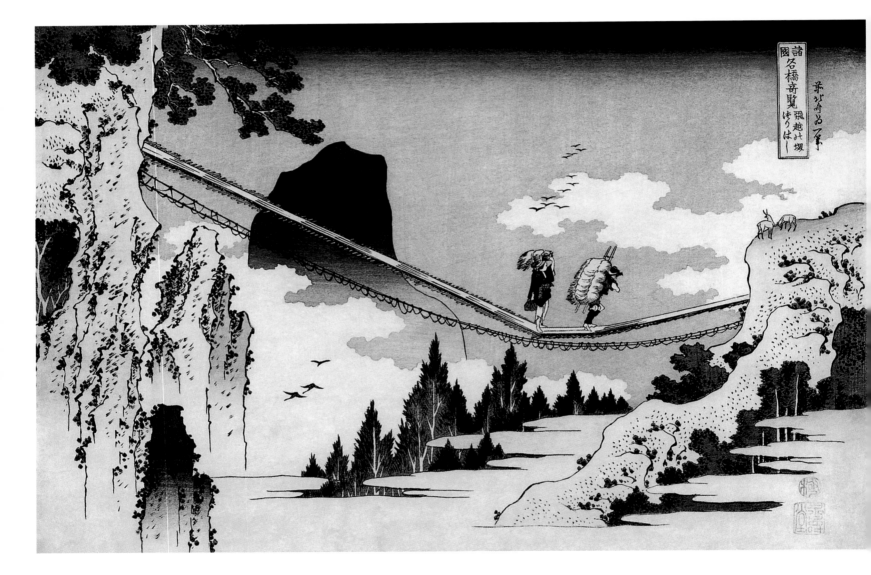

Katsushika Hokusai,
*Farmers Crossing a Suspension Bridge, on the Border of
Hida and Etchu Provinces,* from the series *Famous
Bridges of Various Provinces*, 1834.
Colour woodblock print, 26 x 38.3 cm.
Pulverer Collection, Cologne.

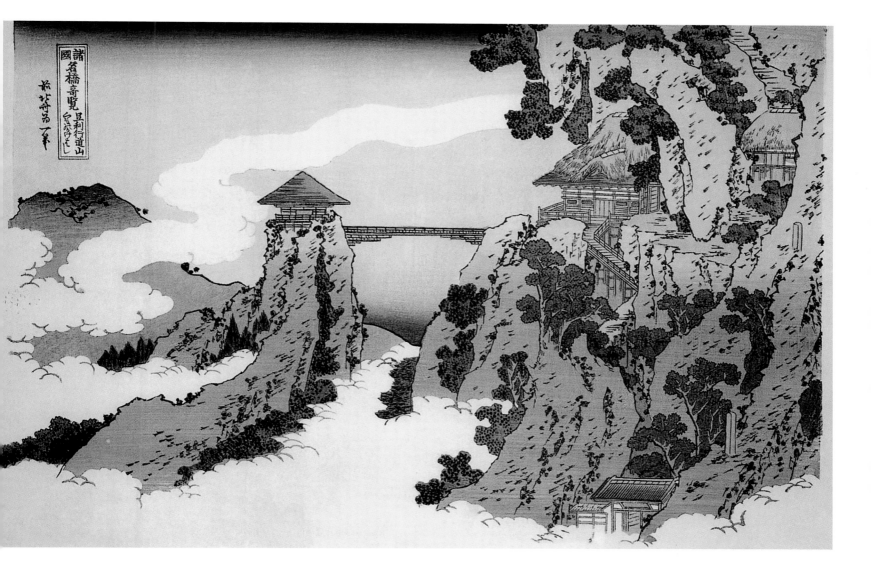

Katsushika Hokusai,
Suspension Bridge on the Mount Gyōtō, next to Ashikaga,
from the series *Famous Bridges of Various Provinces*,
c. 1834.
Colour woodblock print, 25.7 x 38.4 cm.
Tokyo National Museum, Tokyo.

Both branches were united, however, in the use of multiple colour-blocks, although Shunshō followed Harunobu's experiments in colouring, varying his actor designs with domestic scenes and book illustrations, whilst Harunobu resolutely refused to portray the life of the stage, and in this determination he was followed by his pupil and successor, Koriusai.

About 1765, the art of printing colours by the use of individual blocks, technically called chromo-xylography, was perfected. It is an interesting reflection, from the standpoint of Buddhism – which teaches that in the fullness of time, the great masters in religion, art and learning become reincarnated upon earth for the benefit of humanity, that at this period Hokusai was born, the crowning glory and master of Ukiyo-e. Had he appeared earlier in the century, his genius might have been diverted to the technical development of printing, and the world thus been the loser of his creative flights.

Professor Fenollosa beautifully defines the inception of the Ukiyo-e print as "the meeting of two wonderfully sympathetic surfaces – the un-sandpapered grain of the cherry-wood block, and a mesh in the paper, of little pulsating vegetable tentacles. Upon the one, colour can be laid almost dry, and to the other it may be transferred by a delicacy of personal touch that leaves only a trace of tint balancing lightly upon the tips of the fibres. And from the interstices of these printed tips, the whole luminous heart of the paper wells up from within, diluting the pigment with a soft golden sunshine. In the Japanese print we have flatness combined with vibration."

The process of wood-cutting seems a simple art, but a close study of the making of prints will show the consummate skill required to produce them. The artist's design was transferred by tracing paper, then pasted on to the face of the wood block, and the white space hollowed out with a knife and small gouges. After the block had been inked, a sheet of damp paper was laid upon it, and the back of the paper was then rubbed with a flat rubber till the impression was uniformly transferred. Where more than one block was employed, as in colour-printing, the subsequent impressions were registered by marks made at the corners of the paper. The colouring matter laid upon these early blocks was extracted by mysterious processes from sources unknown to the Western world, which, alas by supplying the Eastern market with cheap pigments, led to the deterioration of this essential skill.

From 1765 to 1780 the school of Ukiyo-e was dominated by four great artists and creators of separate styles: Suzuki Harunobu, succeeded by Isoda Koryūsai, taking for motive the subjects of Shunsui; Katsukawa Shunshō (changed by Shunsui

Keisai Eisen,
Landscape under the Moon, c. 1835.
Colour woodblock print, 71.9 x 24.9 cm.
Baur Collection, Geneva.

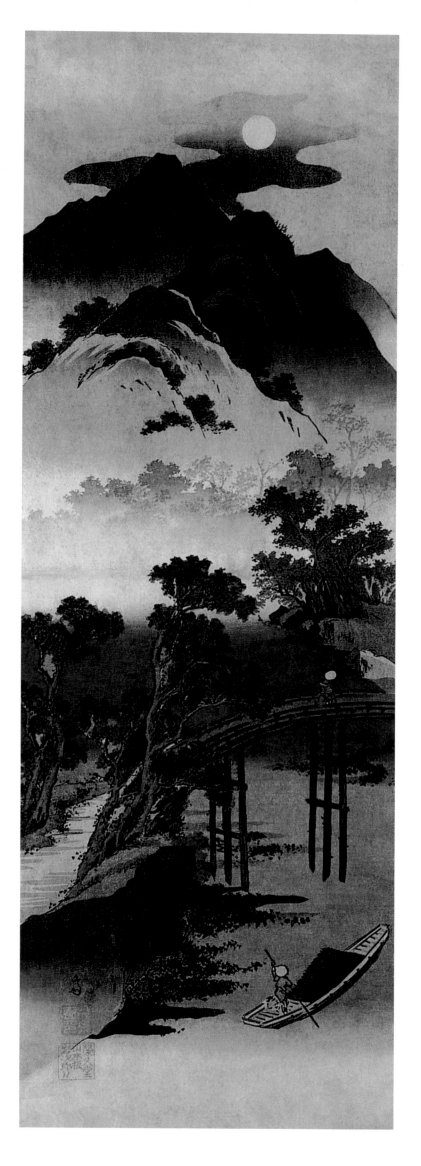

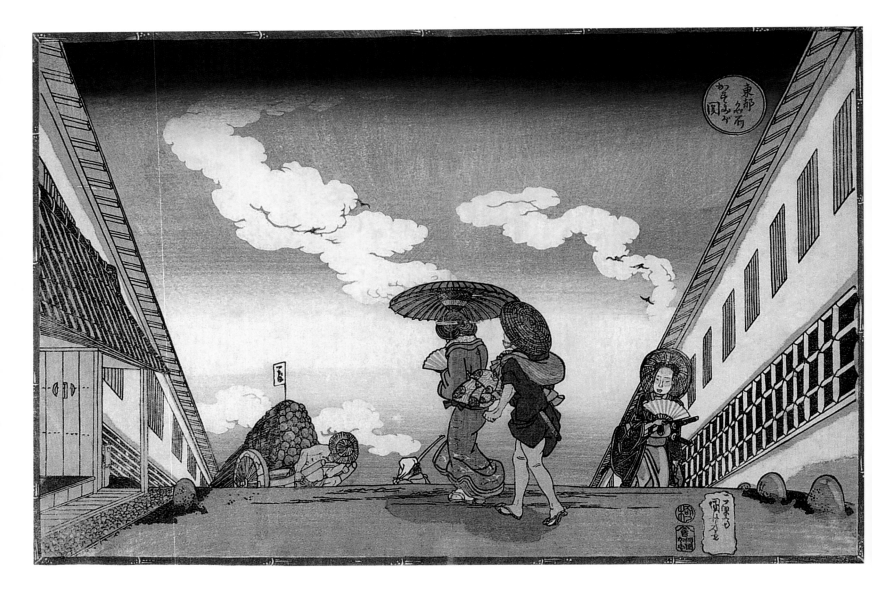

Utagawa Kuniyoshi,
Kasumigaseki, from the series *Famous Places of the*
Oriental Capital [Edo], c. 1830-1844.
Colour woodblock print, 25.6 x 37.7 cm.
Chiba Art Museum, Chiba.

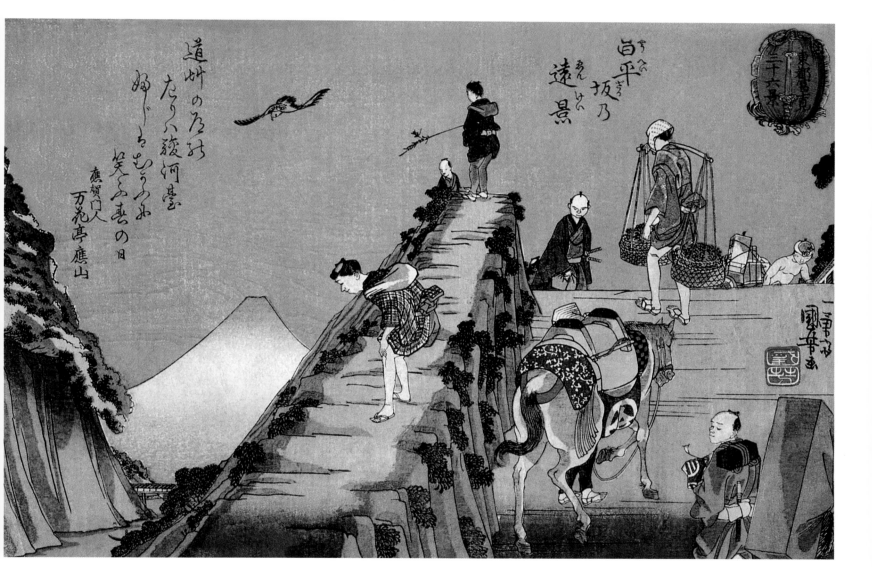

Utagawa Kuniyoshi,
Distant View of Mount Fuji from Shōhei Hill, from the
series *Thirty-Six Views of Mount Fuji from Edo*,
c. 1843.
Colour print from woodblocks, 38 x 25.5 cm.
Victoria & Albert Museum, London.

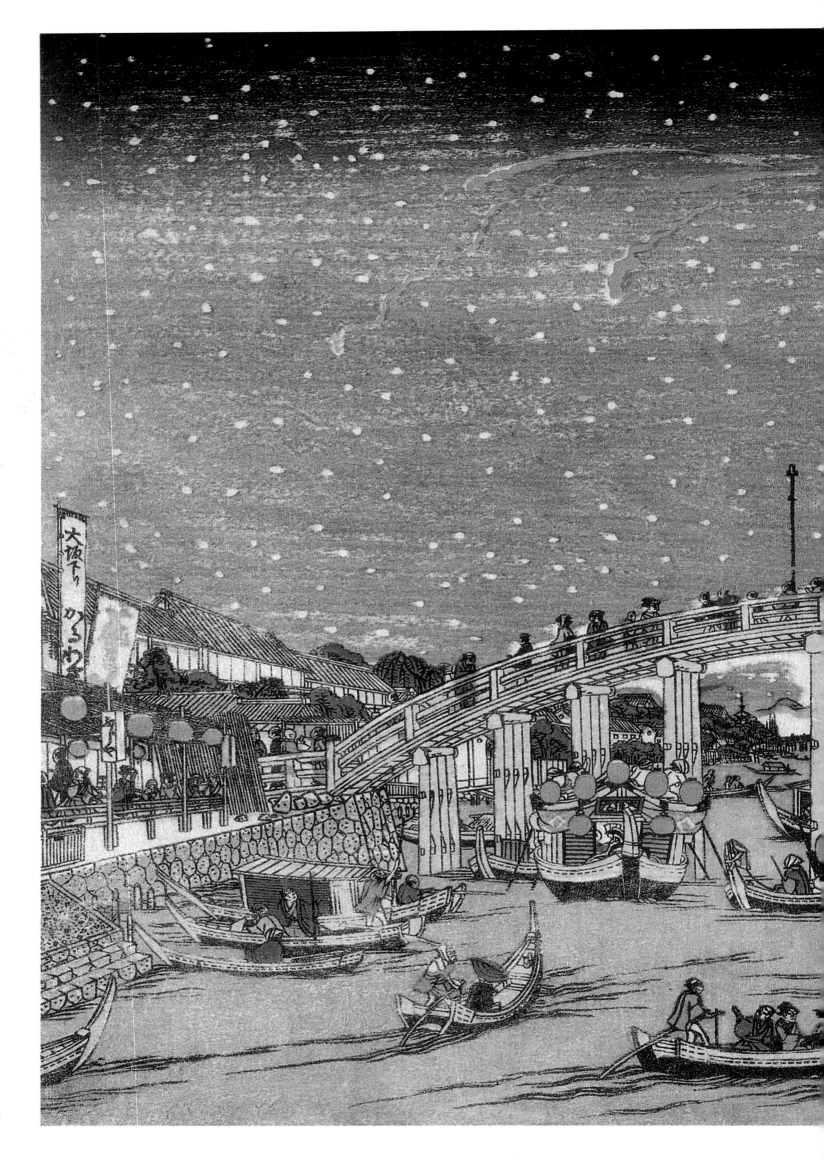

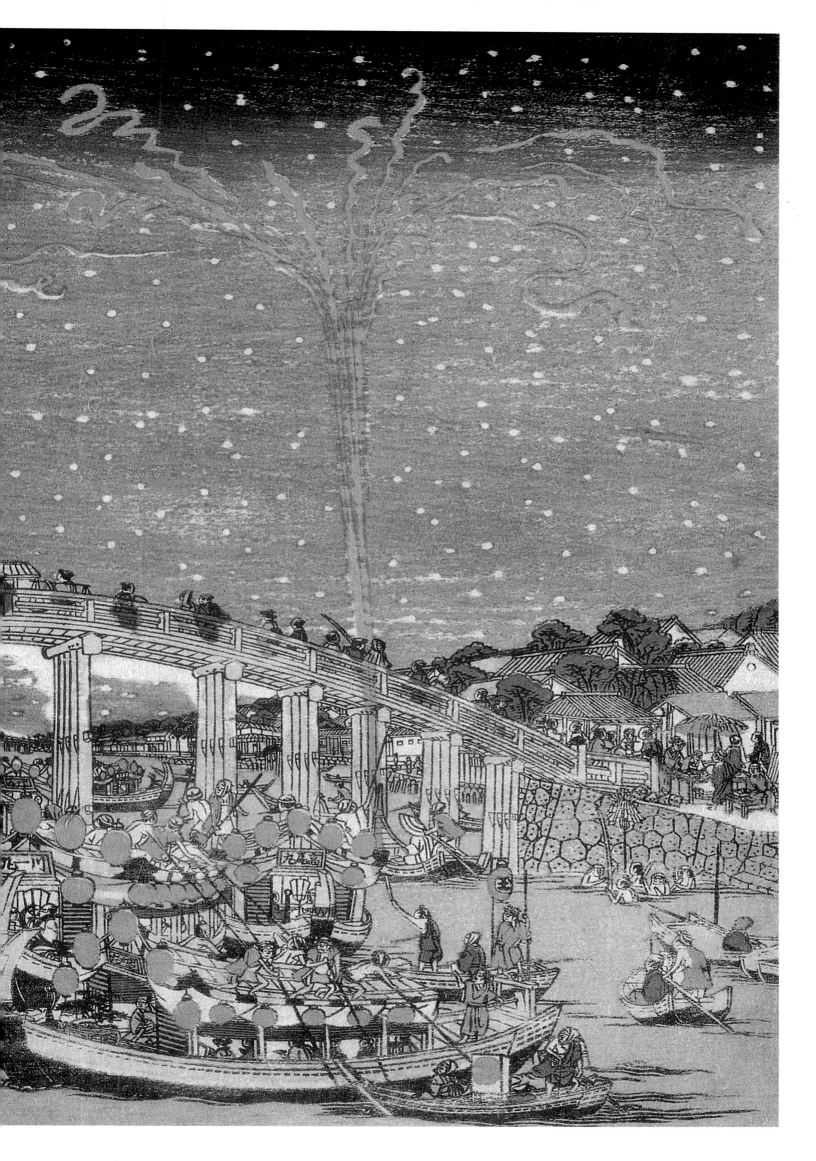

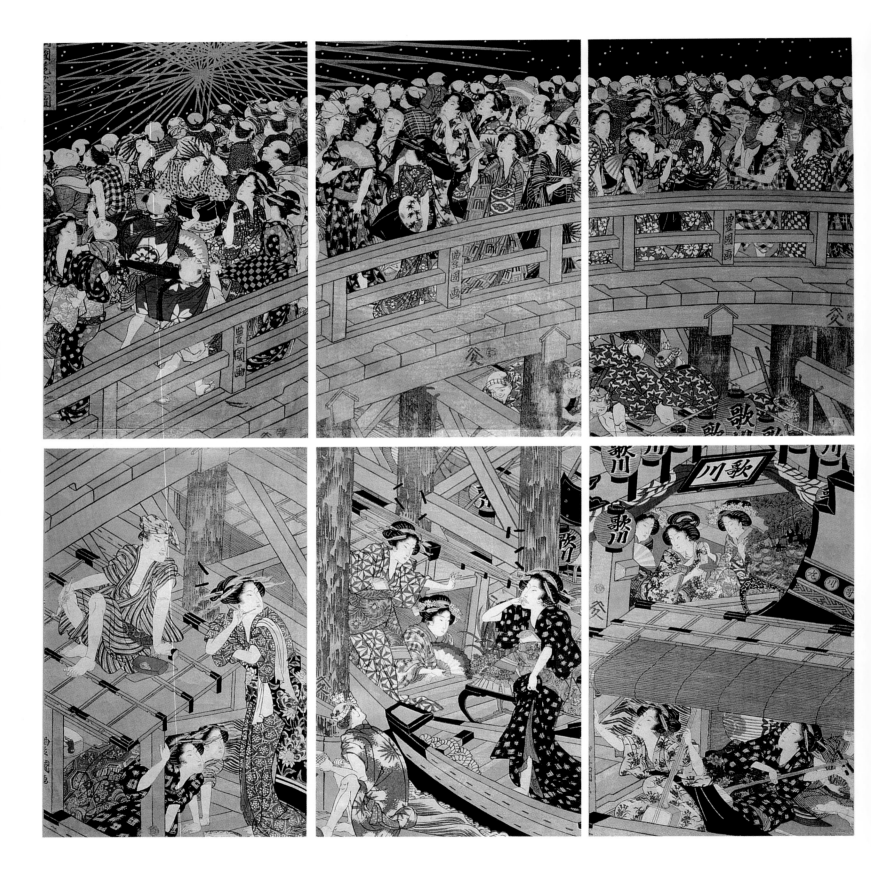

from its former title of Miyagawa), upon whose shoulders had fallen the mantle of the Torii; Kitao Shigemasa, working upon Shunshō's lines, but breaking into a rival academy, the Kitao; Utagawa Toyoharu, pupil of old Torii Toyonobu, founder of the school of Utagawa, whose most illustrious pupil was Utagawa Toyokuni, the doll-maker, and brother of Utagawa Toyohiro, Hiroshige's master. (Utagawa Kunisada, noted for his backgrounds, succeeded Toyokuni, and after the death of his master signed himself Toyokuni the Second.)

Shunshō is considered one of the greatest artists of Japan, both as an inventor and powerful colourist. Louis Gonse used to say: "All the collections of coloured prints which are today the delight of the teahouses; all the fine compositions showing magnificent landscapes and sumptuous interiors; all those figures of actors with heroic gestures and impassive faces behind the grinning masks, and with costumes striking and superb, came originally from the atelier of Katsukawa Shunshō, who had for a time the monopoly of them." While the Torii artists were beguiling the Edo populace with theatrical portraiture, and aiding the growing tendency toward cosmopolitanism by issuing printed albums, books of travel, and encyclopaedias, art was also expanding at the ancient capital, Kyoto. Nishikawa Sukenobu, the prolific artist, was bringing out beautifully illustrated books, and Okyo Maruyama, from sketching on the earth with bamboo sticks, while following his father and mother to their work in the fields, had risen to be the great founder of the Maruyama school of painting, and the Shijo or naturalistic school was named after the street of the master's studio.

The Popular School, aided by Okyo, effected a revolution in the laws of painting at Kyoto, for the artists forsook their academic methods, painting birds, flowers, grass, quadrupeds, insects and fishes from nature. Okyo's name ranks high among the great masters of Japanese art, of whom so many fanciful legends are told. The charming artist with brush and pen, John La Farge, said: "As the fruit painted by the Greek deceived the birds, and the curtain painted by the Greek painter deceived his fellow-artist, so the horses of Kanaoka have escaped from their *kakemonos*, and the tigers sculptured in the lattices of temples have been known to descend at night and rend one another in the courtyards."

Then the story is told of a moonlight picture, which, when unrolled, filled a dark room with light. A pretty legend of Kanō Tanyu, the great artist, and the crabs at Enryaku-ji Temple, is given by Adachi Kinnotsuke. Upon one panel of the *fusuma*, or paper screen, is seen a crab,

Utagawa Toyoharu,
Fireworks at Ryōgoku Bridge, 1820-1825.
Woodblock print on paper, 38 x 25.5 cm.

Utagawa Toyokuni,
Fireworks at Ryōgoku Bridge, 1830-1844.
Colour woodblock print, 72.7 x 74 cm.
Victoria & Albert Museum, London.

Utagawa Toyoharu,
View of a Harbour on the Sumida River, Catching Fresh Air on the Eitai Bridge, Fukugawa, c. 1770. Colour woodblock print, 24.1 x 35.5 cm.

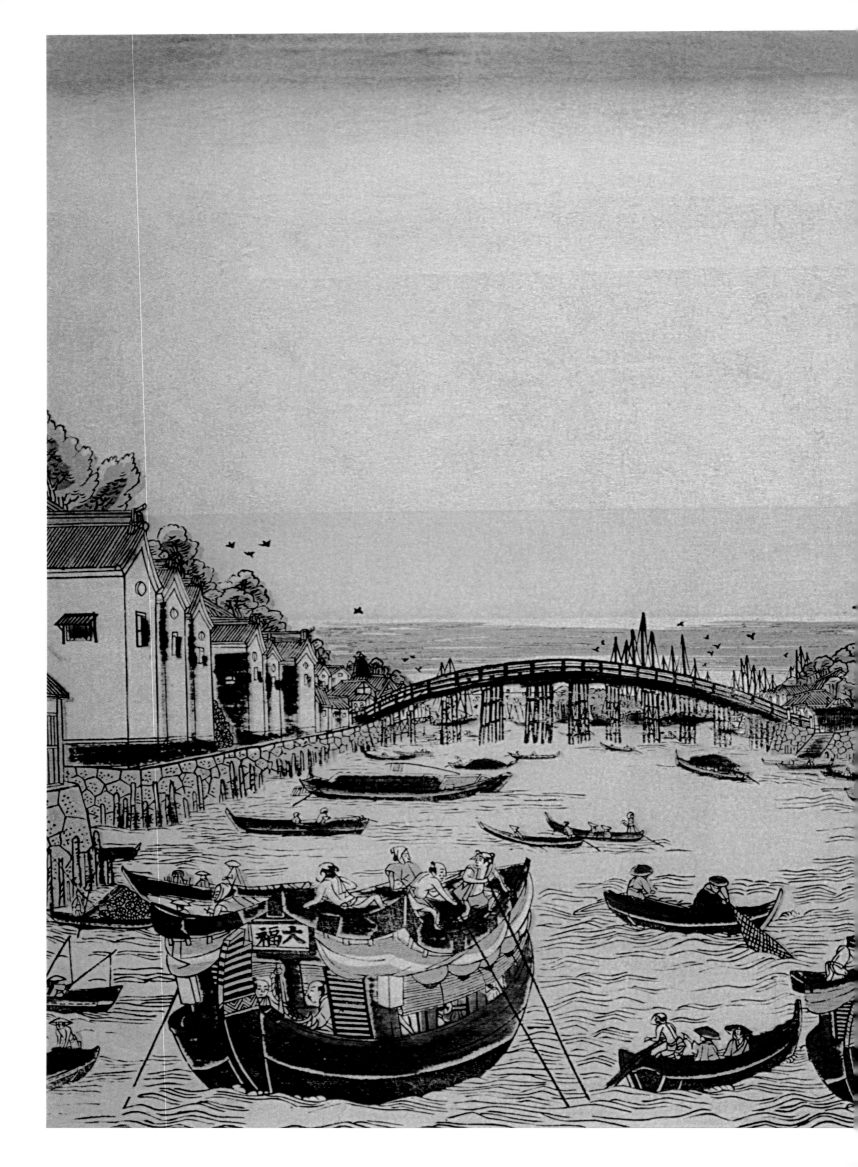

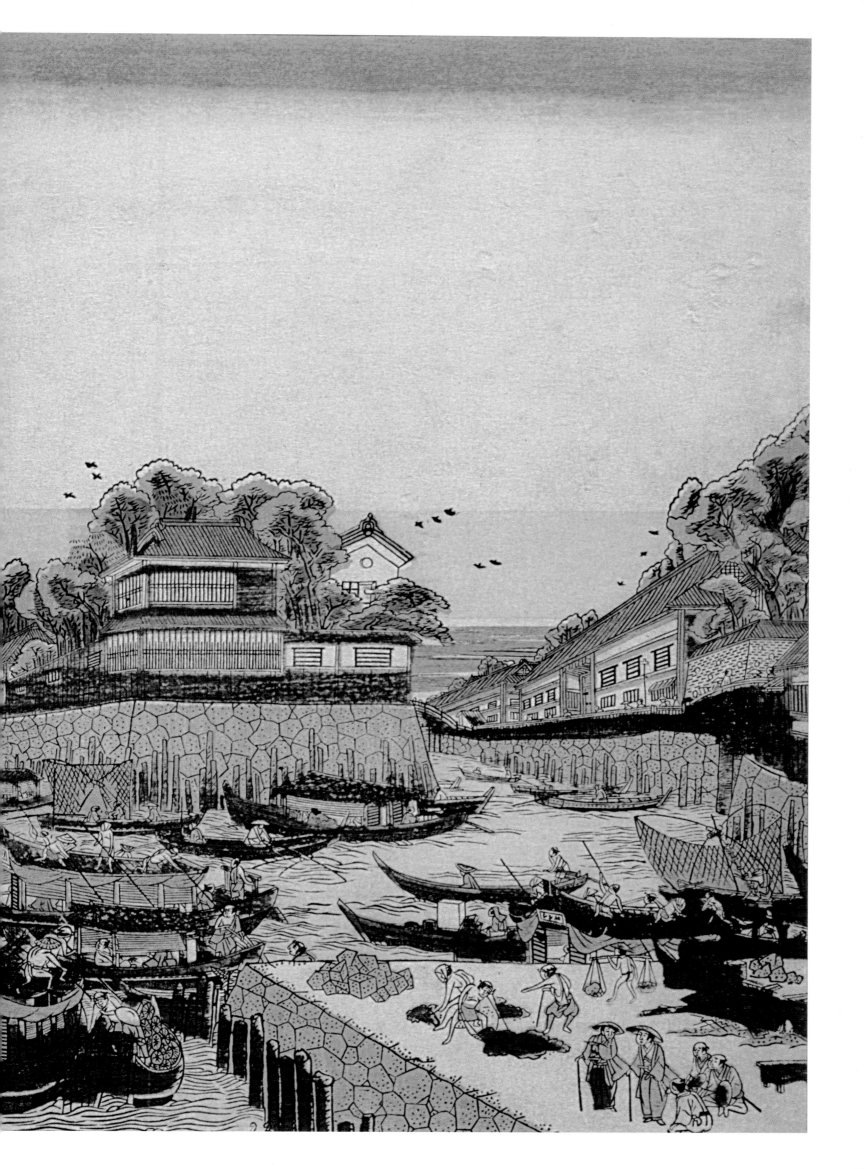

marvellously realistic, only with claws invisible. On the other panels the artist had painted its companions, and at the bidding of his patron furnished them with claws. "Nevertheless," the master declared, "I warn you that if I give these crabs claws they will surely crawl out of the picture." As the visitor glances from the wonderful counterfeit crab to the four empty panels beside it, he knows the old master had spoken the truth.

So it was also with Okyo. He breathed the breath of life into his pictures. His animals live, and his flights of storks swoop across the great kakemonos, each bird with an individuality of its own, though one of a multitude of flying companions. To view Okyo correctly, we should see him at home in his own environment, not in Europe, where so many copies of his masterpieces abounded. John La Farge gave us a glimpse of an Okyo, fitly set, framed in oriental magnificence, in the Temple of

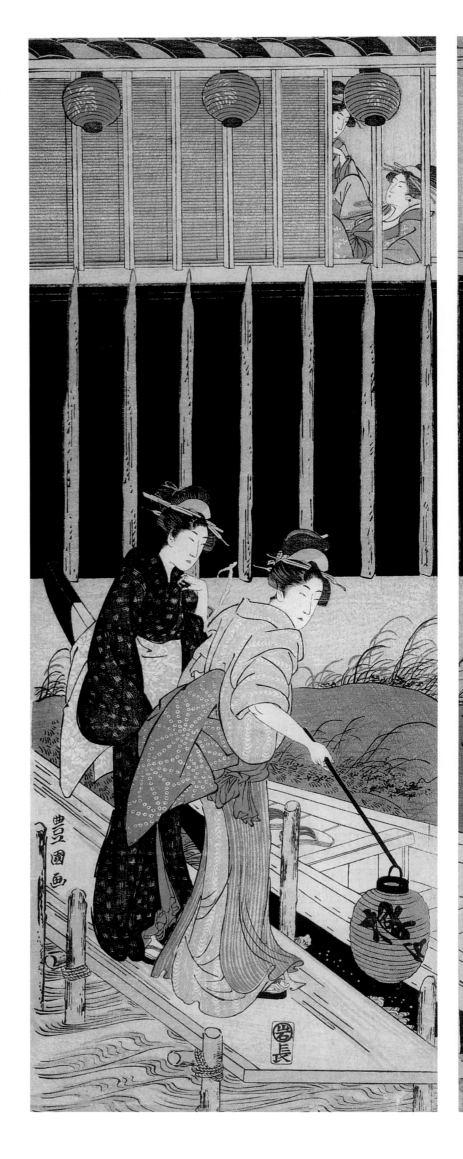

Utagawa Toyokuni,
Akatsutaya in the Temporary Quarters, 1800.
Brocade triptych, 50 x 20 cm.
Tokyo National Museum, Tokyo.

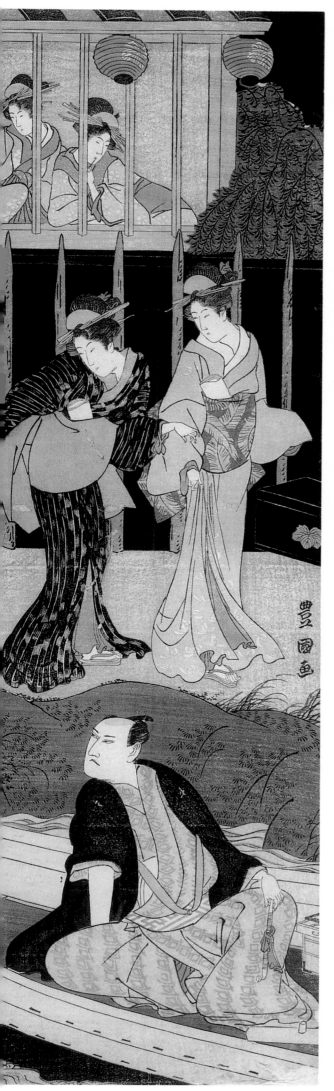

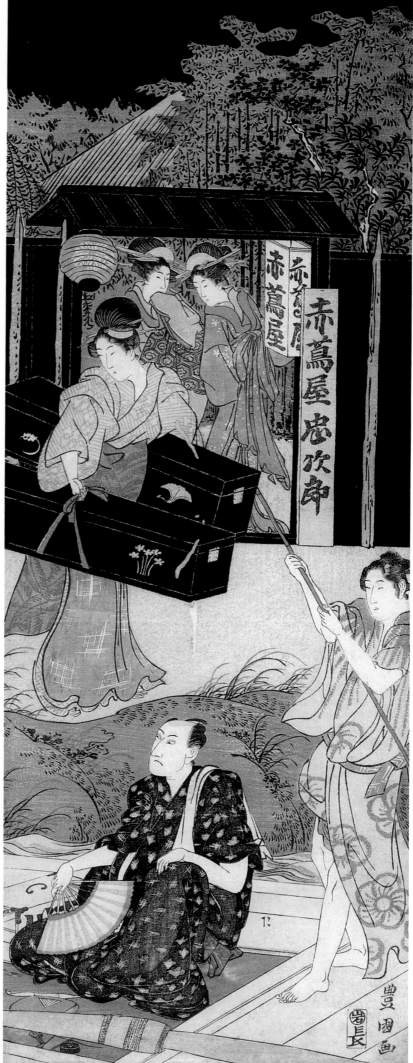

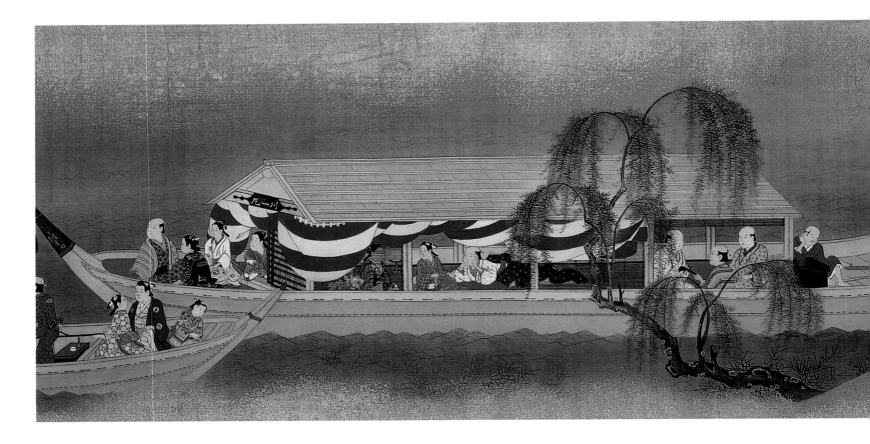

Iyemitsu at Nikko: "All within was quiet, in a golden splendour. Through the small openings of the black and gold gratings a faint light from below left all the golden interior in a summer shade, within which glittered on golden tables the golden utensils of the Buddhist ceremonial. The narrow passage makes the centre, through whose returning walls project, in a curious refinement of invention, the golden eaves of the inner building beyond. Gratings, which were carved, and gilded trellises of exquisite design, gave a cool, uncertain light. An exquisite feeling of gentle solemnity filled the place. In the corridor facing the mountain and the tomb, a picture hangs on the wall. It is by Okyo. Kuwannon, the Compassionate, sits in contemplation beside the descending stream of life."

About 1775 arose a legitimate successor to the school of Torii in the adopted son of Torii Kiyomitsu, Kiyonaga. He discarded the theatrical tradition of his school, but the boldness of his drawing was foreign to the style of Harunobu. "His brush had a superhuman power and swing." He rivalled the three great masters, Isoda Koryūsai, Kitao Shigemasa, founder of Kitao, and Utagawa Toyoharu, and the masters of Ukiyo-e, forsaking their individual predilections, flocked to his studio.

The simplicity and dignity of the early Italian masters, sought after and adored by the pre-Raphaelite brotherhood, their noble lines and contours, are again realised in the panels of Kiyonaga. Professor Fenollosa said that "classic" is the

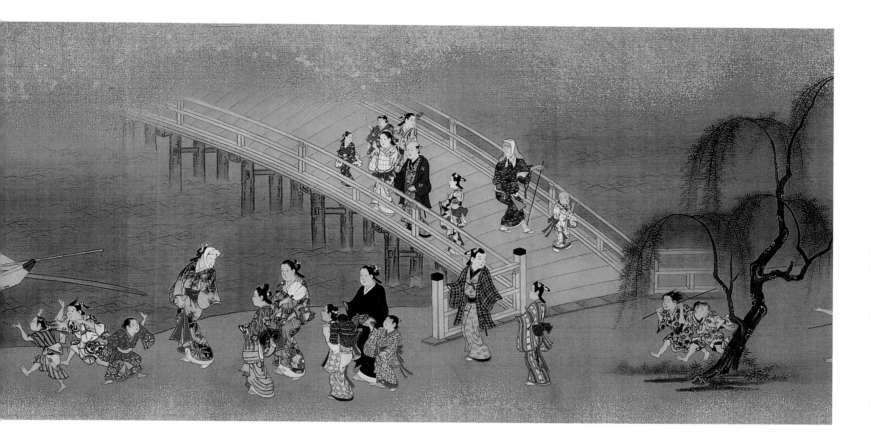

instinctive term to apply to Kiyonaga, and that his figures at their best may be placed side by side with Greek vase painting. Ideally beautiful is the fall of his drapery, determining the lines of the figure in the fewest possible folds. In indoor scenes he almost rivalled Harunobu, but he loved best to paint in the open air. In imagination we see Kiyonaga, the lover of beauty, gazing at the wealth of lotus blooms which fill the moats of feudal Edo, and in the crucible of his fancy transmuting them into the forms of women. The lotus, of all

flowers, has the deepest art significance, and is the oldest motif. The author of *Greek Lines*, Henry Van Brunt, said: "The lotus perpetually occurs in oriental mythology as the sublime and hallowed symbol of the productive power of nature. The Hindu and the Egyptian instinctively elevated it to the highest and most cherished place in their Pantheons."

It is the flower of religion, of beauty, and of love. From the ocean the Hindu Aphrodite, Lakshmi, ascended. Isis in Egypt reigned, crowned by the lotus,

and there the tender, flowing lines became sublime, monumental, fitted to symbolise death and eternal repose. In Japan its joyous curves represent life, immortality, and, delicately sensuous, they conjure up visions of ideal beauty. The lotus, sweetly blooming before the artist's eye, expanded into a vision of fair women, whose lissom forms he clothed with swirls of drapery. And the women of Japan, enamoured of these enchanting poses, endeavoured to assume the curves of Kiyonaga, sheathing

Miyagawa Chōshun,
Genre Scene at Edo (detail), 1716-1736.
Ink and colours on silk, 34.4 x 782.7 cm.
Idemitsu Museum of Art, Tokyo.

69

their delicate limbs in silken draperies, and simulating in their enchanting slenderness the stems of flowers – or, to borrow an enchanting simile from Lafcadio Hearn, "looking like a beautiful silver moth robed in the folding of its own wings."

The Japanese woman, with her untrammelled form arrayed in draperies designed by consummate artists, may dare to follow classic Kiyonaga – youth and grace may acquire oriental plasticity. But let fashion rest there. The use of embonpoint is

a pitiful and ludicrously futile way of attaining sinuosity. Lines of beauty cannot be manufactured; as well imagine the slender stem of the lotus encircled in steel, its curves determined by a multiplicity of wires and tapes.

Although the leaders of Ukiyo-e followed so closely in the footsteps of Kiyonaga that his type of face stamps the years from 1780 to 1790, yet his style was too classic, too noble to suit the taste of the Edo populace, which, in its thirst for realism,

had become depraved. Rather than lower his standard he chose to resign, leaving the field to his followers, Yeishi, Utamaro and Toyokuni. These masters, at first as dignified in their method as Kiyonaga, now yielded to the public craze for the exaggerated, the abnormal and grotesque. It was an apotheosis of ugliness and vulgarity, a "Zolaism in prints".

Coarse pictures of actors, masquerading in female dress, replaced the charming little domestic women of Harunobu and Koriusai – the ladies of

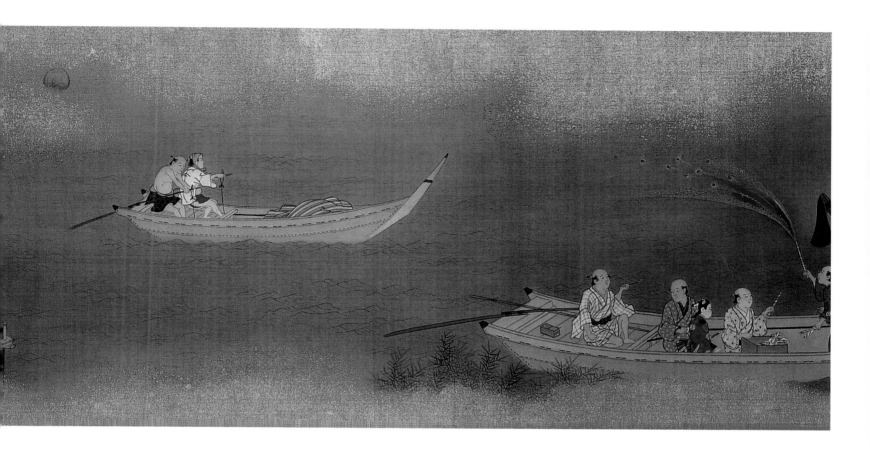

Japan, as we see them in reality – and the noble figures of Kiyonaga. Gigantic courtesans, bizarre and fantastic, with delirious headgear, took the place of Shunshō's fair children of the "Underworld," who, in the modesty of their mien, seemed to belie the calling they so often deplored, as the songs of the Yoshiwara testify, plaintively sung to the syncopated rhythm of the samisen, tinkling through the summer nights.

The school of Ukiyo-e was sinking into obscurity, when Hiroshige and Hokusai appeared, two children of light, dispersing the gloom: Hiroshige, the versatile painter, lover of landscape and ethereal artist of snow and mist; Hokusai, the prophet, and regenerator of Ukiyo-e. He was the artisan-artist, in the land which recognises no inferior arts, and the Mang-wa, consisting of studies as spontaneously thrown off as those in the sketch-book Giorgione carried in his girdle, that were published for the use of workmen. Living in simplicity and poverty he gave his life to the people, and the impression of his genius is stamped upon their work. A true handicraftsman was Hokusai – the Mang-wa a dictionary of the arts and crafts, as well as the inspired vehicle of art. In it "balance, rhythm and harmony, the modes in which Beauty is revealed, both in nature and art," were manifested – for he was a vital artist, laying bare the enigma of evolution, and the mystery of creation.

Miyagawa Chōshun,
Genre Scene at Edo (detail), 1716-1736.
Ink and colours on silk, 34.4 x 782.7 cm.
Idemitsu Museum of Art, Tokyo.

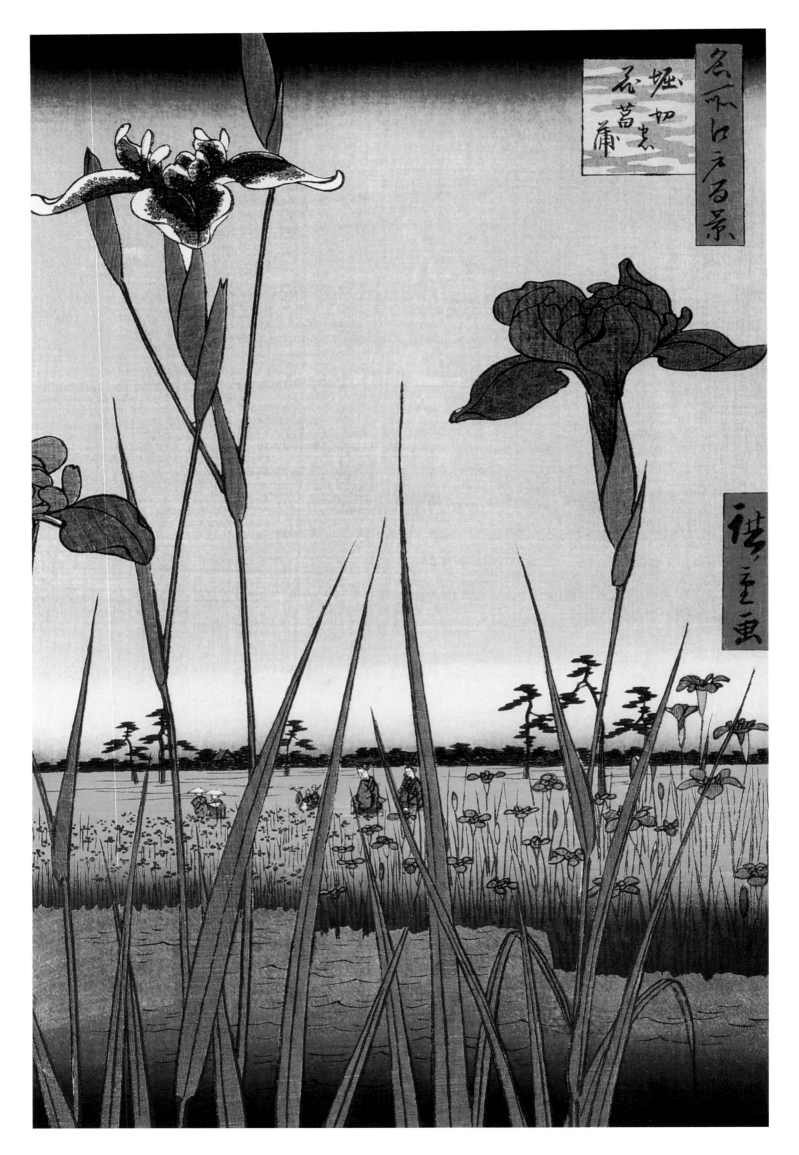

ANALYTICAL COMPARISONS
BETWEEN THE MASTERS OF UKIYO-E

It is difficult rightly to determine the distinguishing characteristics of the noted artists of Ukiyo-e: but the connoisseurs speak of the extreme grace of pictorial line in Moronobu: the sweeping areas of pattern in the garments of Kiyonobu and his followers, and their forceful ways of outlining the folds of drapery, all full of meaning.

Grace and delicacy mark the idyllic compositions of Harunobu and his successor Koriusai (the face of the Japanese woman is the face of Harunobu, Koriusai, Shunshō and his school). Monsieur de Goncourt says: "The Japanese woman is lithe, little, and rounded. Out of this woman Utamaro created the slender, svelte woman of his prints – a woman who has the delicate outlines of an early Watteau sketch. Before Utamaro, Kiyonaga had drawn women, larger than nature, but fleshy and thick. The face of the ordinary Japanese woman is short and squat, and except for the inexpressible vivacity and sweetness of the black eyes it is the face which Harunobu, Koriusai and Shunshō represented. Out of this face Utamaro created a long oval. He slid into the traditional treatment of the features a mutinous grace, a naïve astonishment, a spiritual comprehension; and he was the first artist who attempted, while preserving the consecrated traditional lines, to blend with them a human expression, so that his best prints become real portraits. Studying them, we no longer see only the universal, but the individual face, and, unlike the other Japanese artists, he idealises his countrywoman through the mimicry of her gracious humanity."

The women of Kiyonaga have a more-than-human dignity and grace, the classic folds of his drapery recalling figures of the Renaissance. The Japanese artist always has an underlying motif in the disposition of his drapery. The most recognisable perhaps are those called "Guantai," signifying rude, with angular outlines, and "Rintai," delicate, supple and wavy, like the undulations of a river.

In the "Guantai" motif we see the angles of the rocks, even in the most delicate folds of drapery. In "Rintai" no angle is visible. Here wavelike ripples descend, flowing around the feet of the wearer. In these swirls of drapery are realised the Buddhist conceptions of Life in everything – the lines are moving, sentient, and all but the leading folds that determine the lines of the figure are suppressed. The Japanese painter knows that the true master selects, does not draw all he sees, but concentrates his efforts towards reproducing the lines of movement, and in figures, the lines of the limbs and flowing drapery. In their designs for

Utagawa Hiroshige,
Irises at Horikiri, May 1857.
Colour woodblock print, 36 x 24 cm.
Brooklyn Museum of Art, New York.

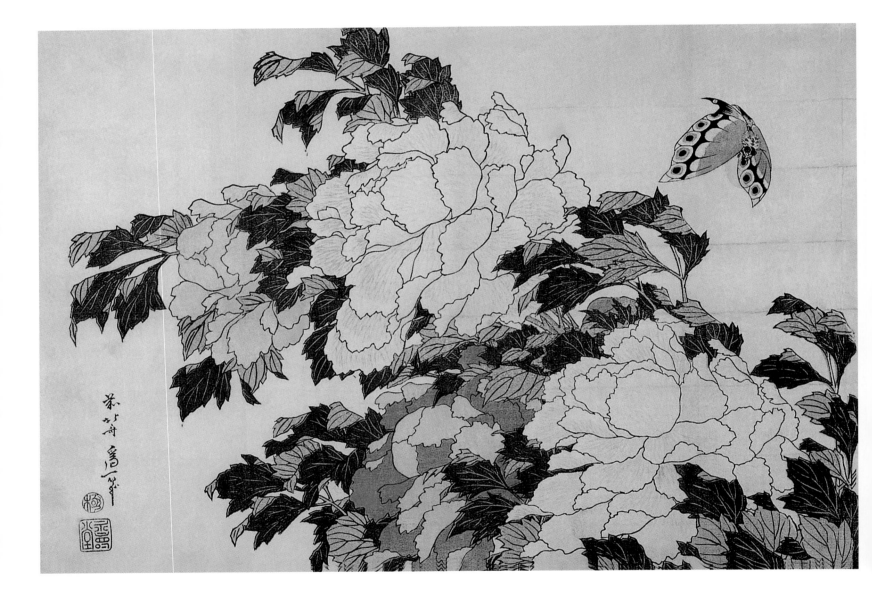

Katsushika Hokusai,
Peonies and Butterfly, 1833-1834.
Colour woodblock print, 24.8 x 38.2 cm.
Pulverer Collection, Cologne.

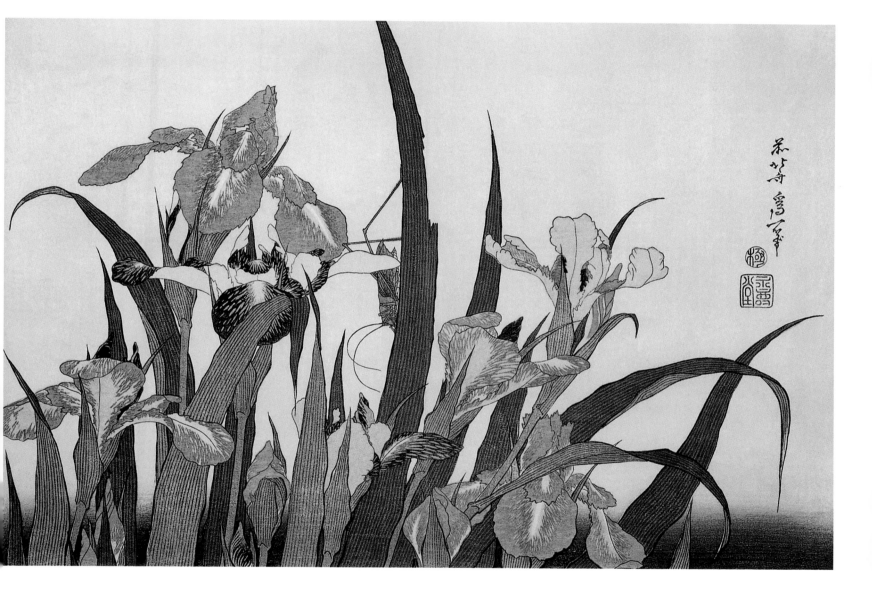

Katsushika Hokusai,
Iris and Grasshopper, 1833-1834.
Colour woodblock print, 24 x 35.8 cm.
Musée Guimet, Paris.

dresses the artists of Ukiyo-e emphasised the theorem that art is the love of certain balanced relations and proportions, for they planned dresses in which every separate part is welded into one harmonious whole. They solved theories in colour, and delighted in selecting as trials for their skill the most unmanageable patterns, such as plaids and checks. They extolled "Notan" or the decorative use of values.

In the best prints the decoration of the dress fits in with the scheme of the picture. Monsieur de Goncourt says: "If the figures are represented out of doors, flowers seem to be shed upon the dresses, as if the wearer passed beneath blossoming trees. If the artist paints butterflies on a costume, they harmonise with the background. If peonies are used he alternates their whiteness with a purple tint. And how admirable is their use of relief! Upon a blue or mauve gown, how charming is

the white relief of an embossed cherry petal, and so marvellously executed is this goffering, that many of the oldest impressions retain the impression as perfectly as if only printed yesterday." Utamaro at first equalled Kiyonaga in the majesty of his figures, later he lost beauty and strength in exaggeration. Yeishi shows a striking resemblance to Utamaro, and he, too, followed after Kiyonaga: his studies of women are noted for their refined elegance. Yeisen compares with Utamaro in the grace with which he portrays women, and Yeizan's lines are stronger, but show a marked similarity. Hartmann says: "The linear beauties of the representations of Yeizan, Yeishi, Yeisen, impress one like a Nautch, like some languid oriental dance in which the bodies undulate with an almost imperceptible vibration. The Japanese see in a woman, a glorification of all beautiful things

– they even study the natural grace of the willow, plum and cherry trees, to find the correct expression of her movements."

Toyokuni was the master of mimetic art. In his actor faces he runs the gamut of emotion – jealousy, passion, fiendish fury and concentrated cunning, rush at us from his prints. Toyokuni, the marionette maker, forced life into the forms of his puppets, and later the same power is shown in his designs for the block. Like many of the Ukiyo-e artists, he employs caricature, but his figures are living, sentient.

Monsieur de Goncourt says: "In comparing two books by Utamaro, and Toyokuni, illustrating the occupations of the women of Yoshiwara Toyokuni, often the equal of Utamaro in his triptychs is beaten by his rival. His women have not the elegance, the willowy grace, the figures of Utamaro possess, nor their resplendent personality. His

Kitagawa Utamaro,
Illustration from the volume *Illustrated Book of Selected Insects*, 1788.
Colour woodblock print, 27 x 18 cm.
The British Museum, London.

76

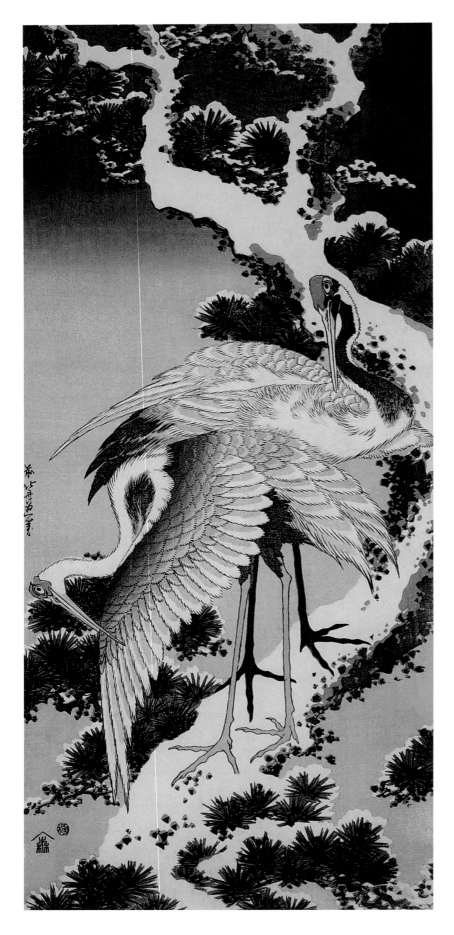

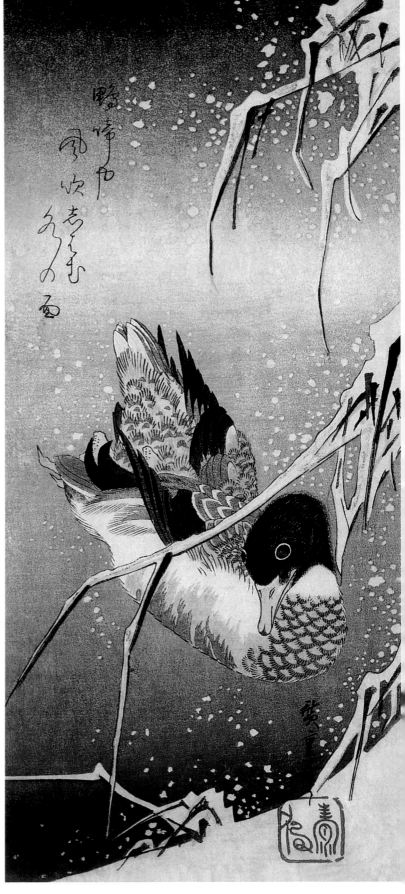

Katsushika Hokusai,
Two Cranes on a Snowy Pine,
from the series *Large Images of Nature*, c. 1833.
Colour woodblock print, 52 x 23.1 cm.
Chiba Art Museum, Chiba.

Utagawa Hiroshige,
Two Ducks in a Stream, c. 1834.
Colour woodblock print, 37.9 x 16.6 cm.
Honolulu Academy of Arts, Honolulu.

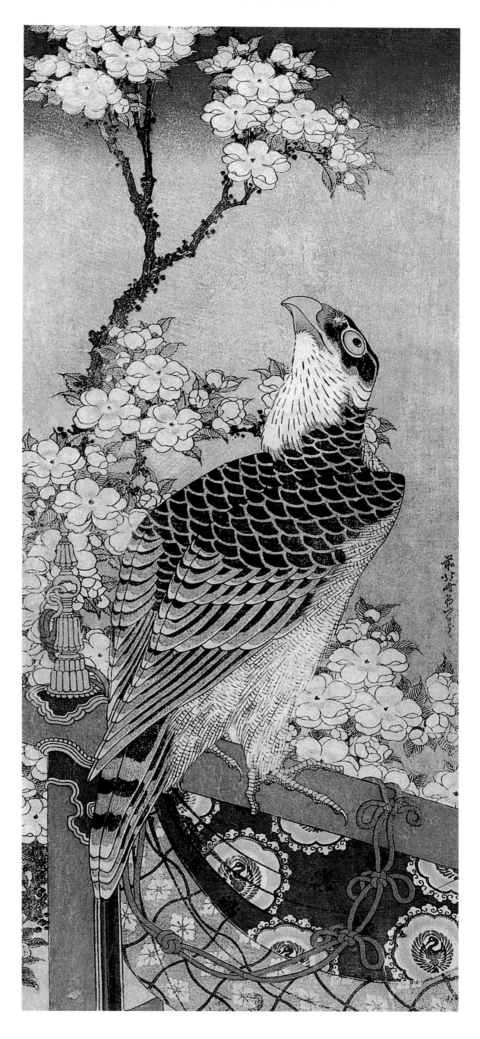

pictures lack the spirit, the life, the 'trick' of voluptuousness of the women of the 'Flower Quarter.' Then the comic note which Toyokuni sought for in representing these scenes, adds triviality to his work. In short, to judge between the rival painters, one has only to place side by side a woman painted by Utamaro and one by Toyokuni. The first is a little marvel, the second only a commonplace print." Kunisada followed in the footsteps of his master Toyokuni, adding charming backgrounds, which he borrowed from Hiroshige; in fact, Hiroshige is said to have supplied many backgrounds to the prints of Kunisada and Kuniyoshi.

Hokusai used all methods, and acknowledged no school. His lines flowing out of the prescribed limits hint at vast stretches of country. Swirls of waves foam up in the impressions, supplying an alphabet of motion. In Mang-wa

Katsushika Hokusai,
Falcon and Cherry Tree, 1832-1833.
Colour woodblock print, 50.2 x 22.2 cm.
Pulverer Collection, Cologne.

are blended sweetness and power, structure and the fundamental vital motif underlying all art. When working for the engraver he was concise, rapid and impulsive, but when contemplating nature he sketched in freedom – his execution became fairylike.

The landscapes of Hiroshige, though confined to the narrow range of the wood-cut, have all the qualities of Impressionism, the details are subordinated, only the salient points of the scene being represented, but the atmosphere supplies what is lacking, and this incommunicable, subtle gift, the birthright of the artists, enabled them to conjure living pictures from the hard medium of the wooden block.

The following suggestive comparisons between the masters of Ukiyo-e, kindly volunteered by Morgan Shepard, are full of value to the student, as the individual opinion of a refined amateur and art critic. Of Harunobu he says:

"Though from the point of proportion his figures seem to lack technique, the naïve artlessness of his lines perfectly satisfies us. In this purpose of simplicity they almost suggest the qualities of the fresco work by the early Tuscan masters, when the spirit was striving for expression and working out individuality along its own spiritual lines. The vigour of his stroke impresses one as being untraditional.

"In the figure of the *Dancer* by Shunkō, the pupil of Shunshō, we observe that, although through training and tradition the pupil has gained a greater facility, yet the simplicity of the master is lost in an excess of elaboration. The lines resemble those of Shunshō, though there is more uniformity of stroke, with a greater delicacy, but the simplicity of 'the first artist' is merged in decorative purpose. Shunshō is distinctly simple and his lines have a blended quality of relation, giving a sense of repose which in the pupil is obscured by the tendency to elaborate.

"In epitomising the cardinal qualities expressed in the Utamaro prints, the most marked is the suggestion of subjective, unconscious skill that gives no impress of the objective. Each line seems to come directly from the fountain-head of the man's spiritual or soul nature, though this very soul nature expresses itself often along sensual lines. Indeed, were the artist less of a spiritual genius, he would often become revoltingly sensual. To the casual observer the lines of Utamaro show wonderful facility, and still greater delicacy, yet we cannot but observe underlying all his art, especially in its later phases, this subtle sensuality. The lower draperies of the Utamaro figures have an almost insinuating fullness.

Kubo Shunman,
Little Owl on a Magnolia Branch, 1789-1801.
Colour woodblock print, 18.3 x 51.1 cm.
Ostasiatische Kunstsammlung, Museum für
Asiatische Kunst, Staatliche Museen zu Berlin, Berlin.

MAIN SUBJECTS
OF THE ART OF UKIYO-E

The main subjects in pictures of the Ukiyo-e are people, to be precise, certain people in certain situations. The artist is mainly concerned with portraying citizens in their domestic life, the bustling activity in the "Pleasure Quarters" of Yoshiwara and the theatres.

The adventures and deeds of the heroes, which were the focus in Tosa art, are now only depicted indirectly through the theatre – that is how remote courtly life has become. Landscapes only appear on Ukiyo-e prints, if at all hinted at, in a stage-like lifelessness; only serving people as an appropriate frame, but never exceeding its secondary function.

Eroticism

It is significant that the focus lies on the portrayal of scenes from the Yoshiwara as a choice of motifs mentioned. Eroticism plays such an important part in the Japanese late period that one has to question the significance of this whole sphere in Japan's intellectual life.

Whilst elsewhere the exposure of erotic desires often means an increased personal involvement or a descent into a sub-personal animal-like manner, it means something completely different in Japan, it is in fact a de-personalisation, a dwindling of individuality in favour of conventions. The strongest

socialisation of the individual takes place on this basis; for the Japanese are led into official and conventional activities by these erotic desires. There was no place where Japanese citizens of the Tokugawa period were connected to old conventions and their obligations to such an extent than in these public brothels.

The *oiran* of the Yoshiwara were given the best education in a strictly conventional sense; their ethos was subordination to steadfast conventions, which meant all personal qualities were eliminated. These girls were never allowed to show their moods, but had to keep the same pleasant official facial expression.

That is why eroticism in Japan was always very cool, almost playful, definitely without any depth or frenzy, as it is inseparably linked to eroticism in India.

The matter of the origin of the delicate and subtle, yet at the same time impersonally rigid forms, in which Japanese eroticism occurs in Ukiyo-e, again leads to the previous courtly cultural situation. The courtly form has been taken over. This has only been possible, because this form was appropriate to the nature of the Japanese people, and that also applies to the citizen of the late period, much more appropriate than the occidental chivalrous thought was for the Western middle classes. Here, adopting a courtly form

Eishōsai Chōki,
Beautiful Woman at Daybreak on New Year's Day,
1794-1795.
Colour woodblock print, 37.4 x 25.6 cm.
Baur Collection, Geneva.

Kitao Shigemasa,
Beauties of the East, from the series *Beauties of East,*
West, South and North, c. 1770.
Brocade print, 36.8 x 26.2 cm.
Tokyo National Museum, Tokyo.

Chōbunsai Eishi,
Itsutomi, from the triptych *Geisha of*
the Yoshiwara in Rivalry, late 18th century.
Brocade print, 38 x 25.5 cm.
Tokyo National Museum, Tokyo.

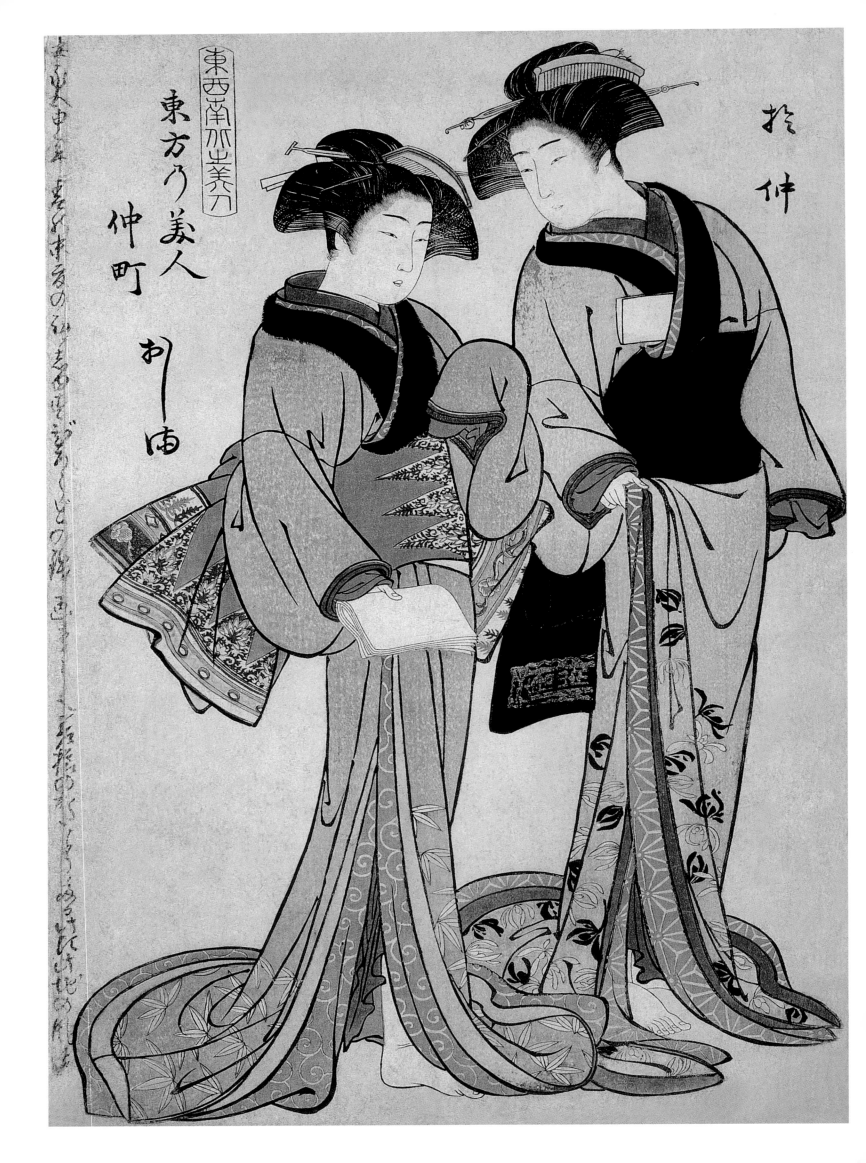

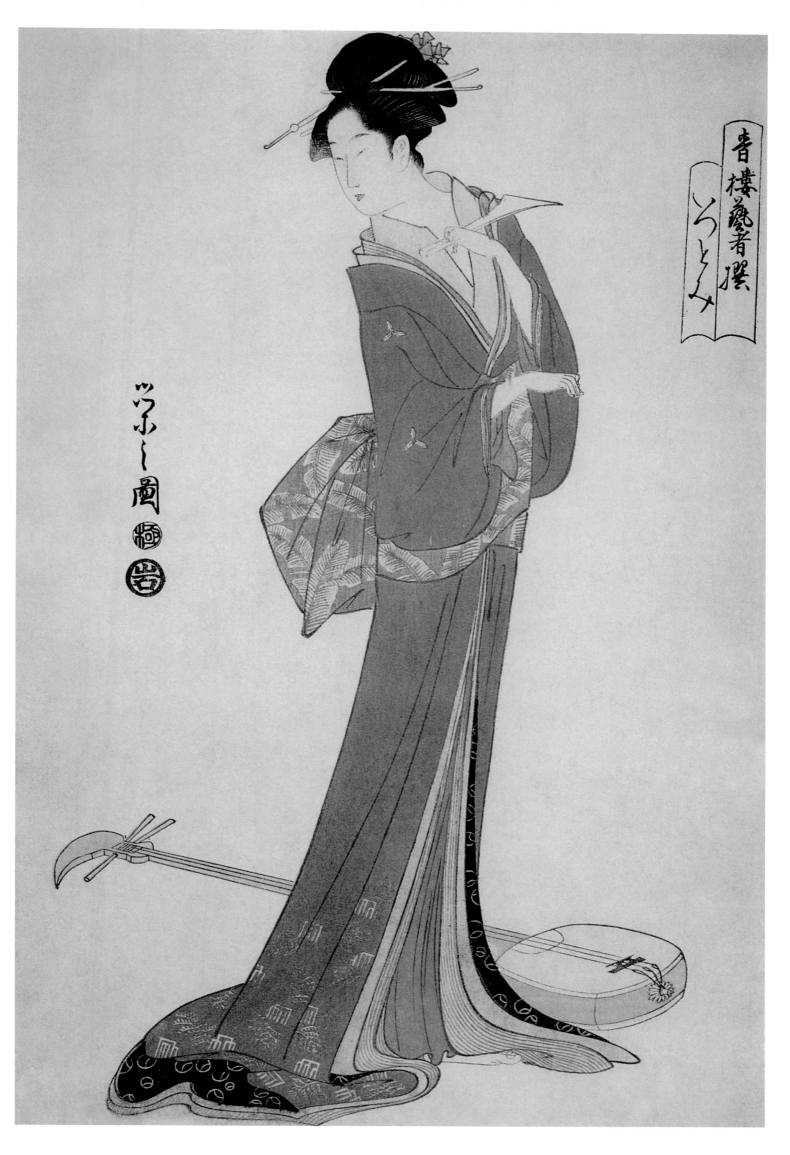

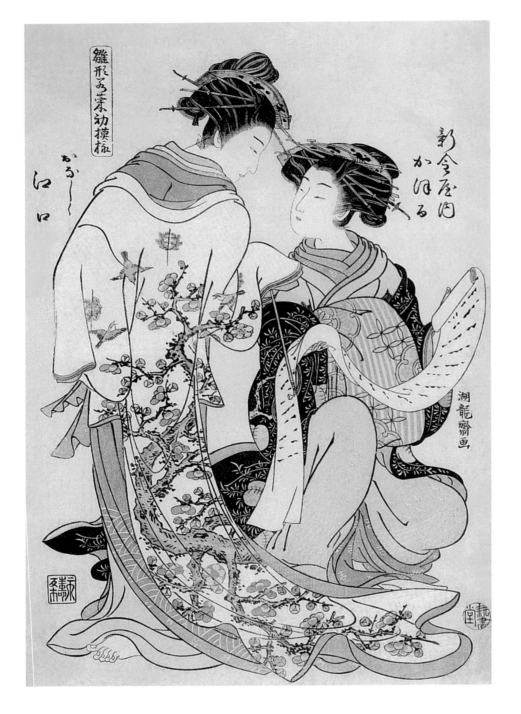

remained outward and was hardly of a longer duration.

In Japan, the transition of eroticism as well as all areas of life from a courtly to a middle-class sphere never meant a return to nature, as it did in many cases during the French revolution, but always an even greater increase of refinement.

The rise of the middle-classes in Japan was not linked to ethical criticism of the conventions of the previous ruling classes as it was everywhere in the West, and did not take place in Japan in the shape of a revolution; but instead, making the most of the economic moment, a shift of the cultural focus occurred without much stir evenly in all areas. Additional circles adopted the culture of the superior classes.

What then are the reasons for the emphasis on eroticism at that time?

Eroticism is the strongest expression for the sphere of

Isoda Koryūsai,
Toyoharu of Chōjiya, from the series *Designs for New Year's Day Clothes for Young People*, c. 1778.
Colour woodblock print, 38.7 x 25.8 cm.
Ostasiatische Kunstsammlung, Museum für Asiatische Kunst, Staatliche Museen zu Berlin, Berlin.

mankind's natural side, for his vitality. To the extent that outward nature was no longer seen, because, due to technical victory followed by the necessary desecration and profanation, it had become completely alien to people, their vital desires demanded their due.

Any sexual excessiveness and perversions existent during the Japanese late period can be explained by this erosion of this outward relation to nature. In profane large towns, remote from nature, people were not aware of the pulse of natural life, and so it could not have an organically regulating effect.

The forms of Japanese eroticism in that period constitute the last stage in a long process of "de-rusticalisation," to which eroticism is subject to everywhere. The process starts, where a detachment from the matter of course of compulsive sexual natural processes takes

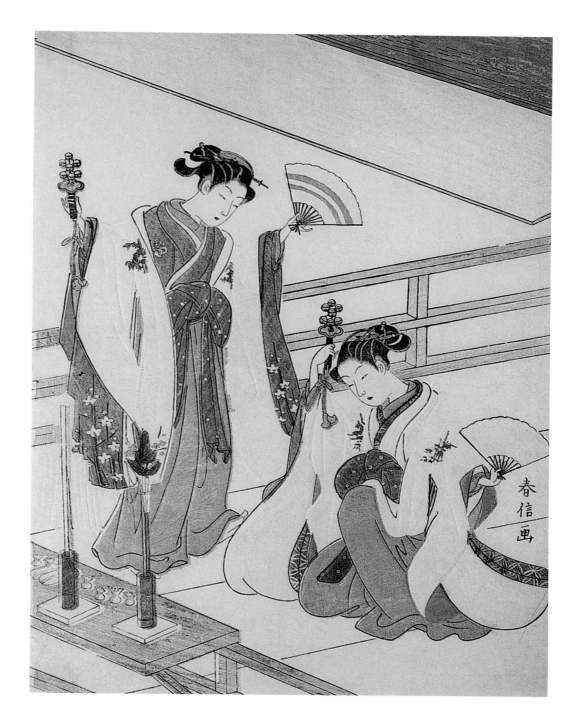

Suzuki Harunobu,
Two Dancers, c. 1769.
Colour woodblock print, 27.7 x 20.8 cm.
Baur Collection, Geneva.

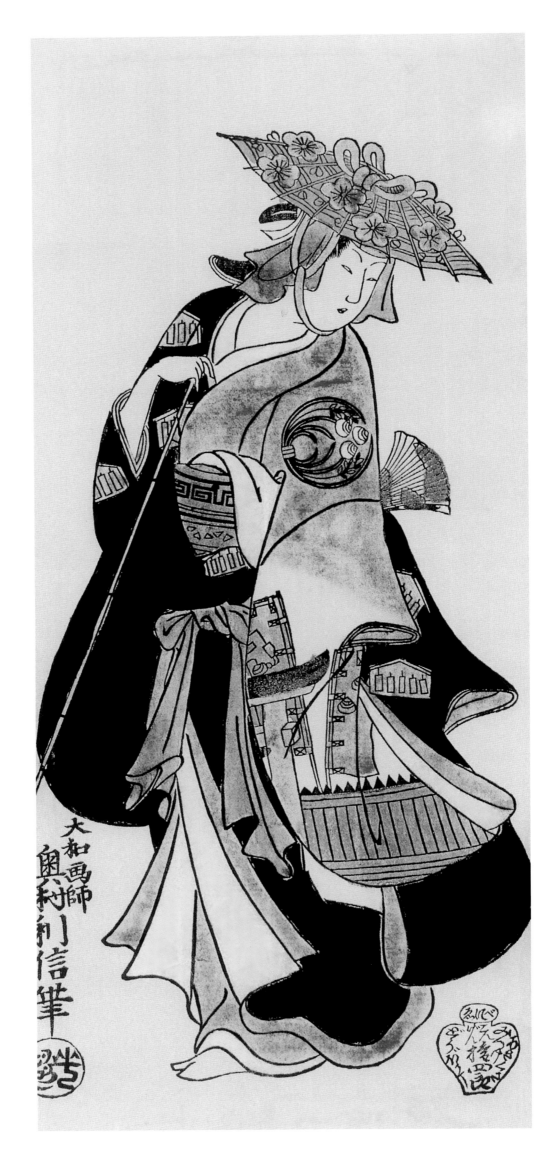

大
和
画
師

奥
村
利
信
筆

place, and a spirituality of this natural area occurs in the sense of an idea.

At the same time the area is subject to moral judgment and reduction in status. Eroticism finds its place in the context of all intellectual forms as a mental phenomenon. Within this process of "de-rusticalisation" of eroticism various stages should be distinguished.

1. In mythological awareness, eroticism presents itself with pronounced frenzied ecstatic qualities in the forms of divine prostitution, orgiastic celebrations and various opening ceremonies.

2. Anti-daemonic criticism arises against these forms; purity is given the characteristic of holiness, clarity in contrast to abundance, previously ruling on its own. A religious consecration of a regulated orderly erotic life takes place, leading to the sanctity of marriage.

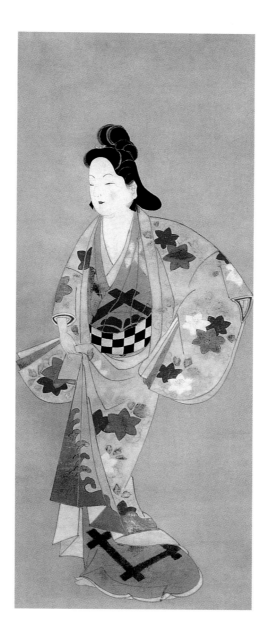

3. The third stage, profanation, is a reaction against the heteronomous forced character of that standardisation, against which the new autonomous people revolt in their massive urge for freedom. Profanation, however, means two things again in this field, the positive and negative; as with the freedom of the individual of all daemonic links a simultaneous detachment occurs from the basic substance.

In East Asian intellectual history our research only has access to the stage of mythical awareness at isolated places. As far as we can see, we discover a comprehensive holy order everywhere in this respect. Especially in the field of eroticism, the continuity of orderly forms of marriage seems a religious demand, the deep significance of which explains itself in the necessary connection of these forms with the central point of all East Asian

Okumura Toshinobu,
Woman with a Green Hat, beginning of the 18th century.

Anonymous,
Standing Beauty, 1661-1673.
Ink and colours on paper, 79 x 27 cm.
The Art Institute of Chicago, Chicago.

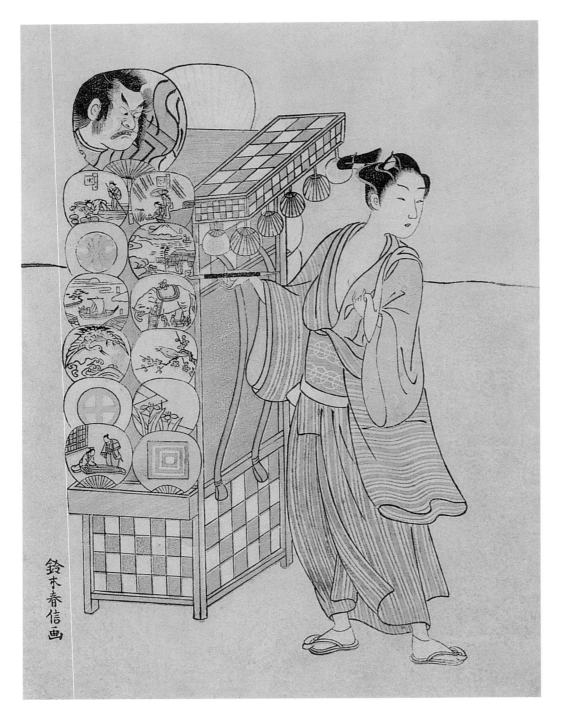

life: ancestor-worship.
The more this sacred awareness was eroded from within – and to a great extent this was already the case during the decadence of the late courtly middle ages – the more the profane attitude displayed itself in eroticism: the human being, now feeling autonomous, gives free rein to his personal desires and tendencies; his sexuality becomes detached from the religious erotic links to prehistory, which then leads to a sumptuous existence in the brothels of the big cities. The fact that citizens do not achieve true free individualism here either, but rather remain in official obligation, as the portrayals of the Ukiyo-e clearly testify to, is a result of the extreme power of East Asia's conventions: the religious bondage, which was expressed in ancestral worship during East Asia's religious period, finds its after-effect in the impact of forms during the

Suzuki Harunobu,
Fan Seller, c. 1769.
Colour woodblock print, 25.2 x 18.6 cm.
Ostasiatische Kunstsammlung, Museum für Asiatische Kunst, Staatliche Museen zu Berlin, Berlin.

Torii Kiyonobu,
Itinerant Salesman of Textbooks of Calligraphy,
c. 1720.
Hand-coloured woodblock print, 33.3 x 16.2 cm.
The British Museum, London.

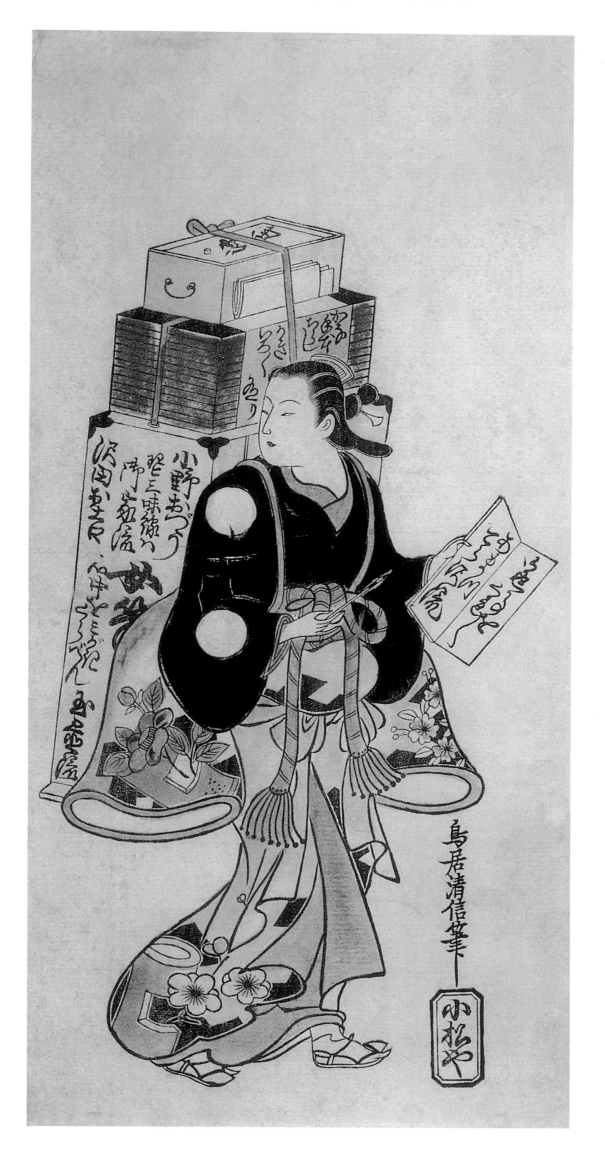

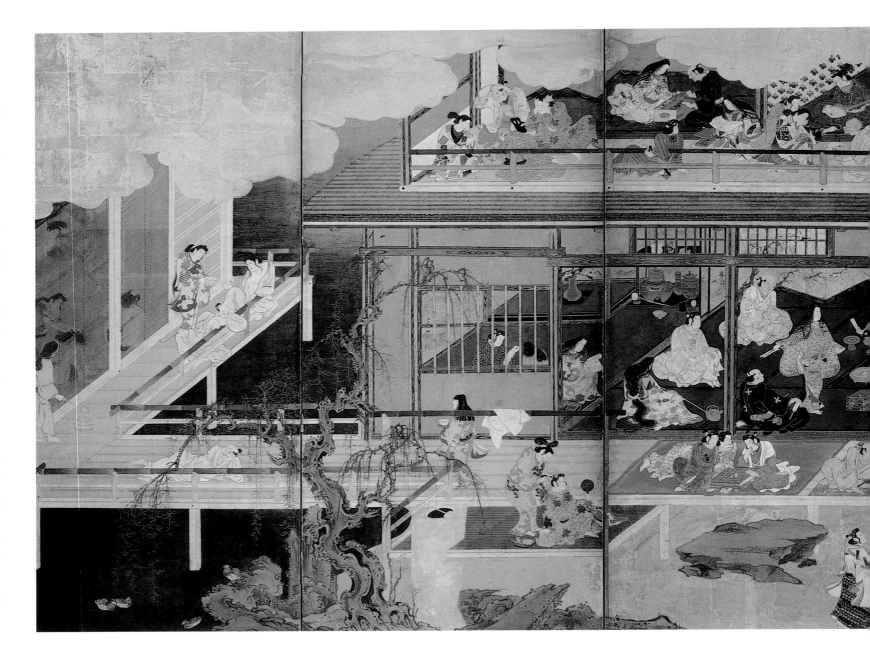

profane Japanese late period, which can still be seen everywhere in eroticism.

This has to do with the fact that art in Japan only portrayed the naked human body in the rarest of cases, and even in these rare cases (pictures of wrestlers, bathing scenes), not erotic nakedness.

For all that, however, life in the Yoshiwara during the Tokugawa period meant a great relaxation of the previous close bonds, an essential broadening of the horizons of those classes that mainly made use of it: the blossoming lower middle classes.

Among the *oiran* in the Yoshiwara the new class on the one hand reached its strongest self-assurance, but on the other hand adopted a major part of the way of life of the previous era.

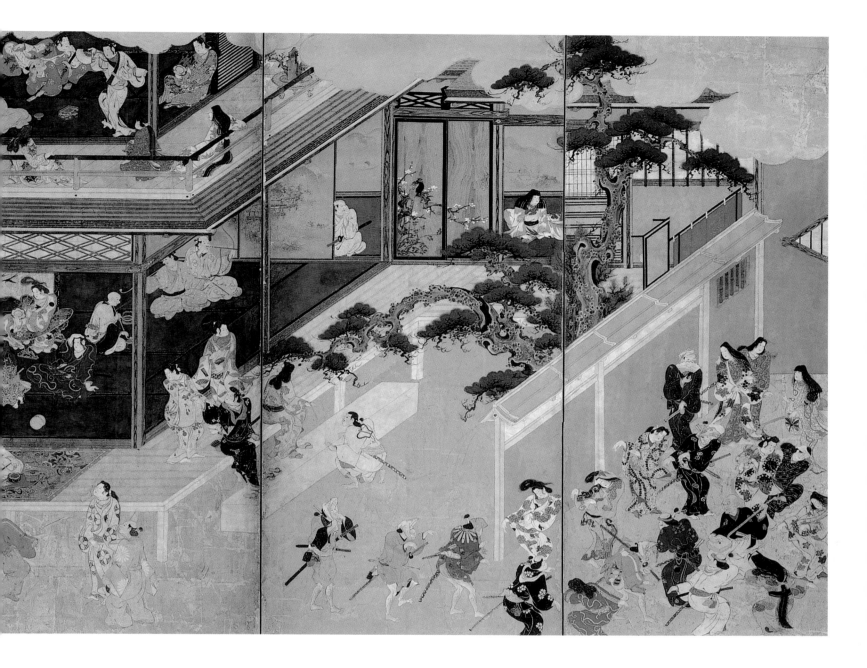

Theatre

The theatre had very much the same functions during the Tokugawa period. The realistic portraits of actors and scenes of the Ukiyo-e masters show the great contrast between this newly developing kind of popular portrayal and the strictly cultic nō plays of the earlier period. If these served the purpose of form and convention, the banishing of all primitive desires, unbridling them now became the basic theme in all plays.

The courtly nō plays have never stopped – their significance has been permanently preserved for certain circles of the court and nobility – but they did indeed recede further and further into the cultural background. Their preservation finally became the

Anonymous,
Screen with Scenes in a House of Pleasure, 1630-1640.

95

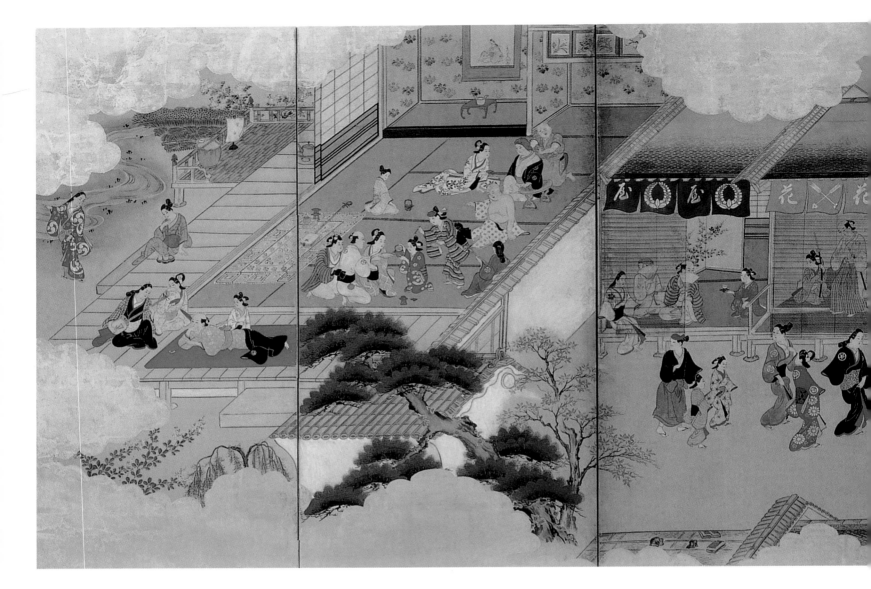

task of archaeologists and philologists, whilst the new popular play spread extensively and intensively. In contrast to the dying nō plays, it was a vividly progressing and strongly developing cultural matter that was backed by the entire population.

As very different circles were gripped by various kinds of plays, the social standing of popular actors was completely different to

that from the nō actors. Whilst the latter came from the most distinguished classes and even maintained a certain family tradition among each other, the popular actors from the numerous large theatres in Edo belonged to the lowest classes. As people they were mostly disrespected and avoided, as much as their play-acting on stage was appreciated and loved.

In the social assessment of the class of actors through all other circles we can see how strongly the judgment of the court nobility rubbed off on the middle classes. These conventional assessments, which are a thoughtless adoption of old matters of course, no longer fit into the new period. Whilst the actors were loved for themselves, they were condemned at the same time "for decency's sake". Even if

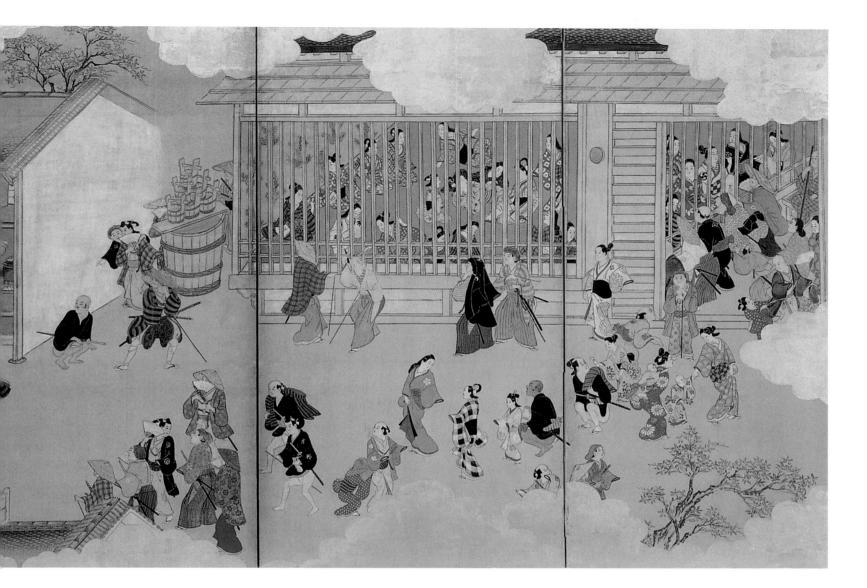

the characteristic and decisive are only displayed in a positive attitude, the immense power of conventional forms, which still meant a constant pressure, is revealed in the insecurity, with which they radually and ponderously developed new attitudes.

The reason why popular theatre had such a great significance during the Tokugawa period was that, due to its lack of substance,

the autonomous middle class had to look for a replacement for the deeper experiences that they missed, which can only exist in the consciously recognised, absolute sense of a time. It found this replacement in sensational stage performances.

Here, they let themselves be "aroused" and thrilled merely psychologically, at certain vital levels by the things, which are

really of the deepest metaphysical significance and suitable to shake a human being in his innermost self. They were not open to delving into true depths with their moments of shock and distress, and yet they wanted to enjoy the outward shiver, which emerges from every strong emotional feeling to the full, but of course, in a safe way. Now, when the numinous shiver could no longer

Hishikawa Morohira,
Scenes of Amusement in Spring and Autumn, 1688-1704.
Ink and colours on paper, 79.1 x 244 cm.
Idemitsu Museum of Art, Tokyo.

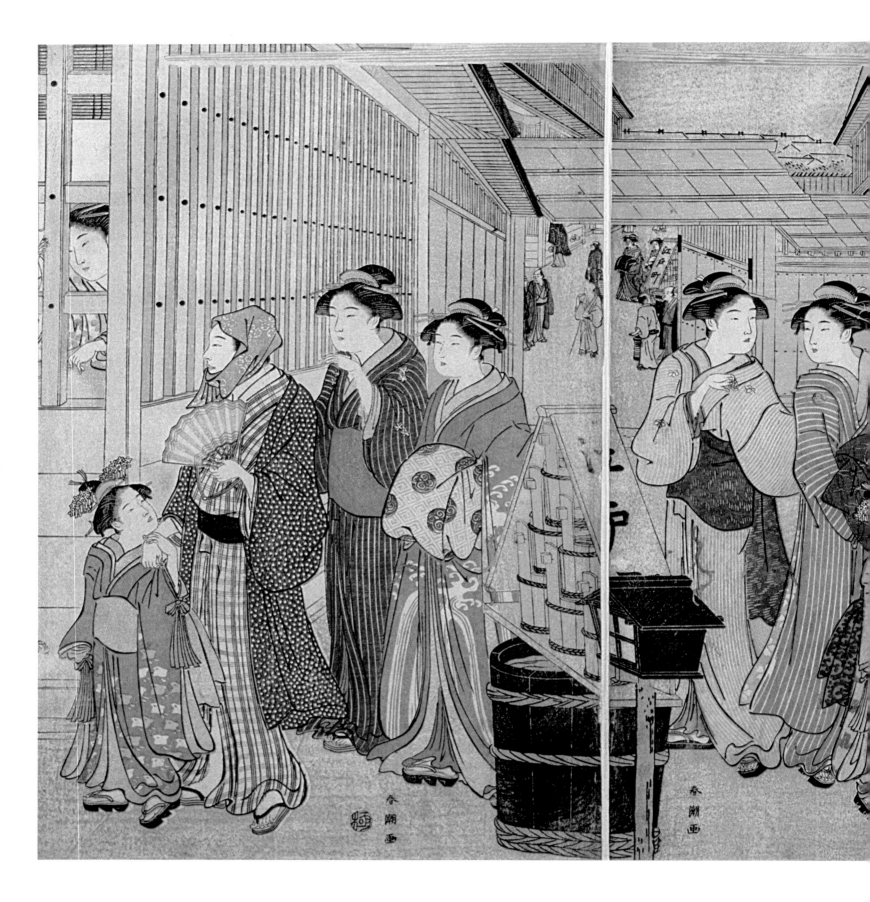

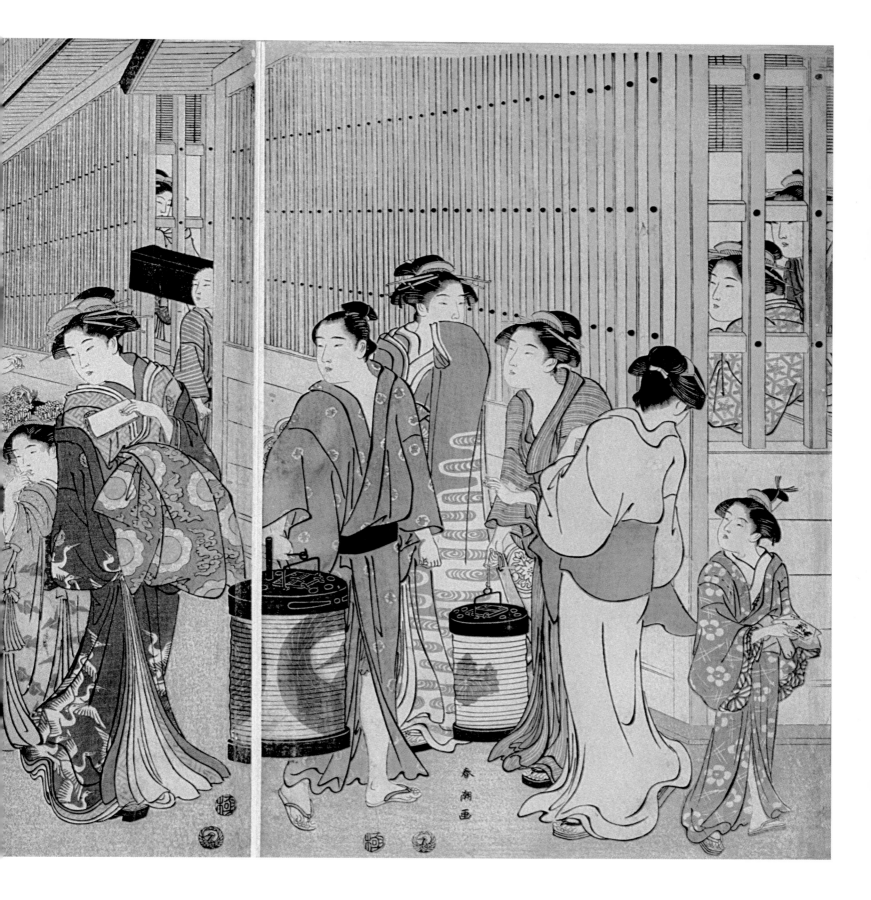

Katsukawa Shunshō,
Street Scene at Edocho in the Yoshiwara, 1791-1793. Triptych,
colour woodblock print, 37.2 x 25 cm.
Musée Guimet, Paris.

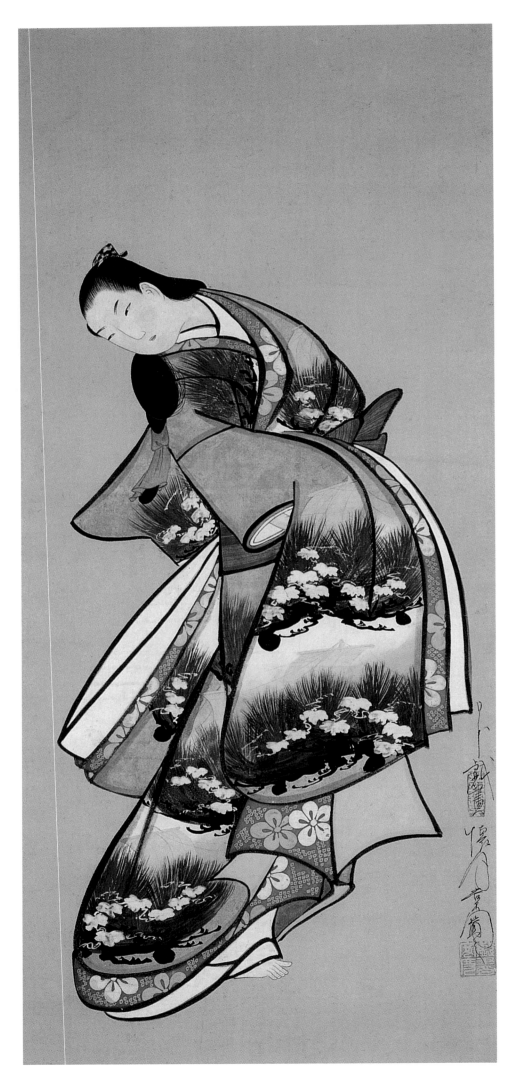

be felt, they longed for the profane shiver.

The theatre complies with this craving for sensation that mankind has, and the popular stage of the Tokugawa period achieved great things in that respect. Without things really penetrating to the centre of personality where they might have lead to new productivity, they offered the citizens of those days a constant opportunity to inflame their senses, which in no way burdened them and which they were able to shake off, as soon as they wanted to. In this respect, the theatre of that time joins the other parallel phenomena as a means to profane the intellectual state – a dangerous means that tries to ward off the great daemonic power of human passion through numerous small, but no less destructive, sensational daemonic powers of emotion. In the sensation, whose mirror is the theatre, the psychological extreme, the flood of emotion has

Kaigetsudō Ando,
Beauty Turning Round, 1704-1711.
Ink and colours on paper, 101.2 x 46.5 cm.
Chiba Art Museum, Chiba.

100

become the symbol of the absolute, it has put itself as a surrogate in its position. This applies in the same way to the mediaeval street ballads, the crime novel, to the newspaper column for "accidents", to all kinds of gatherings of crowds, to the term "celebrities", and to the fuss of names, which is made of "famous men" in art, science and politics, to polar expeditions, records in sports and many more things. Here, the unusual is confused with the "completely different"; it maintains its character on a changed basis. Sensation is felt everywhere where the system of the usual order is broken through (the medium as a means of breaking through the rational psychological order; the extraordinary accident as a means of breaking through the usual technological order etc.), this matter of breaking through, however, is not experienced as a judgment of the absolute, but

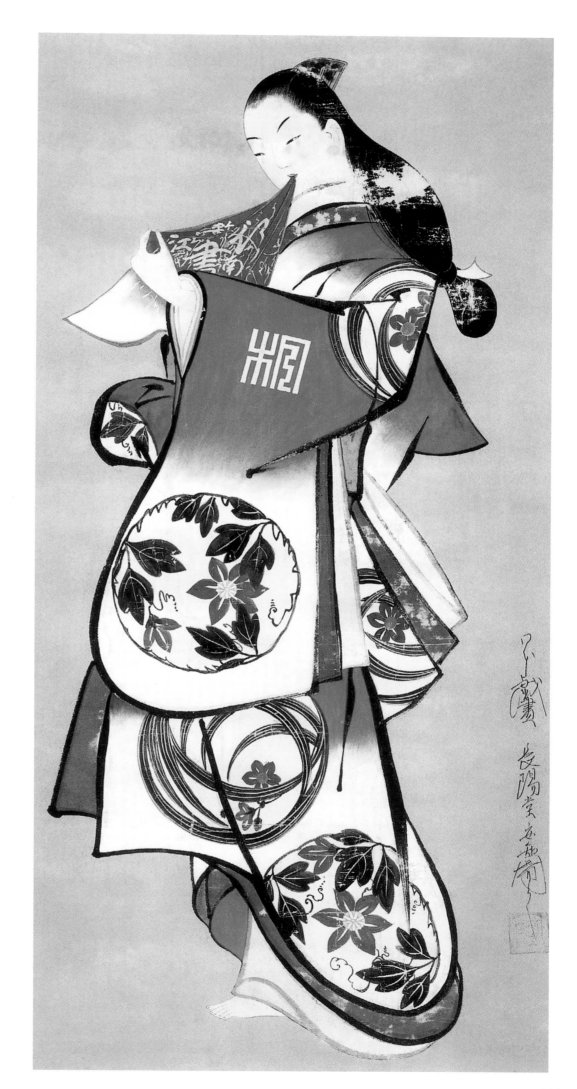

Kaigetsudō Anchi,
Portrait of a Standing Courtesan (Yujo tachisugata zu),
Edo period.
Colours on paper, 85.1 x 40.2 cm.
Tokyo National Museum, Tokyo.

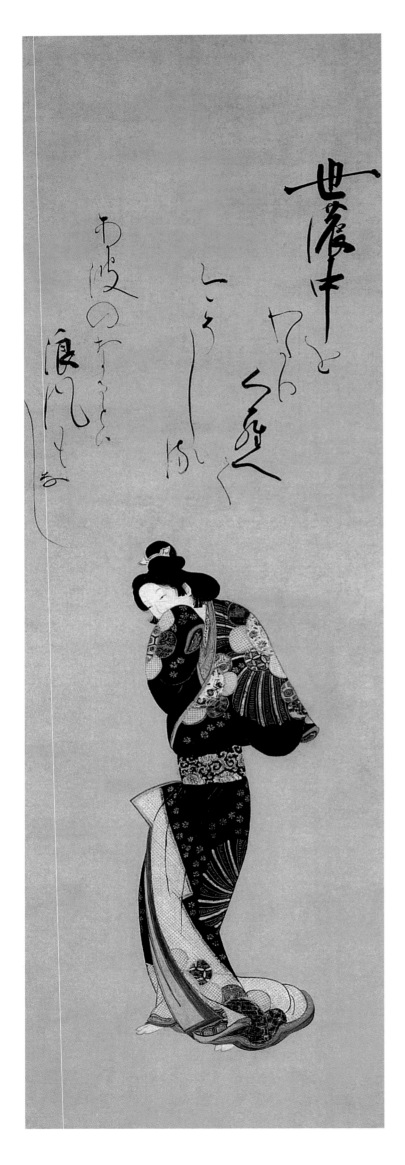
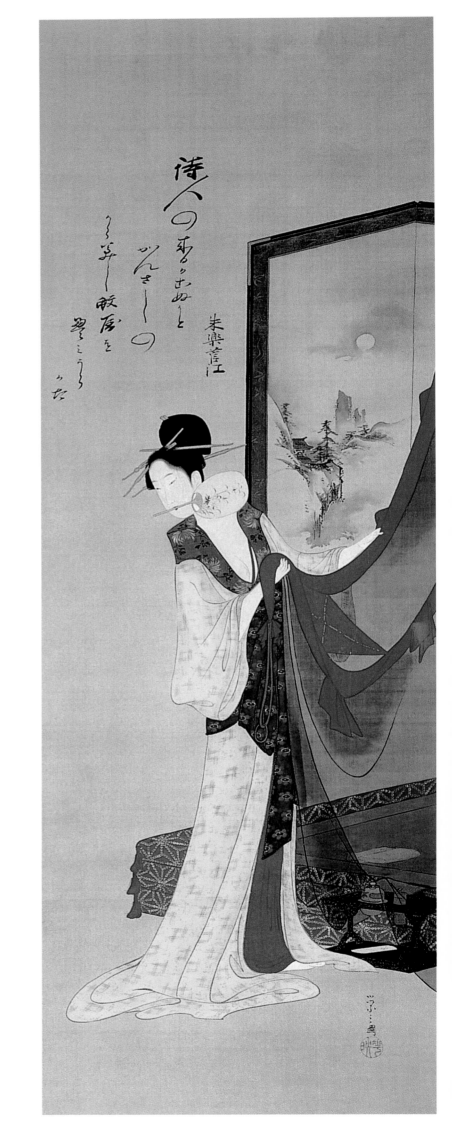

instead without any relation to the absolute in its purely worldly shape and form. The profane city person has no other option of understanding such extraordinary phenomena than the sensational. And yet these are the same phenomena which become the reason for deep religious upheavals on the basis of a mythical-sacred religious level, from which prophecies and revelations can radiate.

Only the latest earthquake in Tokyo had a stronger effect than this, as it struck the Japanese population to such an extent in its basic life that a purely objective attitude was hardly possible for anybody.

However, the mental effects which this triggered off cannot be compared to the earthquake of Lisbon in 1755. This was a real tremor of a religious kind for the West, and is closely connected to the growth of the Romantic Movement.

The Tokyo earthquake was the cause of a revival of half forgotten cultic conventions and it aroused primitive religious refuge instincts in the population. But, as can be seen so far, these religious effects appeared to have been of a very fleeting and temporary kind.

Women

The standing a woman has in any era is of the greatest significance for research into the history of religion. Whether she is seen as the symbol of eternity and as such at times enjoys cultic reverence, or whether she is regarded as a creature of a lower level and therefore has no access to the more serious matters of men, especially to the religious ones, that is all closely linked to the basic religious tenor of intellectual circumstances.

If we follow the standing of women in the religions of Japan in a theonomous sense relating to the history of ideas, we see that they were not given true freedom at any point at all. No Japanese religion gave women a completely equal position next to men.

Shintoism and the entire ancestor cult were completely oriented towards the rights of fathers. The Chinese-Confucian conventional laws that later spread further and further afield, restricted women's freedom to the extreme in their personal life, bound them to strict customs and made them the subjects of men, also in respect of the ethical assessment of ways of life.

Right from the beginning, Buddhism displayed a disregard for women. Admittedly, that lessened during the course of its development, especially in Mahayana Buddhism, and in the East Asian forms of Buddhism dependent on this. But where in the sects personal redemption was not regarded as the main factor,

Anonymous,
Standing Beauty, 1661-1673.
Ink, colours and gofun on paper, 79 x 27 cm.
The Art Institute of Chicago, Chicago.

Chōbunsai Eishi,
Beauty Going to Bed, 1796-1797.
Colour woodblock print, 100.1 x 35.2 cm.
Idemitsu Museum of Art, Tokyo.

103

but rather concentration and self-discipline, thus, where the intention was primarily the clarification of knowledge, the systems demonstrate a very male character from the start. The female element is more or less excluded. In this context we only need to recall the link of the Japanese samurai ideal with the spirit of the Zen cult. In order to understand the difference in class and standing of the two sexes in East Asia, it is important to take their completely different education into account.

In the late period of Japan, dealt with here, women's emancipation was very gradually starting to develop; a phenomenon which was not able to have a full effect and therefore become really apparent until the most recent age after the great upheavals in Japan.

This emancipation is not of a religious-sacred character, but a purely profane one; i.e. it does not take place on the basis of a new awareness and knowledge of the metaphysical depths of the female nature, but as a concomitant of awakening personalism. Content-related, it does not mean enrichment but instead impoverishment. It did not occur because women reflected on their true nature and new qualities emerged, which at the same time required new formations, but on the basis of the disappearance of obsolete bonds, belonging to the no longer existent, formerly sacred situation.

So that it does not seem here that theonomous and profane developments are meant to be pure opposites, the religious-positive character of the tendency for profanation in this area should be pointed out again. Their meaning is the real liberation of the inner and outer woman's life from burdens and inhibitions, which have been recognised in their unproductiveness and daemonic power. Profane liberation however, is lacking, as it never inquires about the target, the positive new aspect, but is always mainly a reaction against the old. "Free of what" is the profane attitude of interest, not "free to do what".

As far as the standing of women in the era of the Ukiyo-e is concerned, the first thing to notice is that women are the most frequent object of portrayal in the prints of the masters of wood engravings. Women are the focus of this whole genre and many of its individual prints. Women had a similar value as the art of the Ukiyo-e itself: people enjoyed their fineness and their grace, without being weighed down by metaphysics. Appreciation and disregard are close together.

The fact that a courtesan, the *oiran*, is again and again celebrated as the jewel among women, makes it very clear what made women really desirable. Nothing was more undesirable about her than individualism.

Chōbunsai Eishi,
Beauty Replacing her Hairpin, c. 1798.
Ink and colours on silk, 93.2 x 30.6 cm.
The Art Institute of Chicago, Chicago.

Kubo Shunman,
Courtesan with Assistants, 1781-1789.
Ink and colours on paper, 76.1 x 29 cm.
Idemitsu Museum of Art, Tokyo.

cute spawns of people's jokes.

That is what, in fact, they widely are. Perhaps we learn more from the pictures of the Ukiyo-e about their true nature, which is very versatile, than from observing certain forms of cultic reverence that people were pleased to show them.

It is also important to pay attention to why and in which demeanour gods and saints were portrayed. The seven wise men in the bamboo grove – an ancient and often depicted motif – are turned into a gallant style in the Ukiyo-e. This makes it clear that the original content of the symbol of the seven men has been completely lost; one is only interested – apart from other purposes – in the solution of the formal-aesthetic problem, to portray seven people in a bamboo grove in a very clever way.

The gods of fortune are almost always portrayed in grotesque positions, during games, which emphasise their rough character in quite a drastic manner. These figures constitute a spoof of any serious thought of godly creatures in the first place, but we should also point out that all this is not an actual reaction to the sphere of the holy, which would indeed be of religious significance.

Personal gods have never played an important part in East Asian history of religion – with the exception of the Jodo-Mon sects. Here, the religious basic facts were generally not symbolised in mythologically personified creatures, just as the lives of East Asian people never displayed a strong personal character.

Profanation does not mean as much in this respect as it may initially seem to the Western observer, according to his standards. All the same, the figures of the gods of fortune also used to be richer in substance. Their likeness to goblins is indeed a result of the profanation now

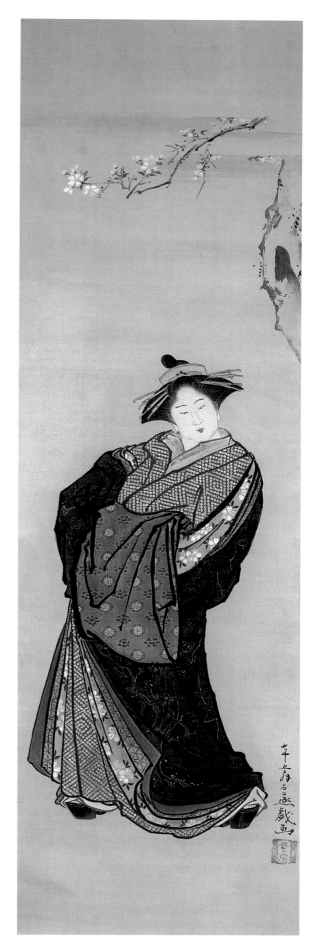

Toriyama Sekien,
Courtesan near Blossoming Cherry Tree, 1786.
Ink, colour and gold on silk, 88.1 x 26.3 cm.
The Art Institute of Chicago, Chicago.

setting in, which in this case meant the loss of the deeper, serious substance of these creatures.

The easy life in those times did not want any problems and obstacles hindering its freedom, and the seriousness of life was already regarded as such. Therefore the gods also had to play tricks on people and have a laugh, if they were to continue their existence. The fact that they in particular were very comical at that time can be explained with the reaction to their original serious character. Thus, people in those days were really deep down painting a picture of themselves in these figures.

To that effect, the intention of the Ukiyo-e masters was nothing more than to amuse and to entertain. Shunshō once said it openly in his foreword to a series of portraits of actors: he hoped to provide pleasant entertainment with his pictures – evidence given by the artist himself, which was of

the greatest significance in respect to the assessment of the entire Ukiyo-e, and which clearly shows us what really mattered during this period.

Humour

With regard to the special emphasis on the jocular aspects in this field we must remember that the Japanese have a very humorous disposition in the first place. Florenz once said that the following claim could be made: "That the original nature of the Japanese finds a more characteristic expression in their humorous work than in their serious products."

This fact is especially important for the way of looking at things with regard to the history of religion. From that point we will have to learn that seriousness is not necessarily a guarantee for religious significance in many

other fields either. Seriousness and gravity are not inseparable attributes of all religious life. On the contrary, in the serious, possibly dark and unreal side being overrated by the branch of science concerned with the history of religion, a psychological element shows itself, which constitutes nothing but a subjective prejudice in the field of objective research and, at least towards problems concerning religion, means crossing the line of a secondary point of view.

During the period we are dealing with, the strong emphasis on humour is particularly striking. No area in life is safe from humorous observation. The self-confidence, which expresses itself in the humorous way of life, cannot be shaken from any point whatsoever. A poet once crowned the fun he had in life and the fun he made of life, with the preparations he made before his death. He wanted his funeral

Chōbunsai Eishi,
The Salt Maidens, Murasame with
Yukihira's Hat (left-hand roll); *Matsukaze with*
Yukihira's Coat
(right-hand roll), c. 1800.
Ink and colour on silk, 82.2 x 30.2 cm
(right-hand roll); 82.2 x 30.2 cm (left-hand roll).
The Art Institute of Chicago, Chicago.

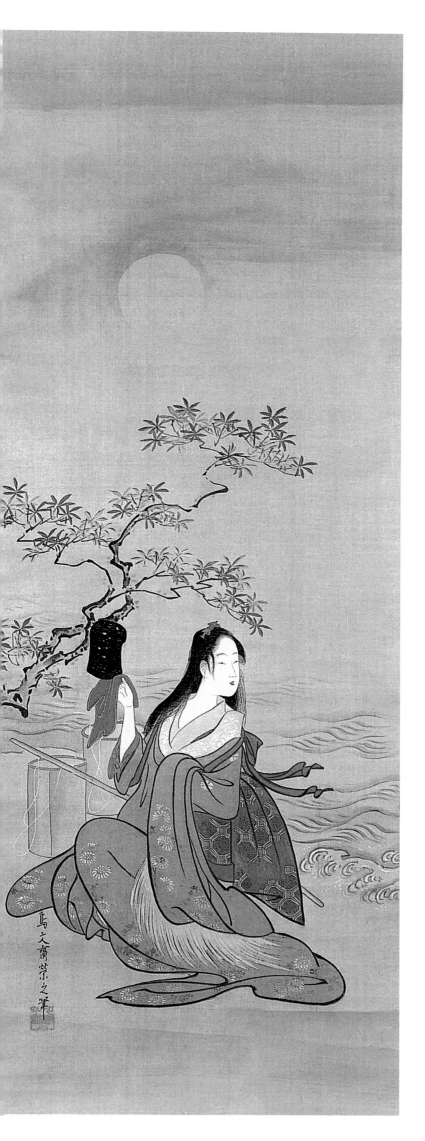
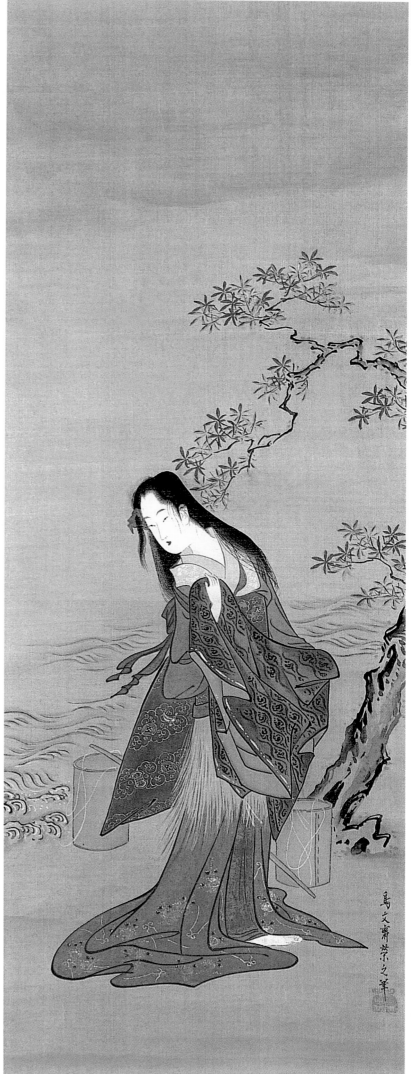

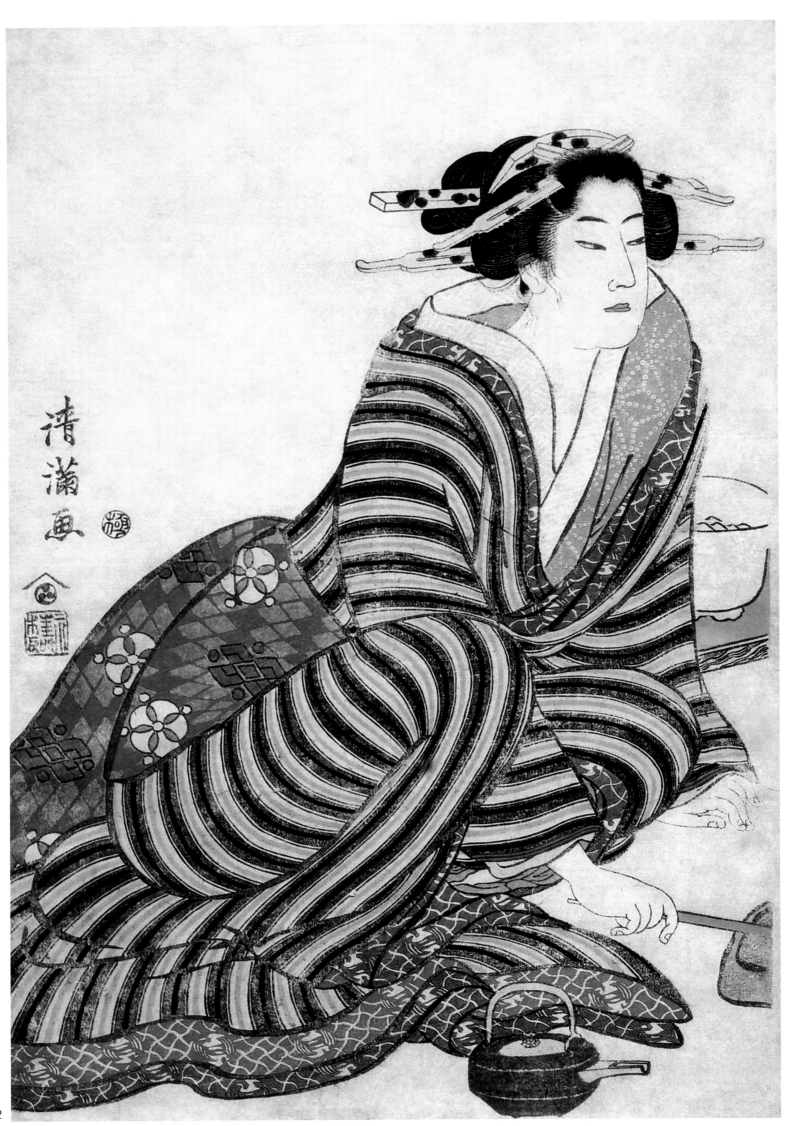

service to be accompanied by laughter by letting himself be burnt with fireworks he had secretly taken with him.

In order to gain some clarity about the deeper meaning of this humorous-grotesque disposition of the Japanese, we shall consider shortly what shape and form it took during the course of the Ukiyo-e's development. Three stages can be clearly distinguished from each other: humour, satire, burlesque. These three forms are based on one final thing they have in common, a deeply optimistic element – precisely that cheerful basic disposition, always with a tendency towards comedy and fun.

In pure humour, this cheerful basic disposition is still unbroken and has a sensitive and subtle and brilliantly witty effect on all areas of life. Thus, it is demonstrated during the so-called primitive period of the

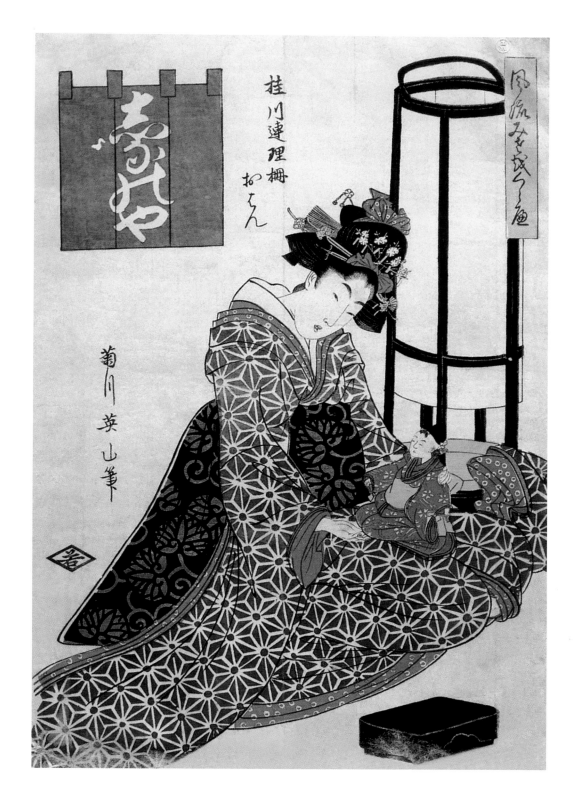

Kiyomitsu II (Kiyomine),
The Angry Drinker, late 1810s.
Colour woodblock print, 38.5 x 25.4 cm.
Victoria & Albert Museum, London.

Kikugawa Eizan,
The Jōruri Character Ohan with a Doll, from the series
Heroines of Double-Suicide Stories, c. 1810.
Colour woodblock print, 38 x 25.5 cm.
Victoria & Albert Museum, London.

Ukiyo-e: these prints full of jokes and fine, delicate allusions ooze pure joy and pleasure.

In contrast, life's seriousness is regarded as a threatening power by some individuals; the harsh element of existence demands its due, and the daemonic world-view breaks through. Horror appears on the scene. Reality is felt in all its naked ugliness.

This new aspect of the world does not necessarily have to lead to satire; the reformatory serious fanaticism of a Savonarola can also spring from it. It only leads to satire, which unites bitterness and comedy, where exposure is coupled with an indelible and humorous disposition, which cannot but exaggerate again on this basis in such a way that the comic aspect is finally victorious. In that respect the optimistic original element presents itself, which opposes a complete immersion into pessimism. This case has to occur in Japan and is

represented in the Ukiyo-e through the horrifying-satirical realism of Tōshūsai Sharaku, about which we will talk later on.

The cheerful disposition leads to burlesque, where satire is no longer felt a real threat, not as closure, but instead has lost its real impact due to gross exaggeration. A child-like humorous people will then also take on a cheerful basic mood over this final possibility of seriousness and will experience joy at widespread indulgence in contrasts, which unfold in satire. This final form adopted the cheerfulness of the Japanese in the burlesque comic element of Hokusai.

What then is the range of meaning of humour in relation to the history of religion?

As it is not intellectual, humour is the most original weapon in the struggle against every phenomenon whose demands on people are considered excessively hard. In so far, humour can appear as a profane phenomenon, where

a struggle against daemons begins, who bind and commit people without carrying and reviving them at the same time. The opposing position of conscious ironisation cannot occur at once against the really damaging effects of strong, lively daemonic powers, by which time is obsessed. However, irony exists where obsolete daemonic powers are recognised as such, a valuable tool to reveal and clarify the negative character in its claim to sanctity.

The special question in relation to the history of religion is what kind of daemonic powers should be fought and overcome in Japan in the late period.

Japanese humour in the Ukiyo-e is mainly directed against Buddhism, as it was seen and known then. Its seriousness and gravity, its pessimistic basic tendency must have seemed paralysing, strange, unjustified and at least much exaggerated to

Chōkōsai Eishō, *Portrait of the Courtesan Hanaogi of Ogiya*, from the series *Comparisons of Beauties of the "Pleasure Quarters" (Kakuchō bijin kurabe),* c. 1795-1798. 38.9 x 25.5 cm. Baur Collection, Geneva.

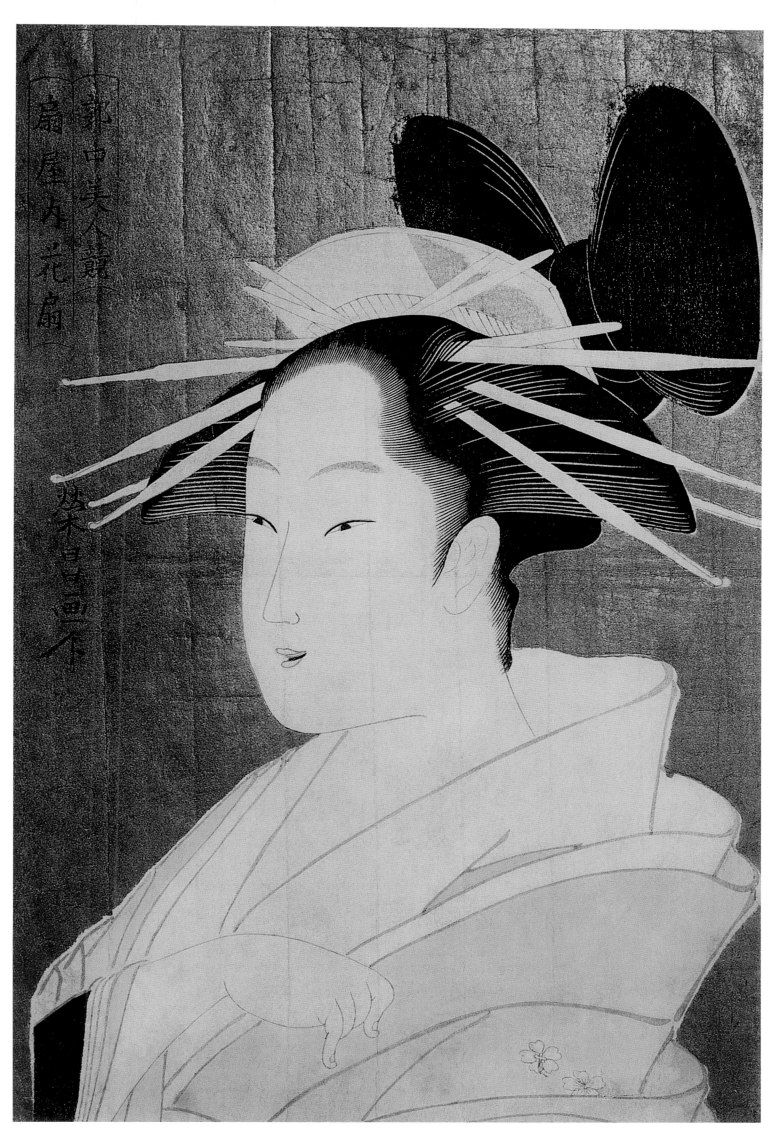

郭中美人競

扇屋内花扇

栄松斎長喜画

115

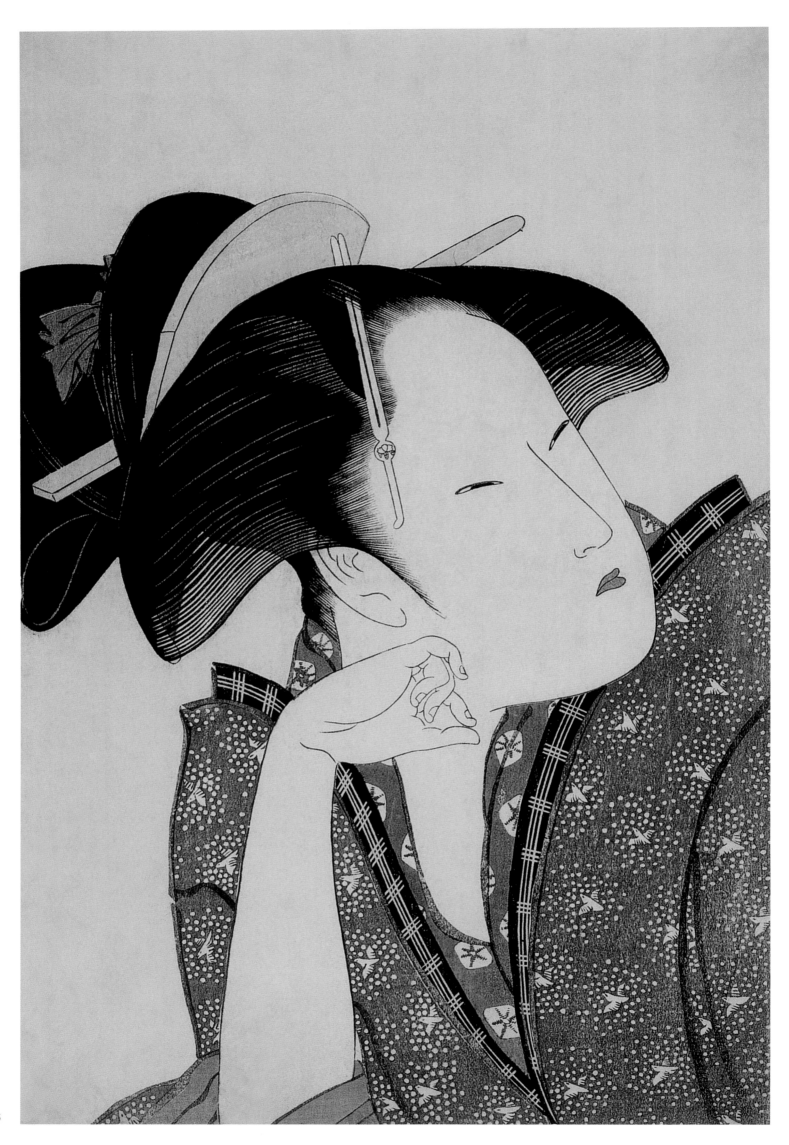

people, who were full of zest for life and development as the Japanese.

An attempt to lessen the effect of Buddhism, which was negative and therefore daemonic for East Asia, had in fact already been carried out on a religious basis: in Amidaism. But this also had origins in the idea of the renunciation of the world, for the essential feature of longing for redemption, and therein a final rejection of the world, was preserved in spite of all positive ideas. Besides, its priests were mainly subject to the damage of nationalisation of Buddhism in Japan, which we have looked at more closely in the above text.

In comparison to escapist seriousness, which was perceived as exaggerated, the most effective tool by far was ridicule. With this, the powers they fought against were much more radically abolished and robbed of their daemonic-absolutist character than would have been possible through any other form of struggle, which, by taking the object fought against seriously, would have left it a character of seriousness, which was perceived as particularly daemonic.

Besides, such popularity could be achieved in no other way. For the general public ridicule is the strongest form of refutation.

The religious spheres of Japan and the West were attacked in different ways, such that in the West, religion could effectively continue as before, in parts even with significant consolidation and growing claims to absoluteness. In Japan, however, all forms of religion suffered severe and decisive upheavals and – in as much as it is still regarded as a force of life – changed its fundamental nature enormously. Everywhere religious thoughts appear alienated, secularised and superficial. They have been forced from their central position in life.

Daemonic Powers

However, cheerfulness is only one side when it comes to Japanese temperament. Even the light, otherwise harmless art of the Ukiyo-e occasionally shows hidden, wild currents, to the source of which we yet have to feel our way forward.

All our ideas about daemonic powers do not come close to what hellish horror occasionally stares back at us from a print of an otherwise so delicate and sensitive master of wood engraving. The dark side of the East Asian character is revealed here, which is usually regarded as the only one by Europe's trashy literature. But it is exactly this side that remains hidden, and only seldom breaks through to current reality – then of course it is with such an elementary impact that it is completely unimaginable and incomprehensible to the people from the West.

Kitagawa Utamaro,
Reflective Love, from the series *Anthology of Poems: The Love Selection*, c. 1793-1794.
37.7 x 24.8 cm.
The Art Institute of Chicago, Chicago.

Chinese and Japanese mythology holds such an abundance of devils, daemons and evil spirits, the like of which is not found among any other people in the world. The religion of the lower class has accordingly not been much else than exorcism and incantations, driving away dark powers that were threatening people everywhere they went and during everything they were doing. But perhaps no other people in the world succeeded so wonderfully either, in liberating the daemons from their cruel-bestial basic instincts. The conventionalism and moral strictness of the East Asian people had to be regarded in their whole dimension as the most effective tool for banishing these basic instincts.

In East Asia it was not the gods who fought against the horde of daemons, but ceremonies. The process of this battle is of a dialectical nature; the weapon used in each case developed into new daemonic powers, for which new weapons are then needed.

The wild and cruel basic instincts of the primitive human being are already restrained by the fact that they are directed towards the outside and clarified through personification. The magician, with his incantations and his mysterious magic powers opposes these evil spirits, which are now constantly threatening people's lives, intending to keep them in a constant state of horror and fear. He banishes the daemons, which frighten the people, by letting other stronger daemons he forms an alliance with fight against them. This struggle demonstrates vividly how certain instincts and passions are repressed by others that are approved of at the time, because they initially appear to be less dangerous. Even today, Taoistic magic priests have the same functions as the magicians in ancient times. However, this instinct-driven, irrational exorcism

Kitao Masanobu,
The Courtesans Hinazuru and Chōzan,
from the series *A Contest of New Yoshiwara Courtesans
with Examples of their Calligraphy*, 1784.
Colour woodblock print, 27.5 x 38 cm.
The British Museum, London.

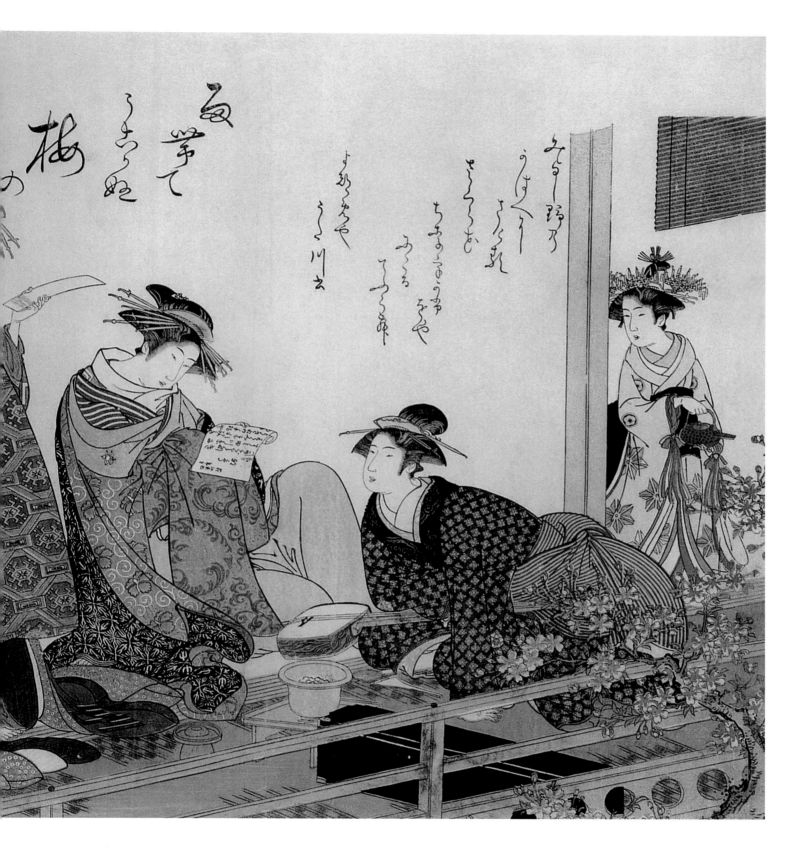

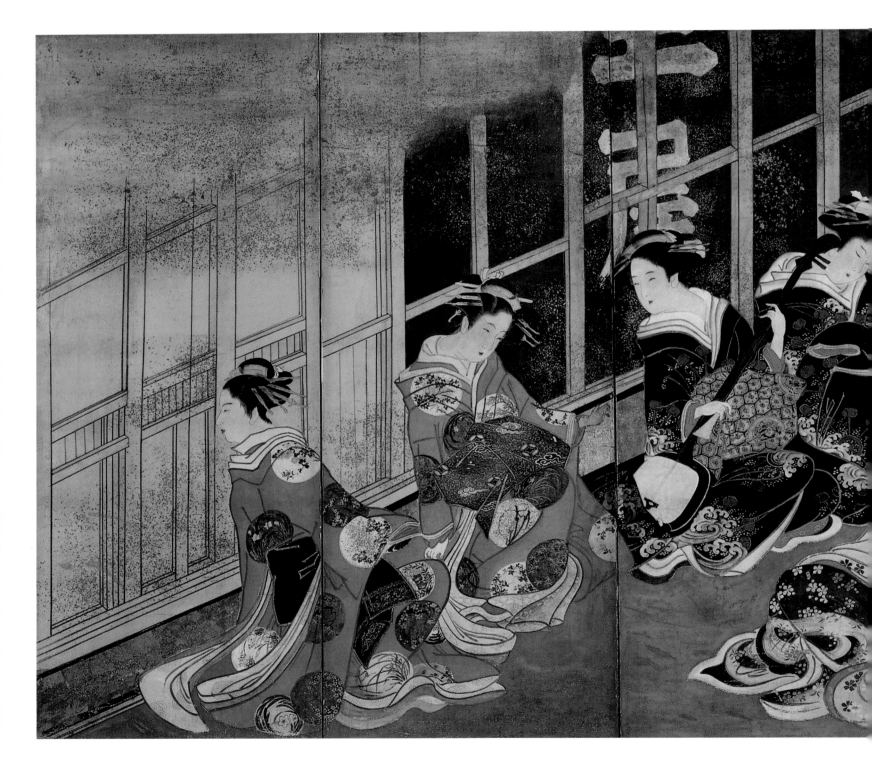

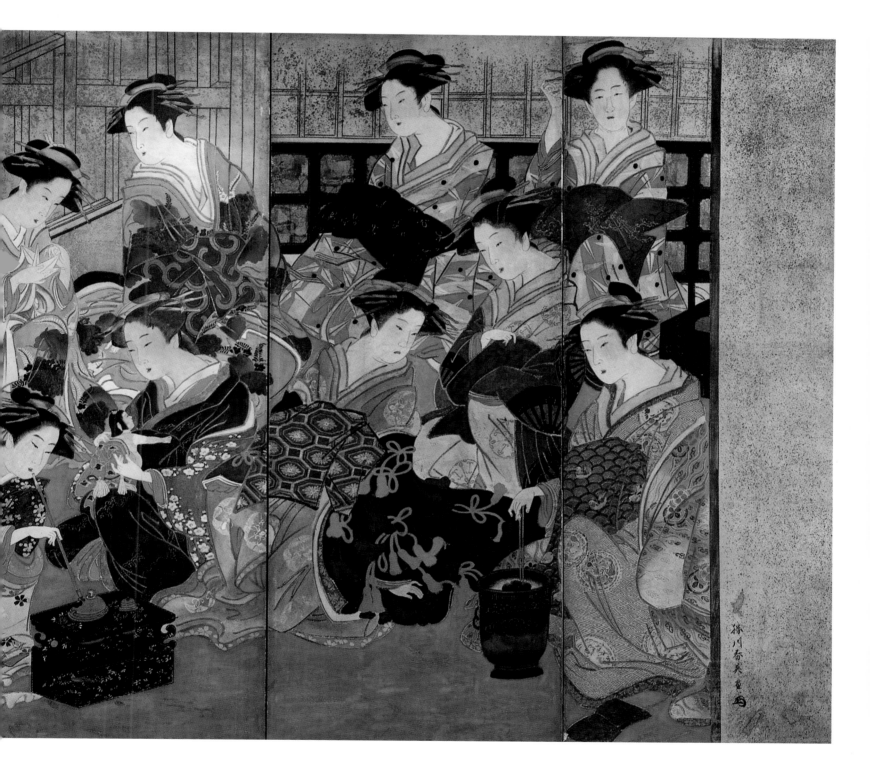

Katsukawa Shun'ei,
Courtesans Exposed to the Public (harimise),
Edo period, Tammei (1781-1789) or Kansei
(1789-1801) era. Ink, colours and golden powder on
paper, six-panel folding screen,
144.2 x 307.2 cm.
Musée Guimet, Paris.

121

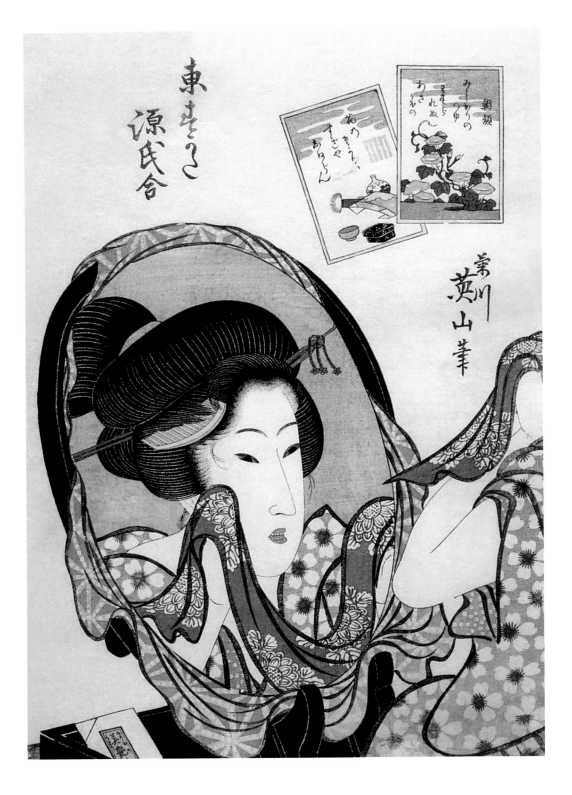

is not able to lead away the spell of daemonic powers from compulsive instincts. For this reason, the human mind rises above it; in East Asia there is a rational and detailed final forming of all areas of life.

The Shintoistic, like the early Chinese system of ancestor-worship, together with Confucian ethics, have the effect of banishing the mysterious-irrational daemons and depriving them of their oppressive powers. Life that originally was completely dependent on the moody arbitrariness of compulsive spirits is now grasped in its entirety and ruled by the human mind. But this system also had tendencies towards daemonic degeneration, which developed to such an extent, when the formal grasp of life related to all areas. The absolutely committing character, the strong bonds of the rational system finally stopped all free movements of life; any intellectual possibility of

Kikugawa Eizan,
Woman at a Mirror, from the series *Edo Beauties,*
c. 1820.
Colour woodblock print, 38 x 25.5 cm.
Victoria & Albert Museum, London.

development was therefore lost. People from the lowest to the highest circles were subject to intellectual paternalism by sacrosanct conventions, which did indeed save them from the realistic daemons, but then led them to an enslavement of the intellectual form. Any sort of freedom was therefore taken from the entire population as well as from the individual, and it was necessary that a reaction followed against this force, which would let people's autonomy be fully exerted.

The stability of the sacred-lawful view of life was revealed as a deception, and the instability of the eternally fluctuating process of existence emerged everywhere in its reality and force.

The word "Ukiyo-e" is the most appropriate symbol for this newly awakening lifestyle. Japanese profanation took its course in the sense of the Ukiyo-e. How these tendencies emerged was described in the first part of our observations

through the ages; now they gained acceptance with full force all over.

However, to the extent at which the stagnating daemons of a lawful mentality were obliterated by profanation, the original, instinct-driven daemons were given space again to develop.

Where in art during this time of transformation, in the Ukiyo-e, the spawn of the daemonic sphere of basic instincts takes on a visible form, we are face to face with the most horrifying fantasies of mankind. Thus, they scream in a most bloodthirsty and brutal manner at us from Hokusai's *Hyaku Monogatari*, his depictions of ghosts, of which even the Japanese publisher only dared to bring out five prints.

Hokusai is not the only one to create these depictions, but their significance is intensified in his prints by the fact that he also lets some of these daemonic powers emerge in other areas of his portrayals. He is possibly the only

Japanese artist who portrayed the destructive, daemonic powers of the force of nature in a realistic, non-symbolic manner.

If horror finds its expression in rather dreamlike-fanciful forms in his depictions of ghosts, it shows the features of a harsh realism in his portrayals of storms and waves. The fact that daemonic powers are by no means softened is demonstrated by the blood-curdling way of Sharaku, for whose brush brutality and reality are simply identical. He made the daemonic powers his characteristic style – from the point where he positions his brush, figures of horrifying, threatening fury are created with massively hard strokes – their representational occurrence can then be of secondary importance.

But these daemonic powers are not the essentially negative of the profane era; the Ukiyo-e art we have just discussed has indeed another meaning.

123

The fact that compulsive daemonic powers appear outwardly during this time and show themselves in works of art, does not prove that it was particularly strong during this time and could no longer be hidden, but rather the opposite. They only possessed true force as long as they dwelled in mysterious primaeval depths, although with the tendency to erupt at any minute, but mostly held in eerie silence. The naked depictions of compulsive daemonic powers visible to everybody meant they would definitely be abolished.

But the compulsive natural daemonic powers are no longer crucial at this stage. The current daemonic powers of profanation are growing up together with it and are only comprehensible through it. For the awakening world awareness, which is becoming clearer, is necessarily linked in profanation with a disappearance and fading away of the awareness relating to the imperative meaningfulness of existence.

Polarity of Man and Woman

The contrast of the male and female sex is felt very strongly in East Asia. It seems as if something of the dualism of yang and yin has been preserved in this form throughout the times. If we look at the work of the Ukiyo-e in relation to this point, there is a massive difference in the portrayal of the characters of men and women.

From the beginning to the later period of the Ukiyo-e, the pictures of women show fine and smooth features, highly cultivated gentleness in expression and attitude. In contrast, men, especially where they are depicted on their own, are shown in all their roughness and unattractiveness, with stubble and wrinkles. Their features occasionally reveal wild passion, their positions and the tenseness of their muscles pugnacity and brutality.

As far as the question of the origin of this completely different appearance of male and female figures in the Ukiyo-e is concerned, two aspects should be distinguished. On the one hand, the mentioned differences can be explained by the actual representational differences of the sexes. Women in Japan were indeed to a much greater extent subject to the strict laws of conventional morals than men. Their submission to conventions at the same time meant extinction of their individuality. Their physical and psychological well-groomed appearance made it quite impossible for any expressions of coarseness or any impulsive stirring to occur and be depicted as was the case with men.

But looking at it in this way the mere consideration of the present point of view is also inadequate.

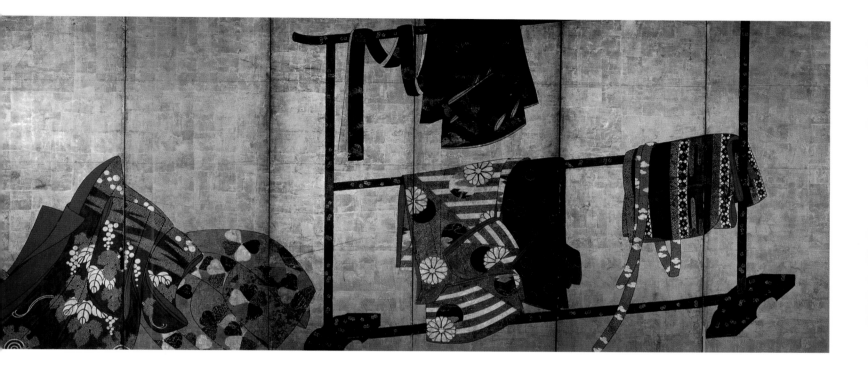

The fact that where men appear not only among their own kind, but in the company of women, their whole nature hardly differs and they are depicted in the same conventional position as their female companions, proving that very different laws apply. Much is said about the tension between realistic and idealistic elements within the classical period of the Ukiyo-e.

Thus, it is important to point out that only men were always portrayed in a "realistic" manner, whilst female figures in this period never deviated from their "idealistic" manner.

If portrayal in a realistic and/or idealistic way has the meaning of "brutalising" and/or "idealising" figures, it would suggest itself to think of the effect of erotic relations. The Ukiyo-e masters setting the tone

were indeed men, who, apart from a few exceptions, were completely into cultivated eroticism of that sensual period. Their intimate familiarity with the *oiran* from the green houses in the Yoshiwara and their preference for this area shows itself in numerous pictures.

To fully understand the difference in the ways of portrayals, other aspects are also important. It

Anonymous,
Whose Sleeve… (Tagasode zu),
Edo period, first half of the 17th century.
Ink, coulours on golden leaves, pair of folding
screens, 6 panels (byōbu),
148 x 350.4 cm (each panel).
Musée Guimet, Paris.

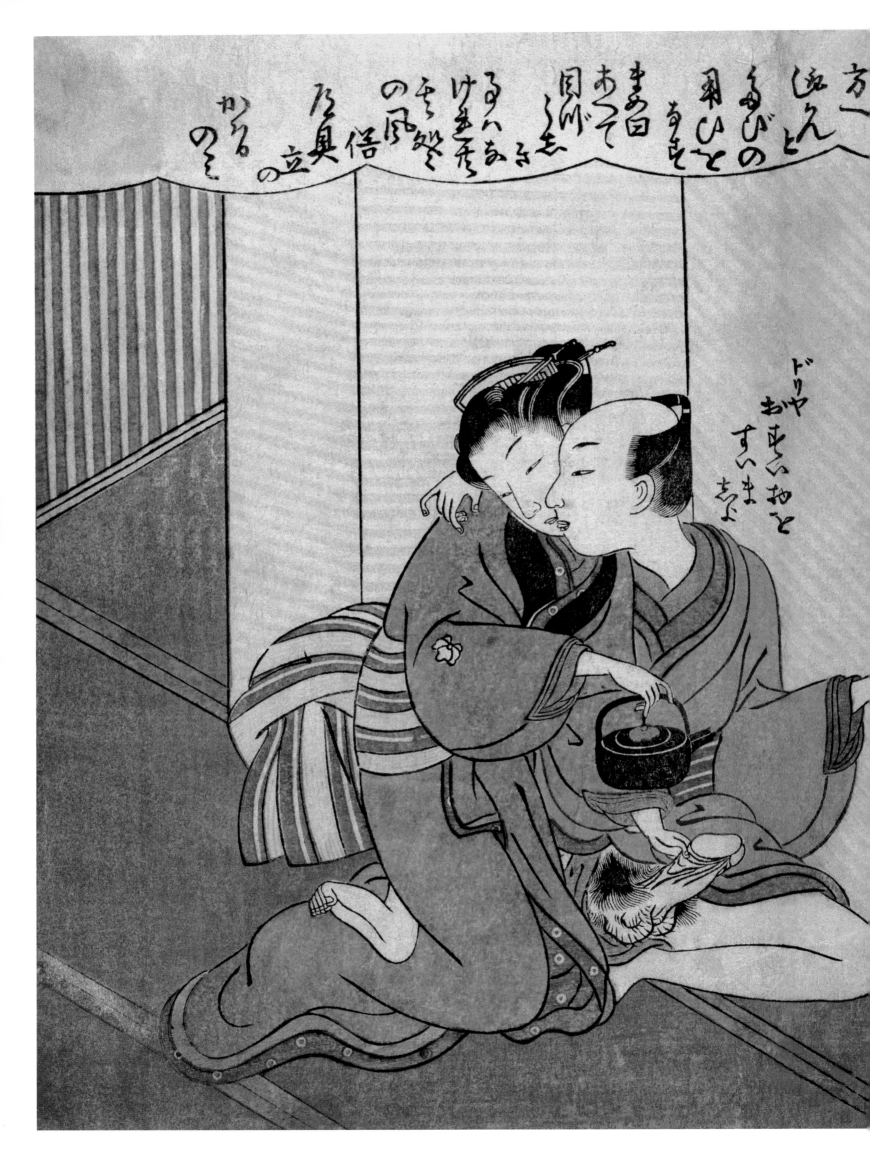

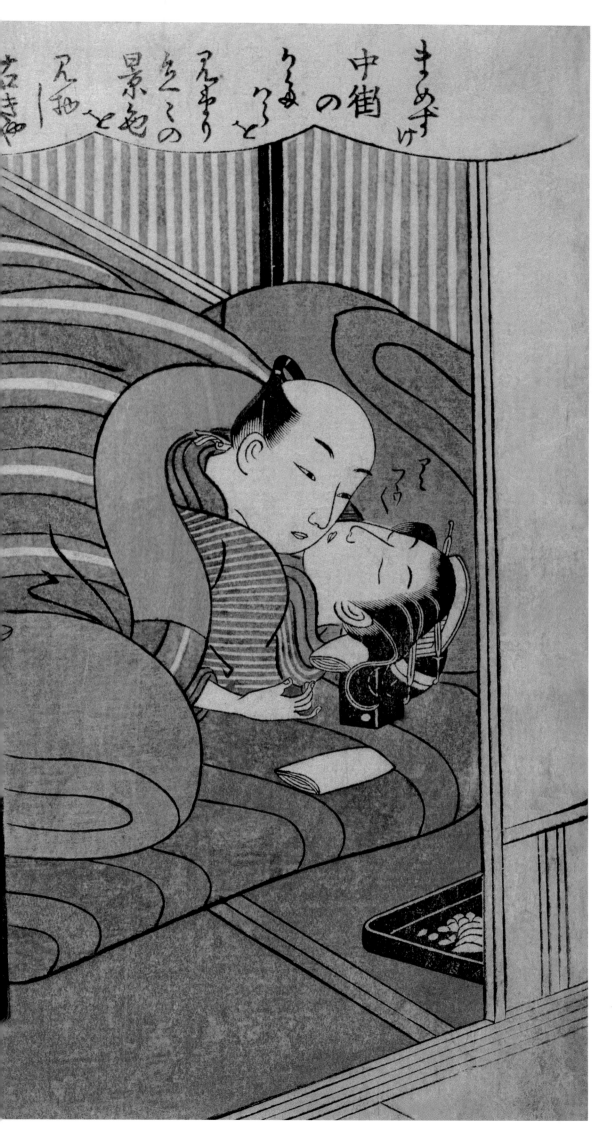

Isoda Koryūsai,
Shunga: Erotic Print: *A Servant Toys
with the Maid While the Master Makes Love
to the Courtesan.*
Colour woodblock print.
Victoria & Albert Museum, London.

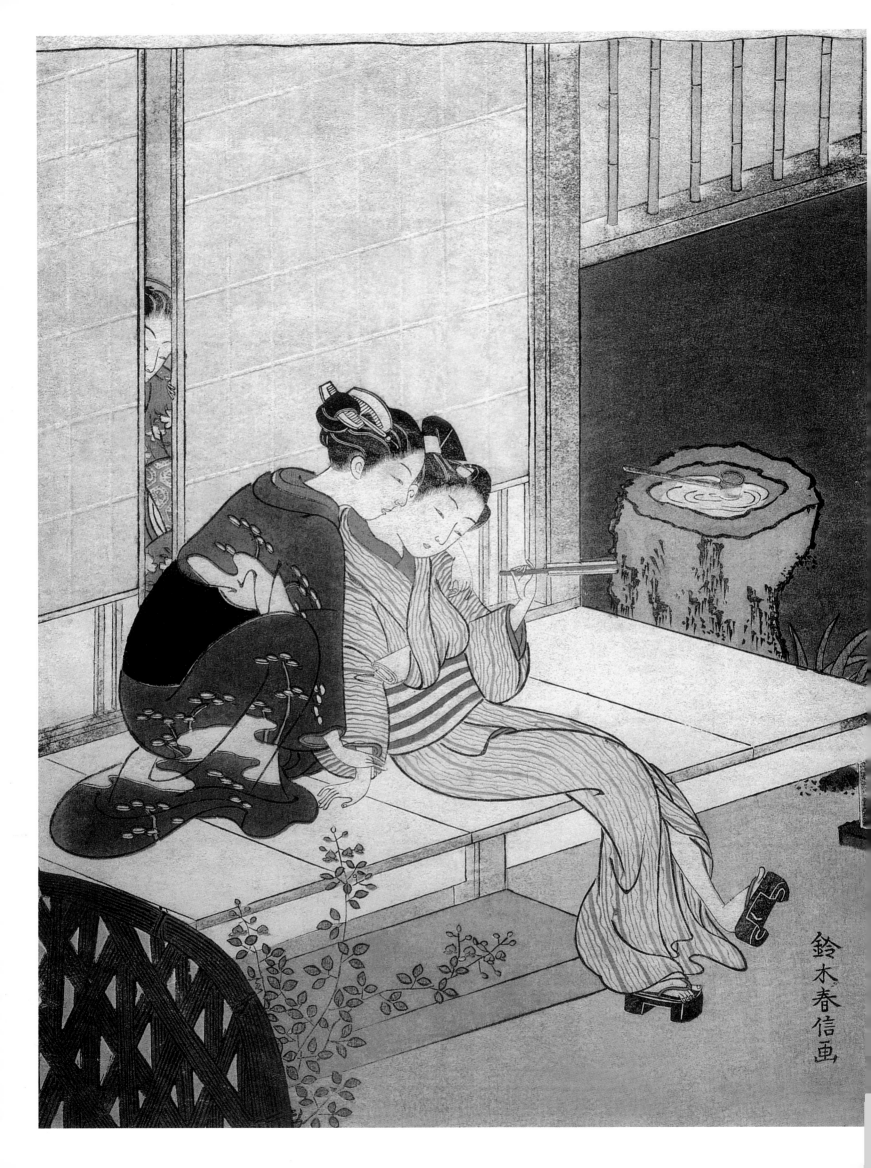

can be seen that the entire development of the history of religion in East Asia comes from the male sex alone and is constantly maintained by them. The male element, as the adaptable, warm, fiery and light yang element, pointing to the heavens, is capable of climbing through all highs and lows; historically it realises consecutively all daemonic powers and realises all stages, all extremes of possibilities for development relating to the history of ideas.

The female element is completely excluded from this at all times; it remains steadfast in the peace and earth-like nature of yin, always representing the same: the completely "unintellectual", motionless, but constant centre of human life. As women played no part in the development of the history of religion, which means, however, they preserved the yin element in a pure state, they had the utmost influence on just this development at the same time.

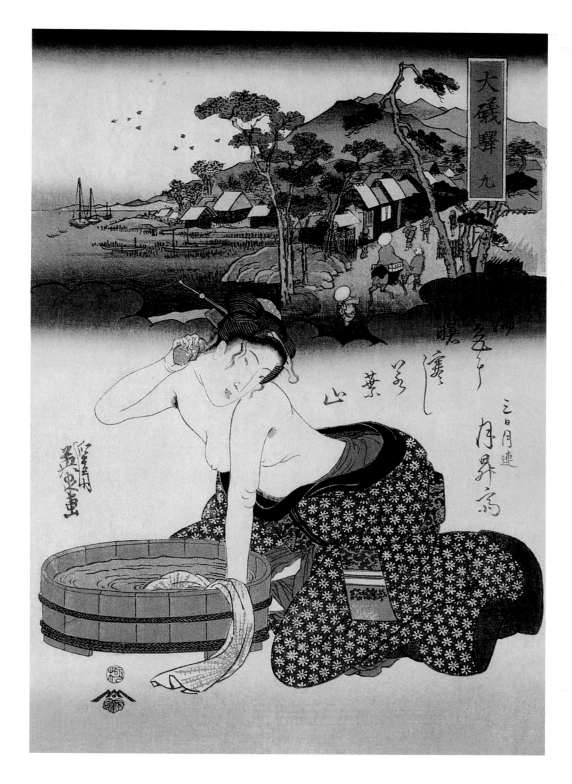

Suzuki Harunobu,
A Story of Love on the Veranda, 1767-1768.
Brocade print, 26 x 19 cm.
Tokyo National Museum, Tokyo.

Keisai Eisen,
Ōiso Station,
from the series *Beauties along the Tōkaidō,* 1830-1844.
Brocade print, 38 x 25.5 cm.

Isoda Koryūsai,
Shunga: Erotic Print: *Lovers Being Observed by a Maid*
from Behind a Screen.
Colour woodblock print.
Private collection.

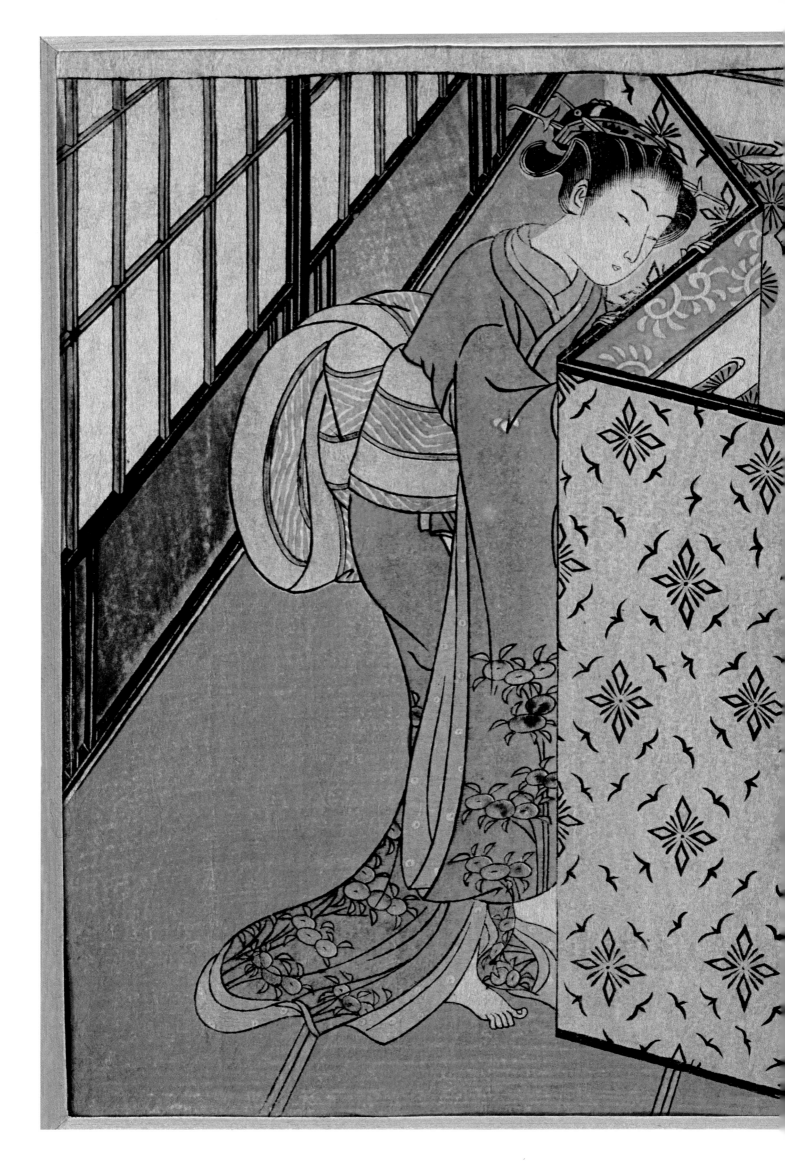

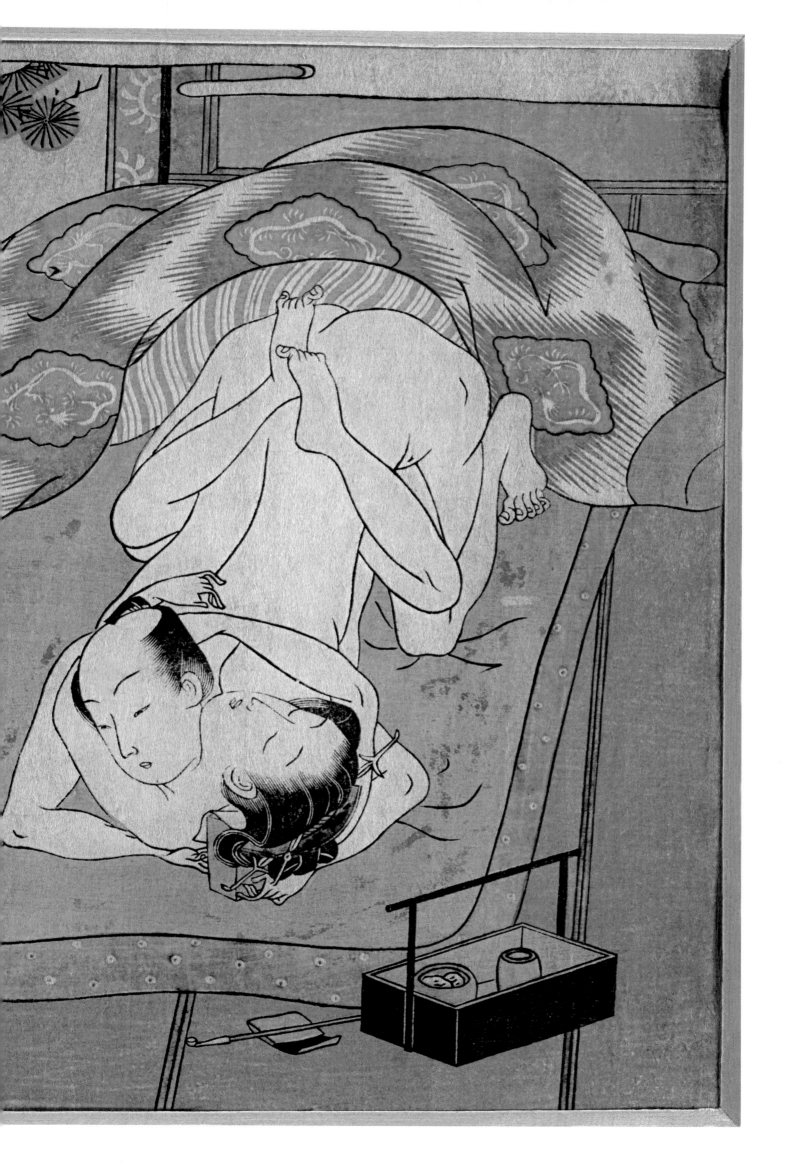

131

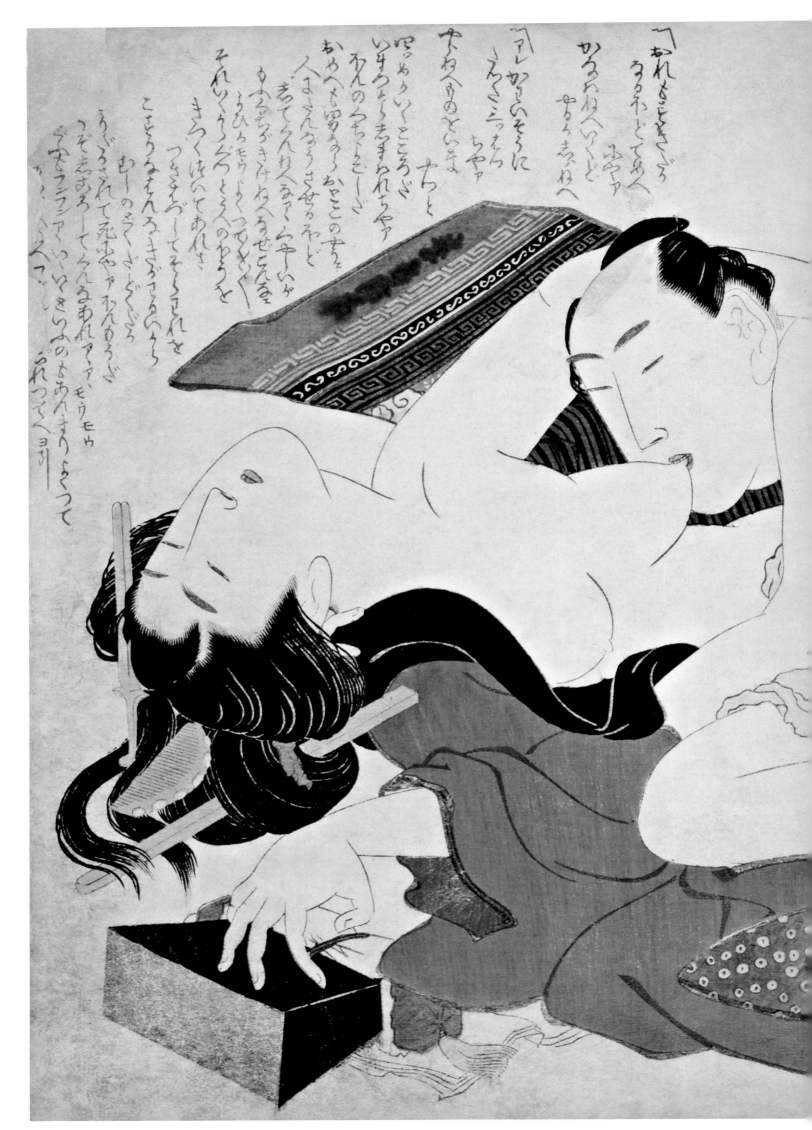

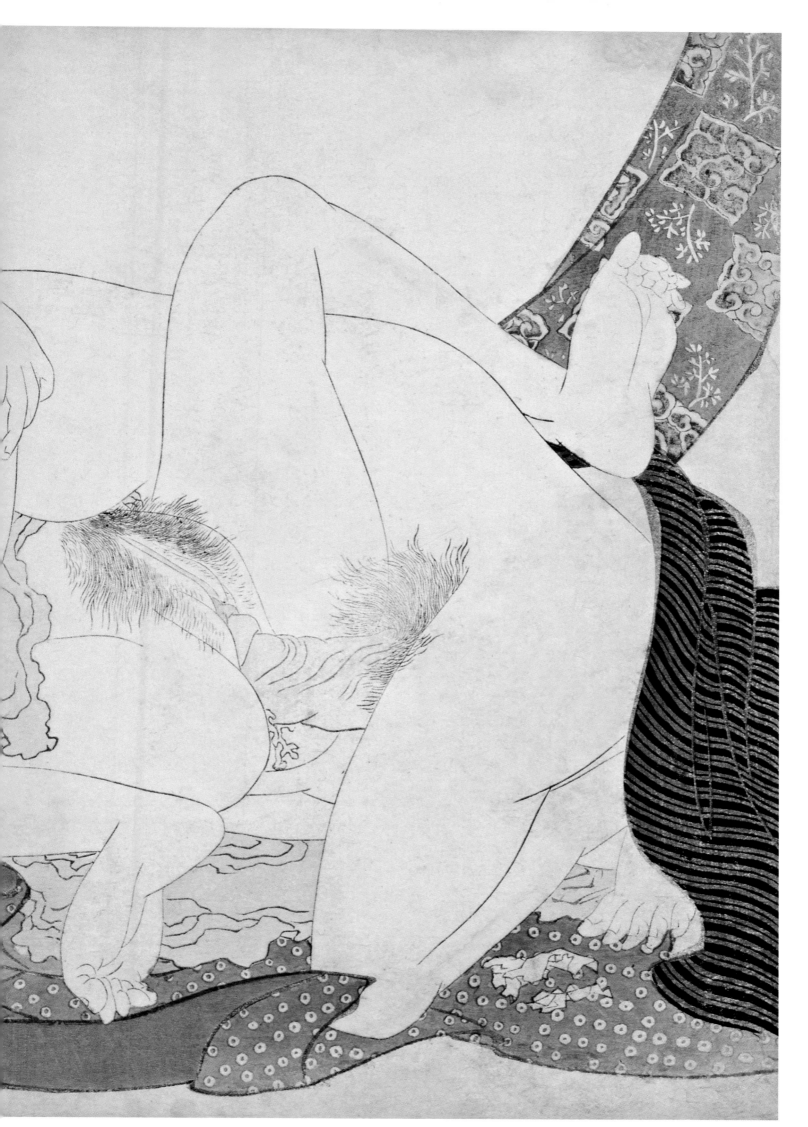

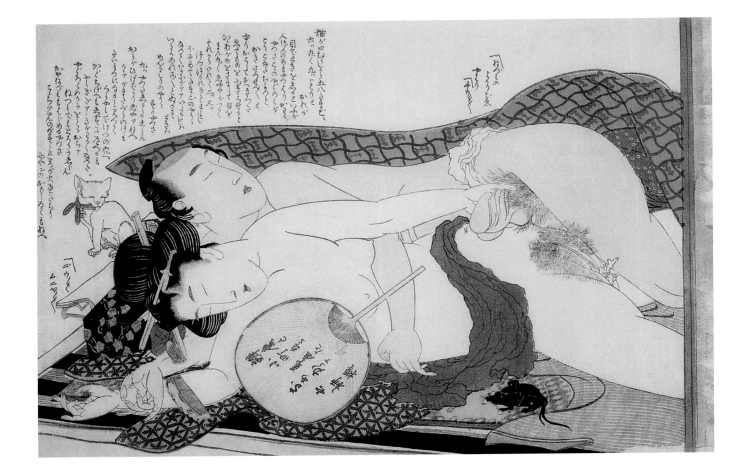

Without changing its course decisively at any one point or introducing new features, they always remained determining in respect to the tone, in which this development took its course.

That is the reason why sobriety, realism and restraint were always preserved during the course of East Asia's entire development of its history of religion as it did nowhere else in the world. East Asia's religions were always protected from extravagance of any kind, which emerged in the history of religion everywhere else. An important reason is that women elsewhere more or less distanced themselves from their purely spiritual original form. In this way mixed forms developed, which are absolutely impossible in East Asia. Here, women have never been demonised, their nature has never been perceived as negative, for just that reason that they constantly preserved their connection with the primaeval principle.

In Japanese mythology, women only play a more important part in one position: as the archetype mother Amaterasu. At this most extreme point her position is very decisive in a religious sense. This figure is extremely symbolic for the real standing of women in Japan, and for the standing of the female element in the life of Japanese people as a whole: only in their very deepest foundations do females achieve a meaningful significance.

In another place, the female

Katsushika Hokusai,
Shunga: Erotic Print:
from the series *Forms of Embracing (tsui no hinagata)*,
Colour woodblock print, 25.1 x 36.6 cm.
Musée Guimet, Paris.

Katsushika Hokusai,
Shunga: Erotic Print: *Drawing of Couples in Love*,
c. 1780.
Colour woodblock print, 24.9 x 37.4 cm.
Honolulu Academy of Arts, Honolulu.

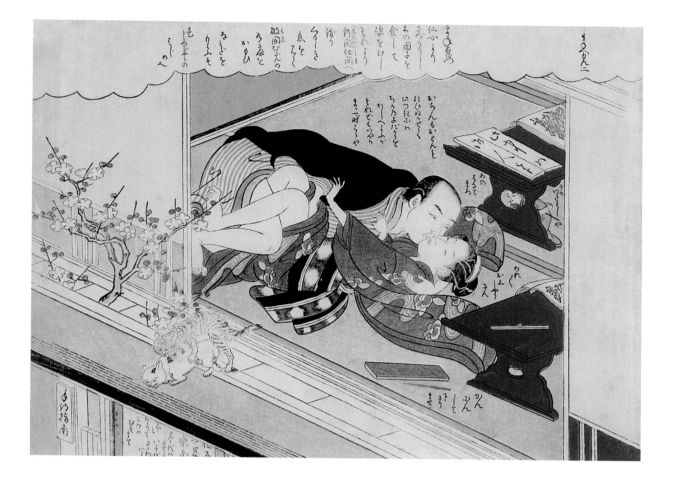

element occurs in Japanese history of religion where the figure of Amida is given female qualities. The yin element in Japan is today only capable of cult in these two forms. Amaterasu and Amida, the source of being and ultimate target – symbolisation of the absolute through the female only becomes a necessity at these two extreme points. Otherwise it is outside the cult, especially as it cannot be grasped in a religious sense. It is superior to all individual religious forms, and therefore also to fate, to which all current symbols in history must be subject.

What sort of an effect this fact has historically in detail and how it is portrayed, has been shown in the observations about the standing of women in East Asia. From here the phenomenon of Japanese eroticism also shows itself in a special light; it does indeed lead men, as we have seen above, into an area that lies completely outside any of their concerns, as women in East Asia represent an almost opposite archetype element.

Of course, during the course of history women have repeatedly been pressed by men into different intellectual forms that were necessary in each case, but have remained true and unchanged in themselves to their own nature through this entire development. They have retained their connection with the principle of yin.

Suzuki Harunobu,
Illustration from the Album *The Romantic Adventure of Man'emon,* c. 1768.
Colour woodblock print, 20.6 x 27.8 cm.
Honolulu Academy of Arts, Honolulu.

Katsushika Hokusai,
The Great Wave of Kanagawa, from *Thirty-Six Views of Mount Fuji,* Edo period, c. 1830–1834.
Colour woodblock print, 25.7 x 37.9 cm.
Honolulu Academy of Arts, Gift of James A. Michener, Honolulu.

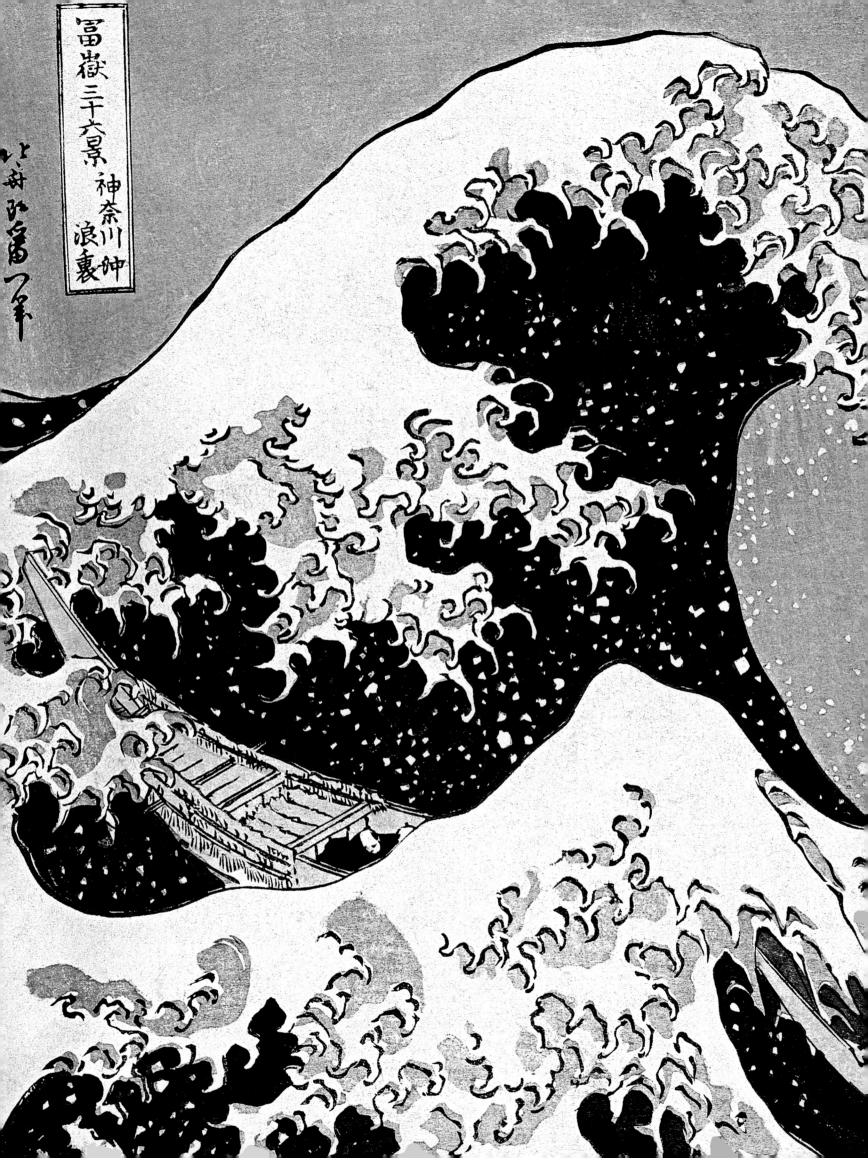

MASTERS of UKIYO-E

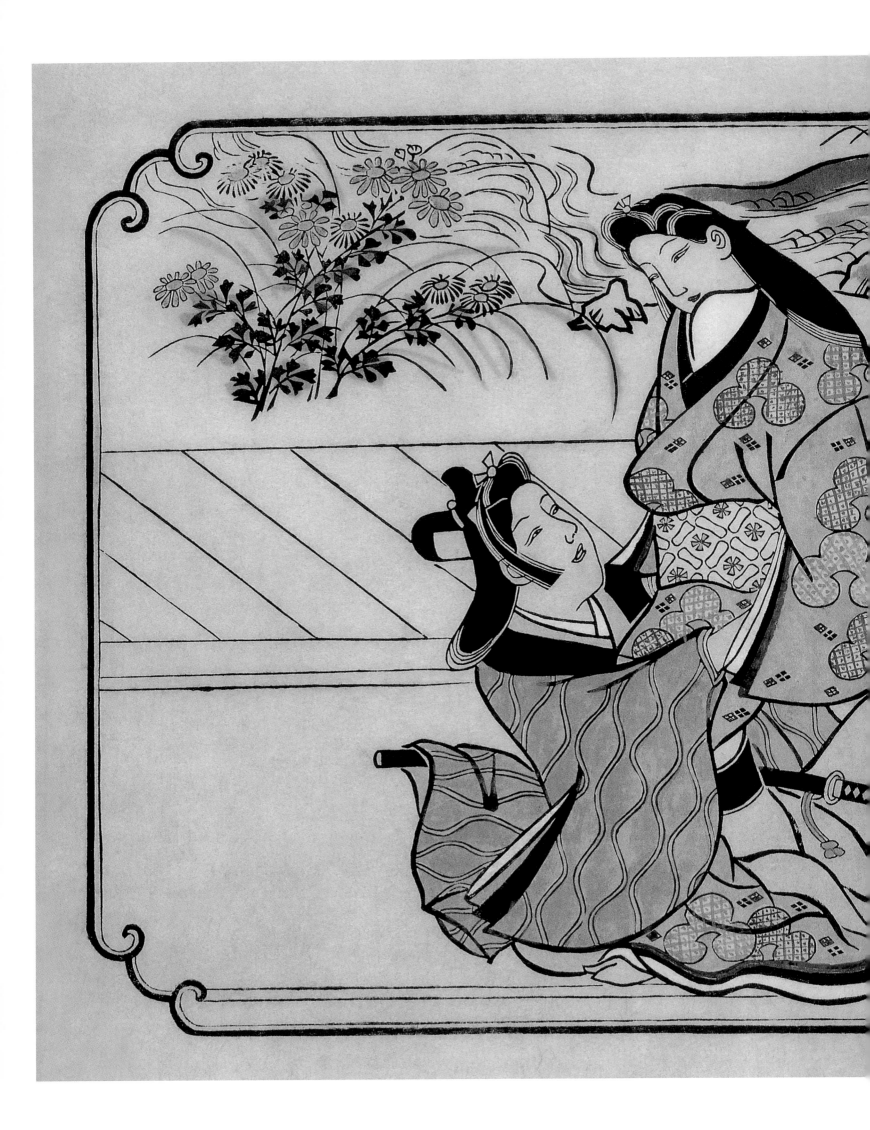

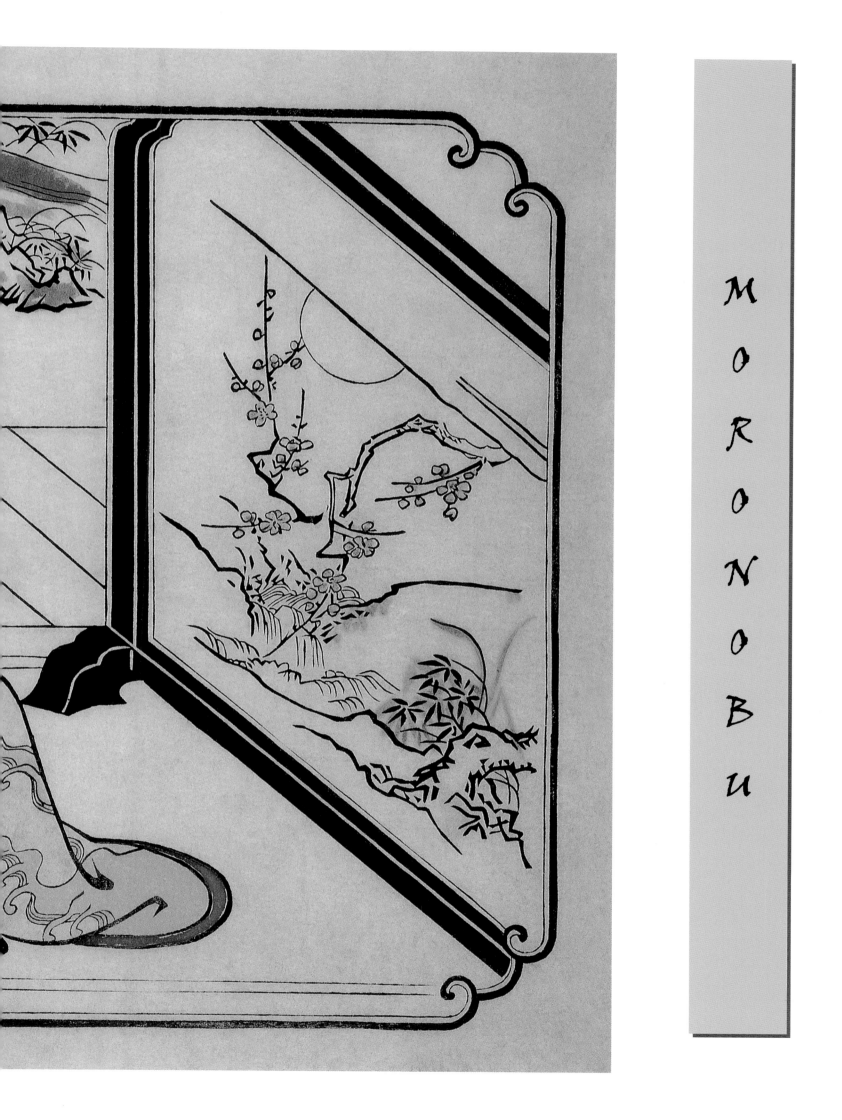

MORONOBU

Hishikawa Moronobu (?-1694) and his Contemporaries

The actual story of Japanese wood engraving only starts in the seventies of the seventeenth century. As so often in art history, it also happened in this case that an individual, extremely talented man, who arrived at the right time, suddenly raised art to its full height. Hishikawa Moronobu was this man of providence. When he began his work there was no talk yet of colour printing: his own prints are all still in black, and only as an exception given some effect by applying a little colour by hand. Fifty years were to pass by after his death, before, after a number of different attempts, first by means of hand colouring, then by means of two-plate and later three-plate printing, fully developed colour printing was invented, which was unlimited in the choice of its

means. However, Moronobu's activity had nothing directly to do with this last form of Japanese wood engraving, which gained worldwide reputation. Even if the development had later not gone as far as this point, he would have maintained his position within the history of Japanese wood engraving: for his significance does not only lie in the fact that he was a forerunner preparing the path, but in the level to which he rose in art.

It was indeed major progress that, instead of the usual illustrations only aimed at the entertainment of the masses, which had been executed in the traditional style and without any special care since the beginning of the seventeenth century, suddenly artistically perceived and artistically executed portrayals took over; it is also to Moronobu's special credit that he took up Isawa Matabei's popular art, which he had

created in the first half of the seventeenth century, but which in the time of general standstill following after had been forgotten again, and breathed new life into it: his actual fame, however, was founded in the fact that he at once developed wood engraving to such perfection that the entire period until the invention of colour printing itself, the time of the "Primitives", which lasted two full generations, remained under his influence.

Such Primitives are now much more appreciated than previously. They are not only seen as forerunners, but heroes, who, without being entitled to the highest divine honours, do actually develop such strength, liveliness and grace, as are hardly ever come across again with such strength in later times. In spite of the inadequacies, which necessarily are attached to their work, in spite of the lack of

Hishikawa Moronobu,
The Dandy and the Maiden: Behind the Screen,
late 17th century.
Monochrome print, 38 x 25.5 cm.
Riccar Art Museum, Tokyo.

Hishikawa Moronobu and his pupils,
Scenes of Craftsmen at Work, c. 1688-1704.
Ink and colours on silk, 27.5 x 833 cm.

Hishikawa Moronobu and his pupils,
Scenes of Craftsmen at Work, c. 1688-1704.

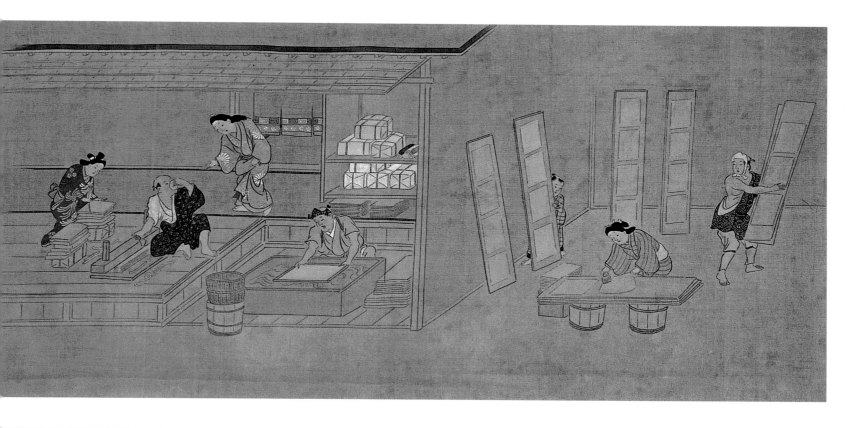

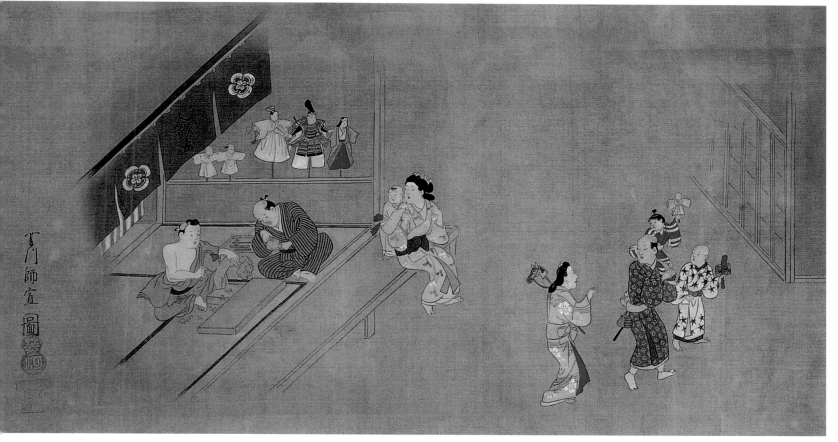

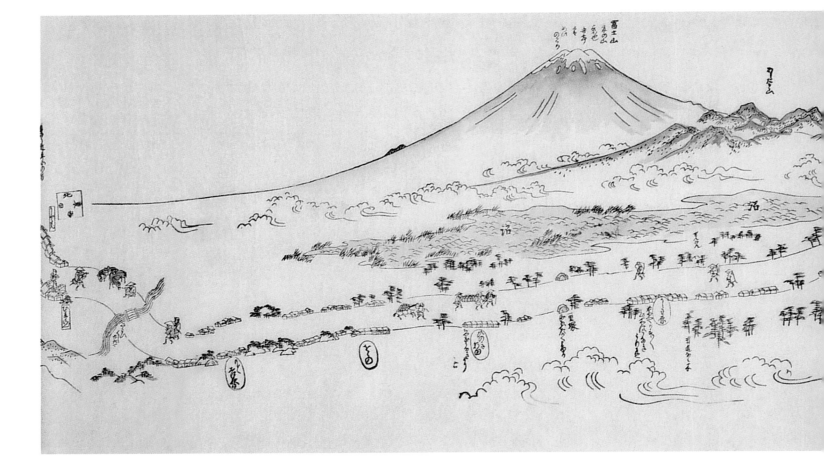

outward correctness, the limitation to few and mostly rough means, the conventionalism, their work has an attraction, which, in such a form, is neither characteristic to the work created in its heyday nor in the period of distinctive naturalism. For in their restriction to strive to make their drawings as expressive as possible, without consideration for a special kind of beauty or truth, these Primitives find the strength for an idealism, for an art of stylising, which later, with an increased knowledge, are completely unthinkable. The conscious striving for beauty and rounding off wears away what has been perceived with intuitive freshness and takes part of its strength away; the endeavour, however, to faithfully copy nature, leads away from the actual objectives of art, by letting the artist forget only too easily that he is the creator, not the copier of the

world. Thus whilst all efforts of later artistic development lead only to the fact that, after many attempts to harmonise beauty with truth, art flourishes for a short while then decays, the Primitives are unconcerned by such difficult problems. They follow their path, and in full freshness develop the powers within them by simply concerning themselves with filling their pictures with as much life as possible and rounding them off, which is required to achieve an artistic impression.

Moronobu's portrayals and those of his school are thus connected by a definite decorative effect, which is achieved as a result of evenly filling in the picture and the strong contrast of the white and black masses, with the utmost liveliness in movement and expression. All people – and these are almost always very eventful scenes – are connected

Hishikawa Moronobu,
Illustrated Map of Tōkaidō, 1690.
Monochrome woodblock print, hand-painted colours.

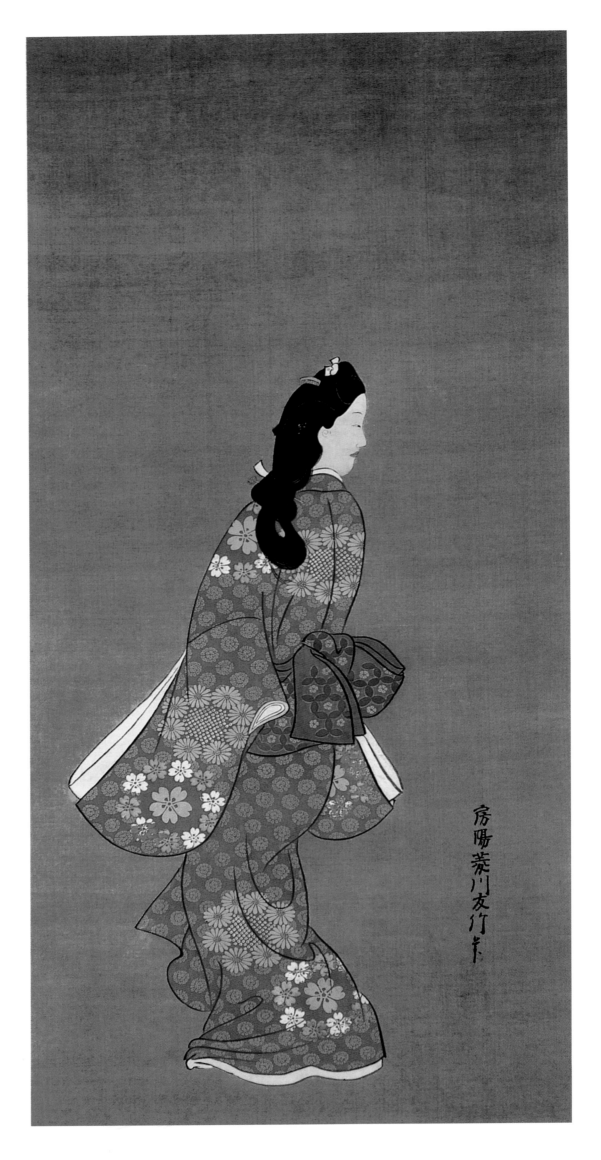

房陽菱川友竹筆

144

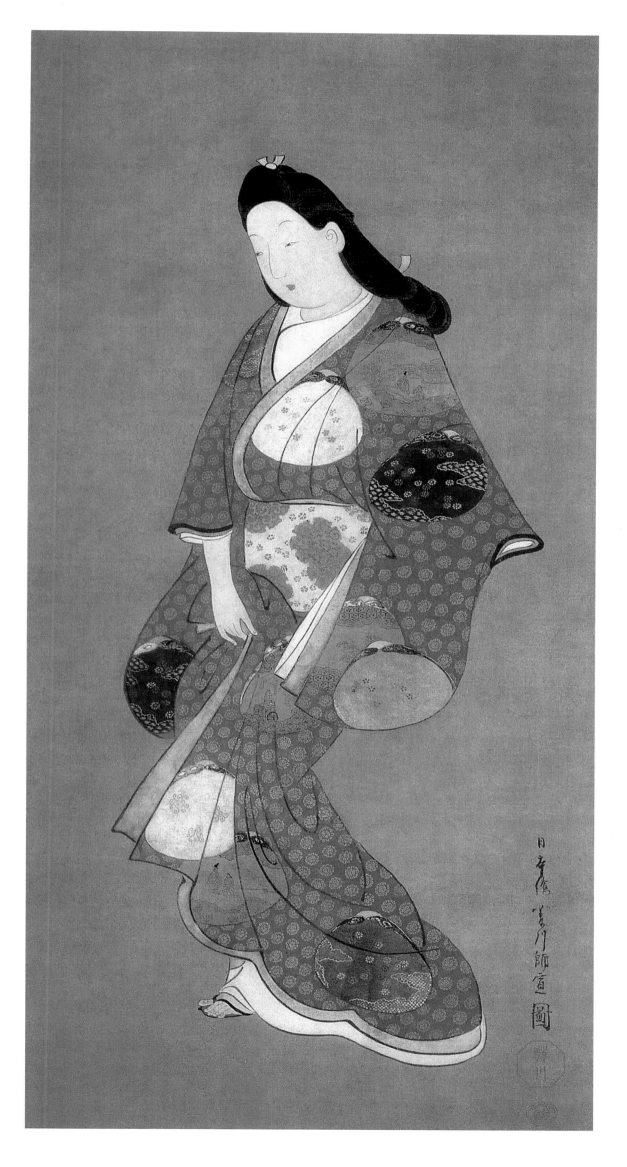

with each other, have an influence on each other, hence creating a highly dramatic impression. With an essentially diagrammatic form, they are nevertheless full of a keen awareness of life, which the artist felt from within. Despite the monotonous formation of the faces, particularly those of the chubby women with their small features, and the prevailing court etiquette, which enforced immobility and lack of feeling, sufficient inner passion is given away through the play of the eyes and brows. The figures, framed by firm, plump and slightly intensified outlines, move with graceful style. Scenes from history and legend, but also numerous portrayals from the present alternate with each other, faithfully depicting the doings of noble society, their fights and love affairs, their games, conversations, entertainment, as well as the fashion in hairdos

and clothes. Although the spirit of a new age of relaxed morals is expressed for the first time, by granting agreeable beauties as well as theatre people access into the portrayals, the artists never actually descend to the vulgar, but instead always maintain good manners and a noble stance. Only where the eventful street scenes full of figures are concerned, which Moronobu loved to depict on large landscape format, he abandons himself to a certain exuberance, but which always remains artistic and has a truly thrilling effect. He never becomes stilted, but always remains simple and natural.

Hishikawa Moronobu was born the son of a famous embroiderer from Hodamura in the Awa province around 1646-1647. After learning his father's craft and gaining a reputation as a graphic artist for colourful garments and embroidery, he

moved to Edo, where he learned to paint and then turned to illustrating books. Although he also made a name for himself as a painter by resuming the popular style that Matabei had established, adopting a gentle execution and a tasteful choice of colours, he gained a much greater influence through the revival he gave to wood engraving by creating great numbers of illustrations with unfailing fervour. He then had these cut into wood under his supervision in a more careful manner than had been usual until then. This work, which began in the seventies, lasted until the beginning of the eighteenth century. The most powerful of his creations originate from the beginning of the eighties. Soon a large number of like-minded people and pupils gathered around him, so that by the end of the century he stood there as the absolute ruler in this

Hishikawa Moronobu,
Beauty Looking Back, c. 1690.
Ink and colours on silk, 63 x 31.2 cm.
Tokyo National Museum, Tokyo.

Hishikawa Moronobu,
Standing Woman, late 17th century.
Hanging scroll, colour on silk, 68.8 x 31.2 cm.
Azabu Museum of Art and Craft, Tokyo.

Hishikawa Moronobu,
Beauty Turning Round, second half of the 17th century.
Ink and colours on silk, 70.6 x 26.5 cm.
Sumisho Art Gallery, Tokyo.

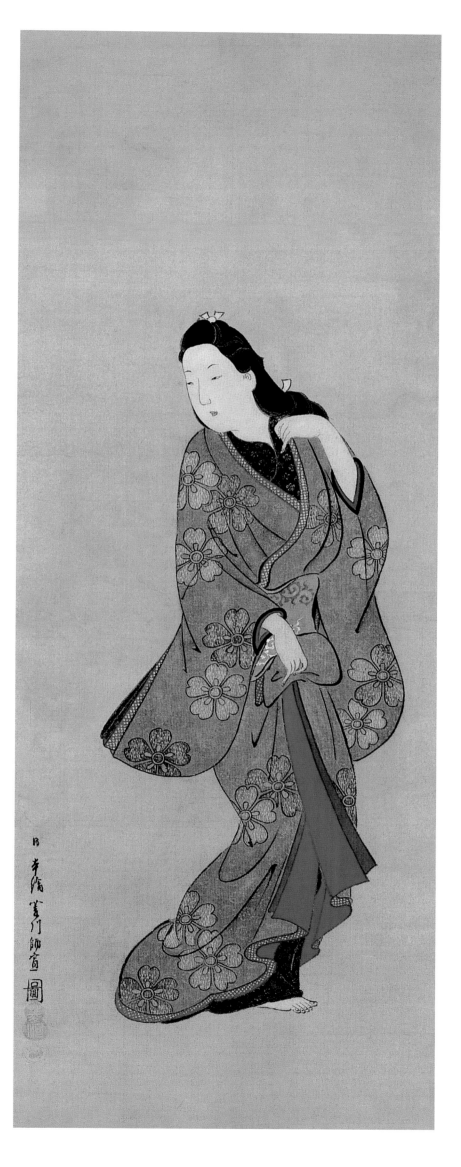

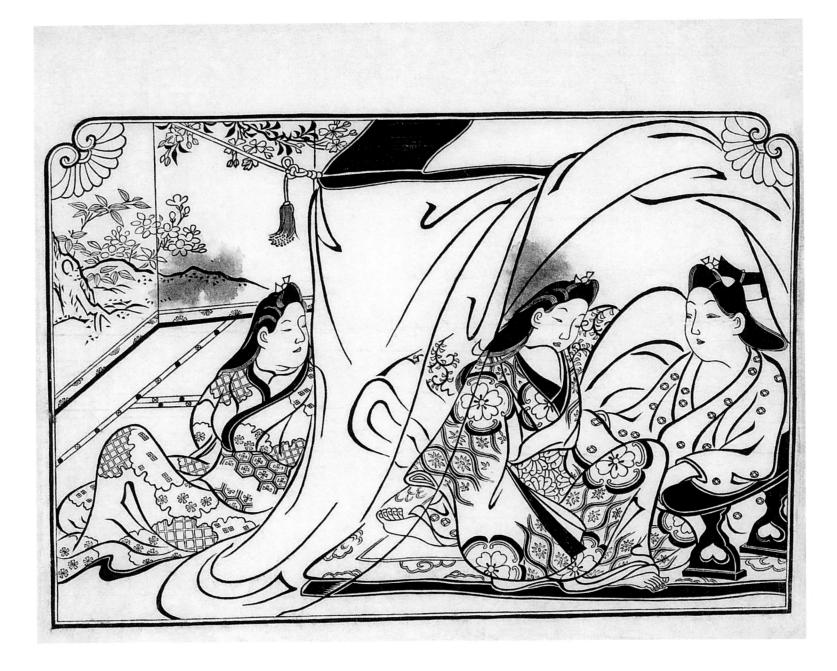

Hishikawa Moronobu,
Lovers and Attendant, c. 1680.
Ōban print, 29.7 x 35.3 cm.
Honolulu Academy of Arts, Honolulu.

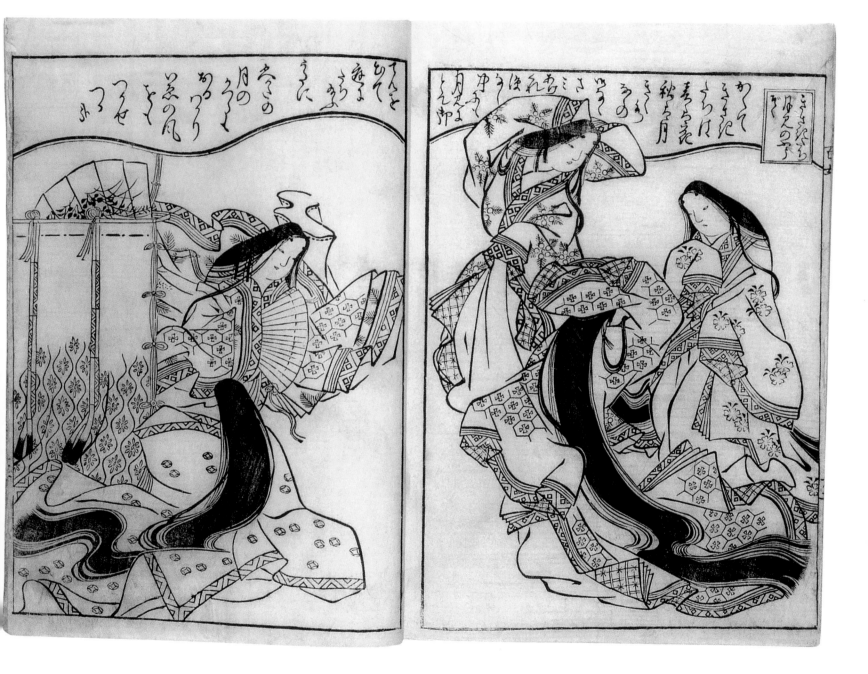

Hishikawa Moronobu,
Illustration from the volume *One Hundred Women of
the Floating World (Ukiyo hyakunin onna)*, 1681.
25 x 18 cm.
The British Museum, London.

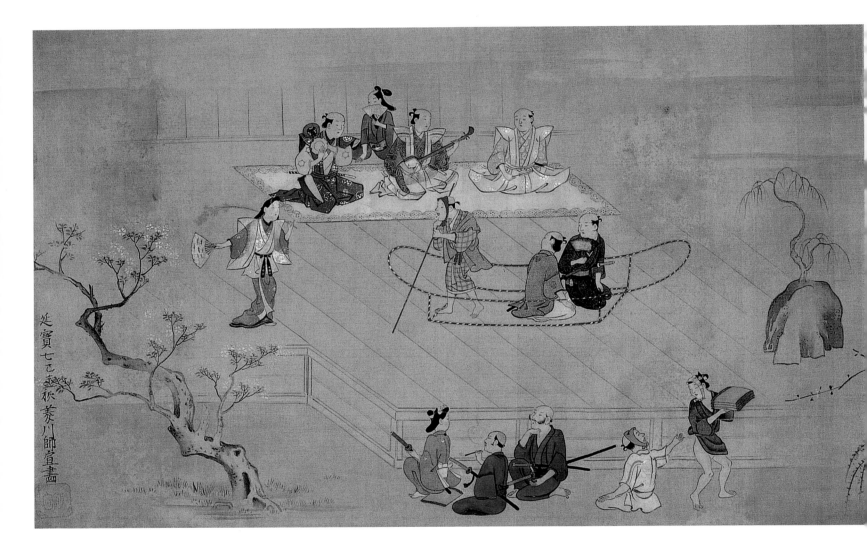

Hishikawa Moronobu,
The Kabuki Play, 1679.

field. His wood engravings, always in simple, strong black, rarely appear coloured, and must then make do with some wide and effectively placed patches in brown-red and green. In old age he renounced the world, had his head shorn, and continued to live like a monk. He died in 1694.

He left two sons behind, of which one is said to have excelled in the art of colouring wood engravings.

His greatest contemporary was Ando Kaigetsudō, whose achievements fall mainly into the first decade of the eighteenth century. He remained caught in a certain mannerism in comparison to Moronobu's figures, which were albeit a little stocky but well-proportioned, as he was prone to forming the heads, hands and feet too small. But even though he could not touch Moronobu with regard to his

capacity for invention and prolific production, he nevertheless knew how to lend his women a dignity of posture. Clothed in puffed, richly patterned garments, which he used for wood engravings with large formats, he elevated them to the most excellent and powerful creations of his technique with a flow of lines and a sweep of garment folds.

As a result of the large patterns of the garments in black and white, these prints are given an incomparable decorative effect.

Like Moronobu, Ando Kaigetsudō was also a painter. Kaigetsudō Norishige seems to have been a pupil of Ando. As a painter of the popular school, Moronobu's pupil Miyagawa Nagaharu (Miyagawa Chō shun) gained a far-reaching influence. A better colourist than his

teacher, he dealt with the same circle of portrayals as he did, but did not draw for wood engravings. He mainly worked during the second decade of the eighteenth century. His son Miyagawa Chosuke worked during the twenties. Chō shun's pupil Miyagawa Shunsui, who, as a painter influenced the further development of this style in the direction of portraying graceful female figures, which reached its full development in the second part of the century, achieved special significance. At least Fenollosa finds it highly likely that he was the same person as Katsukawa Shunsui, who was still working in the second part of the century, and who supplied some not really important prints and mainly became known as the teacher of the great Katsukawa Shunshō.

Okumura Masanobu,
Kabuki Stage at Nakamura-za during the Kaomise
Performance of 1740, 1740.
Hand-coloured woodblock print, 38 x 25.5 cm.
Philadelphia Museum of Art, Philadelphia.

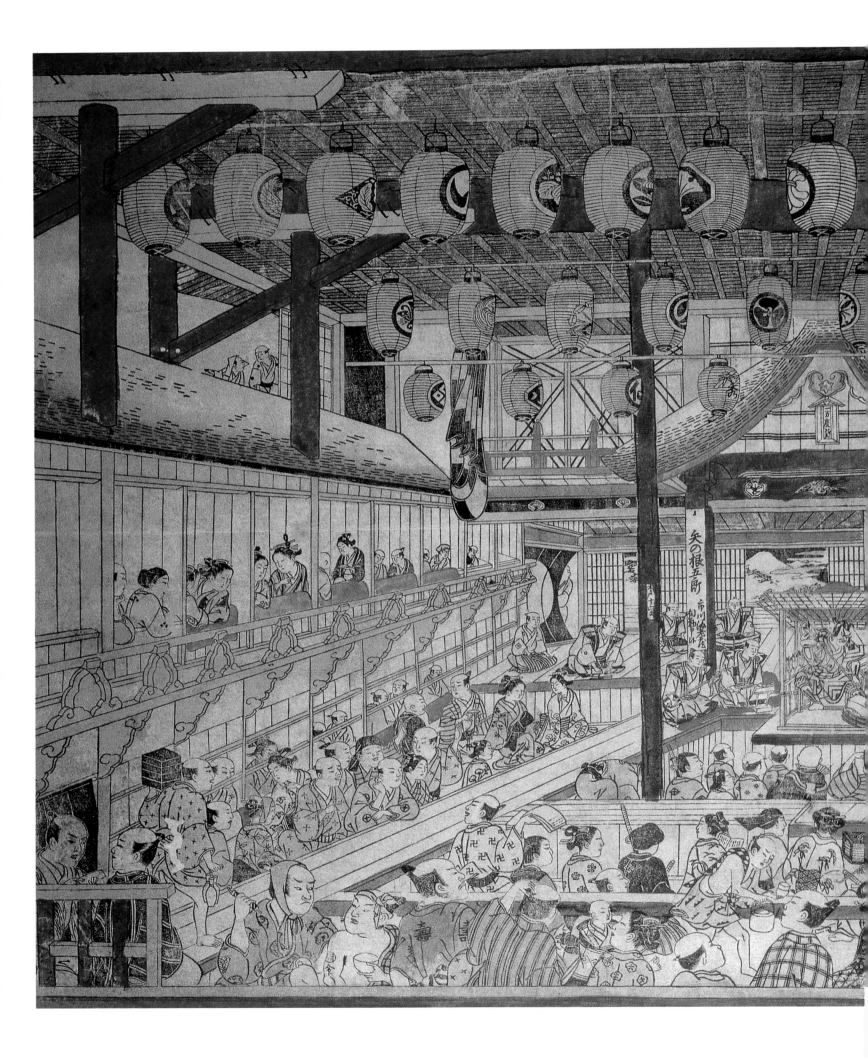

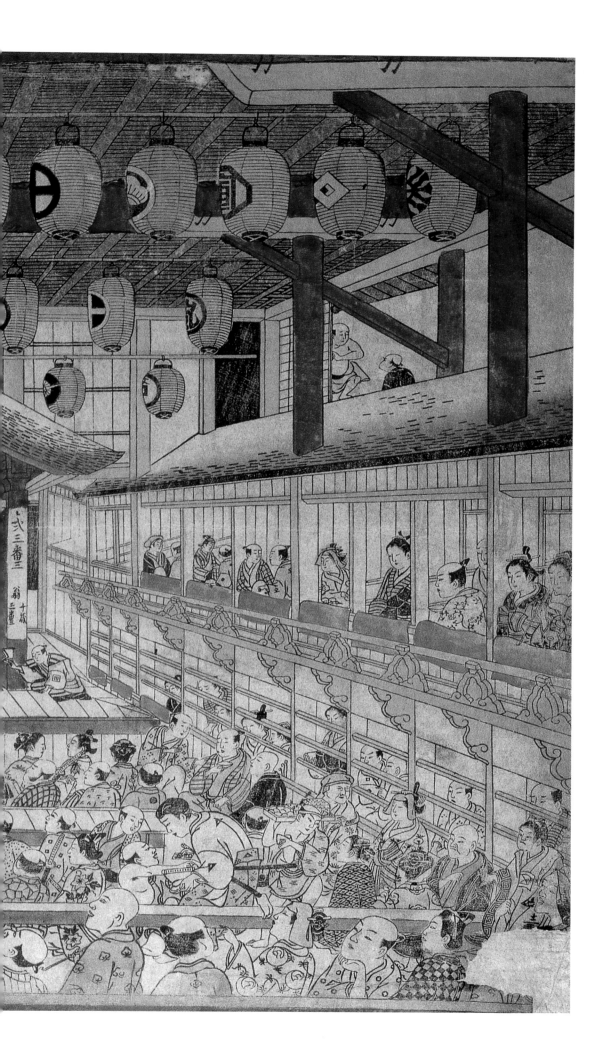

MASANOBU

The First Torii and Okumura Masanobu (1686-1764)

The art of the whole first part of the eighteenth century is under the influence of two masters, competing with each other, who, in a rare way, keep their balance with each other through all changes that time brought with it, although each one of them went their own way, according to their temperament. Okumura Masanobu and Torii Kiyonobu, both painters, but mainly working on wood engravings, established the style in which art was initially to develop. Masanobu dedicated himself mainly to portraying graceful female figures and merry scenes from society, but Kiyonobu, the founder of the Torii School, which was influential until beyond the end of the eighteenth century, to the depiction of actors, who had reached special popularity at that time. In the nineteenth century it

was thought that this period could be identified with that of the bi-coloured wood engravings, whose appearance was dated to around 1710. However, since Fenollosa established that the production of these first and probably earliest coloured prints cannot be dated earlier than approximately 1743, we have to assume that for the whole time until then that largest part of the work of the mentioned masters was dedicated to black printing. The painting of these pictures, which were begun with particular care at an early period, certainly around 1710, requires special attention. Here the tone that provided the model for true colour printing was developed.

Although Masanobu started his work at the same time as Kiyonobu in the first years of the eighteenth century, the latter should definitely be considered first, as Masanobu, according to Fenollosa, stopped drawing for wood engravings for a long interim period, from circa 1715

to circa 1735, and only painted, and only developed his principal activity for this kind of technique in the ensuing years, which already coincides to a large extent with the development of bicoloured wood engraving. During this time, however, an interim period especially important for hand colouring, Kiyonobu had the absolute rule.

Torii Kiyonobu was apparently born in 1664 and lived until 1729. From Kyoto, where he had lived first, he moved to the breezier Edo, and here turned to the portrayal of actors, as well as the production of theatre leaflets and posters. Whilst until then such objects had only been dealt with occasionally, he made them an established genre of wood engraving, which was continued within the Torii School he founded, almost like a privilege. His drawing was wide, strong and determined, calculated on the effect from a distance, like painting with a lush brush. Simple rounded outlines were sufficient for him, in

Okumura Masanobu,
Beautiful Woman after her Bath and a Rooster, c. 1730.
Benizuri-e, 31 x 44 cm.
Tokyo National Museum, Tokyo.

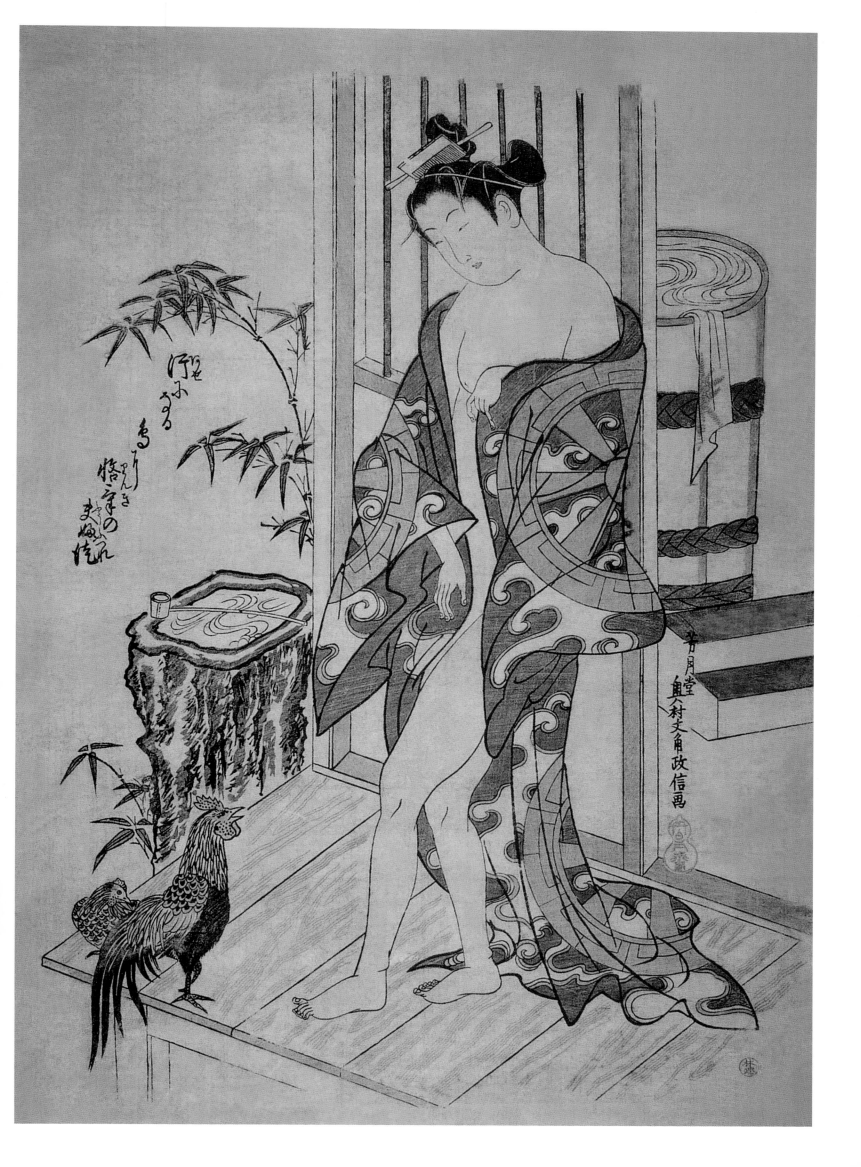

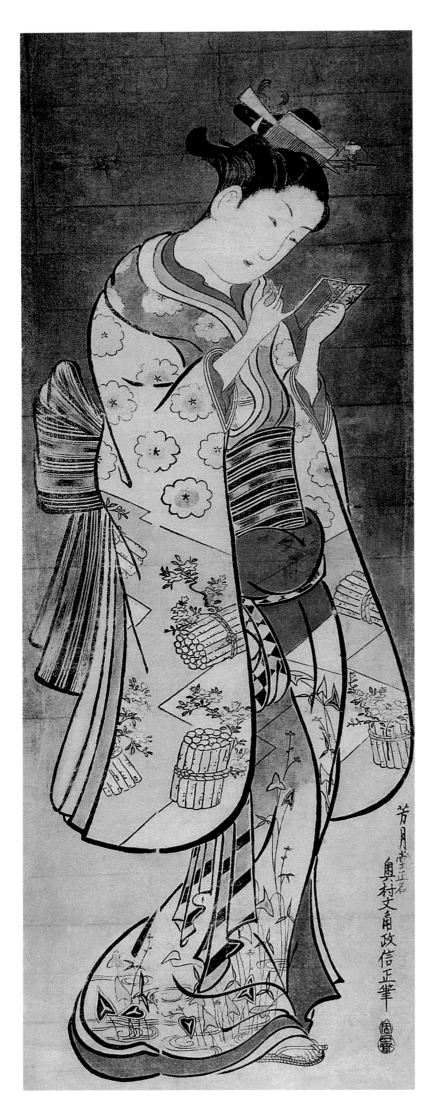

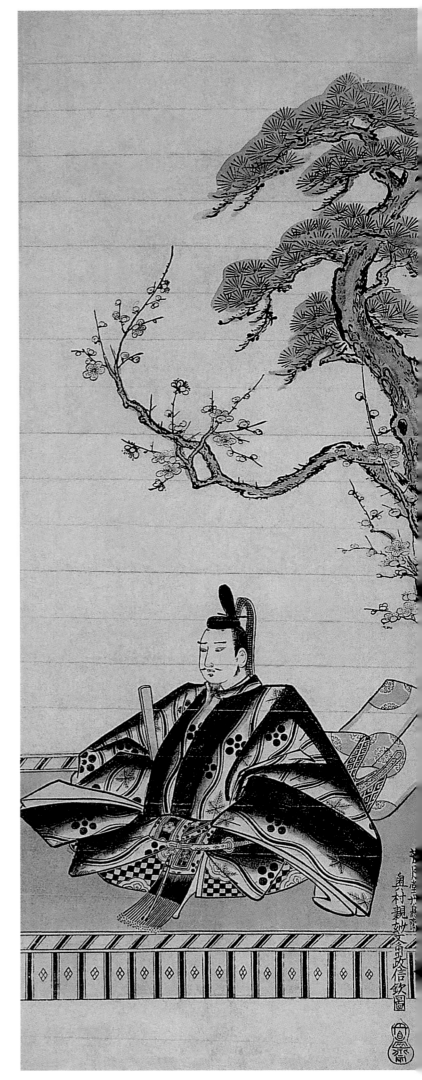

芳月堂丹縁画
奥村親妙文角政信欽圖

芳月堂正名
奥村文角政信正筆

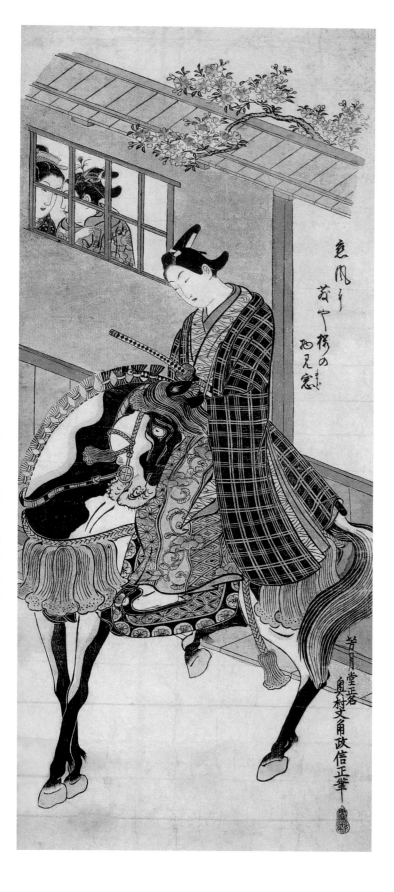

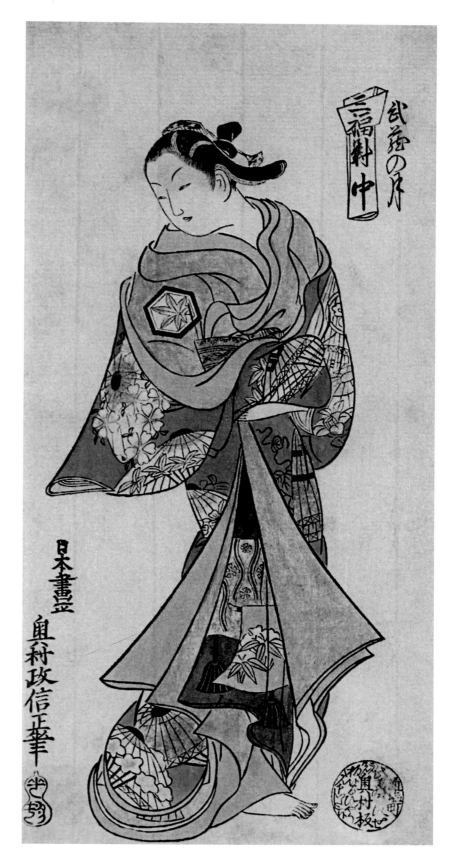

Okumura Masanobu,
Beautiful Woman Looking into a Mirror, 1741-1748.
Beni-e, 60.6 x 21.9 cm.
Ostasiatische Kunstsammlung, Museum für
Asiatische Kunst, Staatliche Museen zu Berlin, Berlin.

Okumura Masanobu,
Sugawara no Michizane in Court Dress, c. 1720.
Monochrome hand-coloured woodblock print, 66.6 x 24.6 cm.
The British Museum, London.

Okumura Masanobu,
Young Dandy on a Horse, early 18th century.
Lacquer print, 38 x 25.5 cm.
Tokyo National Museum, Tokyo.

Okumura Masanobu,
The Moon of Musashi,
One of a Set of Three, c. 1735.

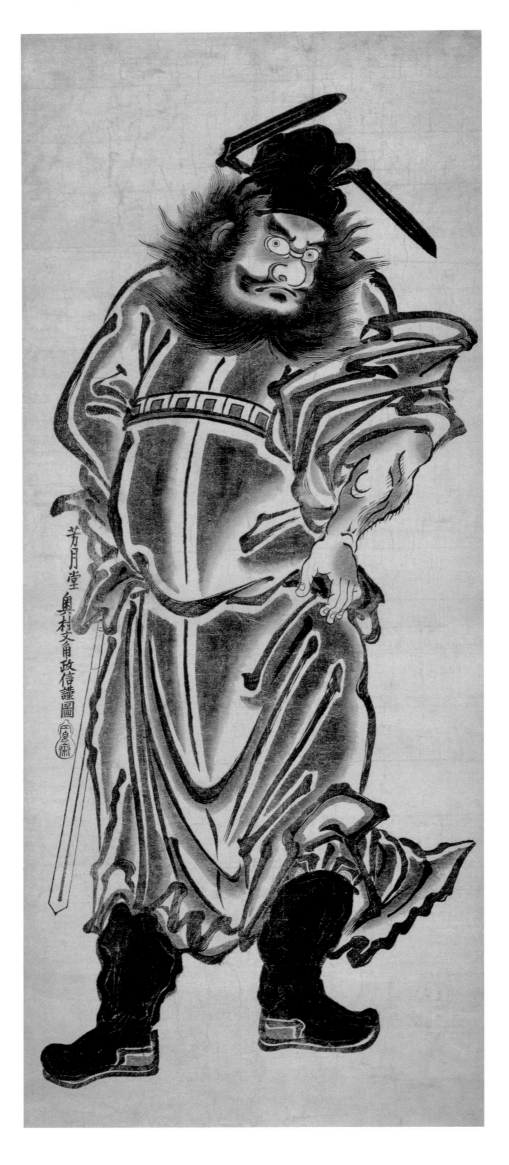

158

order to create the impression of strength. His faces are long, of an oval shape. At first, he used the orange red (tan, a lead-colour) for colouring his prints, which was common at that time, and were afterwards called *tanye*, orange paintings. From approximately 1715, however, he used carmine instead (*beni*, a plant juice), which he combined with violet, blue and a bright yellow. In the twenties, Indian ink was added, which was varnished. This formed the distinguishing feature for painting in that time and lasted approximately two decades; gold dust and mother-of-pearl dust for the white base (mika) were also used. Such wood engravings, coloured by hand, were called *urushiye*, lacquer painting. Especially during this time, as painting wood engravings came to its utmost perfection and received wide-spread circulation, Masanobu, who had started working on wood engravings pretty much at the same time as

Kiyonobu, had suspended his activity and had almost exclusively turned to painting. At the same time that was the period, when hair-styles, after the rich formation of the seventeenth century had been given up and were given a more and more flat shape, approached a square shape, which was distinguished only by a long flat plait. But when, towards the end of the thirties, obviously under the influence of a new culture movement, which distinguished itself outwardly by the middle shock of hair gradually becoming higher, Masanobu entered the scene again, and when, at the beginning of the forties the coloured print with two colour plates, in pink and green, was developed, Kiyonobu proved with his performance that he had lost nothing of his old strength and energy. As easily as he transferred to this new technique, he knew how to maintain his characteristic trait until the end, and he

remained the recognised head of the Torii School.

Following Japanese custom, his pupils adopted part of his proper name and added a syllable. Torii Kiyotada, who had already started his work around 1720, but stopped long before his master, stood out among them as the best; his pieces of work are therefore very rare. Together with Kiyonobu, Kiyomasu is named as the second great master of the School. He is normally taken for a son of Kiyonobu, but he follows all changes of this master's style at his heels from the beginning to the end during the course of fifty years, so that Fenollosa is decidedly of the opinion that he is his contemporary, e.g. his twin or younger brother. As a graphic artist he may have exceeded him, and at any rate seems to have been more prolific. His compositions, which consist of black as well as bicoloured prints, are filled with life and massive strength.

Okumura Masanobu,
Shoki, the Demon Queller, c. 1745.
Woodblock print, 62.3 x 25.5 cm.
Fitzwilliam Museum, University of Cambridge,
Cambridge.

Okumura Masanobu,
Girls Going to the Theatre, c. 1755.
Ōban print, 37.5 x 25.6 cm.
Musée Guimet, Paris.

Okumura Masanobu,
Banquet Beneath the Maple Trees, c. 1750s.
Ōban print, 43.3 x 30.9 cm.
Musée Guimet, Paris.

Okumura Masanobu,
Kamuro, Three Leaves in One (Kamuro sanpukutsui),
Benizuri-e, 30 x 45.3 cm.
Chiba Art Museum, Chiba.

Okumura Masanobu,
Pheasant on Plum Tree in Blossom, c. 1720.
Hand painted sumizuri-e, 31.9 x 12.8 cm.
The British Museum, London.

Work attributed to either:
Shigenaga Nishimura or **Okumura Masanobu,**
Tiger and Bamboo, c. 1725.
Woodblock print with gold powder, 33.5 x 15.4 cm.
Private collection.

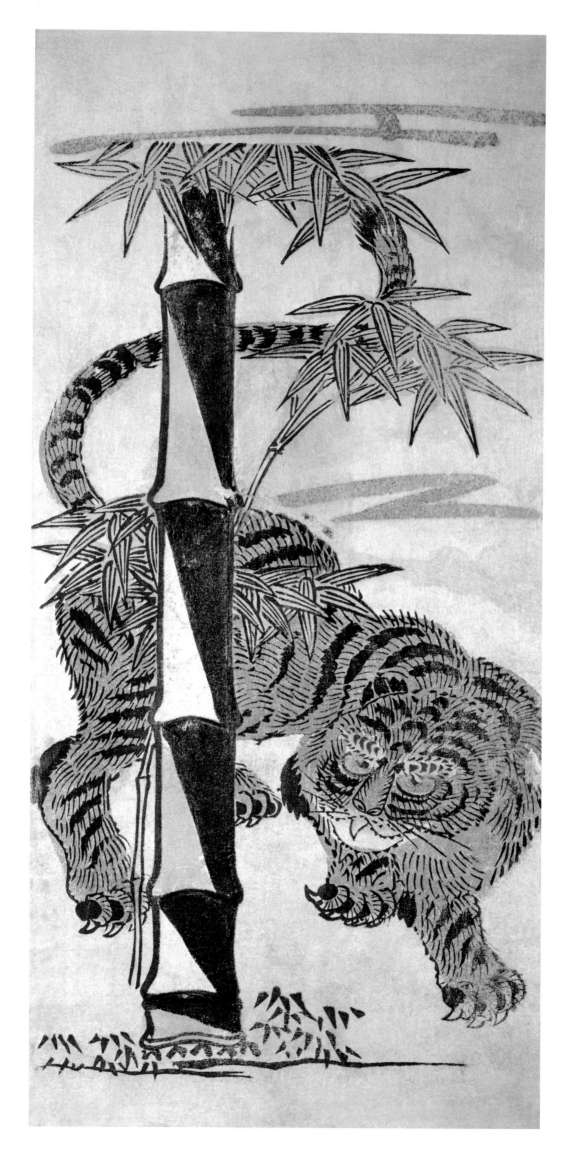

The third in the trio, besides Kiyonobu and Kiyomasu during the first half of the eighteenth century, was Okumura Masanobu, whose work also began in the first years of that century, and who lived until around 1764. He is different than the other two because as the direct pupil of Moronobu, he followed much closer in his style, only rarely supplying portraits of actors. He preferred glorifying the beguiling charm of delicate female beauties, and, thanks to his great sense for elegance and agreeable composition, he succeeded in lending the style of this first period a perfection and rounding off, as was only found again later with more liberated designs in the work of Kiyonaga. Initially, like his teacher Moronobu, he seems to have mainly provided book illustrations, *Yehons*, in black. Some illustrations depict how well he knew how to gracefully and tastefully round off his compositions and fill his figures with charm. This is not Moronobu's

energetic zest for life bubbling over: a female, more elegiac sense becomes noticeable; but this tendency towards the soft and gentle prepares for the development, which Japanese wood engraving would take later on. In a series of fifteen double-sheeted mythological scenes a rich picture of life at that time is revealed, boat trips, playing the mandolin, love scenes alternate with each other, all with a landscape that is only lightly indicated at, but has a stimulating effect. He coloured few prints by hand, as throughout the time when such painting was common, between 1715 and 1735, he seems mainly to have dedicated himself to his original job; painting.

The portraits of actors in their wildly emotional parts, which were sought after at that time, will not have provided the desired scope for his milder nature. In the second part of his life he turns to wood engraving with renewed enthusiasm, now creating the long

series of those prints, in which his style has reached perfection. The naturalistic landscape also starts with him, which subsequently reached its full development in the second half of the century. Apart from small prints, he now also created large scenes with individual figures or rich in figures, as they had been out of fashion since Moronobu. He reached the highest level with bicoloured prints, which he created during the last years of his life, between 1743 and 1750, partly with blind pressing; mostly three-part compositions of individual figures or groups, partly against a backdrop that is architecturally structured, in which the full charm of his group formation as well as the sharpness of his drawing is fully revealed.

Okumura Toshinobu is the best and most well-known among his pupils; but he had already stopped working before the master's death.

Okumura Masanobu,
A Courtier with Attendants, Fuji in the Distance.
The Newark Museum, Newark, New Jersey.

Torii Kiyonaga,
A Moored Pleasure Boat beneath the Bridge, 1784–1785.
Brocade triptych, 38 x 25.5 cm.
Tokyo National Museum, Tokyo.

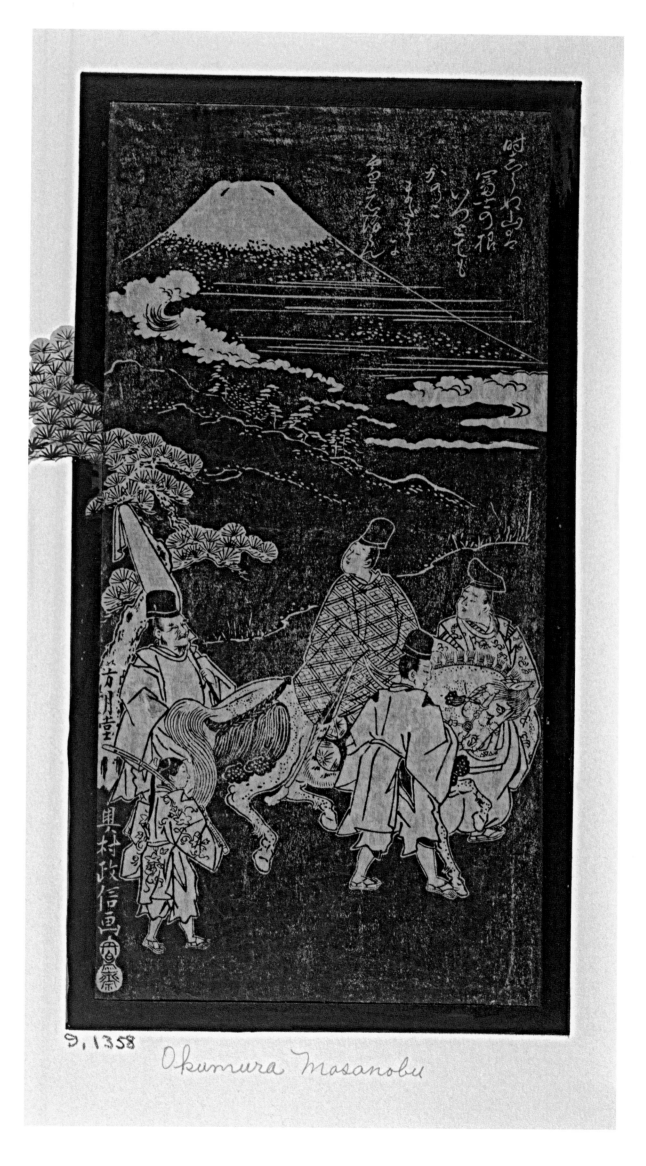

時つ〱〱山や
冨二う根
いつそも
かうこ
もゝや
知え申し

方月堂
奥村政信画

9,1358

Okumura Masanobu

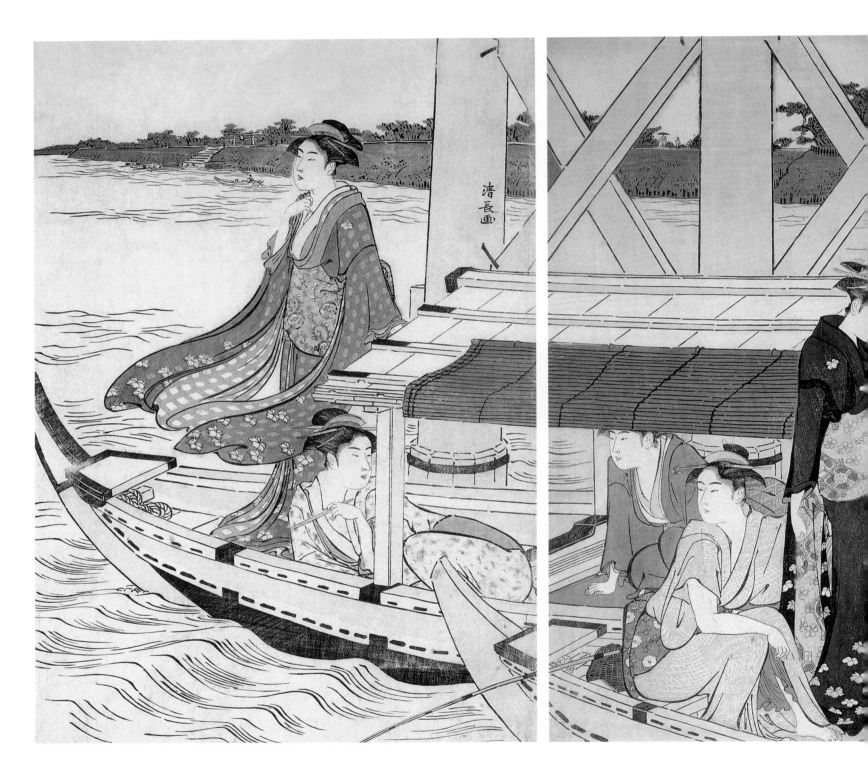

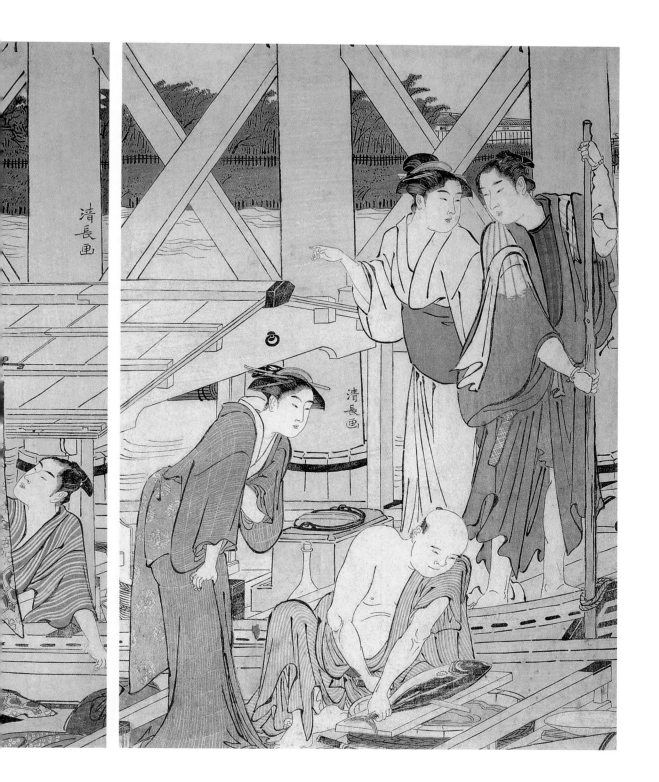

Torii Kiyonaga (1752-1815)

When Torii Kiyonaga appeared on the scene around the mid-1770s, he dominated the art of wood engraving in Japan for a decade and a half, and led it to its climax as only Moronobu had undisputedly done a century earlier. The great and noble School of the Torii, which had characterised primitive art in the field of wood engraving and taken part in all changes of its manifestation with determining intervention, from black print coloured by hand to bicolour and then three-colour print, had by that time disappeared completely from the scene for a decade.

The completely radical innovation, which had been brought about around 1765 through the invention of perfect colour printing, had in the meantime shifted the objective of art, whose task until then had

been the most impressive design of a personal view to that of a graceful play with colours and forms. To the old school that may have seemed incompatible with their present striving, which was so simple and yet so powerful. Even more sudden than Giotto's school in old Florence had made way for the victorious appearance of the new generation, the Torii School faded away in the presence of the overwhelming work of the three young masters Harunobu, Shigemasa and Shunshō. However, the creative power of the school, which had been cultivated and perfected for three generations, then found its last but at the same time greatest manifestation in Kiyonaga after a ten-year break devoted to careful preparation. He added the perfect means of expression to his artistic efforts, which were orientated simply towards the great and beautiful.

Characteristically, it was not so much the influence of his teacher Kiyomitsu, the last of the genuine Torii masters, determining the full development of his nature than that of the most versatile of the new successful masters, Shigemasa. Although Kiyonaga, the son of a publisher, had created portrayals of actors in the old way, in three-colour print, shortly before the new period, nobody would have been able to anticipate the future greatness of the man from such a performance at that time. During the time that Shunshō occupied himself with the neglected area of portrayals of actors, and made it into a characteristic design, mainly as a result of the attraction of the colour, Kiyonaga was resting and gathering his strength, by following the new movement with understanding interest. But then around the middle of the seventies he suddenly emerged as the fully

Torii Kiyonaga,
The Iris Festival, from the series *Precious Children's Games of the Five Festivals (Kodakar a gosetsu asobi)*,
Colour woodblock print, 39.2 x 25.7 cm.
Museum of Fine Arts, Boston.

Torii Kiyonaga,
An Arranged Introduction at a Shrine, mid-1780s.
Diptych, two ōban-size sheets.

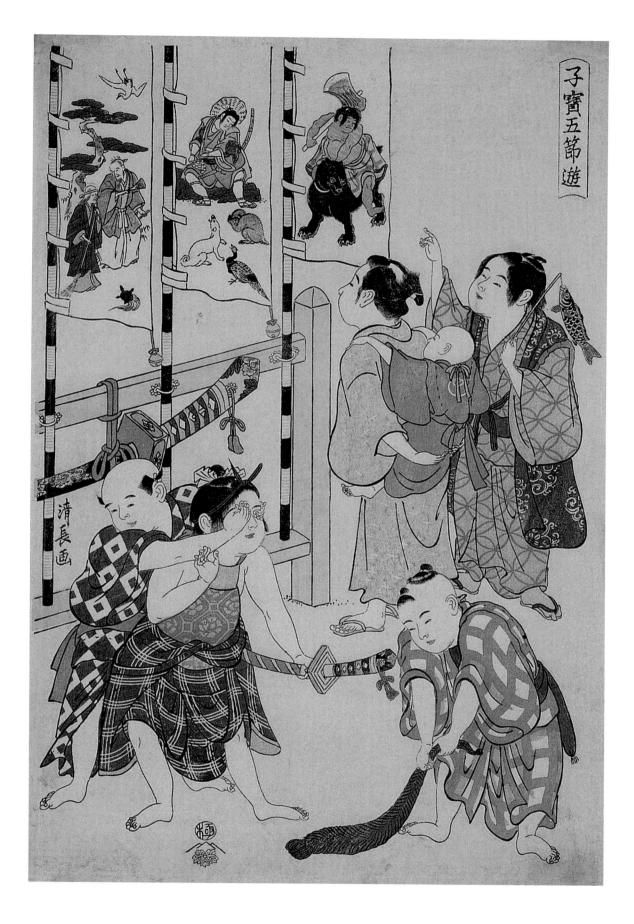

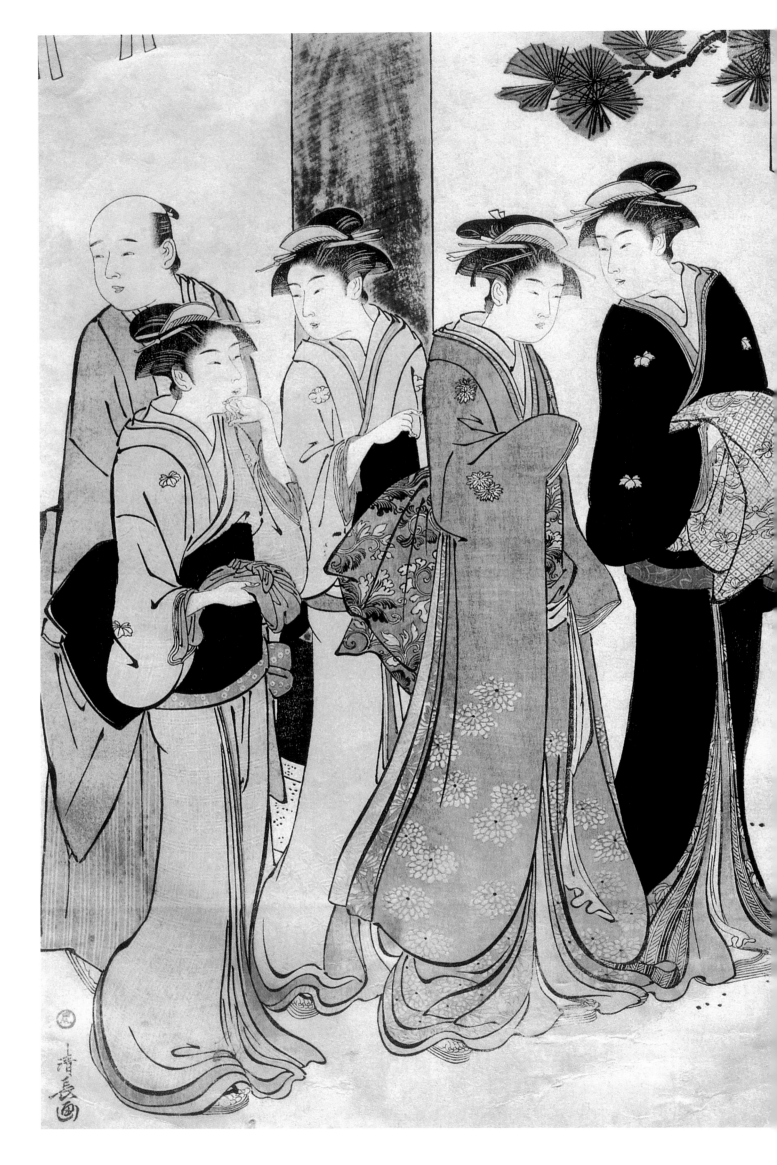

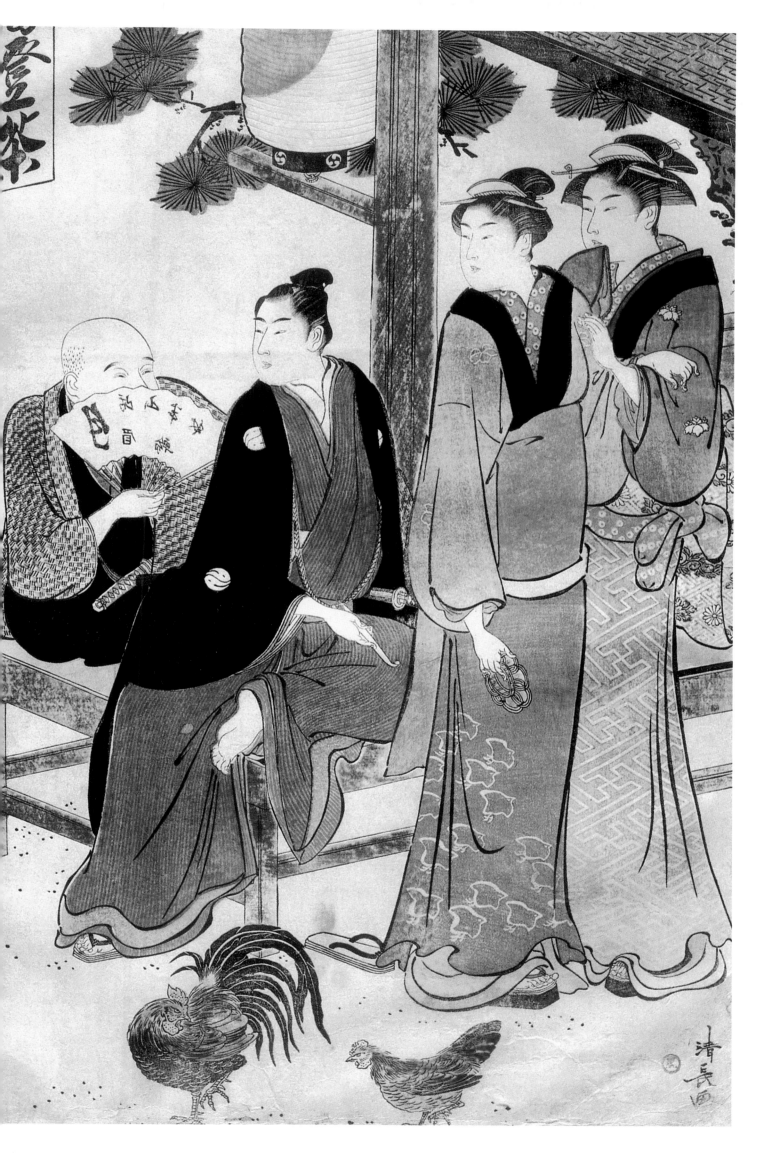

171

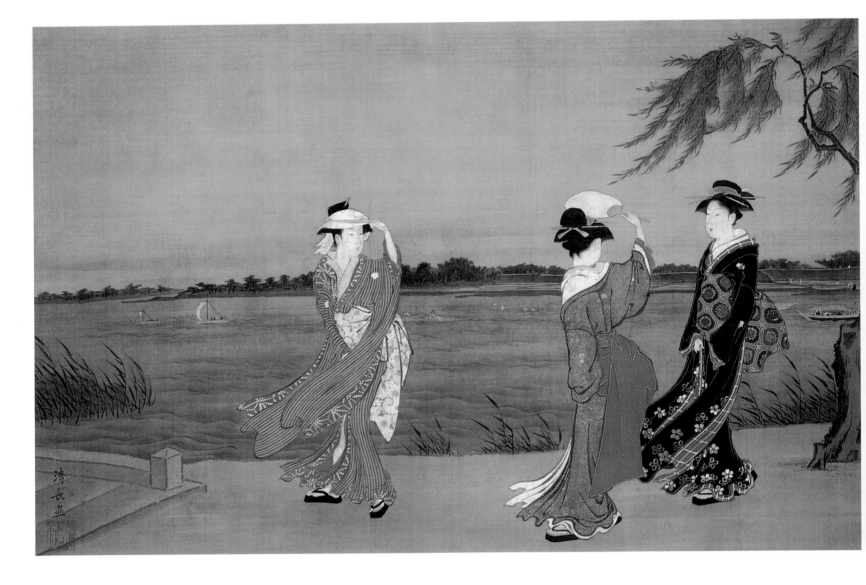

matured artist, who, thanks to his inherited great sense and noble taste, found it easy to outshine the innovators. In their own way they too were of outstanding merit, but more or less stuck to formalities; he pushed them aside without any problems, and as if without intention positioned himself in their place. In the second half of the seventies his characteristic style had fully developed; from the beginning of the eighties he alone dominated the field of wood engraving, and saw his predecessors' pupils change over to him.

What then are the innovations that he introduced and to which Japanese art owed its progress beyond the previous achievements right up to its climax? First of all, absolute freedom from any conventionalism. From the arbitrary treatment which the Primitives had provided the human body with, a small rest

had still remained up to his time; soon, in favour of a stronger decorative effect or to achieve greater elegance, hands and feet were shaped too small, soon the body too slender and too supple, then the inner face parts too delicate. Kiyonaga now contrasted these with normal body proportions, selected with a highly developed sense of beauty; his figures are, at least during the time of his full power – for later he also showed the tendency, following the modern trend, towards exaggerated proportions – absolutely well-proportioned, with a healthy roundness and firm in their manner. They move with a natural calm, grace and dignity, so that they could quite rightly be compared to the noble figures in highly developed Greek art. Everything mannered has disappeared from them, which had played such a major part in the creations of the Primitives,

without, of course, in anyway diminishing the artistic effect, as these artists had not been concerned with depicting the full reality, but only with capturing individual, especially characteristic motifs of movement. The stiltedness that had dominated the work of the first artists of colour printing, which had developed to its full freedom as a result of limited nature studies, is already almost entirely missing here. The knowledge of reality and reverence for it led to a complete innovation of the style of portrayals.

This healthy realism in Kiyonaga's creations means a complete change for Japanese art, as from then on – until a new mannerism emerged – the one-sided decorative element in the drawing became completely unimportant and purposes of that kind were only aspired to with the help of colouring. Of course, this

Torii Kiyonaga,
Three Women on the Riverside, 1785-1790.
Ink and colours on paper, 40 x 59.1 cm.
The Metropolitan Museum of Art,
The Howard Mansfield Collection, New York.

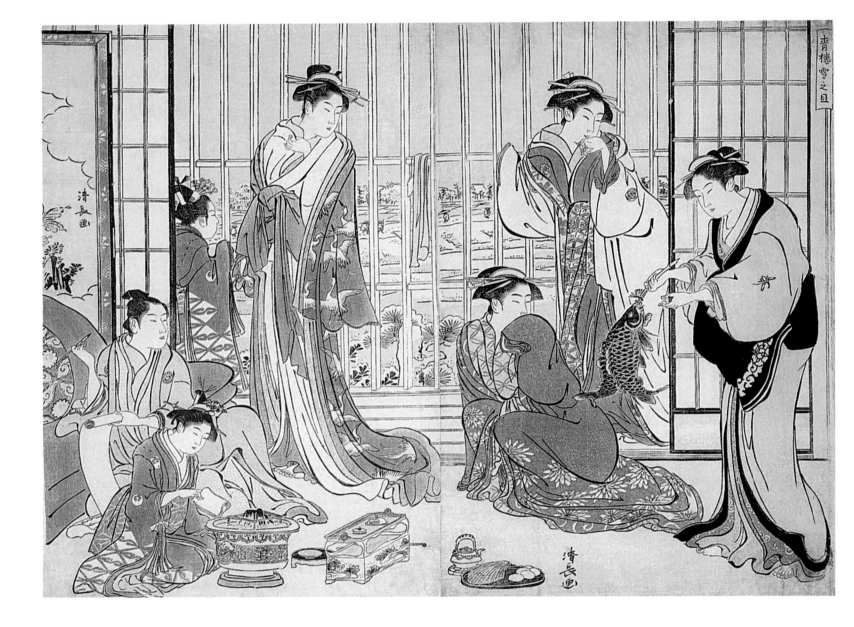

Torii Kiyonaga,
The Day after the Snow in One of the Green Houses,
c. 1784. Colour woodblock print, 38.3 x 25.2 cm
(right-hand panel); 38.3 x 23.2 cm (left-hand panel).
Honolulu Academy of Arts, gift of James A.
Michener, Honolulu.

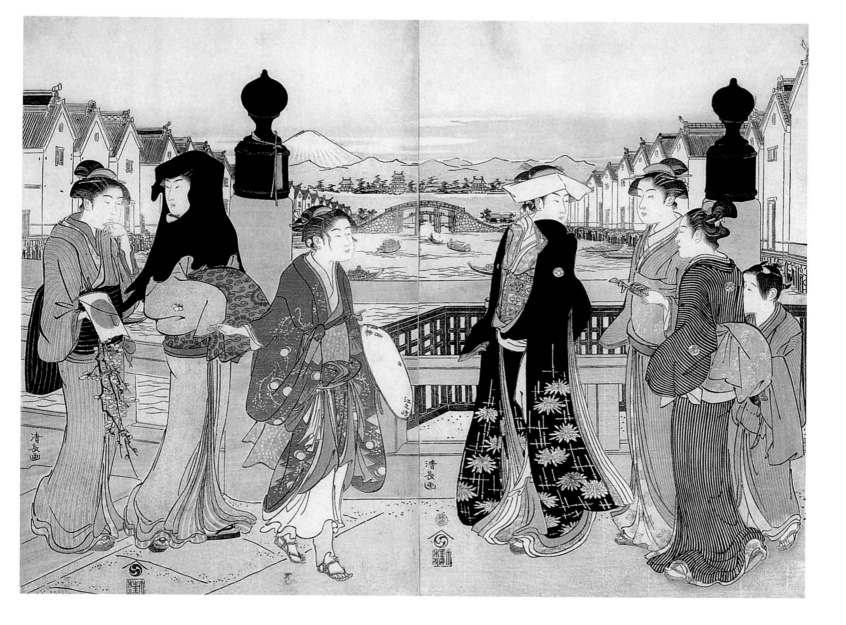

Torii Kiyonaga,
People Coming and Going on the Nihonbashi, c. 1786.
Colour woodblock print, 38.3 x 25.7 cm
(right-hand panel); 38 x 25.2 cm (left-hand panel).
Honolulu Academy of Arts, gift of James A.
Michener, Honolulu.

is not striving for naturalistic reproduction: that remained, as can be seen from the missing shadows, completely alien to Japanese art during the time of its heyday. But something essentially new had already been achieved in as much as that the life-like figures had to be placed in a real space, which gave the portrayal a picture-like finish. In place of the background, only hinted at by one shade of colour, the actual inside space or the completed landscape took its place, which had so far only happened occasionally and without realisation of the necessity. In contrast to previous attempts, Kiyonaga can be regarded as the first real landscape artist in Japan. Due to the choice of his colouring, especially by cleverly mixing in yellow tones, he knew how to lend these portrayals of nature the attraction of a sunny brightness.

The picture-like finish of these portrayals finally also led to a completely new kind of composition. Until now, only the balance of individual parts, in black and white as well as in colour, had been important, but now they aimed at completely filling the given space in a way that pleased the eye. Kiyonaga did this with complete mastery. As for the figures themselves, he found the harmony for the whole of the composition with complete ease, so that everything in his pictures seems completely natural. Each of his compositions, in which women are usually conversing, going about their daily activities, going for a walk with their children, forms a complete whole; but how many of them are only a part of those large three-part pictures, which from then on appeared more and more often and indeed in a coherent form. For Kiyonaga it is really true, what so many collectors like to say to themselves in view of such fragments: the prints have been composed from the start in such a way that they could be used individually, in twos or as a triptych; although, as a rule, the effect the artist intended them to have is only shown to its best advantage in the complete composition. In Kiyonaga's prints, neither the drawing nor the colouring aim for independent meaning: the colouring only has the purpose to give the object a clear and graceful expression; but in its pure simplicity it contributes just as much to the effect of monumental size as the design. Unfortunately, in Kiyonaga's work in particular, the colours have not been fully preserved, be it as a result of their chemical composition or as a result of circumstances that these prints were preferably used as wall decorations and were therefore exposed to the harmful effect of sunlight; the opinion that the

Torii Kiyonaga,
Shin Yoshiwara Edomachi Nichome Choji Ya No Zu, 1787.
Colour woodblock print, 31.8 x 45.2 cm.
Boston Museum of Fine Arts, Boston.

Torii Kiyonaga,
First Gathering of Actors for the Kaomise Performances at the Great Theatres of Edo
(*Edo ōshibai kaomise kyōgen sōza chū yorizome no zu*), 1784.
Ink and colour woodblock print on paper, 32.3 x 44.7 cm.
Boston Museum of Fine Arts, Boston.

Torii Kiyonaga,
Women of the Pleasure Quarters, left-hand panel of a diptych.
Colour woodblock print.
Pushkin Museum, Moscow.

Torii Kiyonaga,
Women of the Pleasure Quarters, right-hand panel of a diptych.
Colour woodblock print.
Pushkin Museum, Moscow.

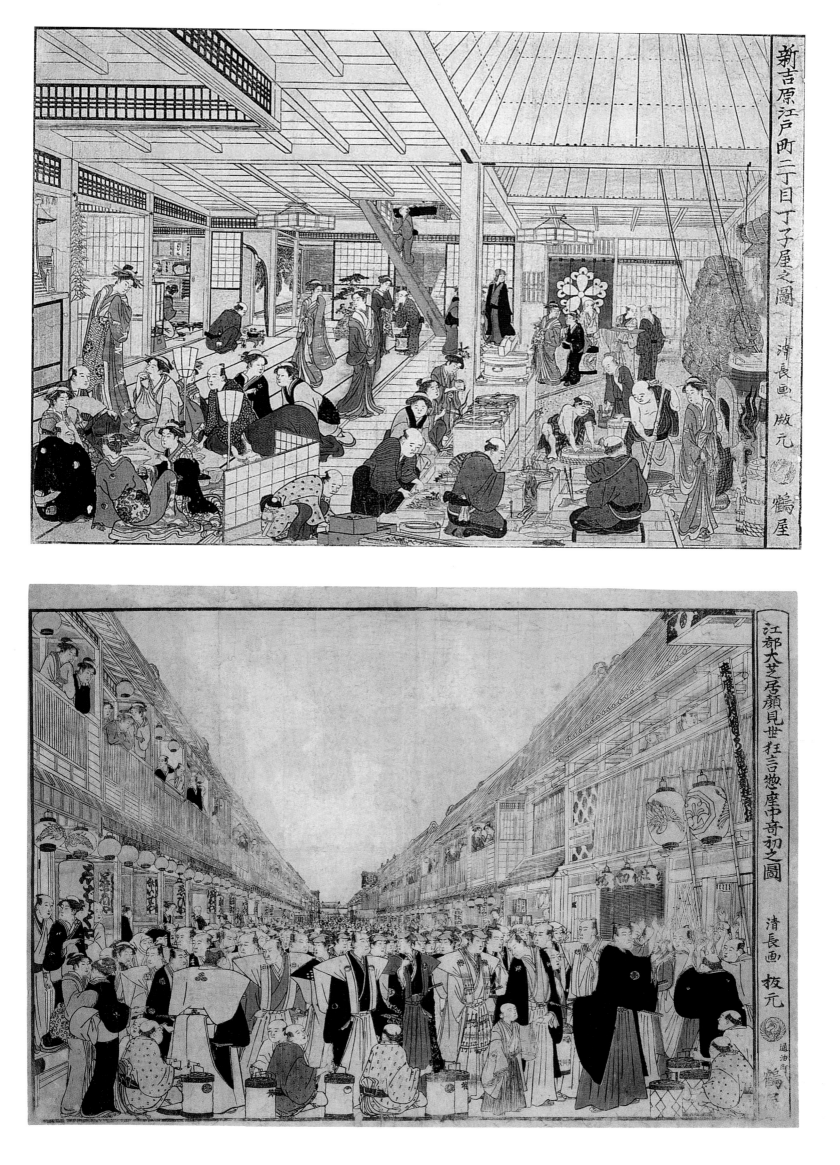

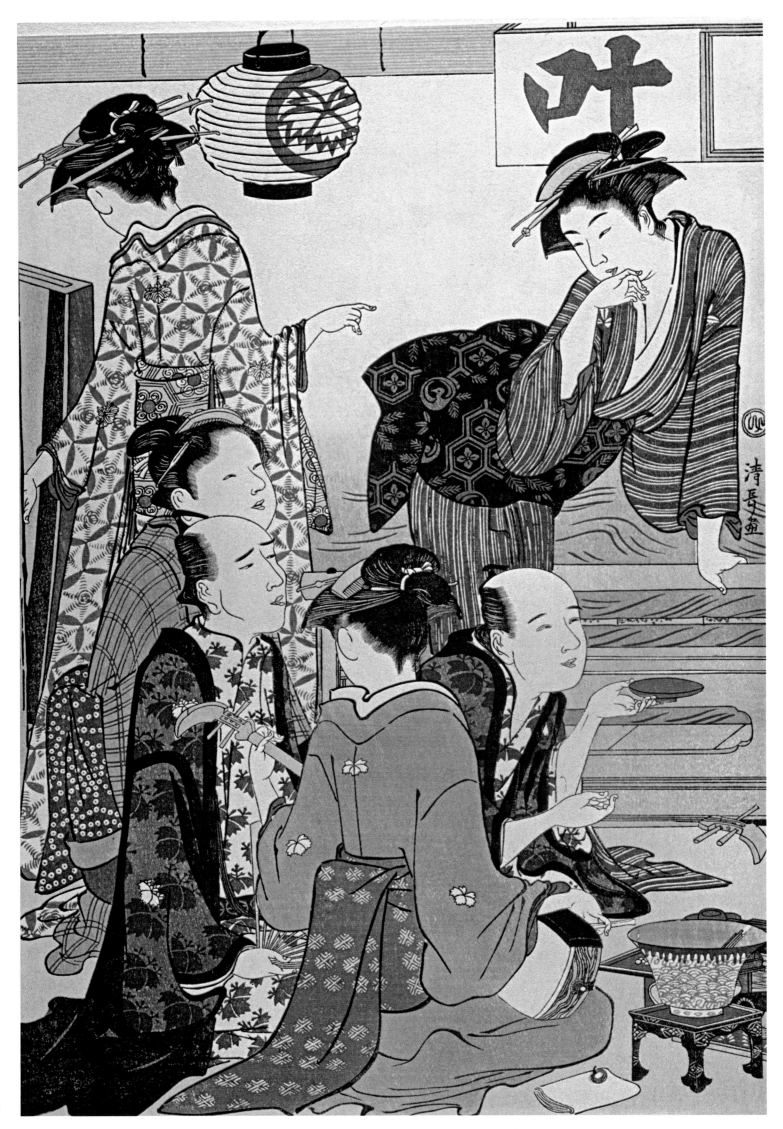

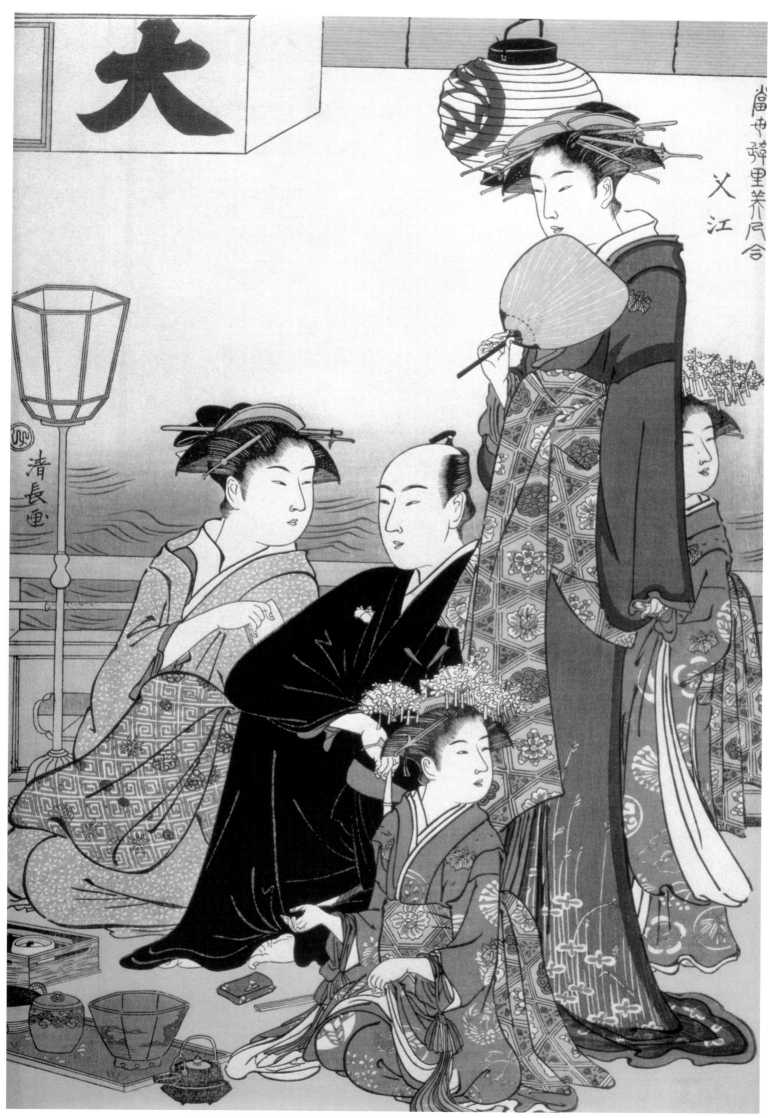

subtlety of the fading of the colour to a slight hint was intended by the artist is probably mainly due to this kind of exposure to sunlight.

The qualities based on this wonderful balance of strength could have secured the artist an outstanding historical position, but might not have elevated him to the highest artistic level of the country without the addition of a definite characteristic. This important characteristic was that Kiyonaga was regarded as an artist with a masculine mind, secure in himself and aiming for greatness through that special magic that flowed from his creations, and which stood in contrast to the weakness that dominated the majority of his predecessors' work.

The pupils of Shunshō who totally followed Kiyonaga's style are the following:

Kubo Shunman was initially one of Shigemasa's pupils, but then changed over to Shunshō. He only took the style of Kiyonaga's design and composition, when the latter reached his full potential, without submitting blindly to him. The period of his influence begins at the end of the eighties and lasts until approximately 1820. A special personal magic that is part of his nature kept him from dependent imitation. Even if the appearance of his prints came very close to Kiyonaga's, he nevertheless bestowed his own characteristics on all details. Very unbalanced in his performance, he could on the one hand be noble in his expression and selective in his drawing, and that was during his best time, at the beginning of the nineties, but on the other hand he could be mannerised and arbitrary. Attempts to base the large three-part prints mainly on grey and adding small but understated amounts of other colours can be attributed to him. It is said that he also occupied himself with illustrations for funny verses.

Katsukawa Shunchō was indeed one of Shunshō's pupils in the beginning, but from the beginning of the eighties closely followed Kiyonaga. Softer in nature than his first teacher, he became the most faithful imitator of his large conqueror. He worked until the end of the century, in later years he is said to have withdrawn from art, but to have lived until at least 1821. He must have carried out the change in his style with conviction, for he definitely knew how to bring out the characteristic in his work. As sharp and clean as his drawing always is, he was never able to overcome the influence of his first teacher, who urged him for a certain calligraphic-decorative design of the outlines; but he created a means of expression for the treatment of the landscape alive with figures, which was very characteristic to him. Now and again the style, in which he creates his landscapes, is even purely

Torii Kiyonaga,
Evening Breeze on the Banks of the Sumida River,
c. 1781-1789.

Torii Kiyonaga,
The Sixth Month, from the series
The Twelve Months in the Southern Quarter (detail), c. 1785.
Colour woodblock print, 39.1 x 52 cm.
Collection Clarence Buckingham, The Art Institute of Chicago, Chicago.

Torii Kiyonaga,
The Seventh Month, from the series
The Twelve Months in the Southern Quarter (detail), c. 1785.

Torii Kiyonaga,
Geisha with Assistant and Maid Returning from a Party,
from the series *Mirror on Women of Fashion,* c. 1783.

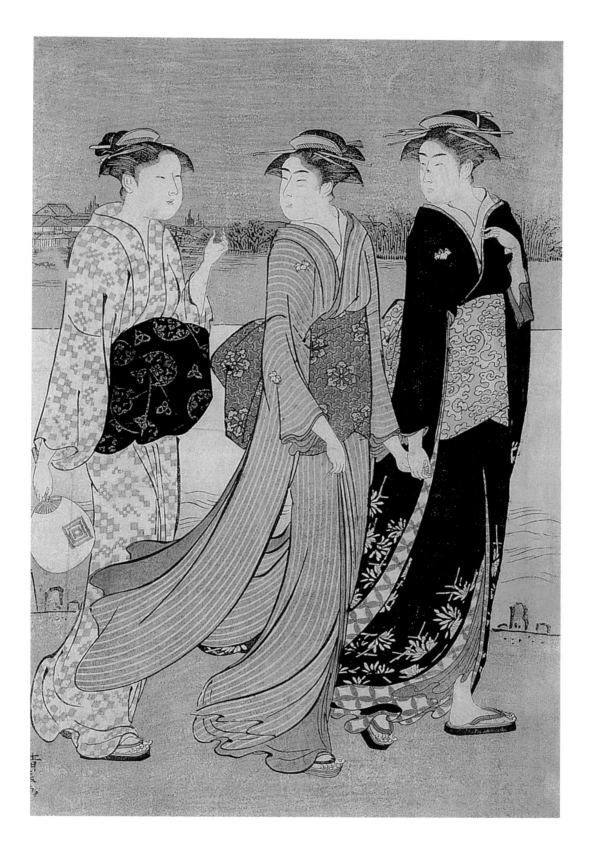

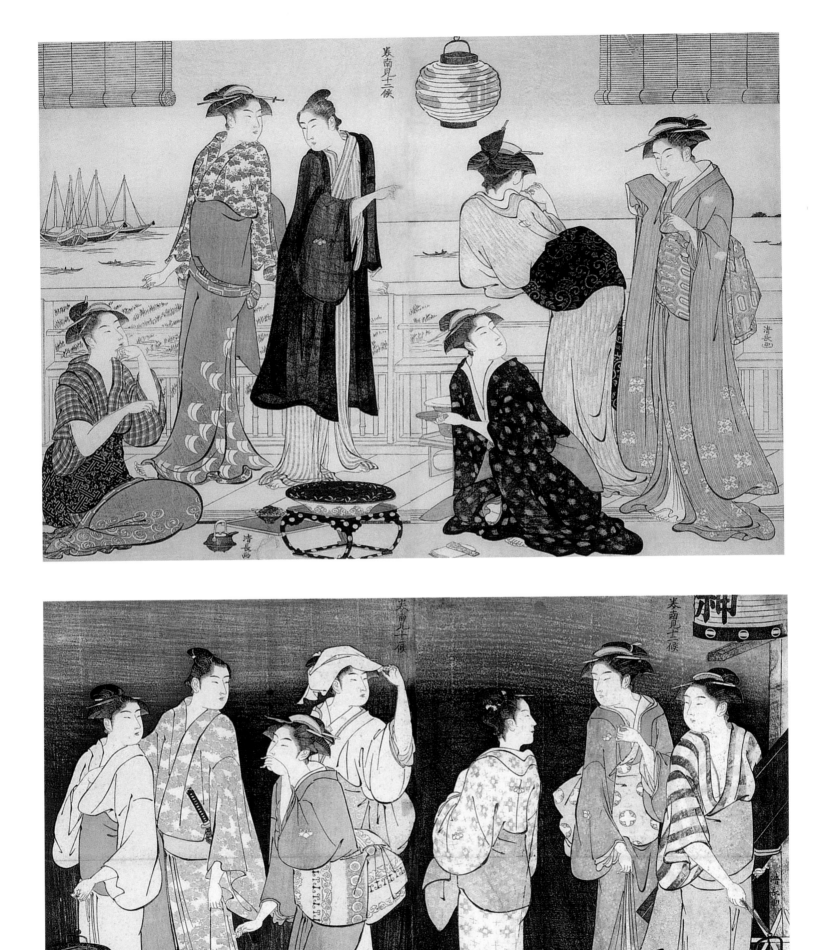

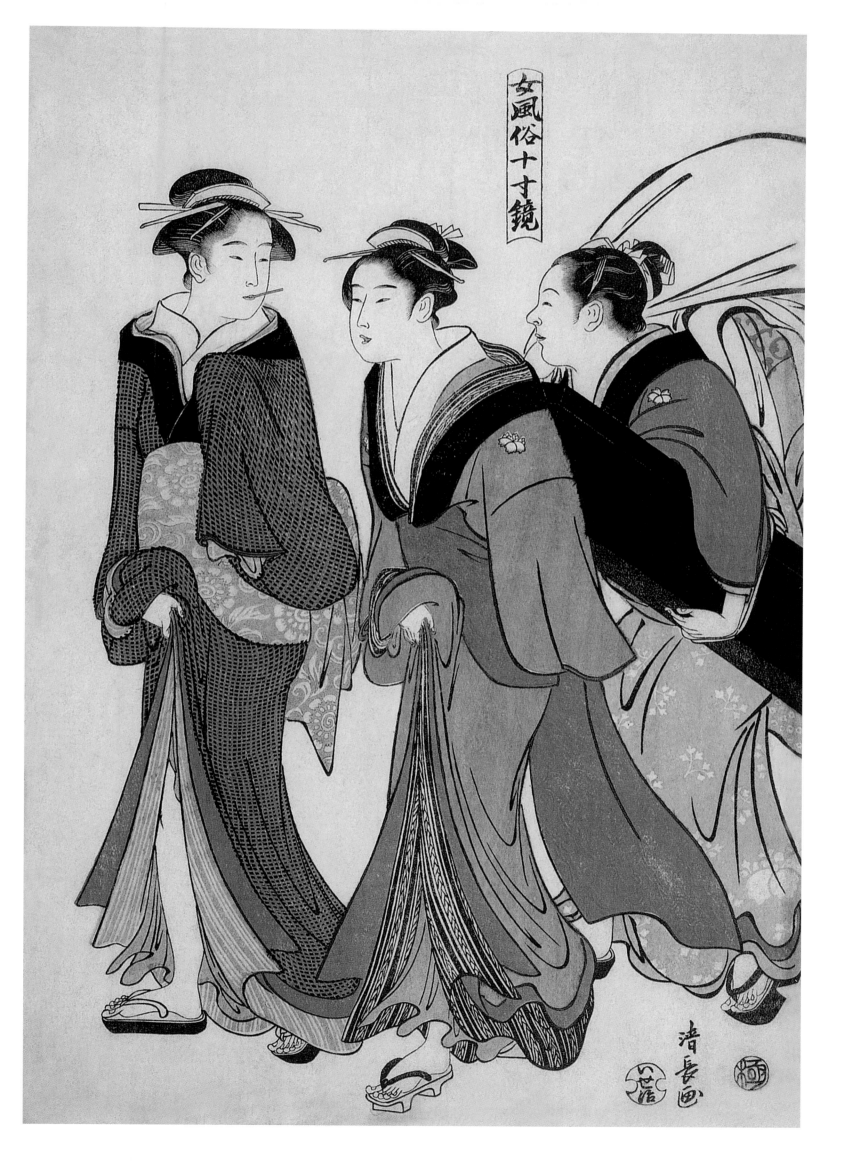

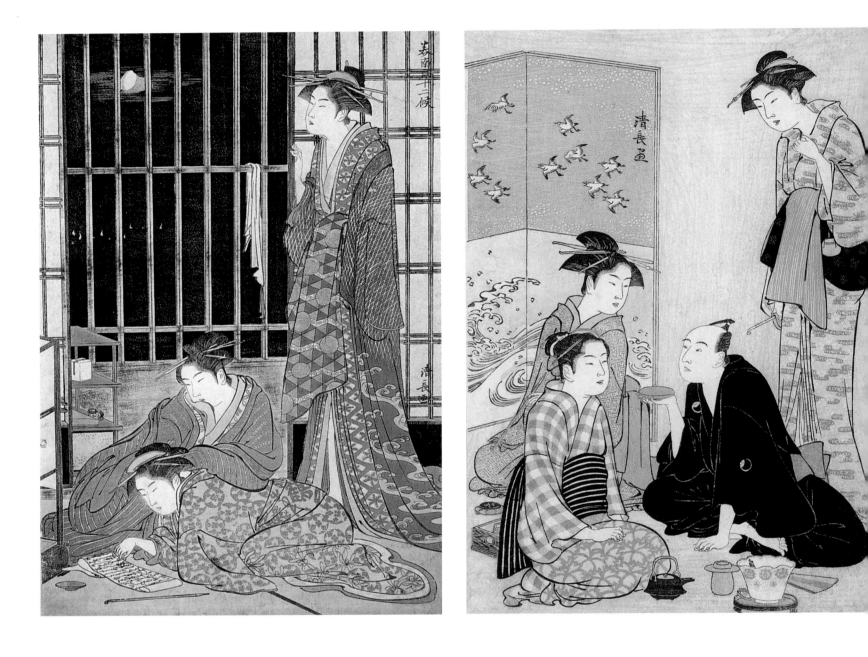

impressionist. Even when he in the course of his work began approaching the newly rising star of Utamaro, he knew how to refrain from direct imitation.

Katsukawa Shunzan began as Shunshō's pupil, and then became a close follower of Kiyonaga; but he lacked neither strength nor originality. He worked from the middle of the seventies until the end of the century.

The following artists were Kiyonaga's fellow pupils: Torii Kiyonaga, who gives away his origin as being from Kiyomitsu, with the graceful formation of his figures and very small hands and feet; he also gives away Harunobu's influence. As well as portrayals of actors he also produced book illustrations.

With Kiyonaga's pupil Torii Kiyomine, the Torii line, the great school for portrayals of actors ends after existing for a hundred years. Kiyomine commenced his work at the beginning of the nineteenth century; he was still alive in 1830 and died in 1868. He worked in a style that is reminiscent of Toyokuni and Utamaro, occasionally very elegant, frequently, however, there is a lack of liveliness in his expression.

At this point we should remember an artist, who, like Korin 100 years before, holds his very own position in the development of Japanese wood engraving, the Kitao Masayoshi. A son and pupil of Shigemasa, he began working around 1780; that was the time when Kiyonaga had his heyday. Between 1789 and 1813 he published a great number of books with reproductions of his brilliantly witty sketches, which would have had quite an effect on the young Hokusai, who had been an aspiring artist since the end of the century; he died in 1824. With him the love and respect for nature was renewed, the conscientiousness in portraying details, which had been dormant since the days of Korin. At the same time as Utamaro, he began lending landscapes an independent importance, closely observing the forms of animals and plants; yet not with Utamaro's almost embarrassing preciseness (who had first and foremost remained a graphic artist), but with the strength and boldness of a painter. He kept the overall coloured impression in mind and knew how to reproduce it with a few wide strokes, without taking his eyes off the fineness of the individual execution.

Torii Kiyonaga,
The Ninth Month: Fishing Boat Fires,
from the series *Twelve Months in the Shinagawa Pleasure Quarter.*
Colour woodblock print.

Torii Kiyonaga,
The Actor Sawamura Sōjurō III, c. 1782-1785.

Katsukawa Shunshō,
Young Women with a Basket of Chrysanthemums.
Colour woodblock print.
Musée Guimet, Paris.

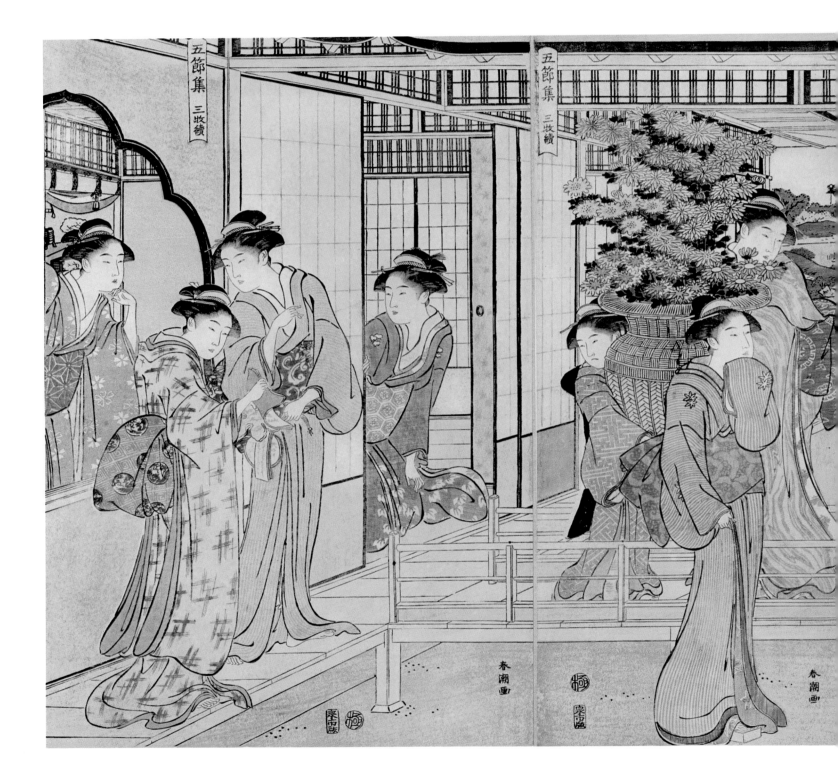

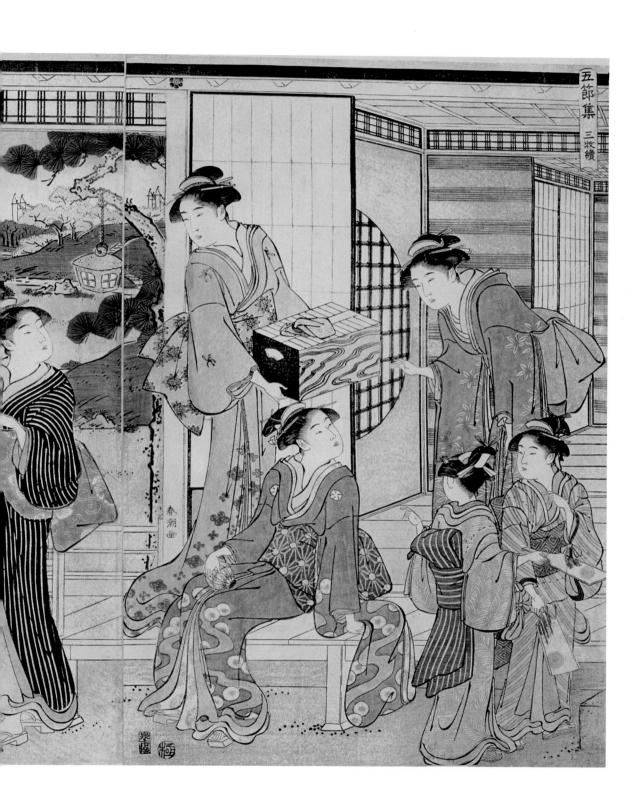

五節集
三牧續

春潮畫

SHUNSHO

Katsukawa Shunshō (active in 1764-1792)

Katsukawa Shunshō, who dominated wood engraving during the seventies and trained many pupils, began his work in 1764 and died in 1792. He is the founder of this new artist family, and became the main artist for portraying actors and was followed by all his pupils in this genre. Shunkō and Bunchō stand out among his pupils, also Shun'ei, Shunman and Hokusai.

When Kiyonaga reached full power in the eighties, Shunshō, as well as his contemporary Utagawa Toyoharu, dedicated themselves wholly to painting.

His first print, around 1764, introduced the five actors, known under the name of Gonin Otoko. The artist developed his full potential towards the end of the sixties. He created numerous portraits of actors, all outstanding through their liveliness of movement and strength of colour, even if the expression of emotions were not as distinct as with Harunobu or Kiyonaga. With an extremely simple and yet effective arrangement of folds, Shunshō knew how to create a highly decorative effect by skilfully distributing black masses. The portrayal of actors in female roles, which were entirely in the hands of men in Japan, gave him the opportunity for this.

Author of probably the most beautiful illustration work Japanese art has ever produced, he created the beauties, who live in the houses painted green and dedicated to pleasure, who are mostly portrayed during different activities of their everyday life, playing, smoking, playing music, painting, writing poetry in the garden. Among them are some prints with beautifully stylised plants. Characteristic for this piece of work is a particularly pale pink, which, next to violet, dun and yellow, dominates and has a very fine effect.

He taught numerous pupils and they are hard to tell apart, as they followed his style faithfully and mainly, like their master, creating portraits of actors. But before going into details about individual pupils, it is important to consider two of Shunsho's contemporaries and competitors, who cannot be separated from him. They worked like he did, but as a result of their special characteristics they were a necessary addition to this artist's profile. They are Bunchō and Toyoharu.

Like his competitor Shunshō, Ippitsusai Bunchō experienced his heyday at the beginning of the seventies. Whilst Shunshō mainly aimed at intense emotion and strong colours for his portraits of actors and often became angular and hard, even if he always remained effective, Bunchō always strived for a soft flow of lines and a delicate tone, which were very appropriate for the portrayal of his favourite subject, actors in women's roles. His prints are perhaps the most delicate and most graceful in Japanese art and distinguish

Katsukawa Shunshō,
The Actors Segawa Kikunojō III and Bandō Mitsugorō II Walking, c. 1785.
Colour woodblock print, 32.1 x 22.1 cm.
Baur Collection, Geneva.

Katsukawa Shunshō,
The Actor Onoe Matsusuke as the Kō no Moronao, 1789.
Colour woodblock print, 30 x 14.5 cm.
Museo d'Arte Orientale Edoardo Chiossone, Genoa.

Katsukawa Shunshō,
The Actor Ichikawa Danjūrō V in a Role of Shibaraku,
1777.
28.9 x 13.4 cm.
The Art Institute of Chicago, Chicago.

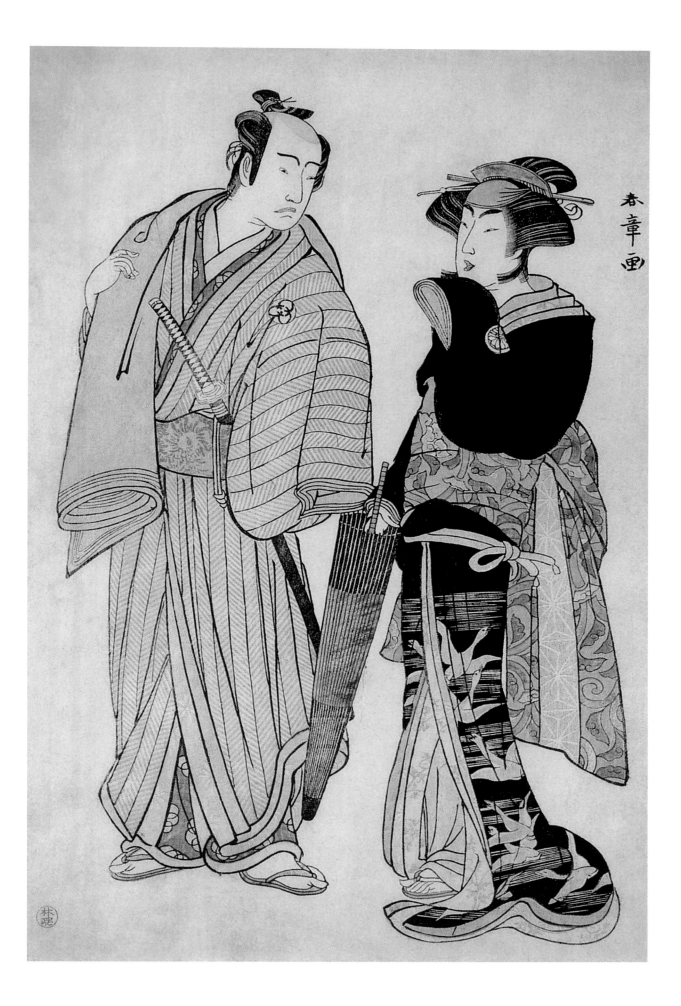

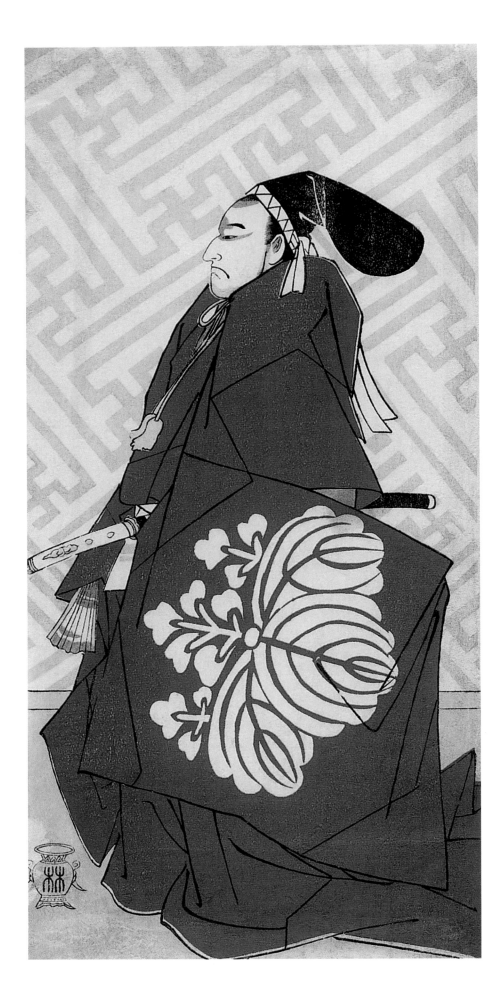

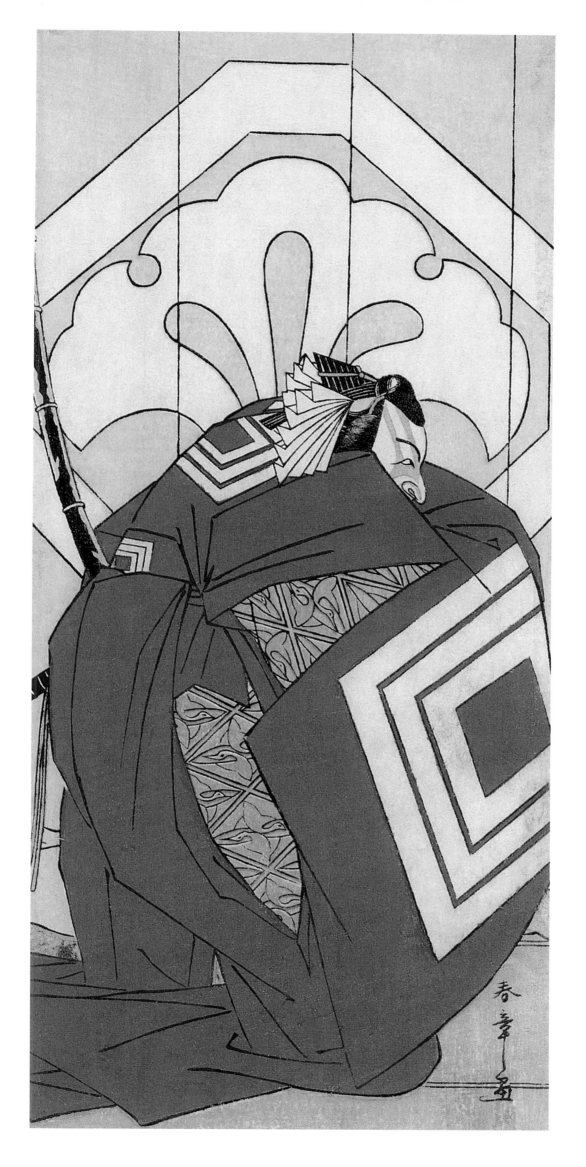

191

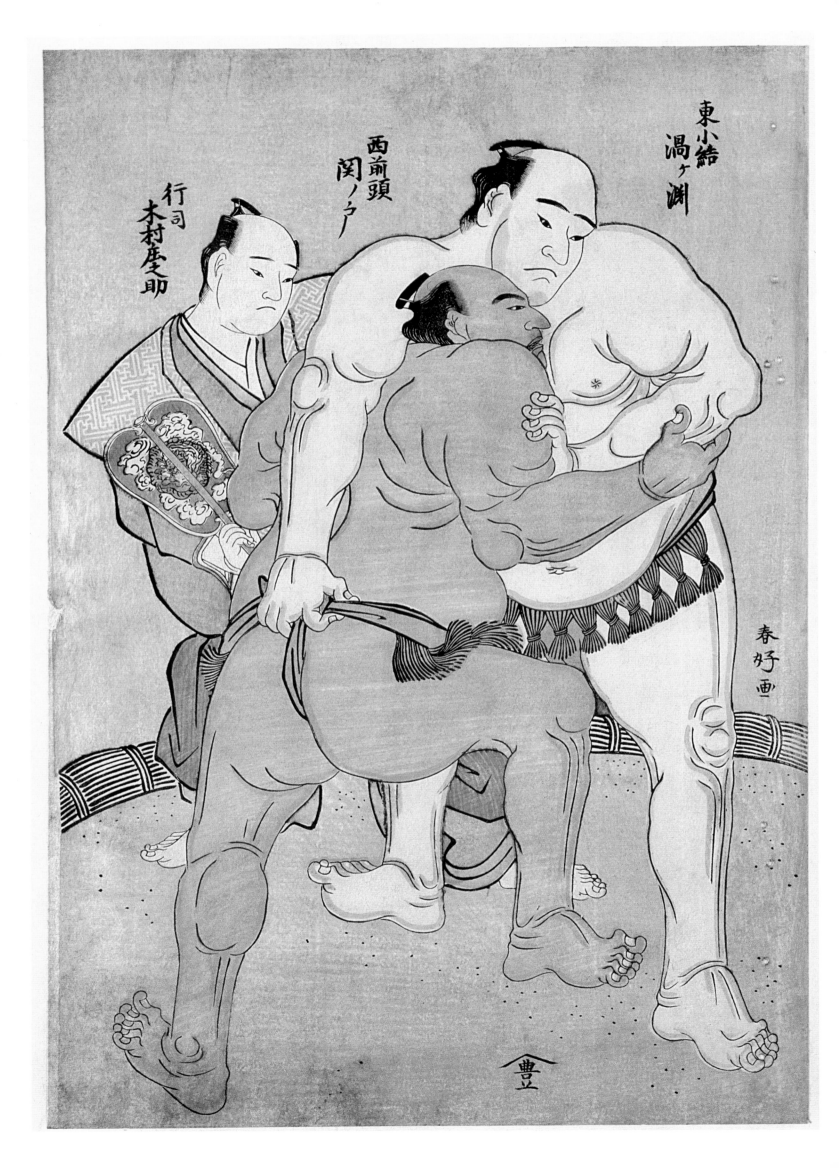

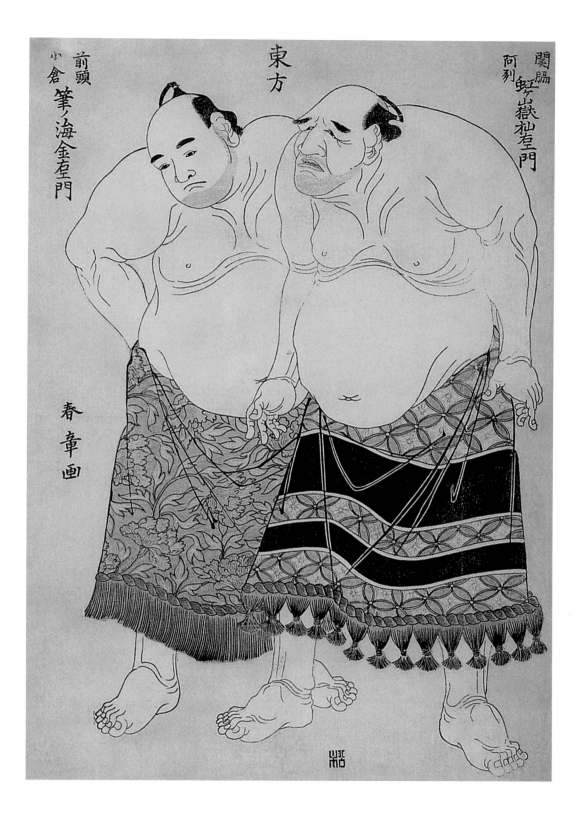

themselves by an unusual sharpness and subtlety of drawing as well as a colour combination, which can hardly be surpassed in its elegance. With a bright green and red that nevertheless had a mild effect, he was able to combine the most delicate tones of grey in such a way that it created an extremely harmonious overall mood. The strong effects of black and brick-red, which occur frequently in Shunshō's early period, are rare for Bunchō. Like Harunobu, he chose his colours with particular care, so that they have kept their original liveliness in his prints, and yet have such a soft effect as we otherwise only find in pieces of art whose colours have gradually been harmonised by the effect of light.

Utagawa Toyoharu started to work towards the end of the 1760s and died in 1814, in the Bunkwa period (1804-1818) at the age of sixty-nine. He was a pupil of Ishikawa Toyonobu and Nishimura Shigenaga. Toyoharu's

Katsukawa Shunshō,
The Sumō Wrestlers Uzugafuchi Kan'dayo and Sekinoto Hazchiroji with the Arbiter Kimura Shōrosuke.
Colour woodblock print, 37.3 x 25.2 cm.
Musée Guimet, Paris

Katsukawa Shunshō,
Matsumos of the Oriental Group, 1782-1783.
Colour woodblock print, 38.7 x 26.5 cm.
Ostasiatische Kunstsammlung, Museum für Asiatische Kunst, Staatliche Museen zu Berlin, Berlin.

Katsukawa Shunshō,
Three Beauties on a Veranda, c. 1795.
Ink and colours on silk, 89.4 x 34.6 cm.
The Art Institute of Chicago, Chicago.

Katsukawa Shunshō,
A Standing Beauty, 1780-1790.

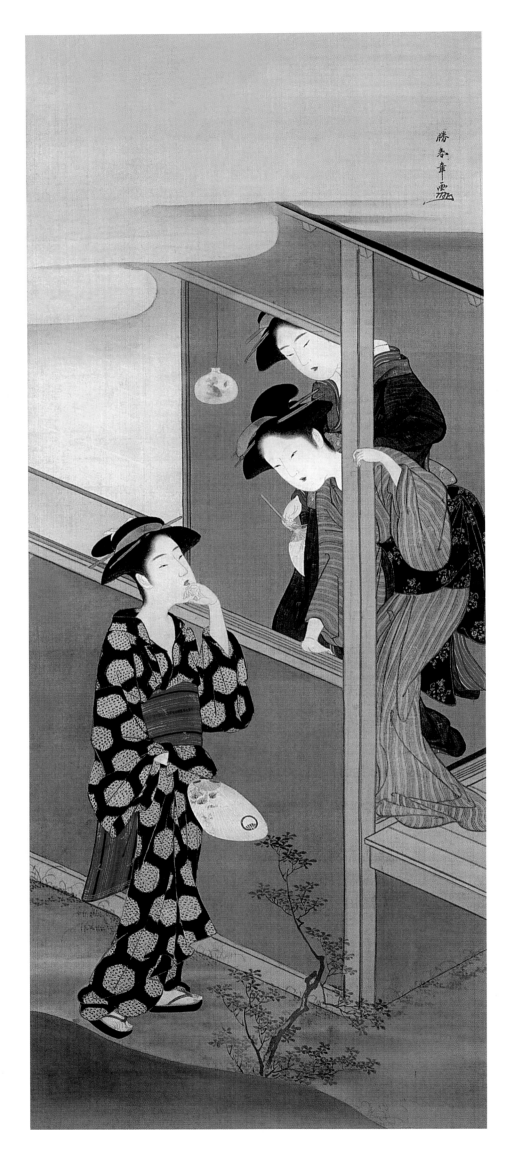

194

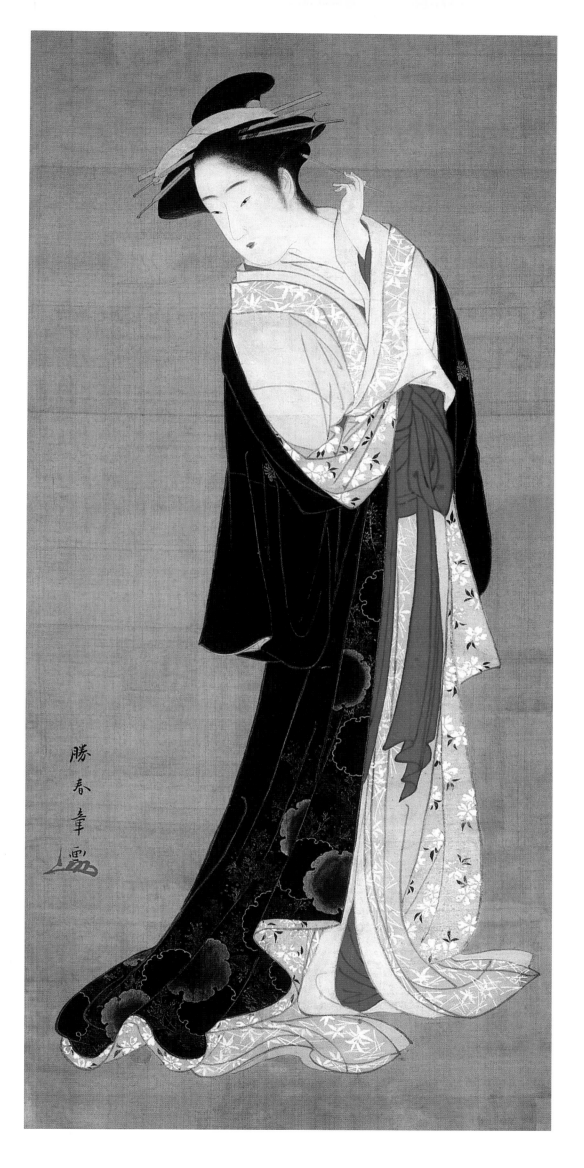

195

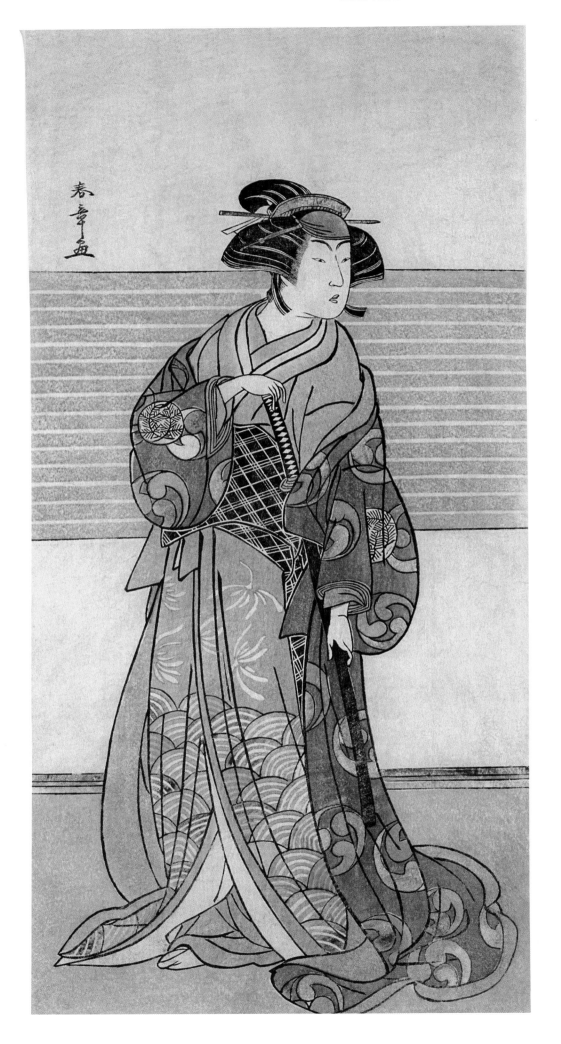

work, particularly that from his early period, has become very rare. Of a highly sensitive nature, he shrunk away from competing with Kiyonaga's newly developing style, and, like Shunshō, mainly turned to painting from the eighties onwards. In contrast to Bunchō, who was mainly oriented towards the decorative, he at least possessed a nature that was so delicate and special that he became the founder of a special family of artists, the Utagawas, who subsequently was to take over the leading position of the Katsukawa family. Fenollosa is right when he tends to place his talent above that of Shunshō's. The pictures of the months he created together with Shunshō have already been mentioned; in addition to this, one of his most beautiful series named is the one consisting of four prints of perfection. He was one of the first to learn the rules of perspective from the Europeans; the performance of the

Shunkōsai Hokushō,
The Actor Nakamura Matsue in a Female Role,
about to Unsheath a Sword.
The Newark Museum, Newark.

Katsukawa Shunshō,
The Actor Nakamura Nakaso I,
from the series *Fans from Edo,* c. 1770.
Brocade print, 38 x 25.5 cm.
Tokyo National Museum, Tokyo.

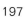

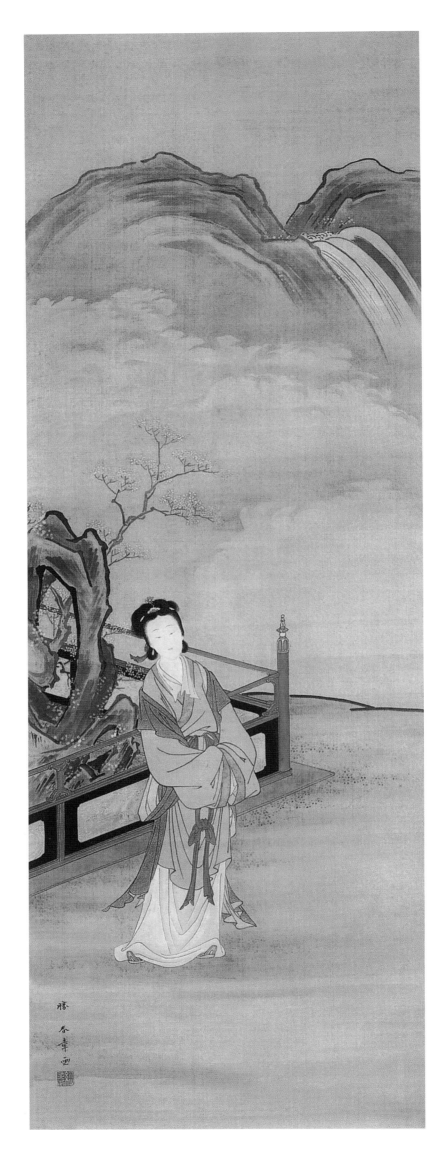

198

Katsukawa Shunshō,
Yang Guifei, 1789-1792.

Katsukawa Shunshō,
A serie of six prints from the series *The Twelve Months*, 1792-1794.

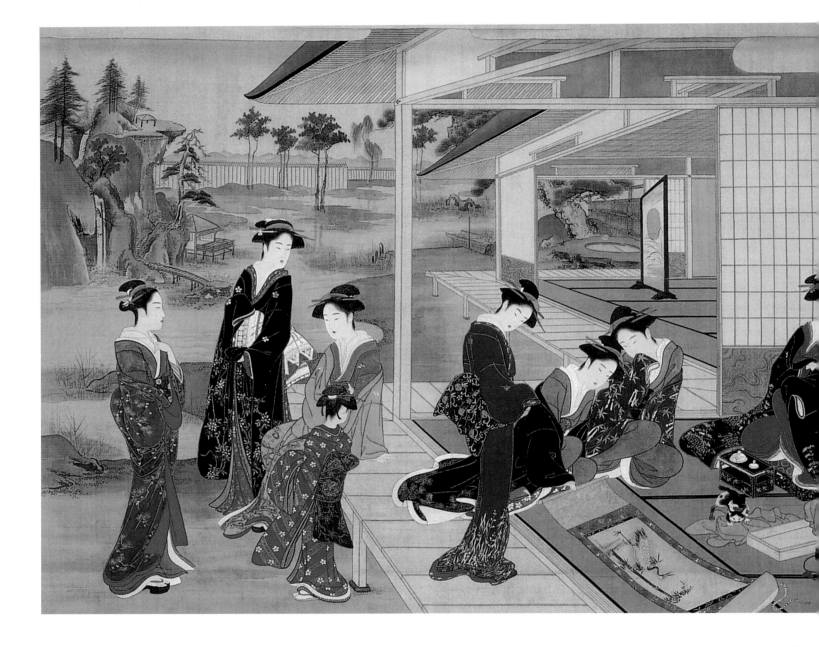

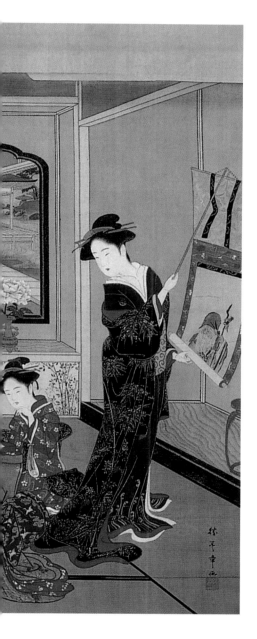

nō-dance at the court theatre of a nobleman is executed in such a way in a large landscape format.

His pupils were Toyohiro and Toyokuni. Another one of Ishikawa Toyonobu's was probably Ishikawa Toyomasu, who worked at the same time as Harunobu, Shunshō, Toyoharu and Shigemasa.

Toyoharu's contemporary, Harushige (Shiba Kōkan) should also be mentioned at this point, who was born in 1747 and died in 1818. He was a pupil of Harunobu, whose manner he continued after the master's death and under his name. He is named as the first Japanese artist to learn the rules of perspective from the Dutch. It is also said that he was the first the do copperplate engraving in Japan. The knowledge of perspective, which becomes clearly visible with Toyoharu and returns with Hokusai, may have been conveyed to these artists by Kōkan.

One of the most faithful pupils from Shunshō's early period was Katsukawa Shunkō, who mainly worked from the middle of the seventies until the middle of the eighties; in the end he was exaggerated in the proportions of his figures. Apart from his portrayals of actors and wrestlers, a dancing blind man should be mentioned.

Katsukawa Shun'ei has an outstanding position among the pupils of Shunshō's later period. He died in 1819 at the age of fifty-seven. Not without reason do some regard him as superior to his teacher. Apart from very effective, large portrayals of actors, he provided large portrayals of wrestlers, whose excellent drawings are outstanding; he created very funny, popular compositions for fans, whose effect came from very few colours; he also created small popular prints, only in grey and pink tones.

Katsukawa Shunshō,
Beauties Admiring Paintings, 1789-1792.
Ink and colours on paper, 69.4 x 123.2 cm.
Idemitsu Museum of Art, Tokyo.

Kitagawa Utamaro,
Lovers in an Upstairs Room,
from the series *Poem of the Pillow,* 1788.
Colour woodblock print, 24.5 x 37.3 cm.
Victoria & Albert Museum, London.

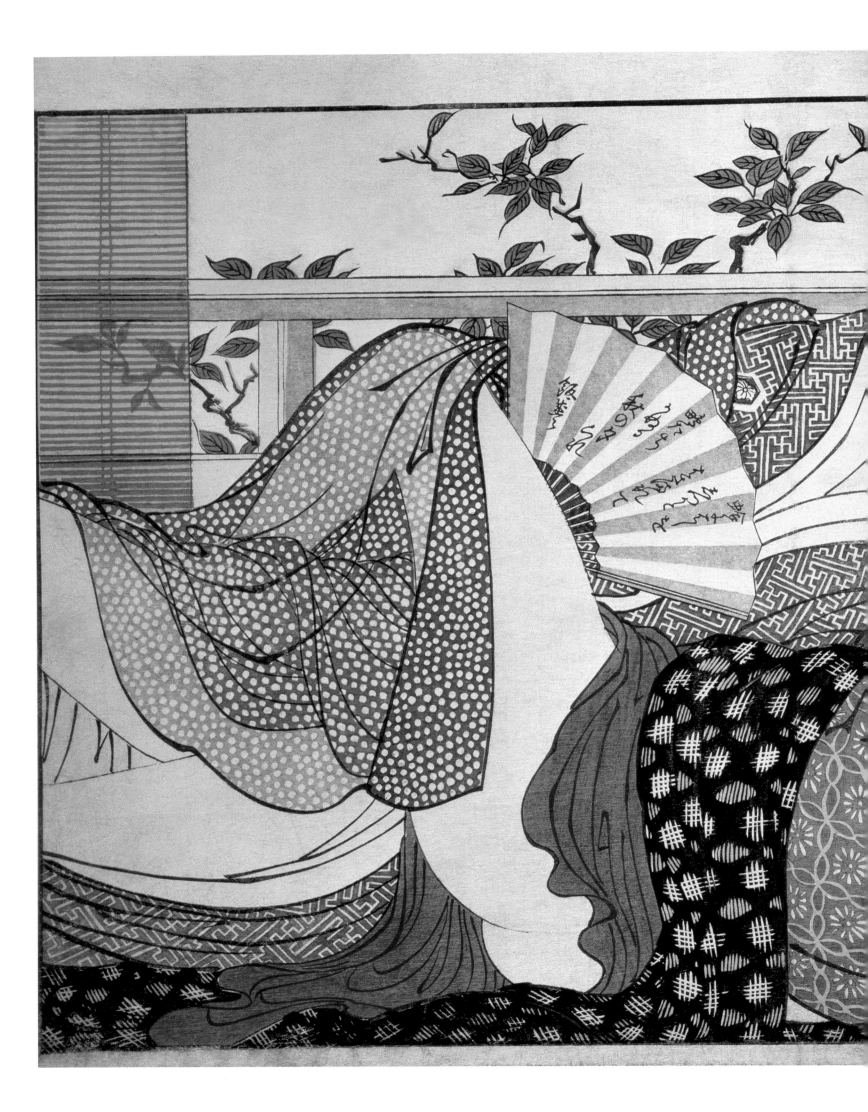

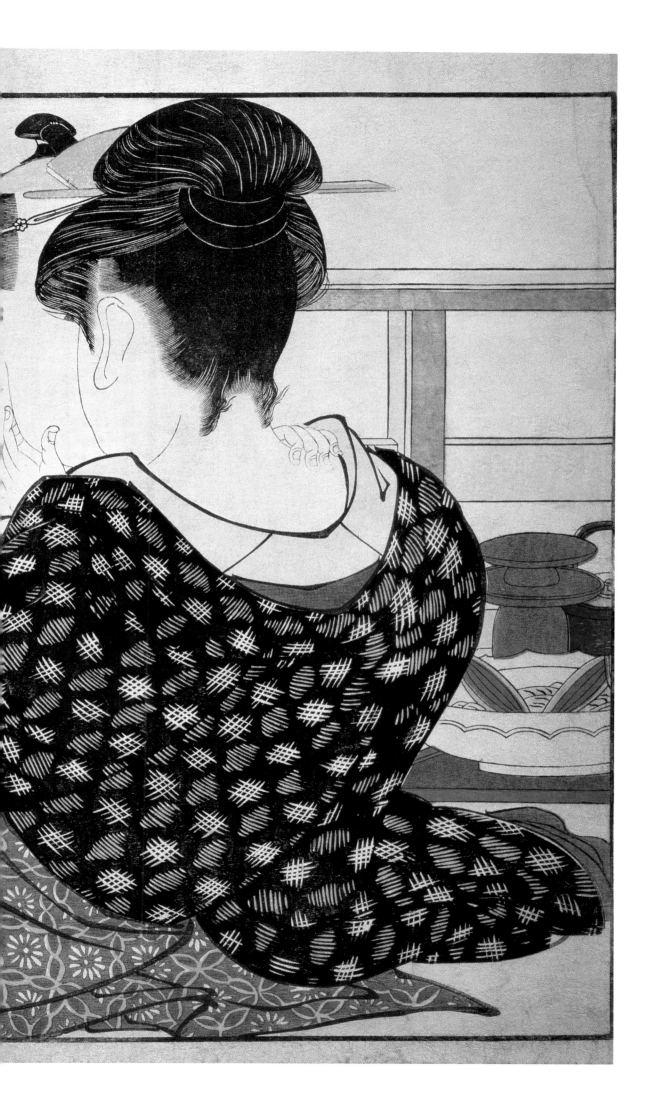

Kitagawa Utamaro (1754-1806)

"*Le Fondateur de l'Ecole de la Vie*". This title is quoted from the work of Edmond de Goncourt, "as one having authority," there being many claimants to the leadership of Ukiyo-e. In the life of Utamaro, de Goncourt, in exquisite language and with analytical skill, has interpreted the meaning of that form of Japanese art which found its chief expression in the use of the wooden block for colour-printing, and to glance appreciatively at the work of both artist and author is the motive of this sketch.

The Ukiyo-e print, despised by the haughty Japanese aristocracy, became the vehicle of art for the common people of Japan, and the names of the artists who aided in its development are familiarly quoted in every studio, whilst the classic painters of "Tosa" and "Kanō" are comparatively rarely mentioned. The consensus of opinion in Japan during the lifetime of Utamaro agrees with the verdict of de

Goncourt. No artist was more popular. His atelier was besieged by editors giving orders, and in the country his works were eagerly sought after, when those of his famous contemporary, Toyokuni, were but little known. In the "Barque of Utamaro," a famous surimono, the title of which forms a pretty play upon words, *maro* being the Japanese for "vessel", the seal of supremacy is set upon the artist. He was essentially the painter of women, and though de Goncourt sets forth his astonishing versatility, he yet entitles his work, "*Utamaro, le Peintre des Maisons Vertes.*"

The beautiful inhabitants of these celebrated houses of the Yoshiwara (the flower quarter) of Edo had ever been sought as models by the artists of Ukiyo-e. But, alas! The sensuous poetic-artistic temperament of Utamaro, undisciplined and uncontrolled, led to his undoing. The pleasure-loving artist, recognising no creed but the worship of beauty, refusing to be bound by any fetters but those of fancy, fell at last into the lowest

depths of degradation, physical and moral. And this debasement of their leader, tainting his art, was reflected in the work of his brother artists and hastened the decadence of the Popular School.

To understand the influences which sapped the self-control of the gay and beauty-loving Utamaro, we have only to glance at the text by Jippensha Ikku of "The Annuary of the Green Houses," two volumes of prints in colour, so marvellously beautiful that they caused the artist to be recognised as, in a sense, the official painter of the Yoshiwara. The writer thus sums up the fatal fascination of the inmates, the courtesans of highest rank, who alone were depicted by Utamaro. "The daughters of the Yoshiwara are brought up like princesses. From infancy they are given the most finished education" (from the Japanese standpoint, be it observed). "They are taught reading, writing, art, music, tea, perfume" (in the game of scents, the art is to guess by inhaling the odour of burning perfumes the secret of

Kitagawa Utamaro,
Woman Smoking,
from the series *Ten Classes of Women's Physiognomy,*
1792-1793.

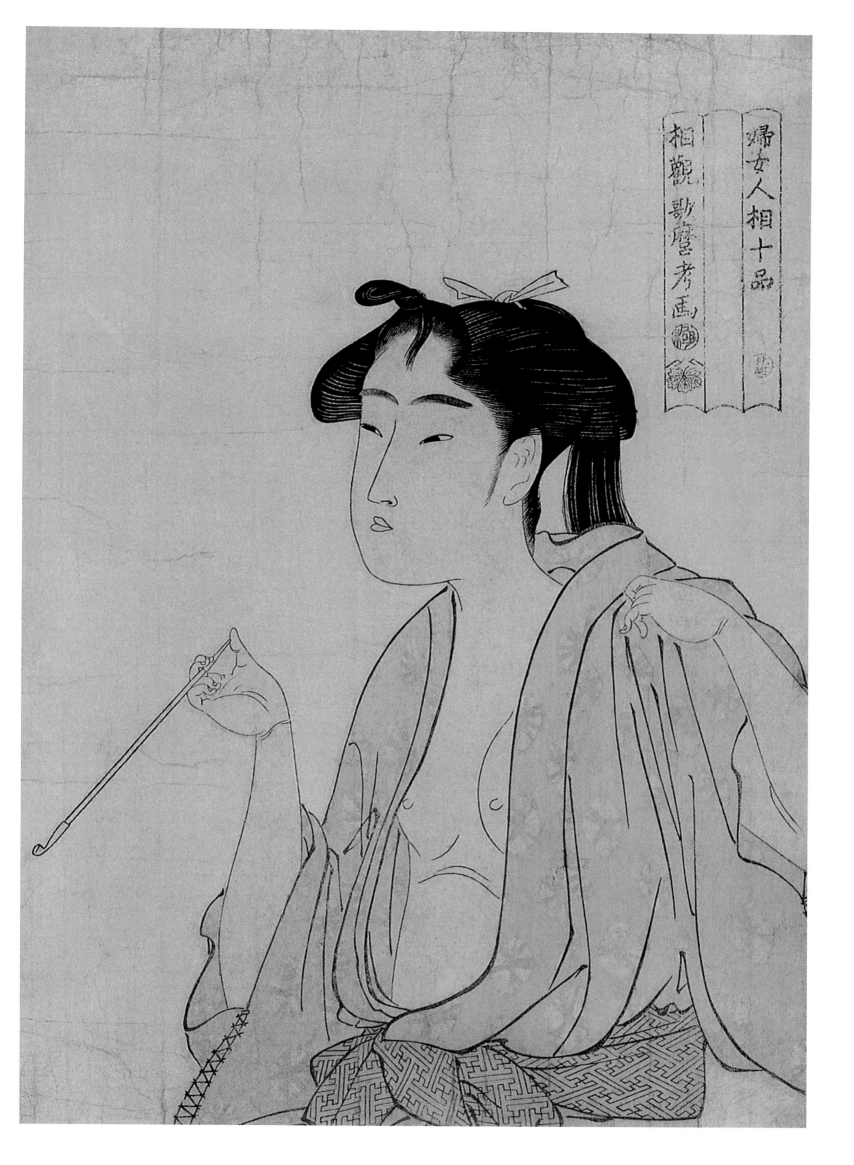

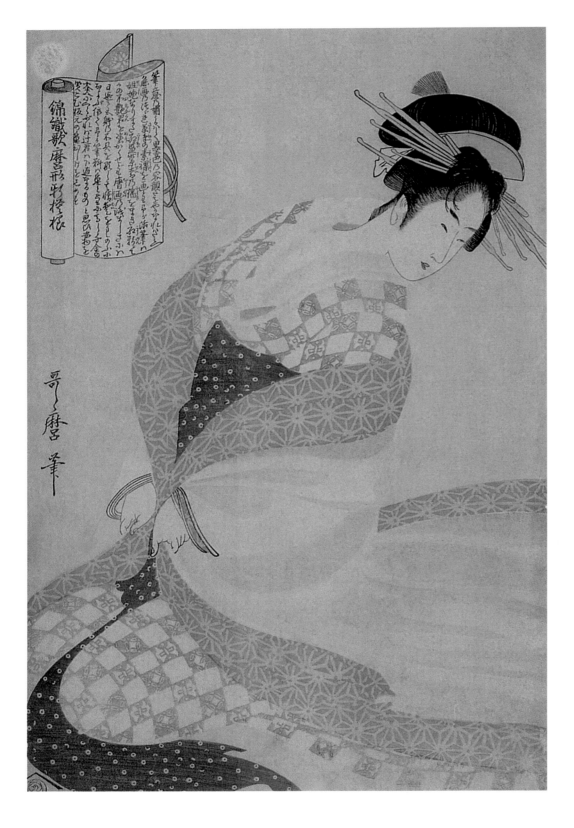

their composition). "Their entourage is that of princesses, brought up in the seclusion of the palace. Coming from all parts of the 'Land of the Rising Sun,' they must discard their individual patois and learn to speak the archaic tongue, slightly modified, the poetic, the noble language of the court from the seventeenth to the nineteenth century."

In the home of the celebrated Tsutaya Juzaburo, who edited the most beautiful books of the time, in his early impressionable youth lived Utamaro, within a stone's throw of the great gate leading to the Yoshiwara. By day he devoted himself to his art, by night he surrendered himself to the fatal enchantment of that brilliant "Underworld," until, like Merlin, ensnared by Vivian, with the charm of "woven paces and waving hands," his art sapped by excesses, he became "lost to life, and use, and name, and fame."

Let us, forgetting this sad sequel, glance at the works which testify to the life of high artistic endeavour

Kitagawa Utamaro,
Beautiful Lady in a White Coat, from the series *New Patterns of Brocade Woven in Utamaro Style,* c. 1795.
Colour woodblock print, 38 x 25.8 cm.
The Art Institute of Chicago, Chicago.

led by Utamaro in the early part of his career. In the preface to the *Ehon mushi erabi* (Chosen Insects), the master of Utamaro, Toriyama Sekien, throws so charming a sidelight upon the youth of the artist, that the temptation to quote is irresistible. The value of these Japanese prefaces to the world, to workers in every field, is incalculable. At the outset of his work, de Goncourt alludes to the well-known preface of Hokusai in the *Fugaku hyakkei* (Hundred Views of Mount Fuji), and doubtless fortified himself by the stimulating example of the old master, when undertaking at the age of seventy the great task of presenting to the Western world, under the title of *L'Art Japonais*, a history of five noted painters, besides that of other artists in bronze and lacquer, pottery and iron – artists in a land where the terms artist and artisan are interchangeable, the only country where industrial art almost always touches grand art.

The translator of the preface of Sekien is gratefully referred to by de

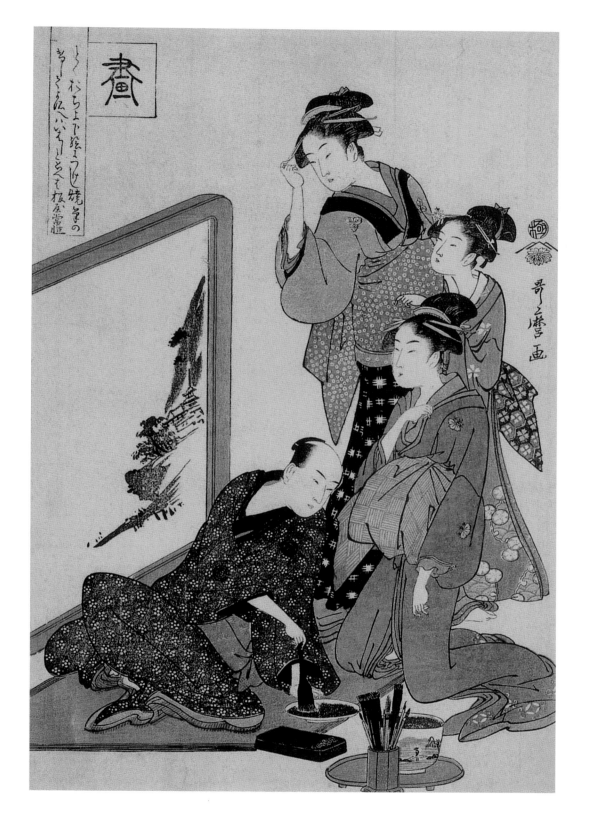

Kitagawa Utamaro,
Painting (Ga), from the series *The Four Disciplines: koto, go, Calligraphy, Painting*,
1792–1793.
Colour woodblock print, 36.7 x 24.5 cm.
The British Museum, London.

207

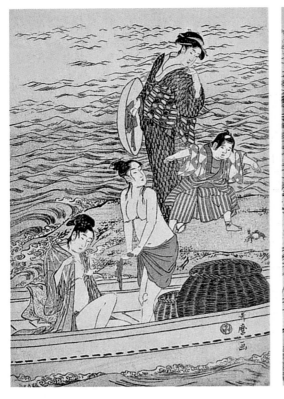

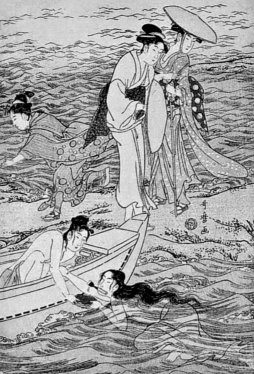

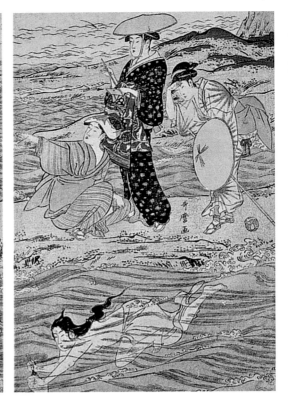

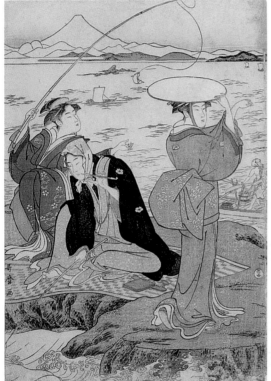

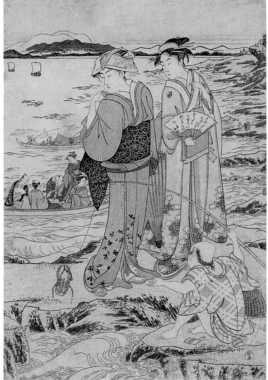

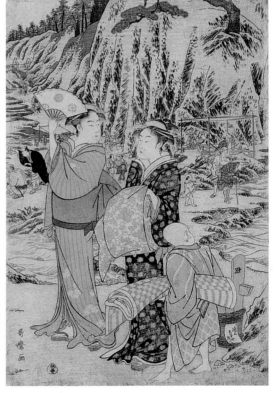

Kitagawa Utamaro,
Illustration of the volume The Gifts of the Low Tide, 1789.
Colour woodblock print, 25.8 x 18.9 cm.
The British Museum, London.

Kitagawa Utamaro,
Awabi Diving Girls, c. 1791.

Kitagawa Utamaro,
Fishing at Leasure in Iwaya, Enoshima, c. 1788-1790.
Colour woodblock print, 37.8 x 25 cm (right-hand sheet);
37.8 x 25.1 cm (center-hand sheet); 37 x 25 cm (left-hand sheet).
The British Museum, London.

Kitagawa Utamaro,
Eleventh Act (Jūichidanme), from the series *Drama Chūshingura Parodied by Famous
Beauties: Series of Twelve Pages,* 1794–1795.
Colour woodblock print, 39.1 x 25.9 cm (right-hand sheet);
39.2 x 25.7 cm (left-hand sheet).
Collection Clarence Buckingham,
The Art Institute of Chicago, Chicago.

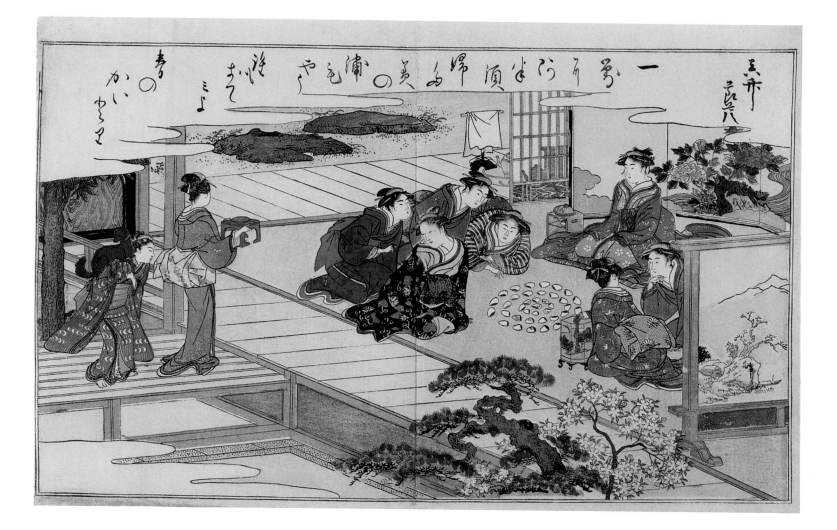

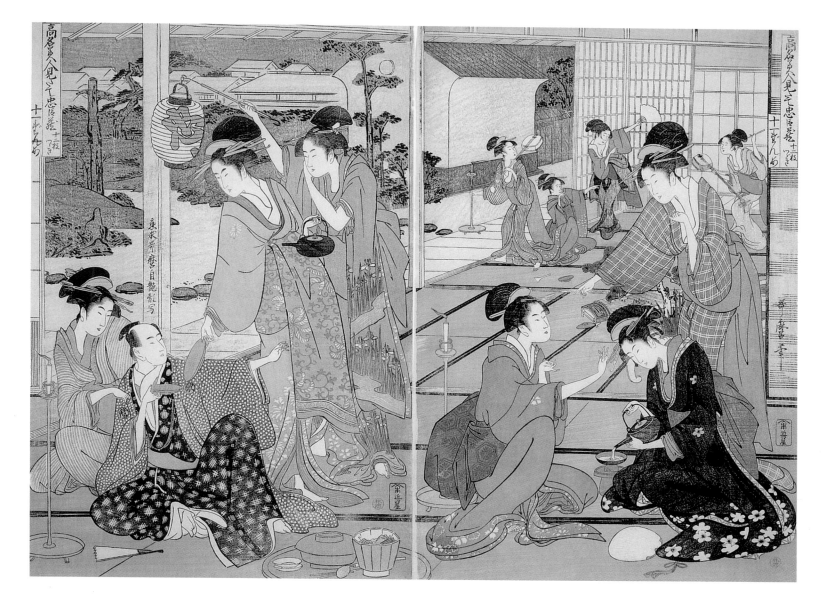

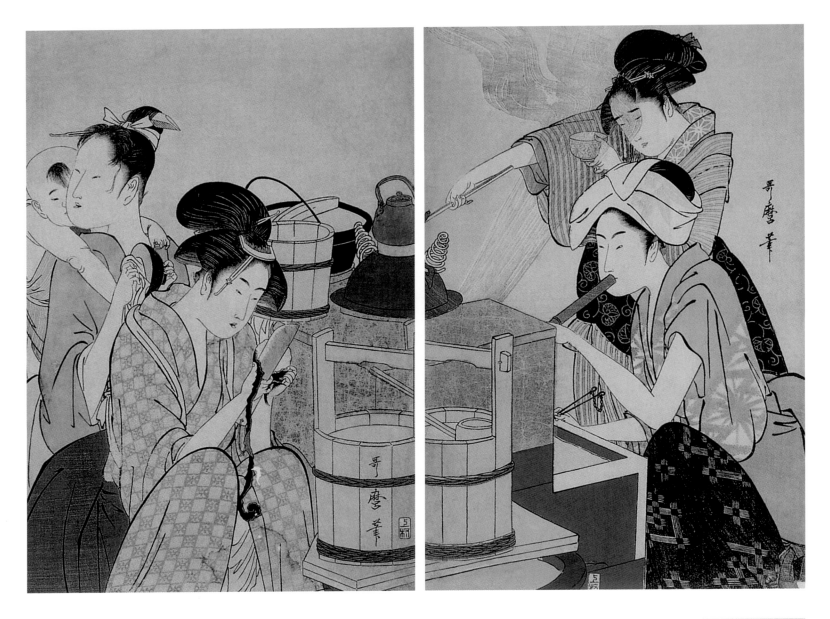

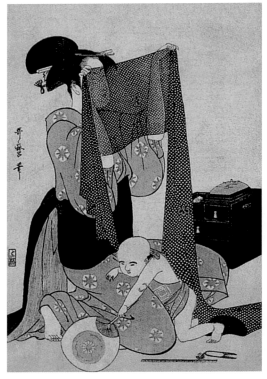

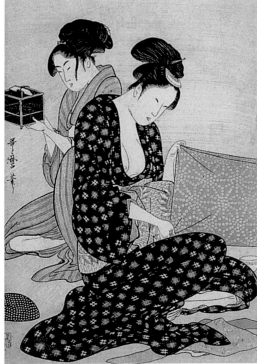

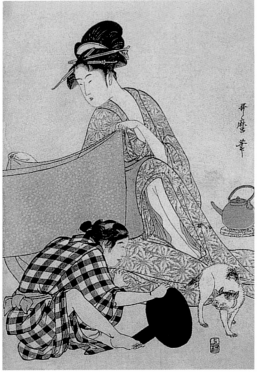

Goncourt as *"l'intelligent, le savant, l'aimable Hyashi."* It may be considered a revolutionary manifesto of the Profane School, the school of real life, in opposition to the hierarchical Buddhist academies of Kanō and Tosa, which had become stultified by tradition and stifled by conventional observances.

"Foreword written by Toriyama Sekiyen, the master of Utamaro, celebrating the naturism (from the heart) of his dear boy, his dear pupil Uta." Depicting life through the heart, and drawing its structure with the brush is the law of painting. The study that my pupil Utamaro has readily published reproduces the very life of the insect world. When I remember the times of yore, I recall that from childhood on, the little Uta watched closely every small detail possible. Thus, in autumn, when he was in the garden, he would hunt insects, and whether it be a cricket or a grasshopper, he always had a full hand, and would keep the creature and delightfully study it. How many times did I

scowl at him, dreading that he would catch the habit of killing living creatures. Now that he has acquired a great talent with the brush, he has made the study of the insect the glory of his profession."

The enthusiastic master proceeds to rhapsodise upon his pupil's genius and intimate knowledge of the structure of insects. "He makes us hear," he says, "the shrilling of the tamanoushi," the cicada of Japan, whose endless peevish twanging upon one string forms an underlying accompaniment to the harmonies of long summer days. "He borrows the light weapons of the grasshopper for making war; he exhibits the dexterity of the earthworm, boring the soil under the foundations of old buildings; he penetrates the mysteries of nature in the groping of the larvae, in the lighting of his path by the glow-worm, and he ends by disentangling the end of the thread of the spider's web."

The colour-printing of these

insects is a miracle of art, says de Goncourt, and there is nothing comparable to it in Europe. Of the methods by which these colour prints are brought to such a height of perfection, it is almost impossible to speak authoritatively. They are the result of a threefold combination: of a paper marvellously prepared from the bark of the shrub, *Kozo,* diluted with the milk of rice flour and a gummy decoction extracted from the roots of the hydrangea and hibiscus; of dyes, into the secret of whose alchemy no modern artist can penetrate. It is safe to say the early "Tan-e" and "Beni-e" prints can never be reproduced; of the application of those colours by the master engraver's fingers – that wizard hand of the Orient into whose finger-tips are distilled the mysteries of bygone centuries. A portion of the colour by means of this calculated pressure is drunk, absorbed into the paper, and only the transparency is left vibrating upon the fibres like colour beneath the glaze.

Kitagawa Utamaro,
In the Kitchen, 1794-1795.

Kitagawa Utamaro,
Women Sewing, Edo period, 1795-1796.
Triptych of hand-coloured woodblock print,
37 x 24.5 cm.
The British Museum, London.

Kitagawa Utamaro,
Three Beauties, mid-1790s.
Ōban size.

Kitagawa Utamaro,
Okita, from the series *Seven Women Applying Make-up Using a Full-Length Mirror (Sugatami shichinin keshō),*
1792-1793.
36.6 x 24.2 cm.
Honolulu Academy of Arts, Honolulu.

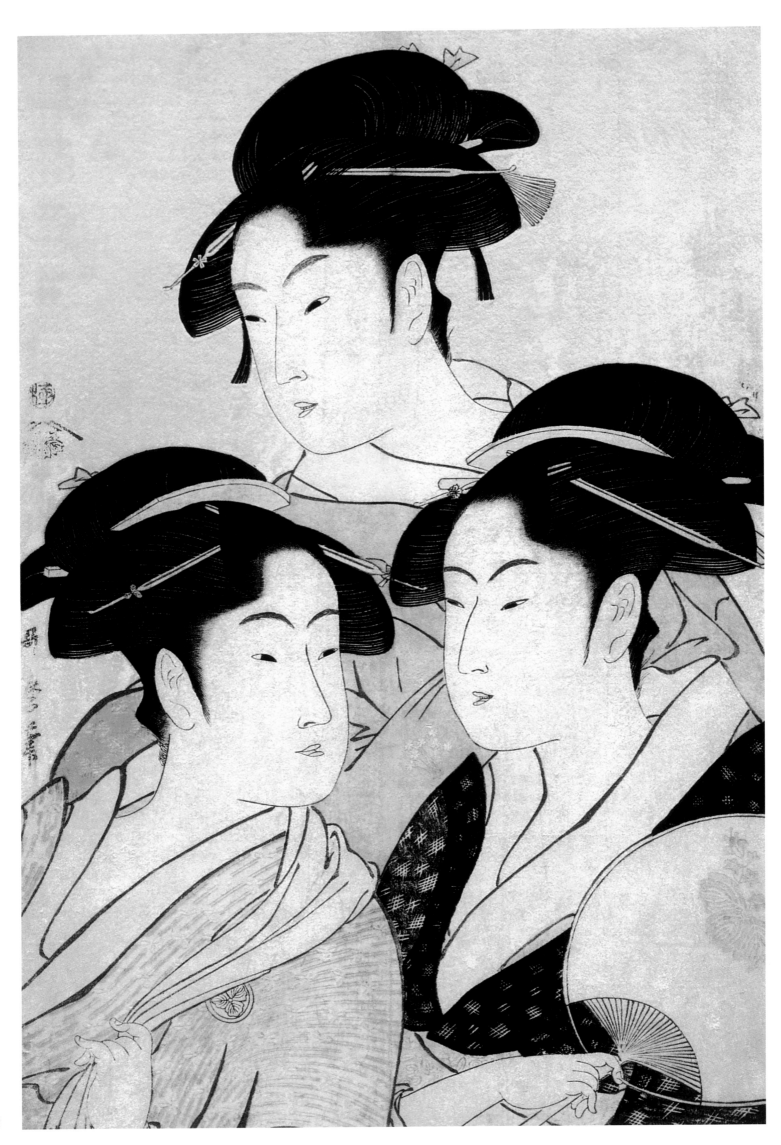

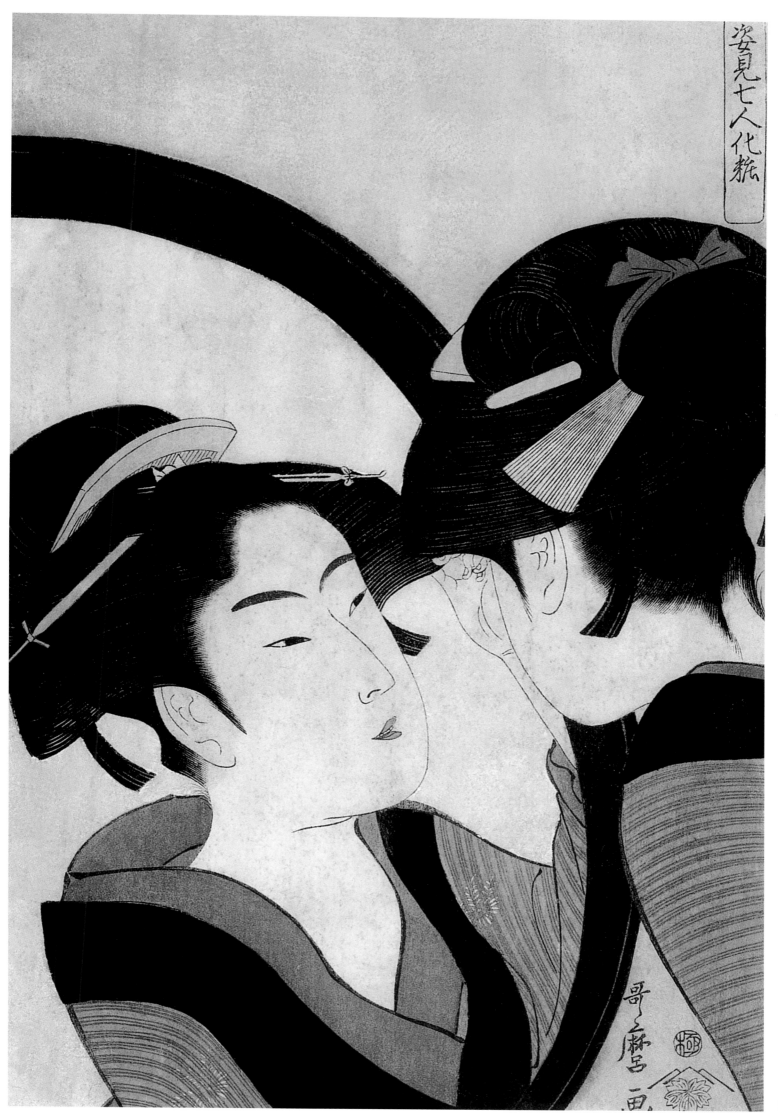

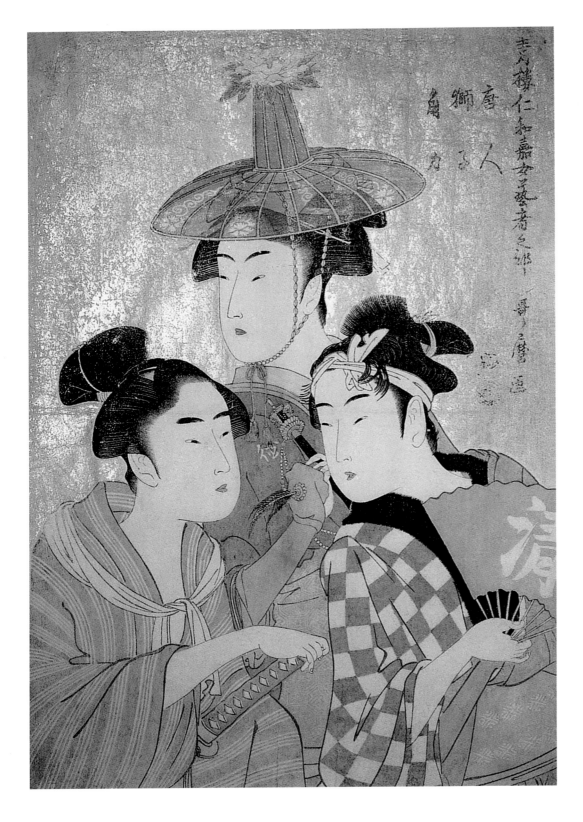

The *Catalogue Raisonné* of de Goncourt is a prose masterpiece. His descriptive touches, like pastels set in jewels, captivate the imagination. Through him we see the albums, the fans, the *kakemonos*, the *surimonos*. Oh, the prints, with their wondrous backgrounds, the delight of Utamaro! Sometimes straw-yellow, the uniformity broken with clouds of ground mica; sometimes grey in tint, like the traces of receding waves upon the beach. Some silvered backgrounds throw moonlight reflections upon the figures; some are sombre, bizarre – all are marvellous beyond words. And the colours! We cannot define them in English. The "*bleus*" (malades des mauves), the "*rose*" (beni) "*si peu de rose, qu'ils semblent s'apercevoir a travers un tulle; l'azur – delavé, et comme noyé dans l'eau,*" – not colours, but nuances, which recall the colours. And the "*Gauffrage,*" so effective with the print artists, with us a mere confectioner's touch!

Kitagawa Utamaro,
(*Three Geishas Dressed up as*)
Chinese, Chinese Lion, Matsumo
(*Karabito, shishi, sumō*), from the series *The Feast of Niwaka in Green Houses: Show of a Geisha*, 1792-1793.
Colour woodblock print, 38.8 x 25.9 cm.
Baur Collection, Geneva.

Kitagawa Utamaro,
Summer Bath, from the series *Seven Episodes of Ono no Komachi and Children*, early 1800s.
Allusion print (*mitate-e*), 38 x 25.5 cm.
Victoria & Albert Museum, London.

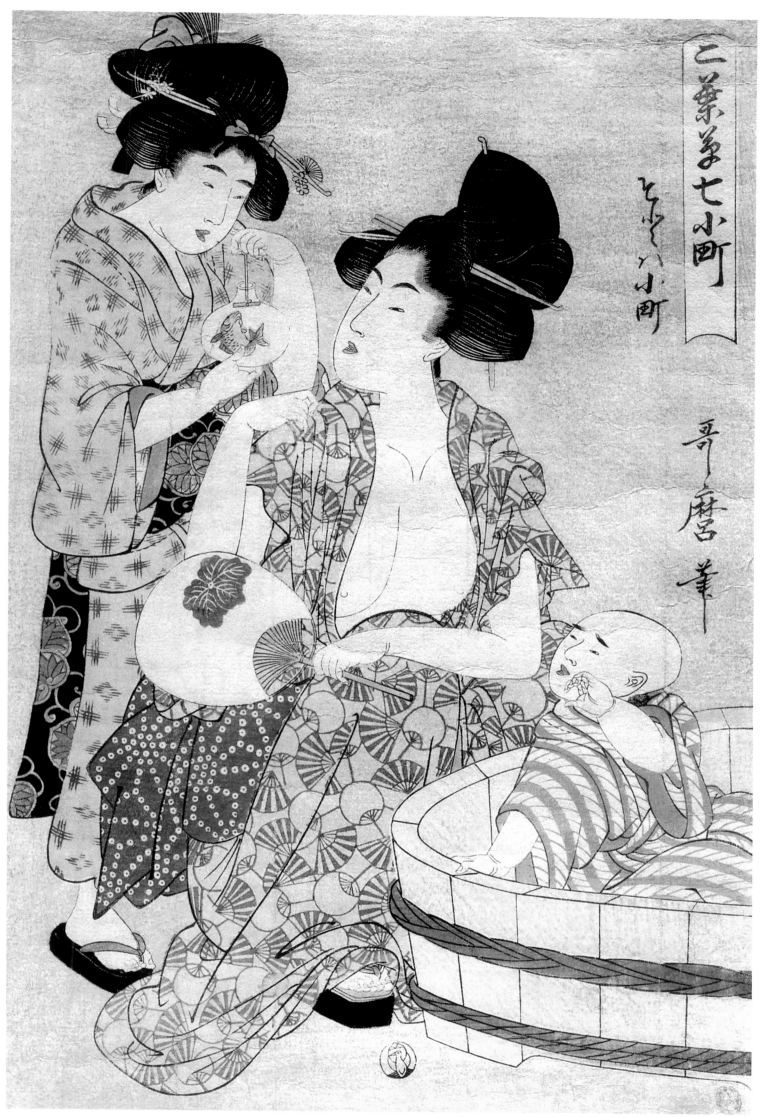

二葉等七小町

そそく小町

哥麿 筆

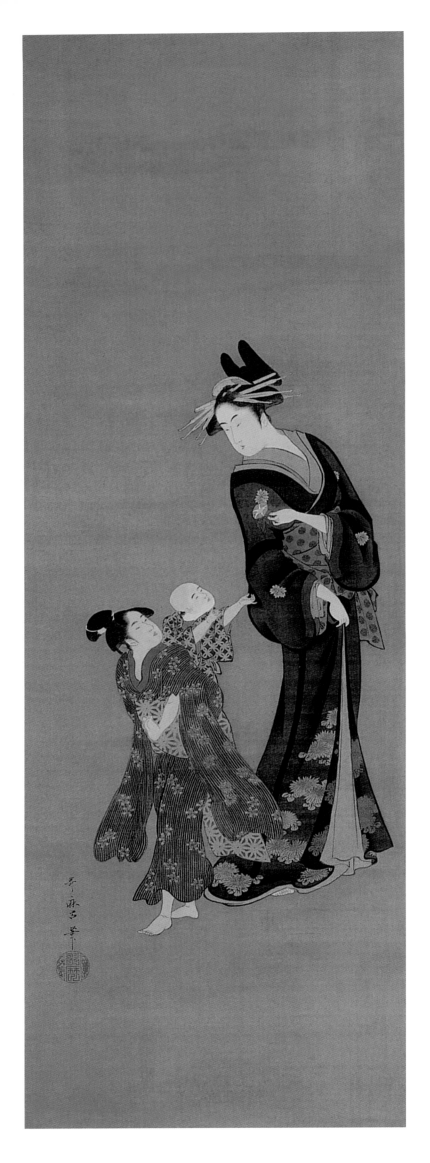

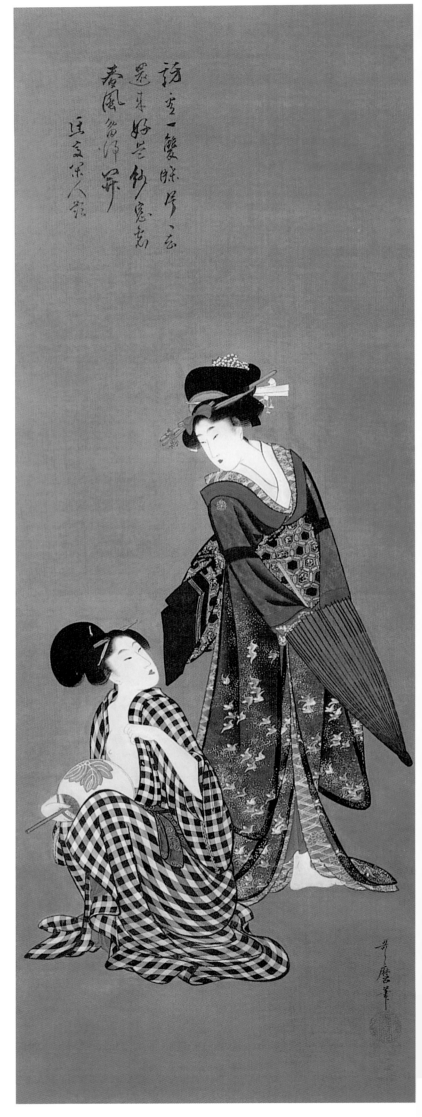

It is said that "the aesthetic temperament of a nation is most subtly felt in the use of colour. Purity, coldness, sensuality, brightness, dullness of tints, are significant terms correlated to mental and physical human phenomena." The assertion of Ruskin, that "the bodily system is in a healthy state when we can see hues clearly in their most delicate tints, and enjoy them, fully and simply, with the kind of enjoyment children have in eating sweet things," is brought to mind in viewing the Japanese people upon the occasion of one of their great flower fetes, feasting their eyes upon cherry blossoms or trailing clusters of the wisteria.

Utamaro planned schemes of colour and devised harmonies – themes which, improvised upon and endlessly imitated by his artist *confrères*, filled his own countrymen with delight and ravished the hearts of Parisian painters. The influence of Utamaro, Hiroshige and the other masters of Ukiyo-e revolutionised the colour-sense of the art world, so that Theodore Child, writing in 1892, remarked of the Japanese influence: "The Paris Salon of today as compared with the salon of ten years ago is like a May morning compared with a dark November day."

The same keen observation and technical skill which would have made Utamaro a famous naturalist is shown in his marvellous studies of women. He was the first Japanese artist who deviated from the traditional manner of treating the face. The academic style demanded the nose to be suggested by one calligraphic, aquiline stroke, the eyes to be mere slits, the mouth the curled up petal of a flower. Utamaro blended with this convention, so little human, a mutinous grace, a spiritual comprehension; he kept the consecrated lines, but made them approach the human. These "effigies of women" became individuals; in one word, he is an idealist, he "makes a goddess out of a courtesan." No detail of her anatomy escapes his eye, no grace of line or beauty of contour. De Goncourt, in detailing the great prints of Utamaro, transports us to the Orient. He unrolls the film of memory, so that again the Japanese woman stands, reclines, and lives before us:

"Vous avez la Japonaise en tous les mouvements intimes de son corps; vous l'avez, dans ses appuiements de tête, sur le dos de sa main, quand elle réfléchit, dans ses agenouillements, les paumes de ses mains appuyés sur les cuisses, quand elle écoute, dans sa parole, jetée de côté, la tête un peu tournée, et qui la montre dans les aspects si joliment fuyants d'un profil perdu; vous l'avez dans sa contemplation amoureuse des fleurs qu'elle regarde aplatie à terre; vous l'avez dans ses renversements ou légèrement elle pose, à demi assise, sur la balustrade d'un balcon; vous l'avez dans ses lectures, où elle lit dans le volume, tout près de ses yeux, les deux coudes appuyés sur

Kitagawa Utamaro,
Beauty with the Morning Glory, c. 1795.
Ink and colours on silk, 91.6 x 31.3 cm.
Chiba Art Museum, Chiba.

Kitagawa Utamaro,
Two Beauties in Summer, c. 1800-1805.
Ink and colours on silk, 103.5 x 31.8 cm.
Charles Stewart Smith Collection, The Metropolitan
Museum of Art, New York.

Kitagawa Utamaro,
Deeply Concealed Love, from the series *Great Love
Themes of Classical Poetry,* 1792-1793.
Brocade print, 38 x 25.5 cm.
Tokyo National Museum, Tokyo.

Kitagawa Utamaro,
Hinazuru of the Chojiya, from the series *A Collection of
Beauties at the Height of Their Popularity,* c. 1794.
Brocade print, 38 x 25.5 cm.
Tokyo National Museum, Tokyo.

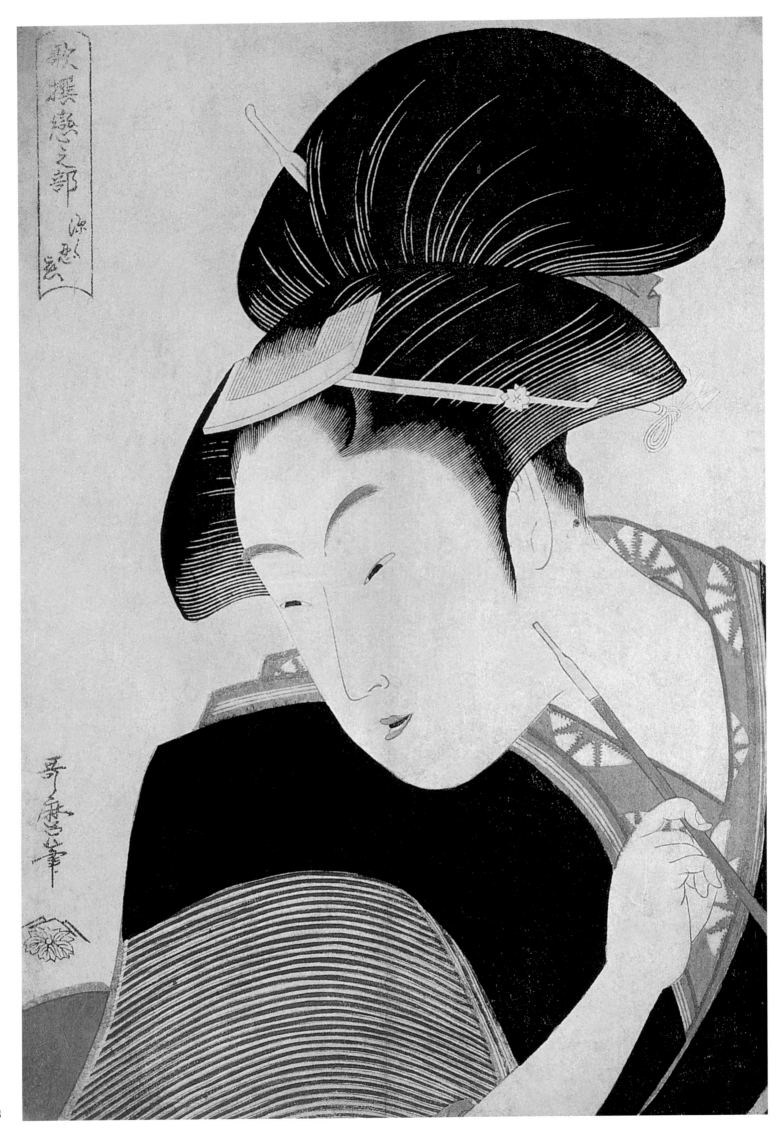

218

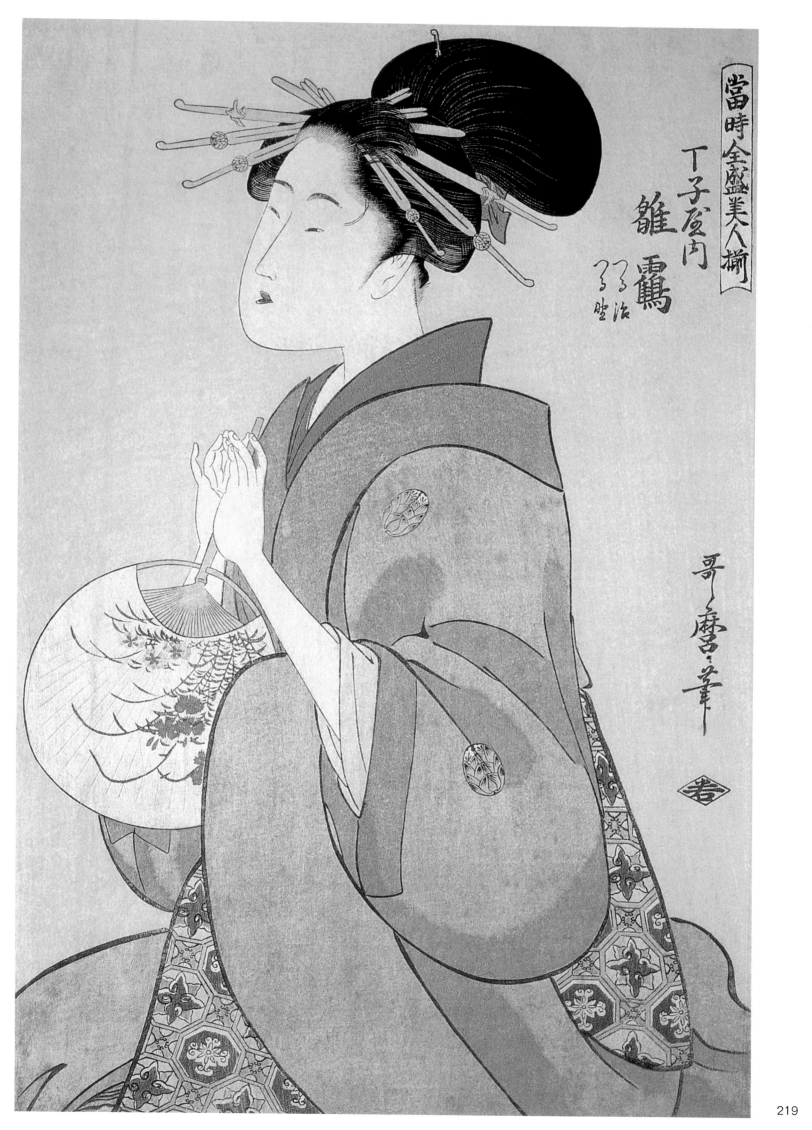

当時全盛美人揃

丁子屋内

雛鶴

つる治

歌麿筆

若

ses genoux ; vous l'avez dans sa toilette qu'elle fait avec une main tenant devant elle, son petit miroir de métal, tandis que de l'autre main passée derrière elle, elle se caresse distraitement la nuque de son écran; vous l'avez dans le contournement de sa main autour d'une coupe de saké, dans l'attouchement délicat et recroqueville de ses doigts de singe, autour des laques, des porcelaines, des petits objets artistiques de son pays; vous l'avez enfin la femme de l'Empire-du-Lever-du-Soleil, en sa grace languide, et son coquet rampement sur les nattes du parquet."[1]

To translate would be a travesty, for the French language seems to be the only medium through which the nuances of Japanese thought can be filtered. They elude the ordinary elements of language, like the perfume of flowers or the bouquet pf delicate vintages. Our blunt Anglo-Saxon mars that language of pictures, where one flexible, curved, calligraphic stroke conveys to the aesthetically receptive oriental imagination what stanzas of rhyming rhapsody fail to define. Approaching the French, Sir Edwin Arnold and Lafcadio Hearn, are, so to speak, orientalised. Ordinary English fails to give a Japanese equivalent. It is too emphatic, too objective; it suggests the dominant British hobnail upon the delicate Tea-house *tatami* – that immaculate, beautiful matting, into whose uniform lines embroidered draperies dissolve deliciously. Oh, the dreams of dresses! The warp and woof of the visions of the masters of Ukiyo-e, of Harunobu and Kiyonaga, Toyokuni and Kunisada, and all the rest, the idols of Parisian colourists!

"For us," says de Goncourt, "Utamaro painted violet dresses, where, upon the border, *degradation rosée"* (fading into *Beni*, that mystic tint, the spirit of ashes of rose), "birds are swooping – violet dresses, across which woven in light, zigzag insect characters, composing the Japanese alphabet – violet dresses, where Korean lions, grim and ferocious, crouch, gleaming in shading of old bronze within the purple folds!

Dresses of mauve, smoky, shading into bistre, where the purple iris unsheathes its head from the slender grey-green stalk!" Mourasiki-ya (maison mauve) was the name of the atelier of Utamaro. "Robes of that milky blue the Chinese call 'blue of the sky after the rain,' beneath clusters of pale rose peonies; dresses of silvery grey, fretted with sprays of flowering shrubs, making a misty moonshine; pea-green dresses, enamelled with rosy cherry blooms; green dresses, fading into watery tints, hidden by groups of the pawlonia, the coat of arms of the reigning family; purple costumes, channelled with water courses, where mandarin ducks pursue each other around the hem. Oh, the beautiful black backgrounds, controlling the scintillating mass of colour! Black robes sown with chrysanthemums, or showered with pine-needles, worked in white. Black dresses, where finely woven baskets are mingled with sceptres of office! *'Oh! les belles robes!'* he cries, where flights of cranes dissolve into

Kitagawa Utamaro,
The Hour of the Rooster, from the *Series of the Twelve Hours in the Green Houses,* c. 1794. Colour woodblock print, 38.3 x 25.5 cm. Honolulu Academy of Arts, gift of C. M. Cooke, Honolulu.

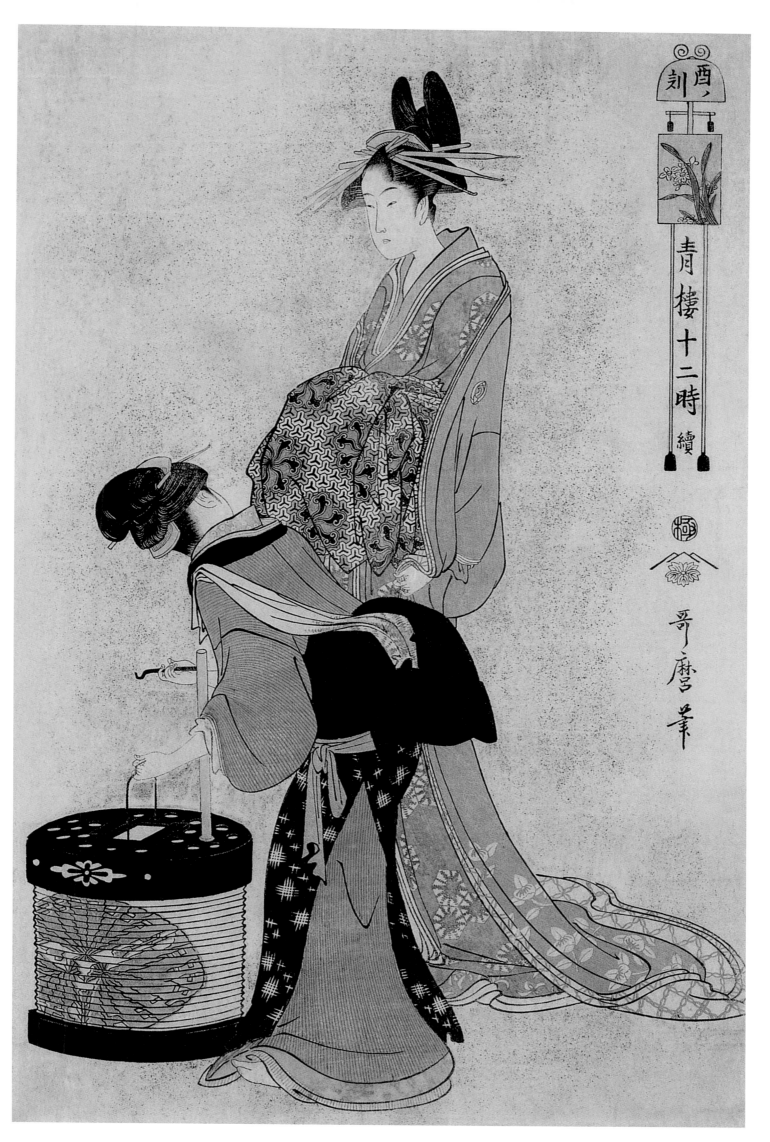

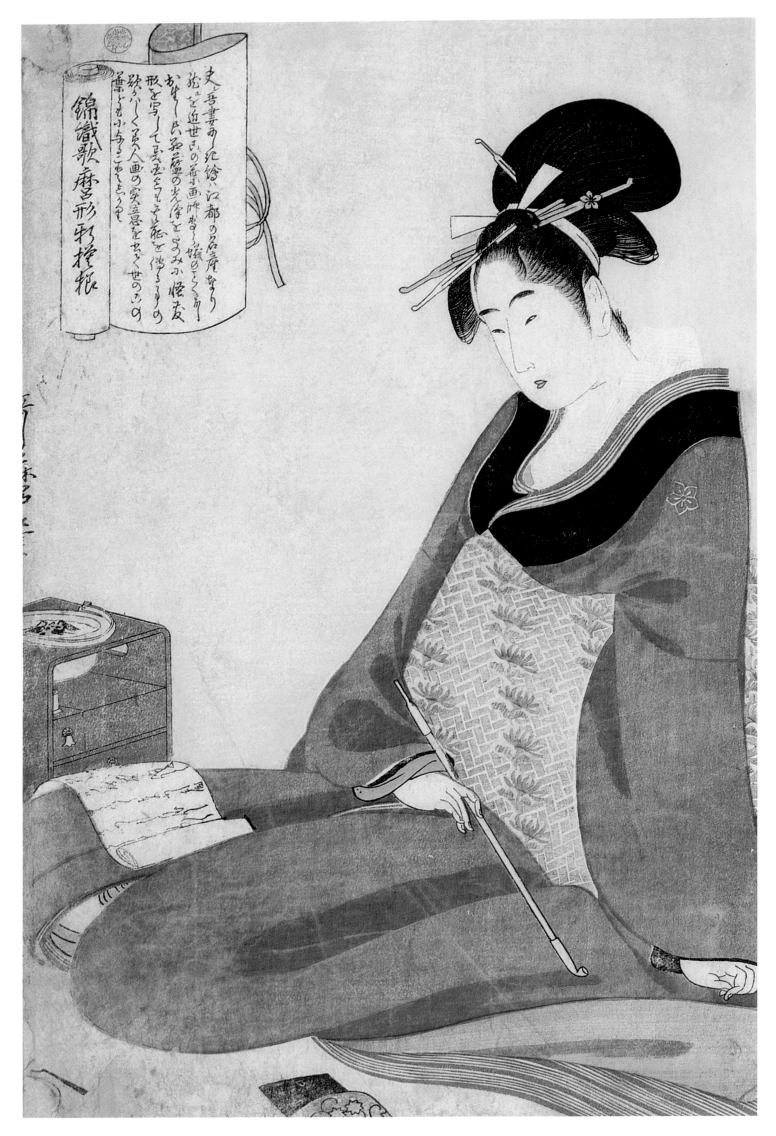

the distance, where birds are fluttering, where lacy fretwork of fans and little garlands are interwoven! – a motif delighted in by Utamaro as a framework for beloved faces." All that is beautiful in nature and art lived and breathed in these dresses, upon which the loving hand of the painter left a grace in every fold. The early inspirer of Utamaro's genius was Kiyonaga, who had restored the glory of the school of Torii – the printer's branch of Ukiyo-e, which had sunk into temporary oblivion under the waning powers of Kiyomitsu. The atelier of Kiyonaga became the sanctuary of the artists of Ukiyo-e, who, upon entering, forsook their individual traditions. There worshipped Utagawa Toyokuni; Yeishi, the scion of classic and aristocratic Kanō; and at the master's feet sat the Young Utamaro, absorbing his methods until, in his early compositions, said de Goncourt, the technique and mannerisms of Kiyonaga "*saute aux yeux.*"

The influence of Kiyonaga

pervades his most beautiful work; but later, under a life of constant self-indulgence, amongst associations all tending to demoralisation, his genius suffered an eclipse. His loss of self-control affected his art, until the sweeping lines and noble contours which his brush had acquired in the atelier of Kiyonaga were lost or widely travestied into a "delirium of female tallness." In these wild flights his brother artists followed in headlong pursuit, and the contagion of the movement swept the studios of Paris. In the modern poster we see the degenerate offspring of the genius of Utamaro, and of Toyokuni. Professor Fenollosa said, "The generation of Aubrey Beardsley prefer these tricks to the sober grace of Harunobu, Kiyonaga and Koriusai." It is art born of excess, a "Zolaism in prints."

The horrors of diseased imagination, the visions begotten of absinthe, which blot the brilliant pages of Guy de Maupassant and the verse of Paul Verlaine, were reflected by Utamaro in his studies

of the loathsome and the abnormal, where Montaigne declares, "*L'esprit faisant le cheval eschappé, enfantes des chimères.*" The blasphemous impieties of this cult, deplored by all true Frenchmen, in the country of Victor Hugo and Molière, were distanced by Utamaro, who suborned his art, his cynical brush caricaturing under the distorted figures of noted courtesans the saints and sages of the sacred Buddhist legends. Trading upon his vast popularity, he issued a pictorial satire upon one of the famous Shoguns, but this act of *lèse-majesté* brought him into disfavour with the reigning Shogun, the Louis XV of Japan, an artistic voluptuary, like his prototype, the subject of Utamaro's cartoon, and the artist was condemned and cast into prison. From his cell the gay butterfly of the Yoshiwara emerged, spent and enfeebled, daring no more flights of fancy, and dying in 1806, before he reached his fiftieth year, from the effects of his confinement and the misuse of pleasure.

Kitagawa Utamaro,
Woman Reading a Letter, from the series *New Patterns of Brocade Woven in Utamaro Style,* 1797.
Colour woodblock print, 35.6 x 23.5 cm.
The British Museum, London.

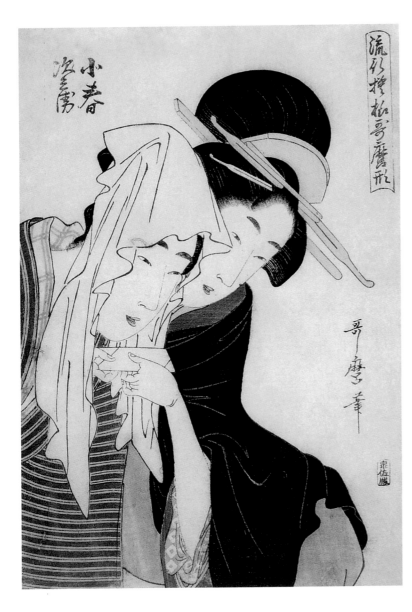

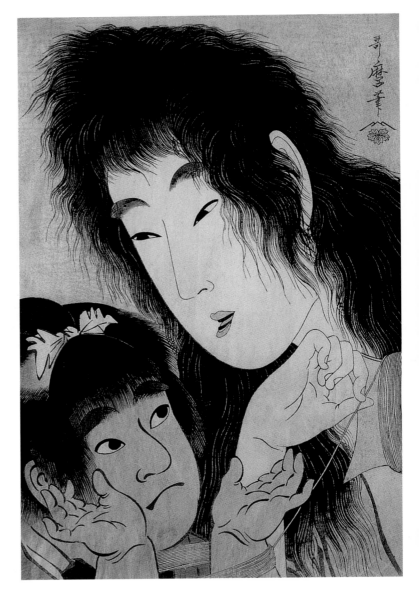

Oh, the pity of it! The profound pathos in the picture, in Sekien's preface of the little "Outa" holding his treasured prize, "*le petit bestiole*," – the childish artist-hands of the embryo master clasping the insect so gently to preserve its ephemeral life, yet later plunging into the dissipation and excesses which shortened his own. Living with the *declasse*, however we may gloss their imperfections and cover

with the cloak of charity their sorrowful calling, he became himself a cynic, an outcast, an iconoclast, learning that: "hardening of the heart which brings / Irreverence for the dreamt of youth."

Though Utamaro was one of the greatest of the popular artists, and his demoralisation led to the decadence of his school, which was later regenerated by the great master of Ukiyo-e, Hokusai, the

artist of the people. In Hokusai, "Dreaming the things of Heaven and of Buddha," breathed the pure spirit of art – that Spirit of poetry and purity which calls to us in Milton's immortal lines:

"Mortals, that would follow me.
Lore Virtue; she alone is free.
She can teach ye how to climb
Higher than the sphery chime;
Or if Virtue feeble were,
Heaven itself would stoop to her."

Kitagawa Utamaro,
The Cheerful Type, from the series *The Ten Types in Physiognomic Study of Women,* 1791.
Colour woodblock print, 35.6 x 24.8 cm.
The British Museum, London.

Kitagawa Utamaro,
Young Woman Blowing a Popen, from the series *The Ten Types in Physiognomic Study of Women,* 1792-1793.
Colour woodblock print, 35.6 x 24.8 cm.
The British Museum, London.

Kitagawa Utamaro,
Okita of Naniwaya, 1793.
Colour woodblock print, 38.2 x 25.1 cm.
Honolulu Academy of Arts, Honolulu.

Kitagawa Utamaro,
Tomimoto Toyohina, c. 1793.
Colour woodblock print, 38.1 x 25.1 cm.
Baur Collection, Geneva.

Kitagawa Utamaro,
Koharu and Jihei, from the series *Patterns in the Style of Utamaro,* c. 1798-1799.

Kitagawa Utamaro,
Yamauba and Kintarō, c. 1796-1804.

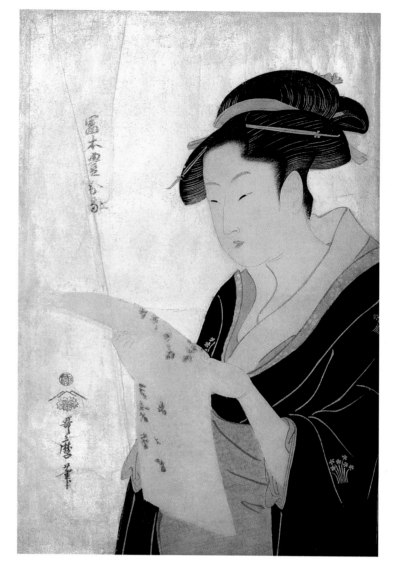

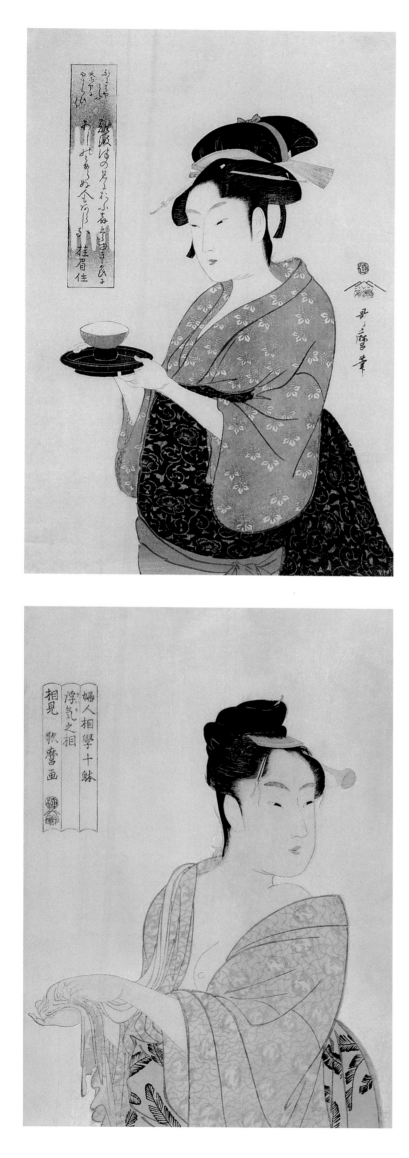

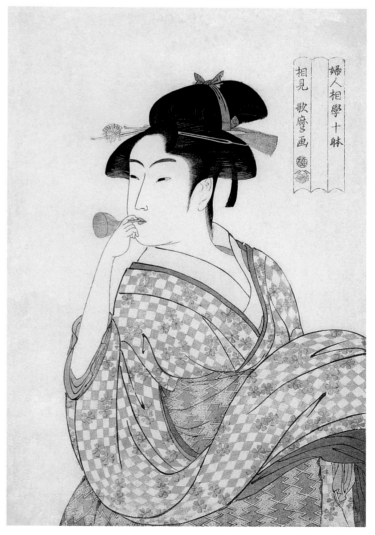

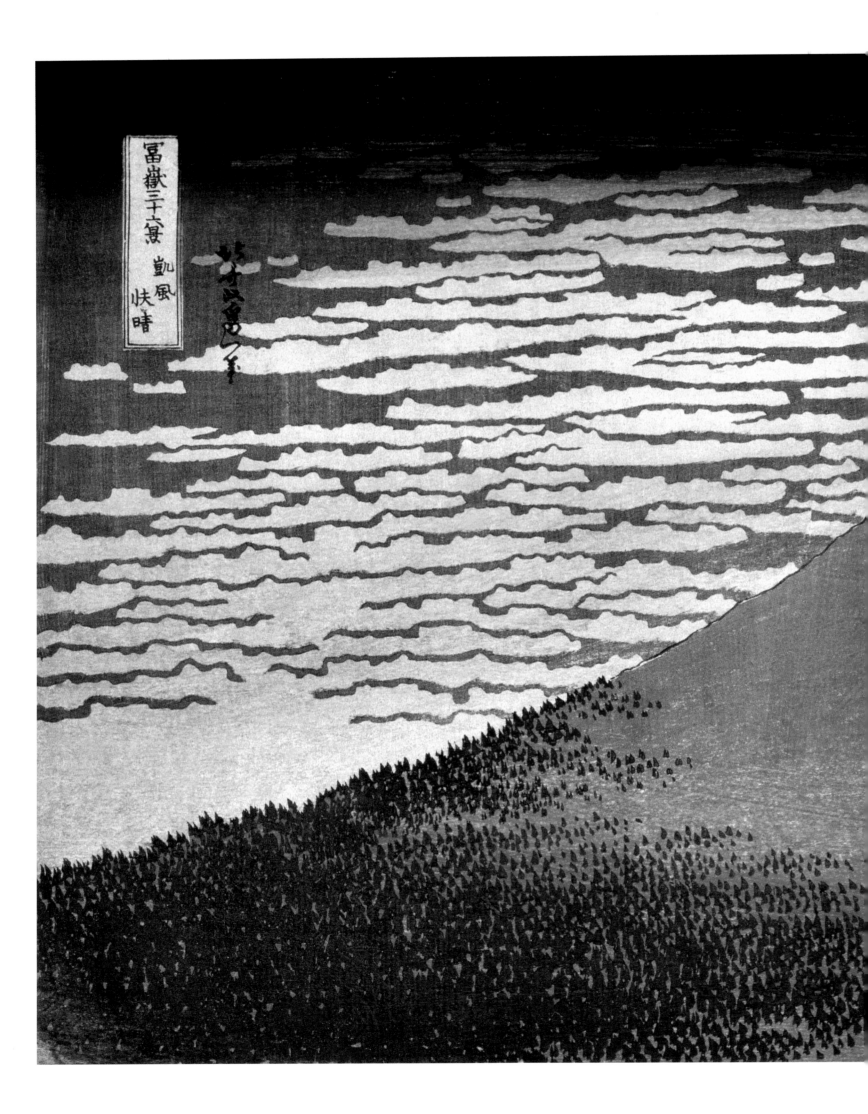

HOKUSAI

Katsushika Hokusai (1760-1849)

"From the age of six, I had a mania for drawing the forms of things. By the time I was fifty, I had published an infinity of designs, but all I have produced before the age of seventy is not worth taking into account. At seventy-five I have learned a little about the real structure of nature – of animals, plants and trees, birds, fishes and insects. In consequence, when I am eighty, I shall have made still more progress. At ninety I shall penetrate the mystery of things; at a hundred I shall certainly have reached a marvellous stage, and when I am a hundred and ten, everything I do – be it but a line or dot – will be alive. I beg those who live as long as I, to see if I do not keep my word. Written at the age of seventy-five by me – once Hokusai – today Gwakio-rojin, 'the old man, mad about drawing.'"

"Ars longa, vita brevis," though a time-worn aphorism, seems the best comment upon these words of Hokusai, which preface the *Fugaku hyakkei* (Hundred Views of Mount Fuji). Judging from what he had accomplished before his death in 1849 at the age of eighty-nine, and the continual increase in his powers, it is easy to believe that had his life been extended to the limit he craved, the prophecy would have been fulfilled. Louis Gonse said of Hokusai, "He is the last and most brilliant figure of a progress of more than ten centuries – the exuberant and exquisite product of a time of profound peace and incomparable refinement."

From the standpoint of Buddhism, Hokusai was the crowning glory, the supreme efflorescence of countless previous incarnations. In his career he epitomised the theory of evolution, the embryonic stages being exemplified by his progress through the schools. Trained in the atelier of Shunshō, the most skilful exponent of Ukiyo-e art, he rapidly absorbed the methods of his master; but even the Popular School was trammelled by convention, and Hokusai's genius, rejecting academic letters, winged its flight through all the realms of oriental art. He drank at the fountain-head of China, then absorbed the traditions of the "two great streams of Kanō and Tosa, which flowed without mixing to the middle of the eighteenth century." Kanō, springing from Chinese models, was transformed by the genius of Masanobu and his followers, and became the most illustrious school of painting in Japan. It was the official school of the Shoguns, in opposition to "Tosa" – that elegant and exquisite appanage of the Emperors, which represented aristocratic taste.

The Tosa School is characterised by extreme delicacy of execution and fine use of the brush, as in Persian miniature

Katsushika Hokusai,
South Wind, Clear Sky, from the series *Thirty-Six Views of Mount Fuji,* 1831.
Colour woodblock print, 26.1 x 38.2 cm.
The British Museum, London.

Katsushika Hokusai,
Sumō Wrestlers Ki no Natora and Ōtomo no Yoshio,
c. 1829. Colour woodblock print with gold and silver,
21.3 x 18.8 cm.
Pulverer Collection, Cologne.

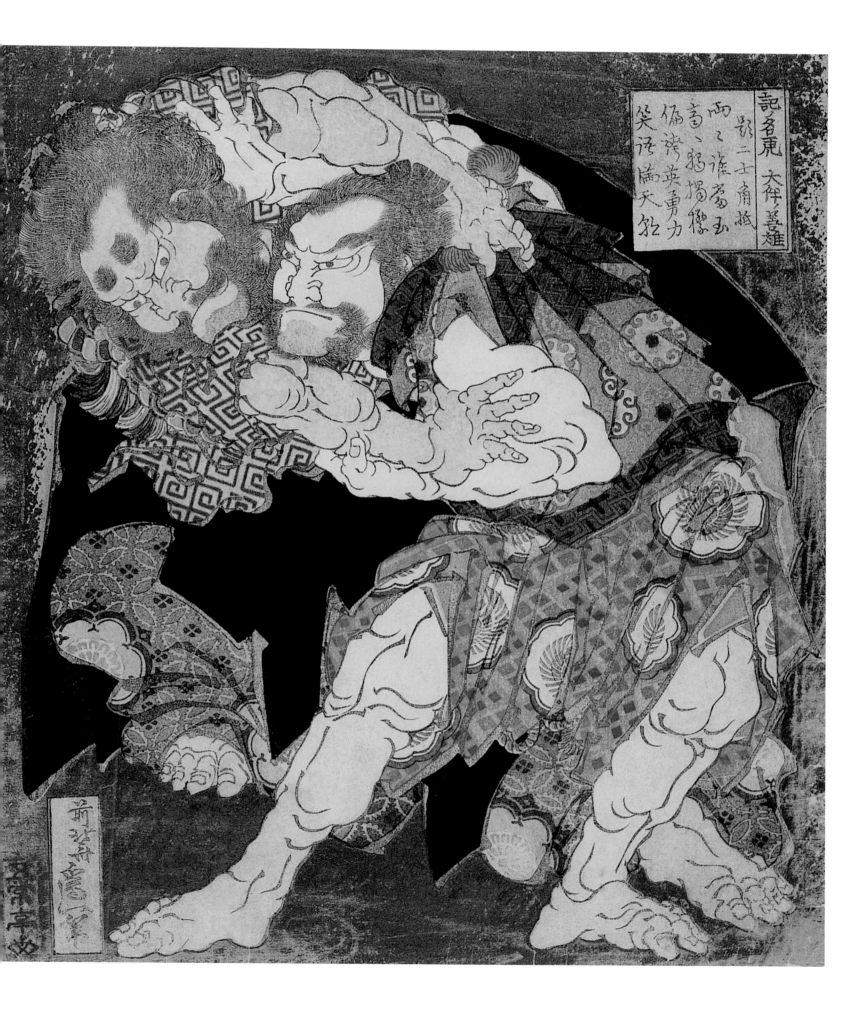

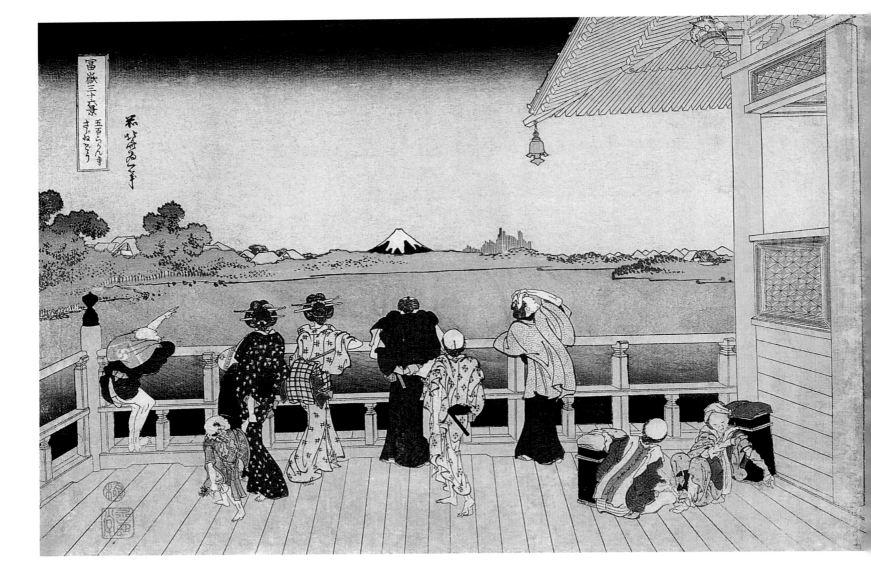

Katsushika Hokusai,
Turban-Shell Hall of the Five-Hundred-Rakan Temple,
from the series *Thirty-Six Views of Mount Fuji.*
The Hokusai Museum, Obuse.

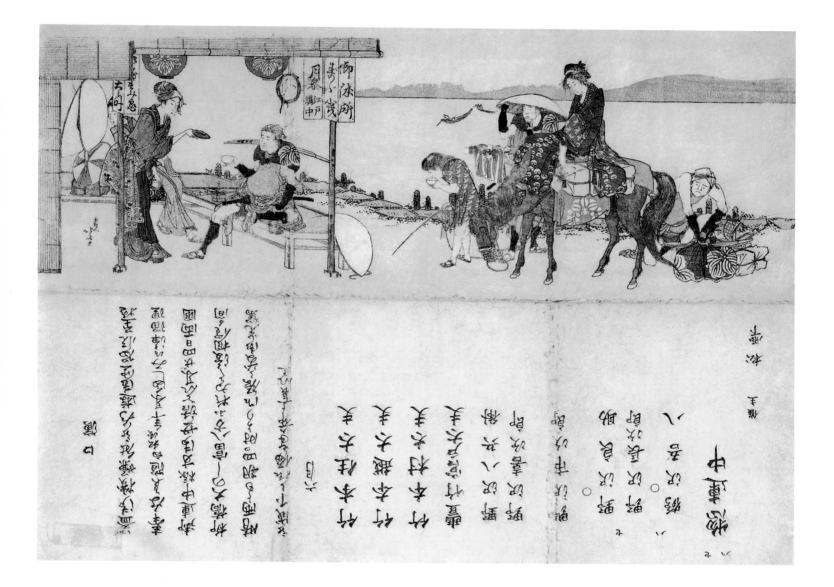

Katsushika Hokusai,
Tea House for Travellers, c. 1804.
Colour woodblock print, 39 x 52 cm.
Museo d'Arte Orientale Edoardo Chiossone, Genoa.

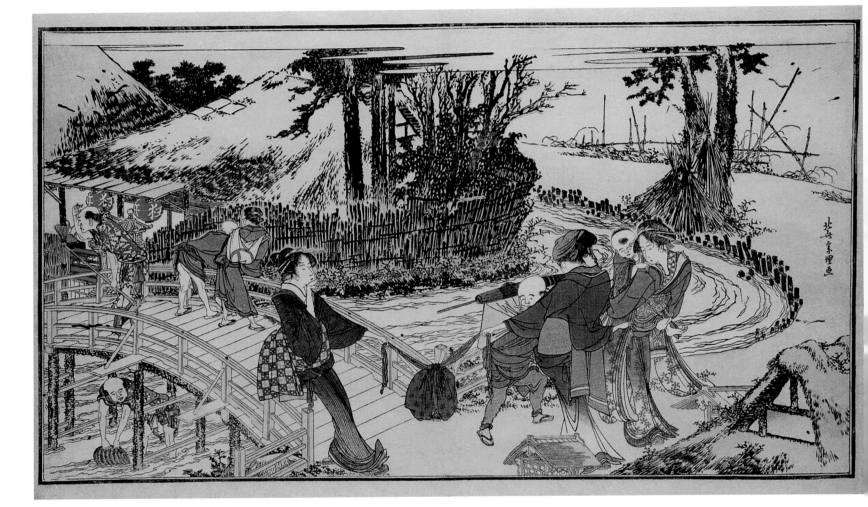

Katsushika Hokusai,
Village near a Bridge, c. 1797.
Colour woodblock print, 25.4 x 18.8 cm.
Chiba Art Museum, Chiba.

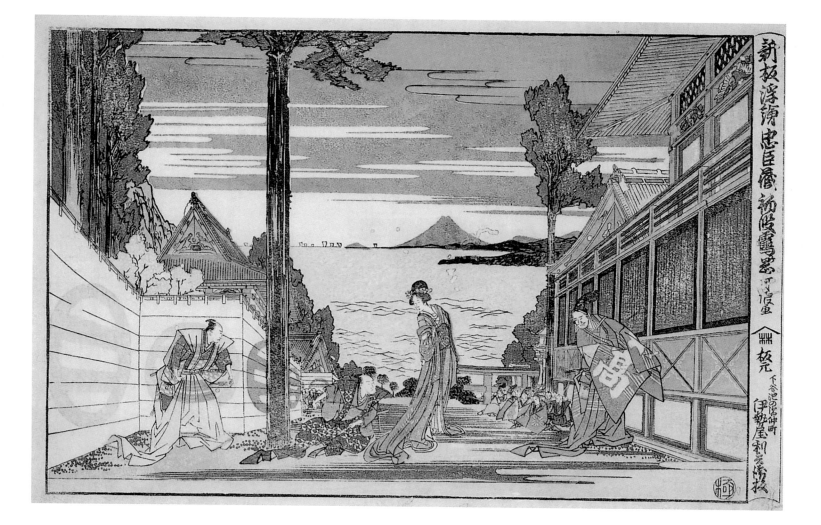

Katsushika Hokusai,
Act I, from the picture book *Chū shingura*, c. 1798.
Colour woodblock print, 22 x 32.7 cm.
The British Museum, London.

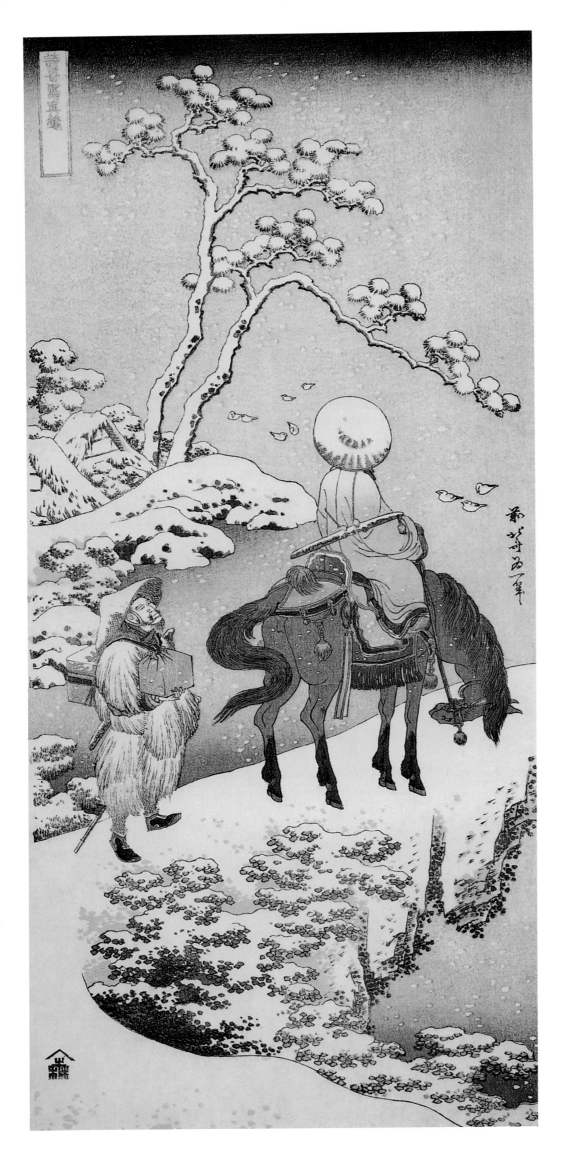

painting. The splendour of the screens of Tosa has never been surpassed, with their precious harmonies in colour and delicate designs (so often imitated in lacquer), against glorious backgrounds in rich gold-leaf.

He studied the technique of Okyo, founder of the school of realism, which, maturing at Kyoto, led up to "Ukiyo-e," the popular art of the masses of Edo. Ukiyo-e, literally "The Floating World," despised by the ascetic disciples of Buddha and Confucius for picturing the joyous world of fashion and folly, was the name of the school which liberated Japanese art from the shackles of centuries of tradition.

Ukiyo-e is the supreme expression, the concentrated essence of the schools, a river of art whose fount was India, Persia and China. For centuries it was forced into narrow channels by the haughty and exclusive aristocracy; but ever widening, its branches at

Katsushika Hokusai,
The Chinese Poet Su Dongpo, from the series *Mirror of Chinese and Japanese Poetry*, 1833-1834.
Colour woodblock print, 49.7 x 22.5 cm.
Boston Museum of Fine Arts, Boston.

last united and swept into their joyous current the common people of Japan, who, intuitively art lovers, had ever thirsted for the living stream. Now they beheld themselves reflected, in all the naturalness of daily life, yet with a spiritual rendering, "appealing," said Jarves, "to those intuitions with which the soul is freighted when it first comes to earth, whose force is ever manifested by a longing for an ideal not of the earth, and whose presence can only be explained as an augury of a superior life to be, or else the dim reminiscence of one gone; and the recognition of this ideal is the touchstone of art – art which then becomes the solution of immortality."

The originators of Ukiyo-e, which included in its scope painting proper, book illustration and single-sheet pictorial prints, were Iwasa Matabei and Moronobu, followed in long succession by Shunsui, the

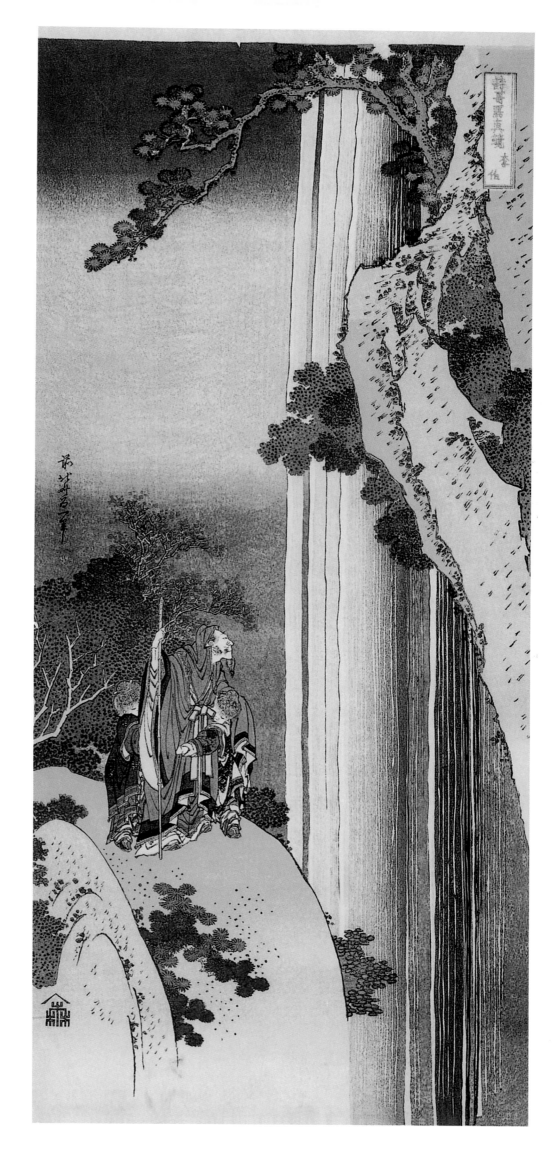

Katsushika Hokusai,
The Chinese Poet Li Bai, from the series *Mirror of Chinese and Japanese Poetry,* 1833-1834. Colour woodblock print, 52.1 x 23.2 cm. Honolulu Academy of Arts, Honolulu.

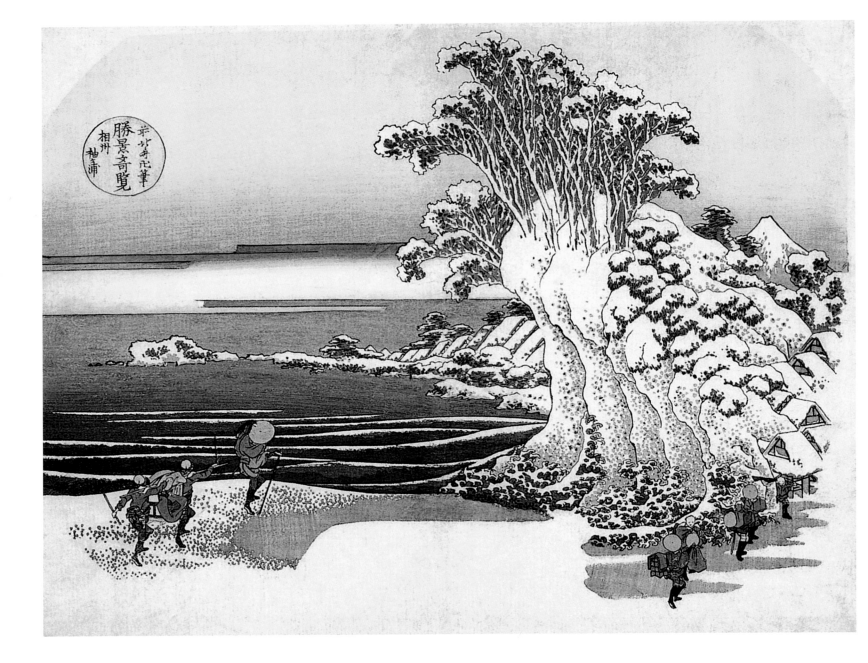

precursor of Hokusai's master, Shunshō; and united with it were the engravers of the Torii school, culminating in Kiyonaga (with whose grace and beauty of line Hokusai could never compete), the refined offshoot of the Kitao, and the elegant scion of Kanō Yeishi.

Hokusai's individuality and independence long galled his master, and a final rupture was caused by the pupil's enthusiasm for the bold and sweeping, black-and-white, calligraphic strokes of Kanō. Then began a hard struggle for the youthful artist, who had no money and no influence. His father was a maker of metal mirrors, Hokusai's real name being Nakajima Tetsujiro, but his pseudonyms were legion. In the atelier of Shunshō, he was called Shunro – taking with the other disciples of this school of Katsukawa, the first syllable of his master's name.

Cast adrift upon the streets of Edo, he sold red pepper, and hawked almanacs, at the same time constantly studying, and seizing the best ideas from all the schools. Blended with an intuitive instinct for art, the Japanese nature is essentially histrionic, and throughout the whole career of Hokusai there is an element which is genuinely dramatic. C. J. Holmes, in his beautiful work on Hokusai, gives many romantic incidents in the artist's life, and was it not by a theatrical *tour de force* that he first won popular favour?

He chose no doubt a national holiday, perhaps the festival of "Cherry Viewing," when Ueno Park is thronged with sightseers of every station in life. Here in the heart of the great city of Tokyo is a hallowed spot – majestic, grand and peaceful, where in mystic solemnity the sacred cedars enshrine that wondrous necropolis of illustrious dead – for at Ueno lie buried six of the famous Shoguns.

In the courtyard of one of the temples, Hokusai erected a rough scaffolding, upon which was spread a sheet of paper, eighteen yards long and eleven in width. Here in the sacred heart of Japan, with tubs of water and tubs of ink, the master and predestined genius of his country manifested his power. He swept his huge brush this way and that, the crowd constantly increasing in density, many scaling the temple roof to see the marvellous feat – a colossal figure, springing into life at the touch of the creator. All who know his work can imagine the grand sweeping curves and graduated shadings that the magic broom evolved; and the artistic people gazed spellbound, while many a murmured "*Naruhodo!*" (Wonderful) and sibilant inhalation of the breath marked their recognition of the master's power.

Displaying less of the artist than the genius at legerdemain were Hokusai's street tricks – almost reprehensible did we not know the

Katsushika Hokusai,
Sodegaura, in the Shimosa Province, from the series
Rare Views of Famous Landscapes, c. 1834–1835.
Print on blue woodblock, 23.6 x 30.1 cm.
Chibashi Collection, Bijutsukan.

Katsushika Hokusai,
The Amida Waterfall in the Province of Kiso, from the
series *A Tour Through the Waterfalls of Japan,*
1834–1835.
Colour woodblock print, 38.7 x 25.9 cm.
Honolulu Academy of Arts, Honolulu.

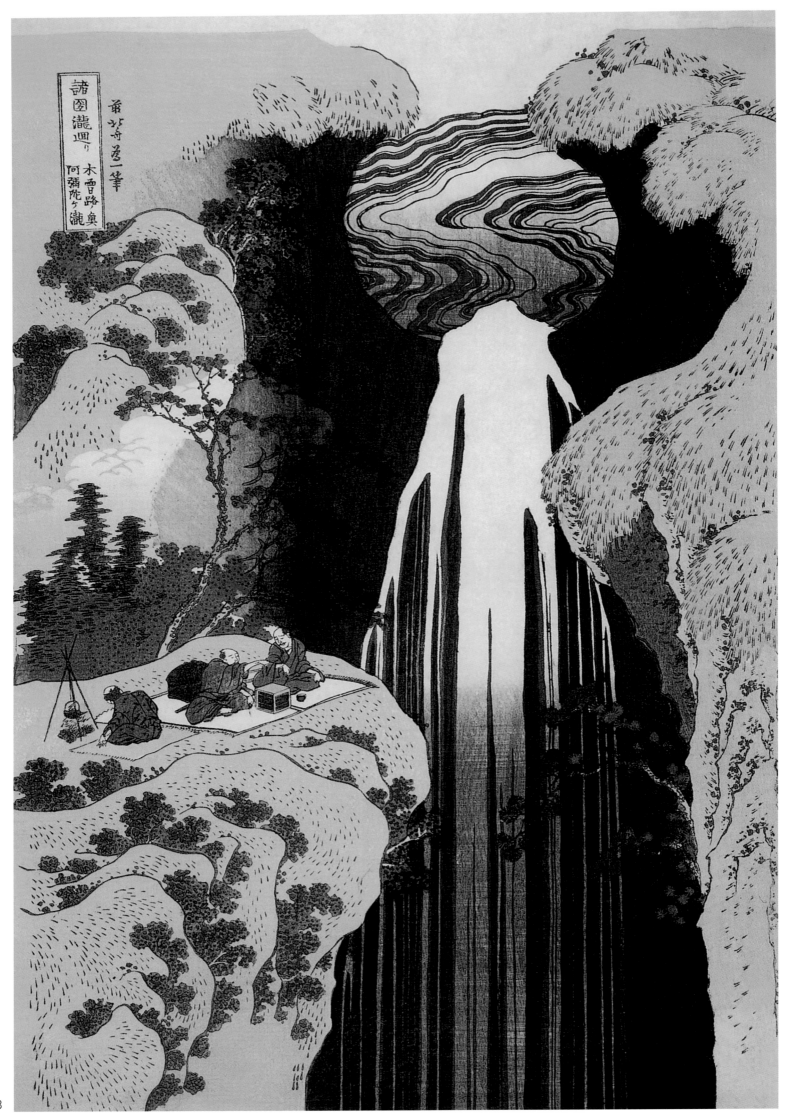

238

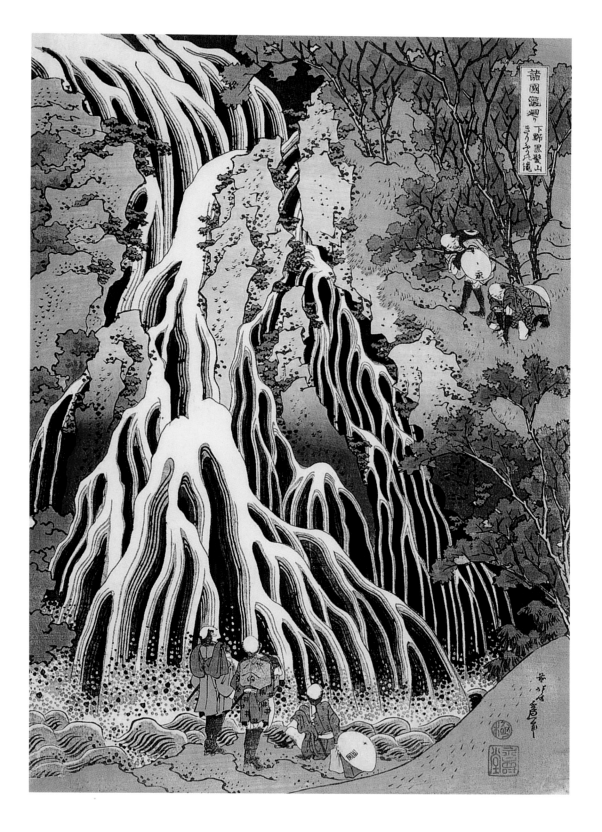

Katsushika Hokusai,
The Kirifuri Waterfall on Mount Kurokami, in
Shimotsuke, from the series *A Tour Through the*
Waterfalls of Japan, 1834–1835.
Colour woodblock print, 38.9 x 26.3 cm.
Honolulu Academy of Arts, Honolulu.

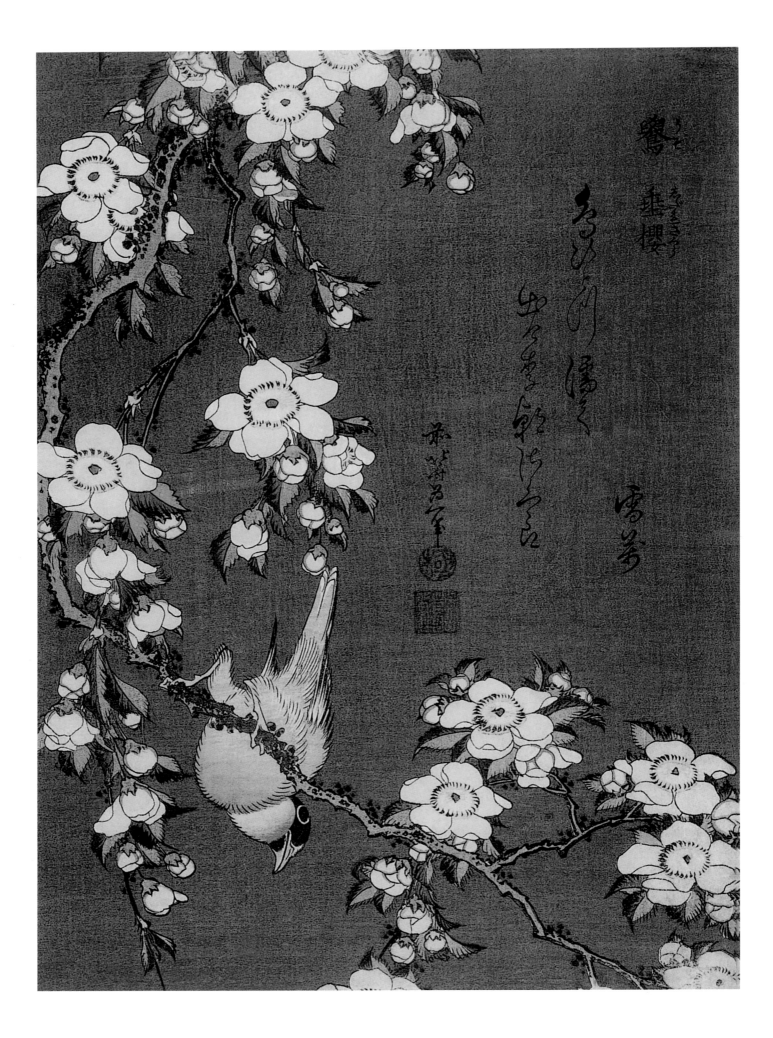

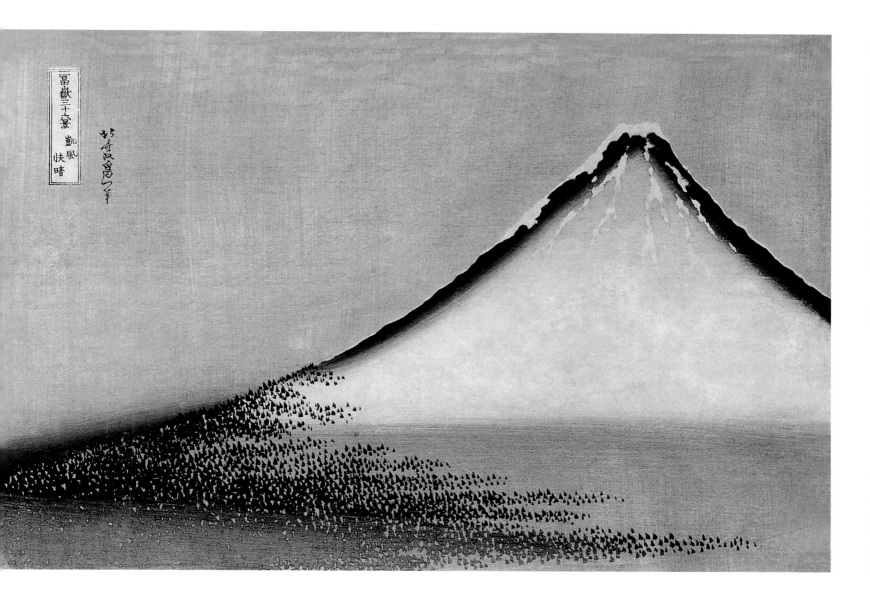

Katsushika Hokusai,
Goldfinch and Cherry Tree, 1834.
Colour woodblock print, 25.1 x 18.2 cm.
Honolulu Academy of Arts, Honolulu.

Katsushika Hokusai,
Clear Sky at Mount Fuji, from the series *Thirty-Six
Views of Mount Fuji,* c. 1830-1832.
Colour woodblock print, 25.5 x 37.1 cm.
Private collection.

dire straits to which genius is often reduced. An eager expectant crowd dogged his footsteps and watched with delighted curiosity, while he sketched landscapes, upside down, with an egg or a bottle, or a wine measure, anything that came to his hand – changing with bewildering effect from huge figures of Chinese heroes and demigods to microscopic drawings on grains of rice, and pictures made out of chance blots of ink.

His fame was proclaimed abroad, and at last reached the ears of the Shogun, and now an unprecedented honour was conferred upon the humble apostle of the artisan, for he was summoned before the august presence to give an exhibition of his skill. The Japanese are ever imitative, and Hokusai may have borne in mind the legend of his prototype Sesshiu, an artist-priest of the fifteenth century, who sketched before the Emperor of China a marvellous dragon, with splashes from a broom plunged in ink.

Still more spectacular and theatrical was Hokusai's debut, for, spreading a sheet of paper before the feet of the monarch, he covered it with a blue wash – then seizing a live cock, he daubed its feet with a red pigment, and let it run over the wet colour, when the Shogun and his astonished courtiers beheld a flowing stream of liquid blue, upon which appeared to float filmy segregated petals of red maple leaves. A mere trick! – unworthy of genius, we might say, but Hokusai had gauged his countrymen, and knew that his *jeu d'esprit* would arouse and impress these aristocratic connoisseurs, jaded with ceremonial observances, more than any display of technical knowledge – for the Japanese, as a nation, are naïvely childish in their love of novelty and amusement, and of the unusual and bizarre.

Is it not possible that this trickery of the master may have unconsciously supplied the motive for Hiroshige's famous print of an Edo suburb, chosen by Professor Fenollosa, in his beautiful work on Ukiyo-e – where he so poetically says, "The orange fire of maples deepens the blue of marshy pools"?

Space does not permit any detailed description of the compositions of Hokusai, and there is no complete catalogue of his works, the one nearest to accuracy being Edmond de Goncourt's *Catalogue raisonné*. His fecundity was marvellous. He illustrated books of all kinds, poetry, comic albums, accounts of travels – in fact his works are an encyclopaedia of Japanese life. His paintings are scattered, and countless numbers lost, many being merely ephemeral drawings, thrown off for the passing pleasure of the populace. The original designs for the prints were

Katsushika Hokusai,
Turtles Swimming, 1832-1833.
Colour woodblock print, 49.9 x 22.7 cm.
Honolulu Academy of Arts, Honolulu.

Katsushika Hokusai,
Famous Sight in China, 1840.
Colour woodblock print, 40.9 x 54.2 cm.
Kobe City Museum, Kobe.

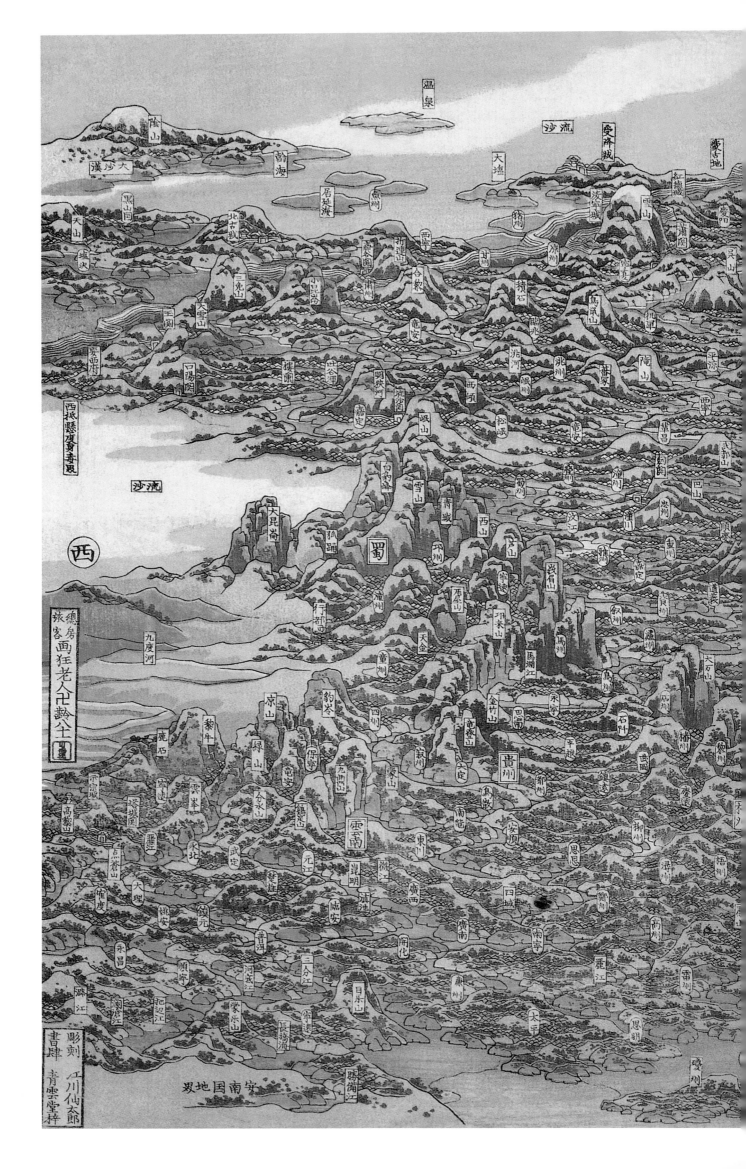

244

245

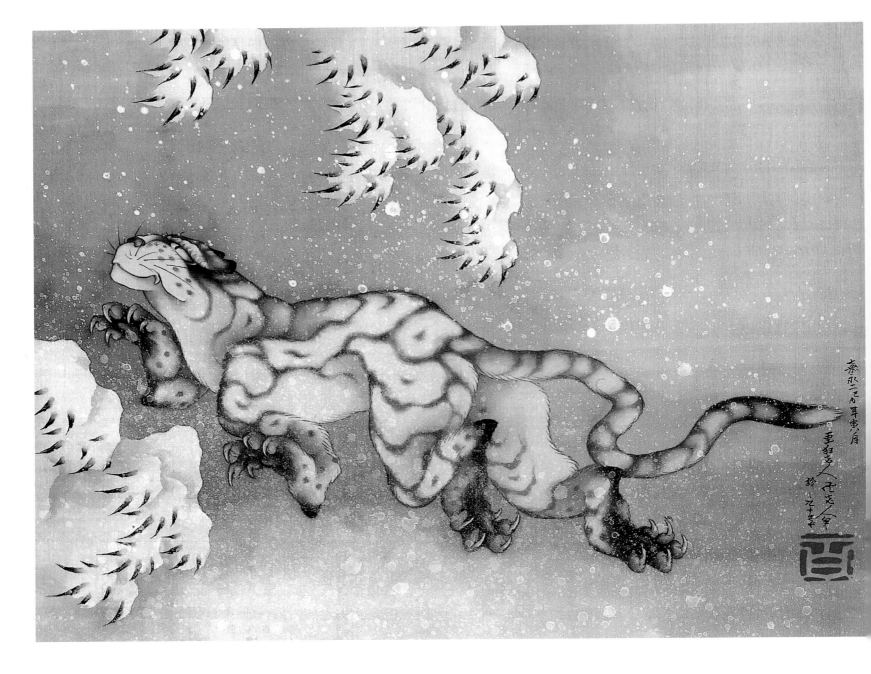

Katsushika Hokusai,
Old Tiger in the Snow, 1849.
Colours, ink and gofun on silk, 39 x 50 cm.
Private collection.

transferred to the blocks, and lost, though the master rigidly superintended the reproduction of his works, and his wood-cutters were trained to follow the graceful sweeping curves with perfect accuracy, many of his compositions being ruled across for exact reduction.

Ukiyo-e art is bound up with print development, and the climax of xylography had been reached in the time of Hokusai. Japanese book illustration, and single-sheet printing, revolutionised the world's art. The great connoisseurs of colour tell us that nowhere else is there anything like it – so rich and so full, that a print comes to have every quality of a complete painting.

Hokusai had served a four year apprenticeship to the school of engraving, and his practised eye was ever ready to detect any in-accuracy in his workmen. "I warn the engraver," he said, "not to add an eyeball underneath when I do

not draw one. As to the nose, these two are mine," – here he draws a nose in front and in profile – "I will not have the nose of Utagawa." The greatest difference exists in the beauty and colouring of the impressions, and the amateur, in his search for Ukiyo-e gems, should not trust his unaided judgment.

Louis Gonse said of the *surimono*, "To me they are the most seductive morsels of Japanese art." They are small, oblong prints, composed as programmes for festive occasions with a text of verse enriched by exquisite illustration. The *surimono* of Hokusai showed the influence of Tosa, the decoration being very elaborate, and delicate as a Persian miniature. In places, the surface of the print is goffered for ornament in relief, and the colouring is enforced by inlaying in gold, silver, bronze and tin.

Some of the best examples of Hokusai's art are the "Waterfalls,"

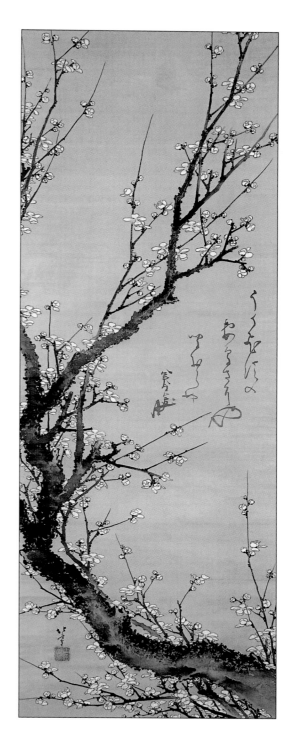

Katsushika Hokusai,
Plum Tree in Flower, 1800.
Ink and colours on silk, 204.5 x 51.7 cm.
Nelson-Atkins Museum, Kansas City.

Katsushika Hokusai,
Gathering Shellfish at Ebb Tide, c. 1832-1834.
Hanging scroll, colour on silk, 54.3 x 86.2 cm.
Osaka Municipal Museum of Art, Osaka.

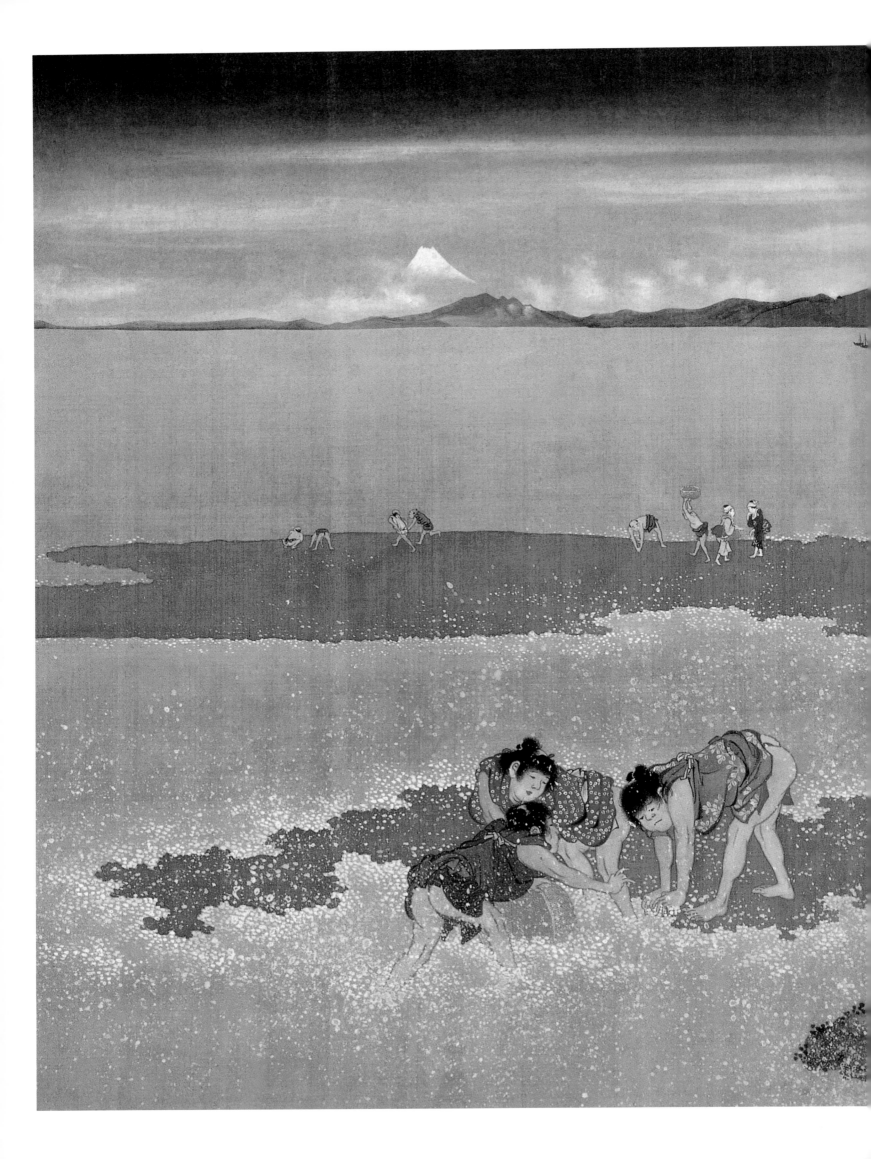

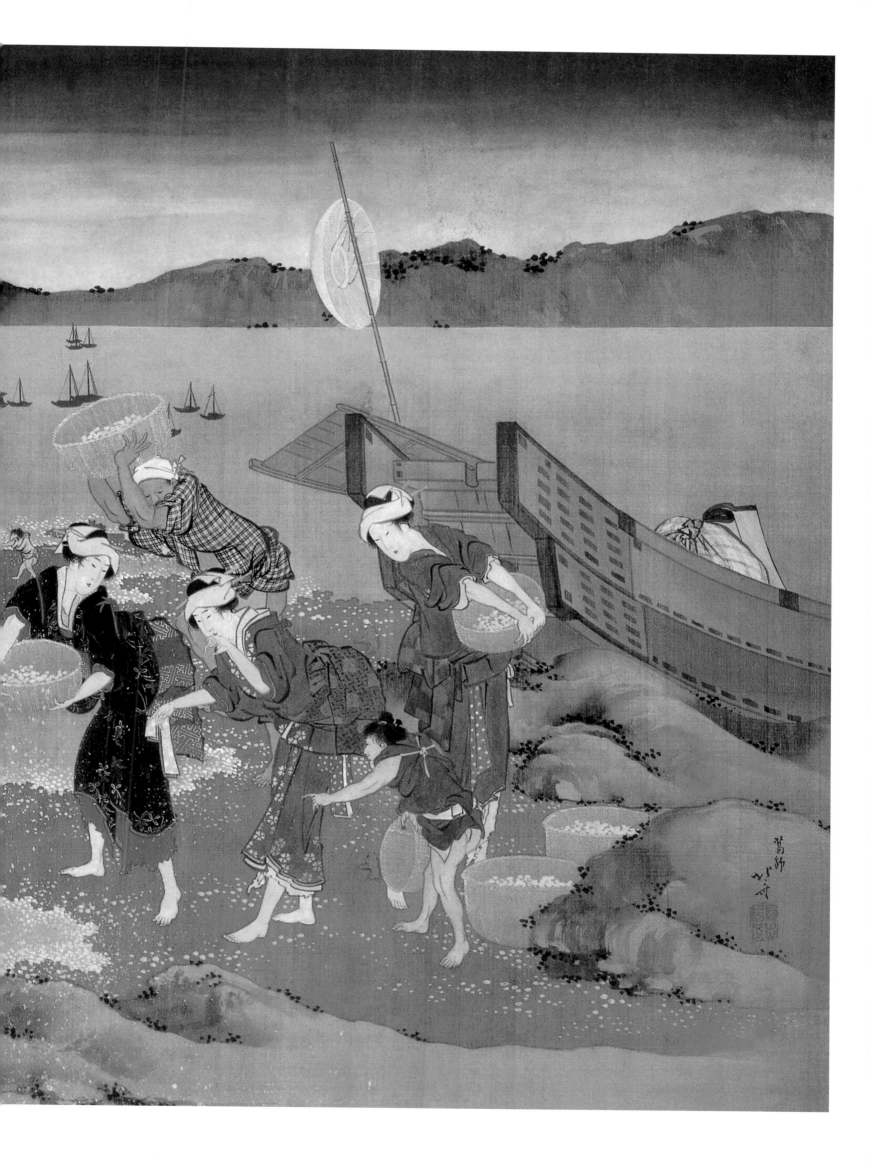

the "Bridges," "Thirty-Six Views of Fuji," "the Gwafu," the "Hundred Views of Mount Fuji", and the fifteen volumes of the "Mang-wa," – a term hardly translatable, but signifying fugitive sketches, or drawing as it comes, spontaneously. The preface best gives us the intention of the master.

"Under the roof of Boksenn, in Nagoya, he dreamed and drew some three hundred compositions. The things of Heaven and of Buddha, the life of men and women, even birds and beasts, plants and trees, he has included them all, and under his brush every phase and form of existence has arisen. The master has tried to give life to everything he has painted, and the joy and happiness so faithfully expressed in his work are a plain proof of his victory."

Hokusai has been called the king of the artisans, and it was for them especially that he composed the drawings of Mang-wa. His influence is expressed in all their works: in the structure of the roofs of temples, in houses and their interiors; upon the things of every-day life, as upon flowers and landscapes, upon lacquer, *inros* and *netsukis*, bronzes and ivory.

Gustave Geffroy truly gauged the genius of Hokusai in speaking of his "flights beyond the horizon." In the master we recognise the creator. He feels the mystery of the birth of mountains, as in that weird composition of Fuji, where the great cone is seen rising above circle upon circle of serpentine coils, forming the mystic *tomoyé* – symbol of creation and eternity. He feels the pulsation of the universe, and the life of ocean, and in a frenzy of creative power, beneath his hand the curved crests of foaming waves break into life, flashing into countless sea-birds born of the froth of ocean. He is the painter of chimera, the prophet of cataclysm; he "gives the world a shake and invents chaos." How vivid is Holmes' description of the wave in the seventh Mang-wa!

"Man becomes a mere insect, crouching in his frail catamaran, as the giant billow topples and shakes far above him. The convention of black lines with which he represents falling rain is as effectual as his conventions for water are fanciful. The storm of Rembrandt, of Rubens, or of Turner, is often terrible but never really wet; Constable gets the effect of wetness, but his storms are not terrible. Hokusai knows how a gale lashes water into foam, and bows the tree before it; how the gusts blow the people hither and thither, how sheets of drenching rain half veil a landscape, how the great white cone of his beloved Fuji gleams through a steady downpour! His lightning is rather odd in comparison with the realistic studies of the great artists of Europe, but what European ever tried an effect so stupendous as

Katsushika Hokusai,
Fuchu Station, from the series *Fifty-Three Stages of the Tōkaidō,* 1804.
Colour woodblock print, 12.6 x 17.6 cm.
The Hokusai Museum, Obuse.

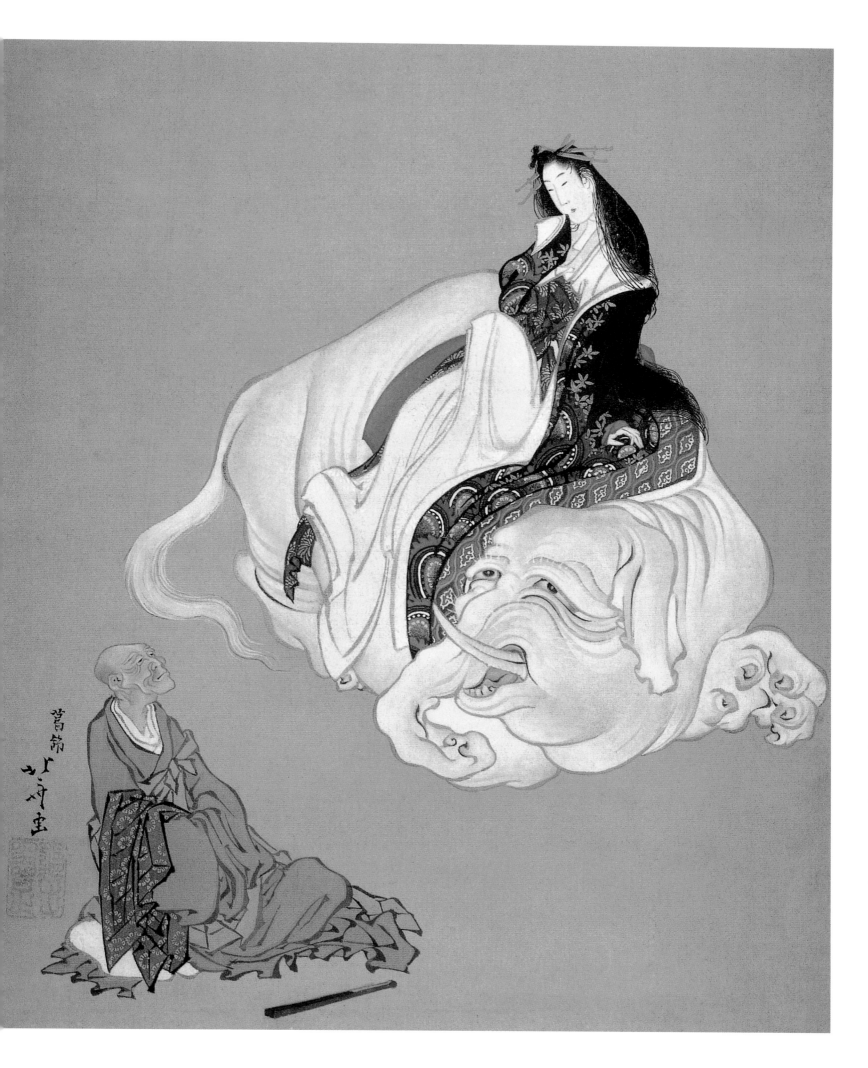

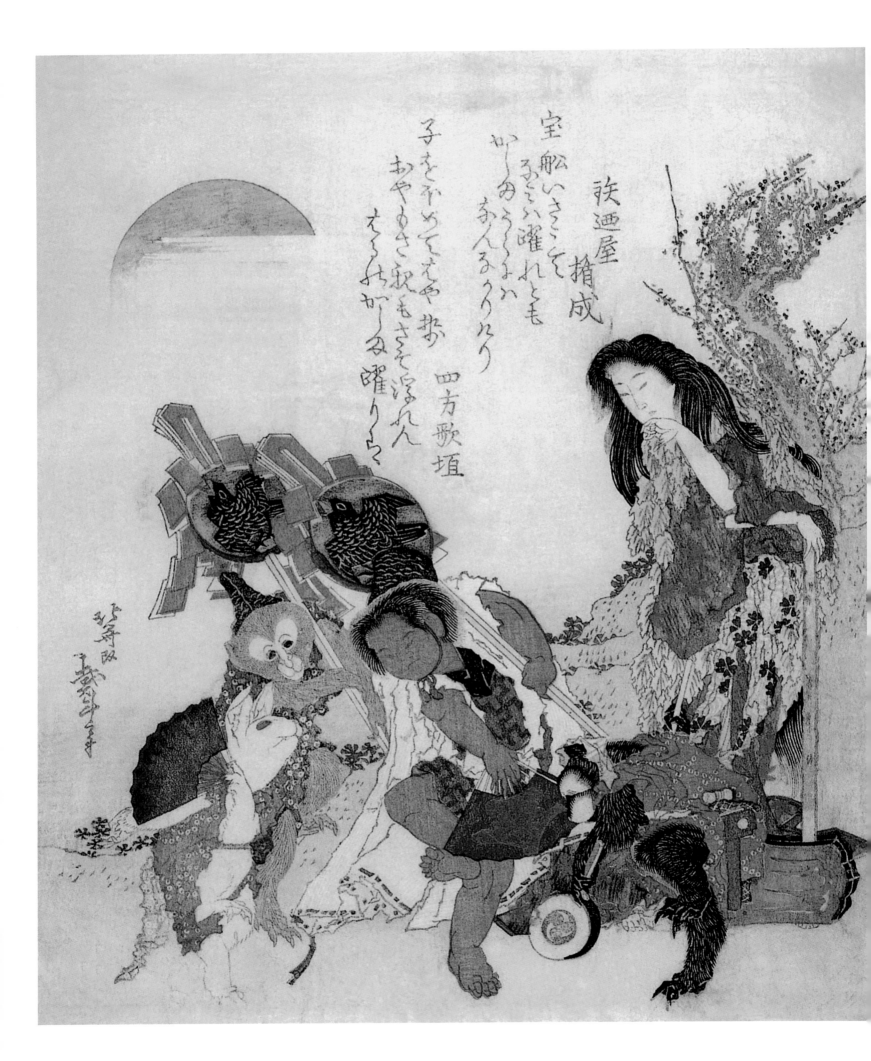

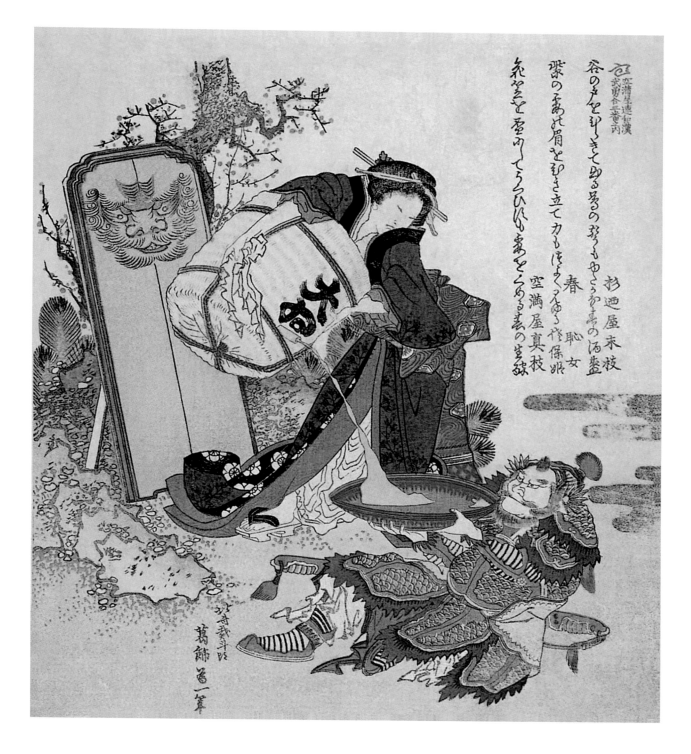

Katsushika Hokusai,
Yamauba, Kintoki and Various Animals, c. 1814.
Colour woodblock print, 21.1 x 18.4 cm.
The British Museum, London.

Katsushika Hokusai,
The Powerful Oi and the Chinese Warrior Fan Kuai,
c. 1820.
Colour woodblock print, 21.3 x 18.8 cm.
The British Museum, London.

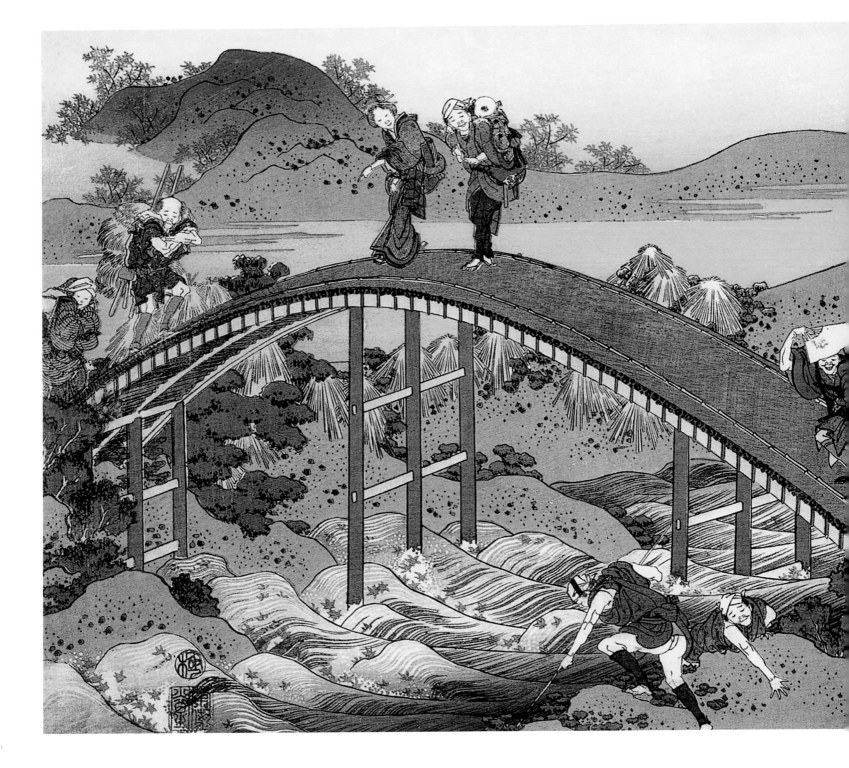

that recorded in *Fugaku hyakkei*, where the snowy top of Fuji is seen at evening, crimson with the last fiery rays of sunset, while all the flanks of the mountain are hidden by a dark storm-cloud, through which the lightning flashes!"

Poetry and art are ever allied, and the vibrations of genius encircle the globe. Byron, Ruskin and Hokusai were contemporaries. Possibly at the very moment when the poet was immortalising himself by composing his "Storm in the Alps," the grand "old man, mad about drawing," was sketching the peerless mountain:

"Far along

From peak to peak, the rattling crags among,

Leaps the live thunder! Not from one lone cloud,

But every mountain now hath found a tongue,

And Jura answers through her misty shroud,

Back to the joyous Alps, who call to her aloud!"

Lord Byron's vivid pen also best describes the squally storms of both Hiroshige and Hokusai, where: "The big rain comes dancing to the earth."

Was not Hokusai truly "a portion of the tempest"? As he represents himself, drawing Fuji, in winter, working in a frenzy of haste – for the ground is covered with snow – two brushes in his hand, and wonder of wonders! one held between his toes.

The closing scene in the drama of Hokusai's life is full of pathos. Though his whole career had been shadowed by poverty, and shrouded in obscurity, his art still held him earth-bound. Upon his death-bed he said, "If Heaven would only grant me ten more years!"

Then, as he realised that the end approached, he murmured, "If Heaven had but granted me five more years I could have been a real painter."

Katsushika Hokusai,
The Poet Ariwara no Narihira, from the series *One Hundred Poems,* 1835-1836.
Blue-coloured woodblock print, 24.9 x 37.1 cm.
Honolulu Academy of Arts, Honolulu.

Utagawa Hiroshige,
Night Snow at Kambara (Station 16), from the series *Fifty-Three Stages of the Tōkaidō,* Edo period, c. 1832.
Colour woodblock print, 38 x 25.5 cm. Honolulu Academy of Arts, gift of James A. Michener, Honolulu.

東海道
五拾三次
之内

HIROSHIGE

Utagawa Hiroshige (1797-1858)

If the lovely 'Land of the Rising Sun' should, during one of those volcanic throes which threaten her extinction, sink forever beneath the depths of ocean, she would yet live for us through the magic brush of Hiroshige. Gazing at his landscapes, the airy wing of imagination wafts us to a land of showers and sunsets – a fairy scene, where the rainbow falls to earth, shattered into a thousand prisms – where waters softly flow towards horizons touched with daffodil or azure tinted.

Here is a gliding *sampan* with closed shutters. Inside, the lantern's diffused light throws a silhouette upon the bamboo curtain, a drooping girlish head bending towards the unseen lover at her feet. Ripples play upon the water, stirred by the amorous breath of oriental night. In fancy we hear the tinkling of the samisen, touched by delicate fingers, sweetly perfumed.

Now we see rain upon the Tōkaidō. A scurrying storm. Affrighted coolies running this way and that. A mountain full of echoes and horror. Down splash rivulets, running into inky pools. Darkness and terror and loneliness, and longing for warmth and shelter and the peace of home.

In marked contrast is one of the "Seven Impressions of Hakone." A glad reveille. The sun breaks out, the clouds have burst asunder, masses of vapour float here and there. All is chaotic, untamed, a palette wildly mingled.

The Japanese so dearly love Nature, in all her moods, that when she dons her mantle of snow they hesitate, even when necessity compels, to sully its purity. In one of Utamaro's prints, sweetly entitled by Edmond de Goncourt *La Nature Argentée*, a little musüme is seen searching the snowy landscape she loves, and, hating to blot the beautiful carpet, she cries. "Oh, the beautiful new snow! Where shall I throw the tea-leaves?" With Hiroshige, the artist of snow and mist, we feel this love, and so successfully does he deal with a snowy landscape that we see the snow in masses, luminous, soft and unsullied, as if Nature had lent a helping hand to portray her pure white magic. So, without formula or technique, but absolutely and sincerely, he unrolls the winter pageant before us.

The Japanese landscape painter sums up nature in broad lines, to which all details are more or less subordinated. This rendering of the momentary vision of life and light – the spirit, not the letter of the scene – is what is meant by Impressionism. Whereas, however the French

Utagawa Hiroshige,
Nocturnal View of the Eight Famous Places of Kanazawa,
from the series *Snow, Moon, Flowers*, July 1857.
Colour woodblock print, 36.7 x 24.6 cm (right-hand sheet);
36.7 x 24.7 cm (center-hand sheet); 36.5 x 24.6 cm (left-hand sheet).
Baur Collection, Geneva.

Utagawa Hiroshige,
Mountains and Rivers of the Kiso Highway,
from the series *Snow, Moon, Flowers*, July 1857.
Colour woodblock print, 37.8 x 25.9 cm (right-hand sheet);
37.7 x 25.9 cm (center-hand sheet); 37.5 x 25.8 cm (left-hand sheet).
Baur Collection, Geneva.

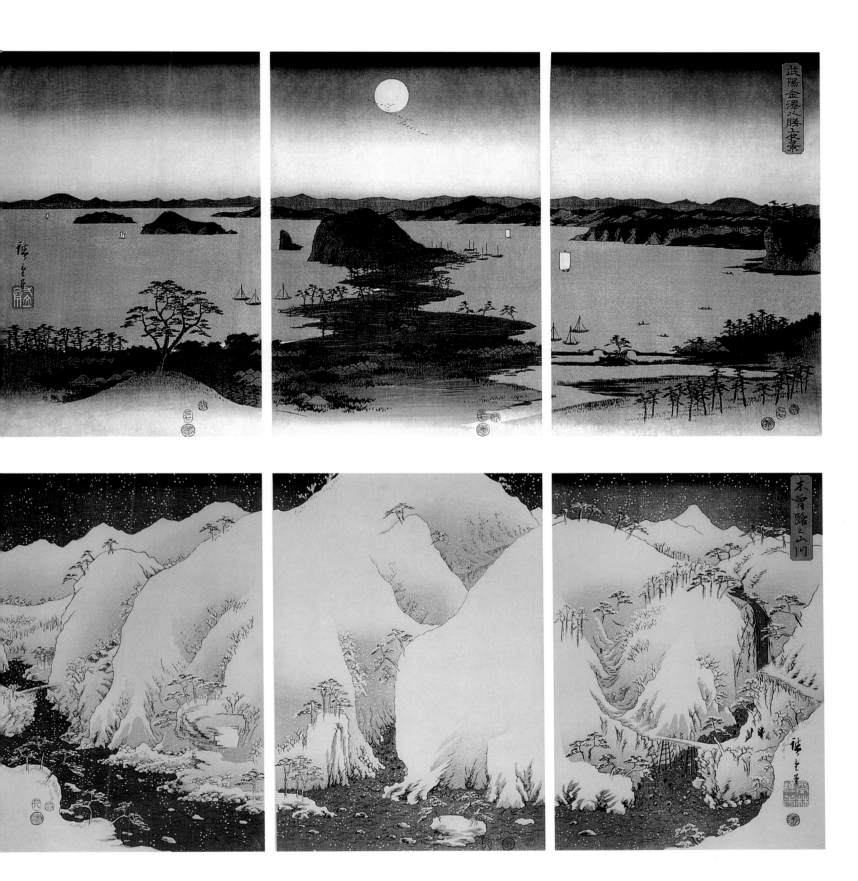

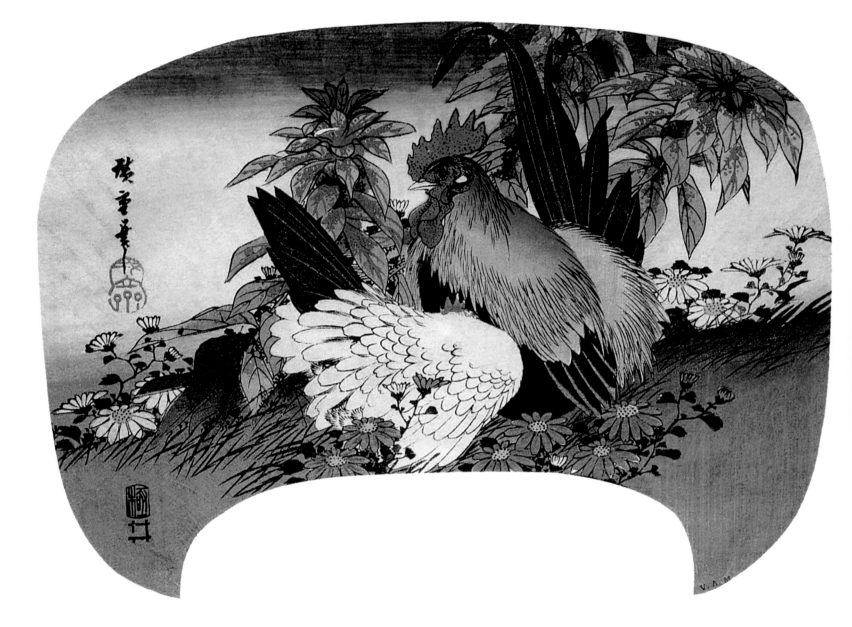

Utagawa Hiroshige,
Rooster, Hen and Autumnal Flowers, 1837.
Colour woodblock print, 21.6 x 29.5 cm.
Victoria & Albert Museum, London.

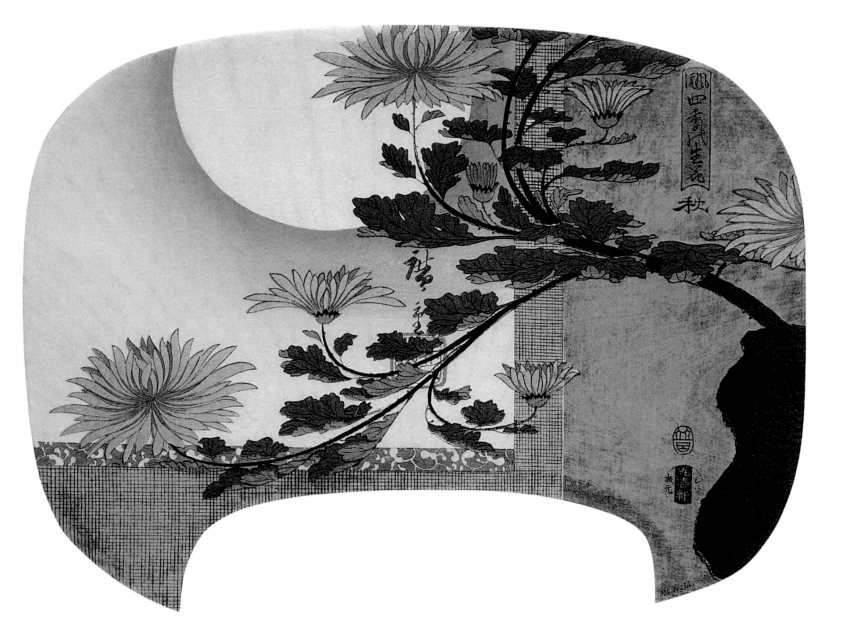

Utagawa Hiroshige,
Autumn, from the series *Fashionable Dispositions of
Flowers of the Four Seasons*, 1843-1847.
Colour woodblock print, 22.2 x 28.8 cm.
Victoria & Albert Museum, London.

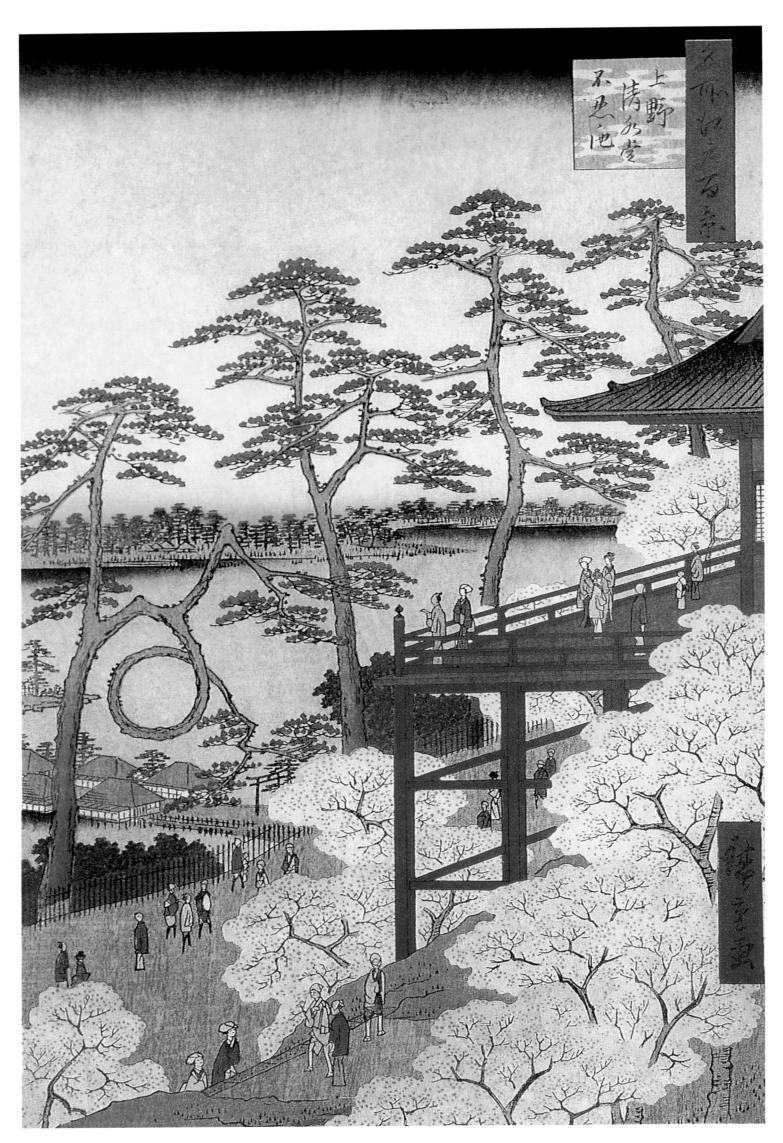

impressionists express light by modelling surfaces, the Japanese adhere rigidly to line, and rely upon gradations of colour and the effect of washes to produce the illusion of light. Their landscape is expressed in clear-cut lines and flat masses of colour. In the prints this virtue of abstract line is exemplified, the outline being the essential element of the composition, for upon line and arrangements of balanced colour the artist must depend, cramped as he is by the necessities of the wood-cut. And here he displays his wonderful ingenuity, his fineness of gradations and opposition, his boldness and infinity of device, and in spite of the limitations which hamper him, he realises absolute values in the narrowest range, by virtue of his knowledge of lines and spaces.

"No scientifically taught artist," said Jarves, "can get into as few square inches of paper a more distinct realisation of space, distance, atmosphere, perspective and landscape generally, not to mention sentiment and feeling."

This virtue of the line is the inheritance of the Japanese, the consummate handling of the brush almost a racial instinct. From China, far back in the centuries, came the sweeping calligraphic stroke, of which in Japan the school of Kanō became the noblest exponent.

As soon as the tiny hand of the Japanese baby can grasp the brush its art education begins. The brush is the Japanese alphabet – it is their fairy wand, their playmate – they learn to paint intuitively, though later the most assiduous study is given to acquire the characteristic touch of the school with which they affiliate. The brush is their genie, subservient to their imagination; they master and "juggle" with it. For no foreign-taught technique will they barter their birthright.

And our masters and instructors in art more and more recognise the value of initial brush-work. The following excerpt from Walter Crane, in *Line and Form,* might serve as a preface to a work on Hokusai or Hiroshige: "The practice of forming letters with the brush afforded a very good preliminary practice to a student of line and form. An important attribute of line is its power of expressing or suggesting movement. Undulating lines always suggest action and unrest or the resistance of force of some kind. The firm-set yet soft feathers of a bird must be rendered by a different touch from the shining scales of a fish. The hair and horns of animals, delicate human features, flowers, the sinuous lines of drapery, or the massive folds of heavy robes, all demand from the draughtsman in line different kinds of suggestive expression."

Utagawa Hiroshige,
The Kiyomizudo Temple and Shinobazu Pond at Ueno,
April 1856.
Colour woodblock print, 33.7 x 22.5 cm.
Art Gallery of Greater Victoria, Vancouver.

Utagawa Hiroshige,
Plum Garden at Kameido, from the series *One Hundred Famous Views of Edo,* 1857.
Colour woodblock print, 34 x 23 cm.
Honolulu Academy of Arts, gift of James A. Michener, Honolulu.

Utagawa Hiroshige,
The Plum Orchard in Kamata, February 1857.
Colour woodblock print, 36 x 24 cm.
Brooklyn Museum of Art, New York.

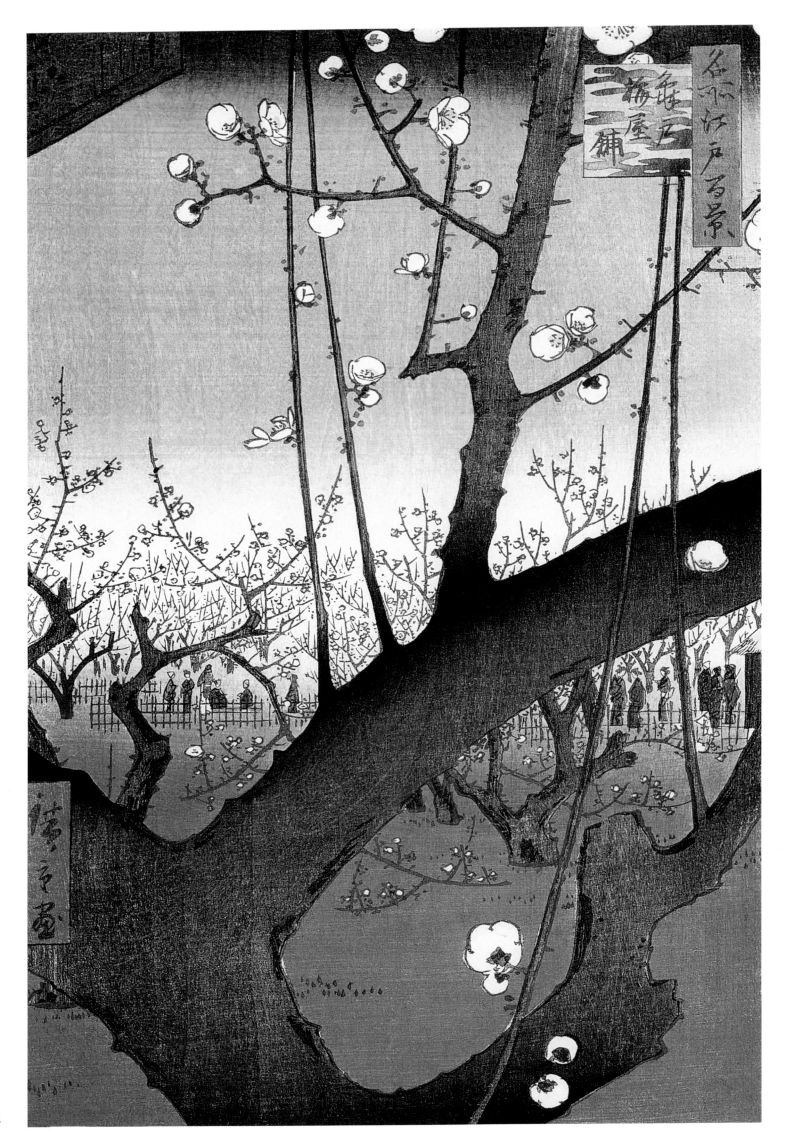

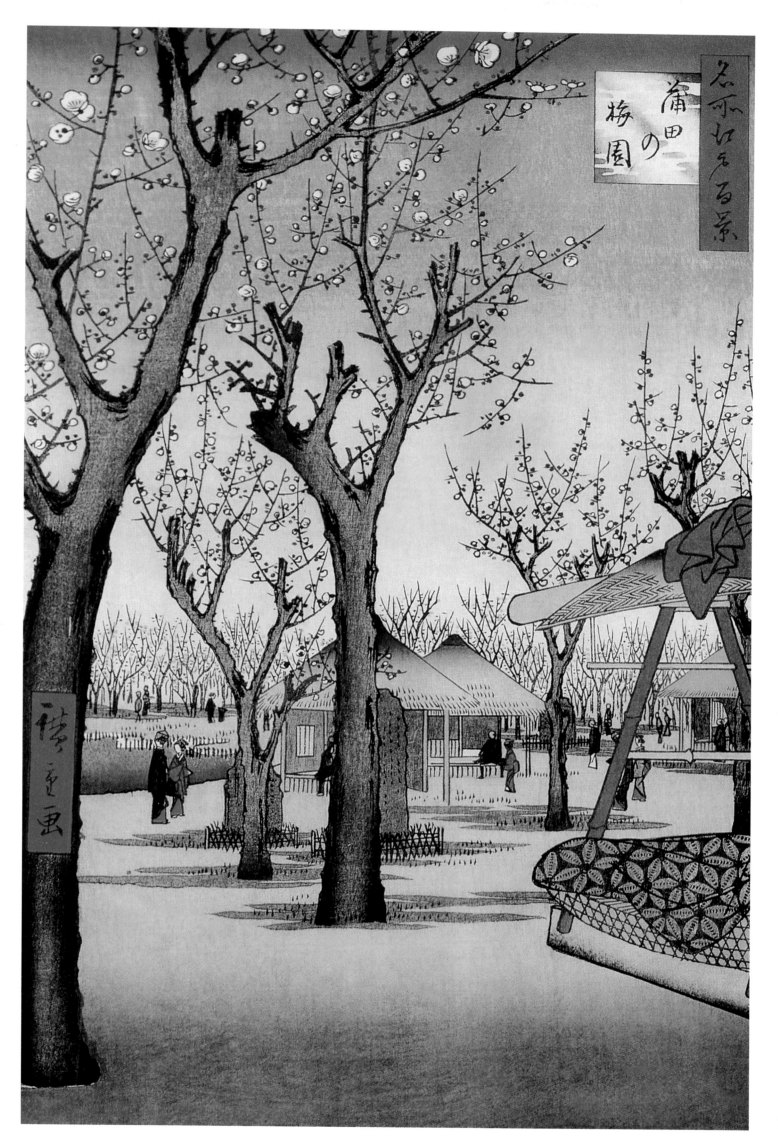

We are told that Hiroshige began his career by making pictures in coloured sands on an adhesive background, to amuse the public, and perhaps this artistic juggling helped him later in arranging his schemes of colour, for the limitations of the block demanded almost equal simplicity in composition.

The impressions of Lake Biwa, one of Hiroshige's finest series of views, serve as a beautiful illustration of the almost exclusive use of line in bringing out the salient characteristics of the landscape. His sweeping brush shows us volcanic mountains, encircling the lake, like rocky billows, torn and jagged, for legend says that as the peerless mountain Fuji-san rose in one night, so the ground sank, and the space was filled by the beautiful lake named from its resemblance in form to the Japanese lute. The trees which fringe the shore, black and misty,

upon close inspection resolve themselves into a network of criss-cross lines and blotches. The *sampans'* sails, the waves, the rushes on the shore, the roofs of the village nestling beneath the cliffs, are all adroitly rendered by horizontal lines and skilful zigzags. The rest of the composition is a wash of shaded blues and greys, fading toward the horizon into smoky violets.

Biwa, the beautiful, suggestive of mystery, the four-stringed lute gives thee her name. Through the music of thy rippling eddies do sighs well up in thee, the murmur of the lost? A pall of darkness hovers over thee, pierced by a gleam of sunshine, beckoning like a lover's hand.

Much diversity of opinion existed with regard to the identity of the artist, or artists, who designed the prints signed Hiroshige. Later researches, however, justified the assertion that there was but one landscape

painter, Hiroshige the Great.

The pupils – notably one, who, among other names, signed Shigenobu (Suzuki Morita), until after his master's death, when he took the title of Hiroshige the Second, faithfully imitated his style, also amplifying the multitudinous designs and sketches made by the master, yet the genius of the great artist is stamped upon his work, and as a clever critic tersely says: "Everything he touched was his autograph."

The masterpieces signed Hiroshige are all by one great genius, the Apostle of Impressionism. "Before Hiroshige there was no Japanese landscape master – after him there is none," cries Happer, in an outburst of enthusiasm.

In the "Happer" Collection is a memorial portrait of Hiroshige by Kunisada (Toyokuni), the inscription upon which is of especial interest, confirming, as it

Utagawa Hiroshige,
New Fuji at Meguro, April 1857.
Colour woodblock print, 36 x 24 cm.
Brooklyn Museum of Art, New York.

Utagawa Hiroshige,
View from the Massaki Shrine of the Uchigawa Sekiya-no sato Village and the Suijin-no mori Shrine, August 1857.
Colour woodblock print, 36 x 24 cm.
Brooklyn Museum of Art, New York.

Utagawa Hiroshige,
Night View of Matsuchiyama and the Sanyabori Canal,
August 1857.
Colour woodblock print, 36 x 24 cm.
Brooklyn Museum of Art, New York.

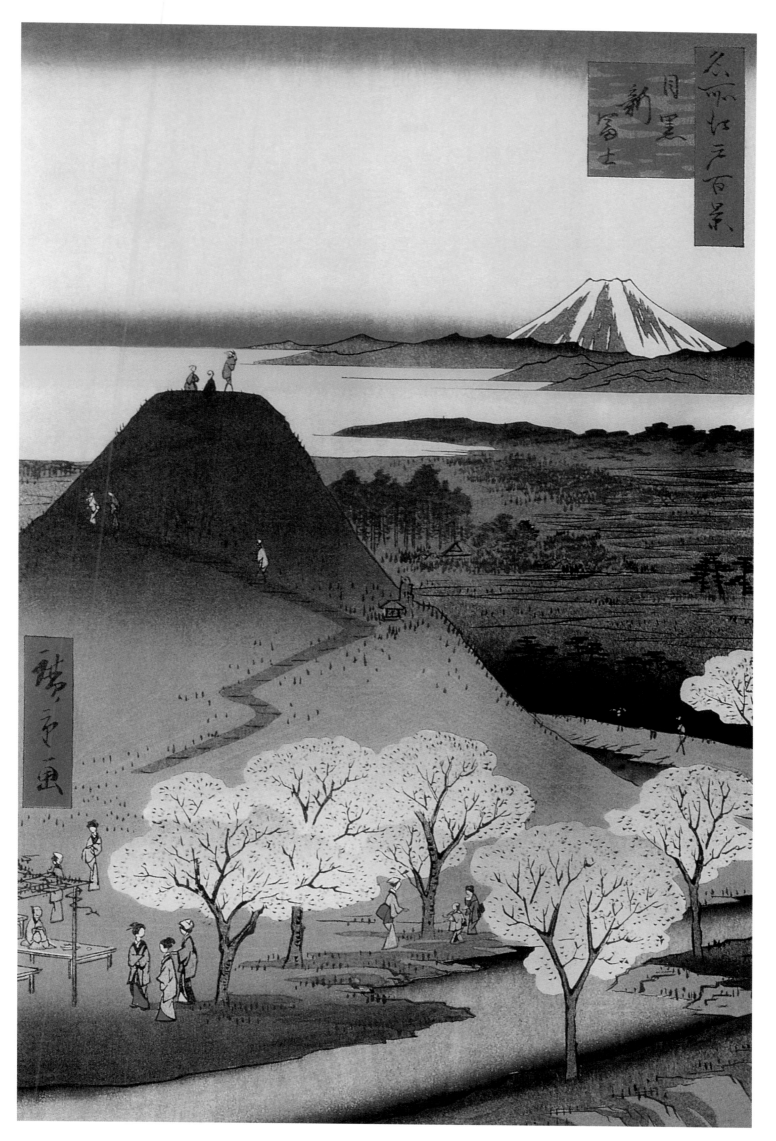

267

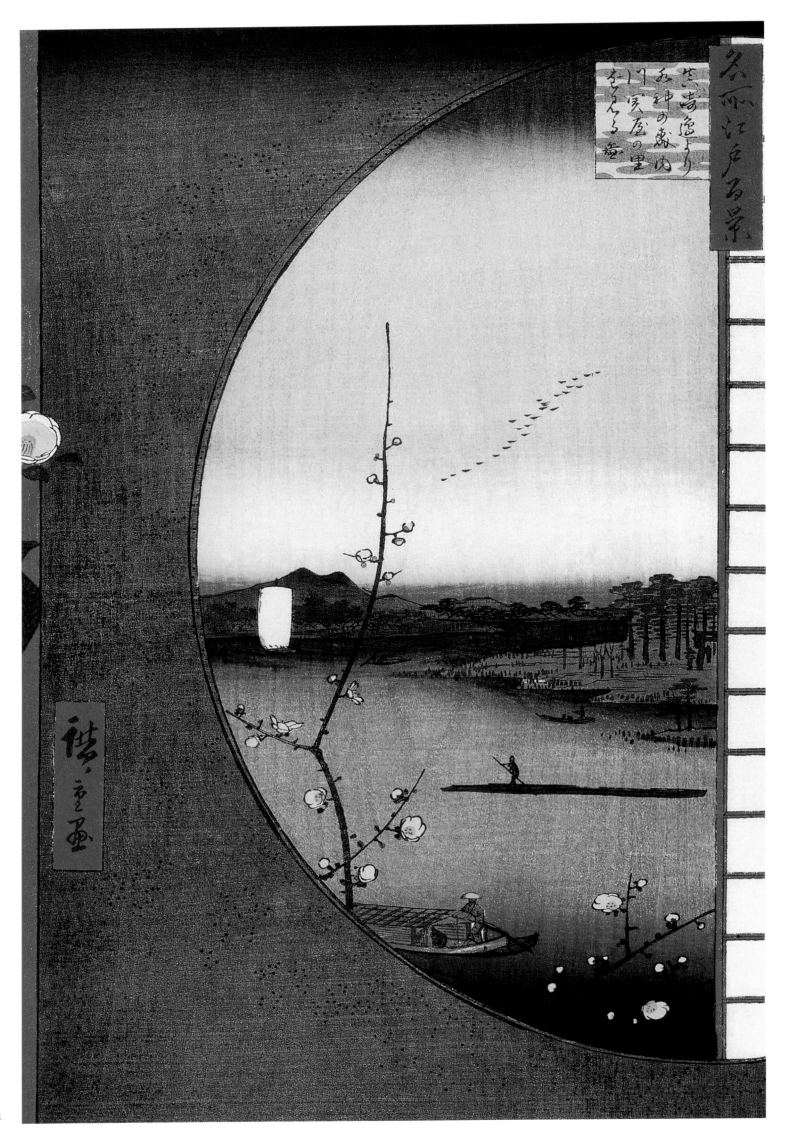

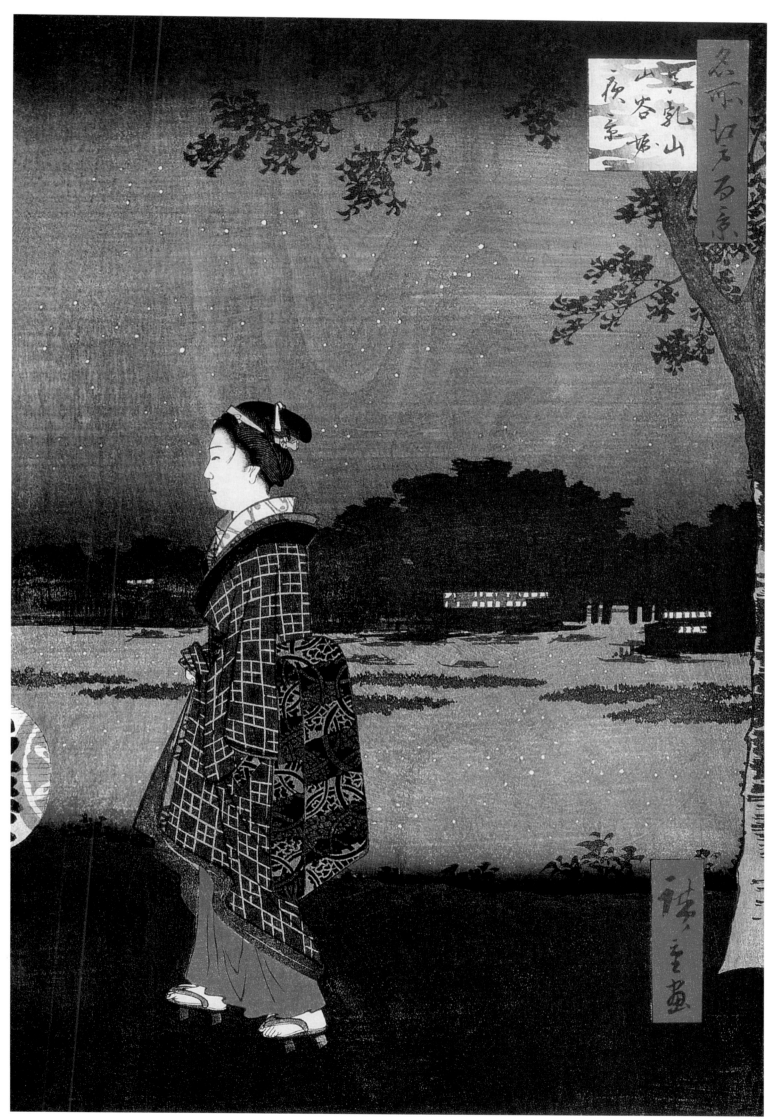

269

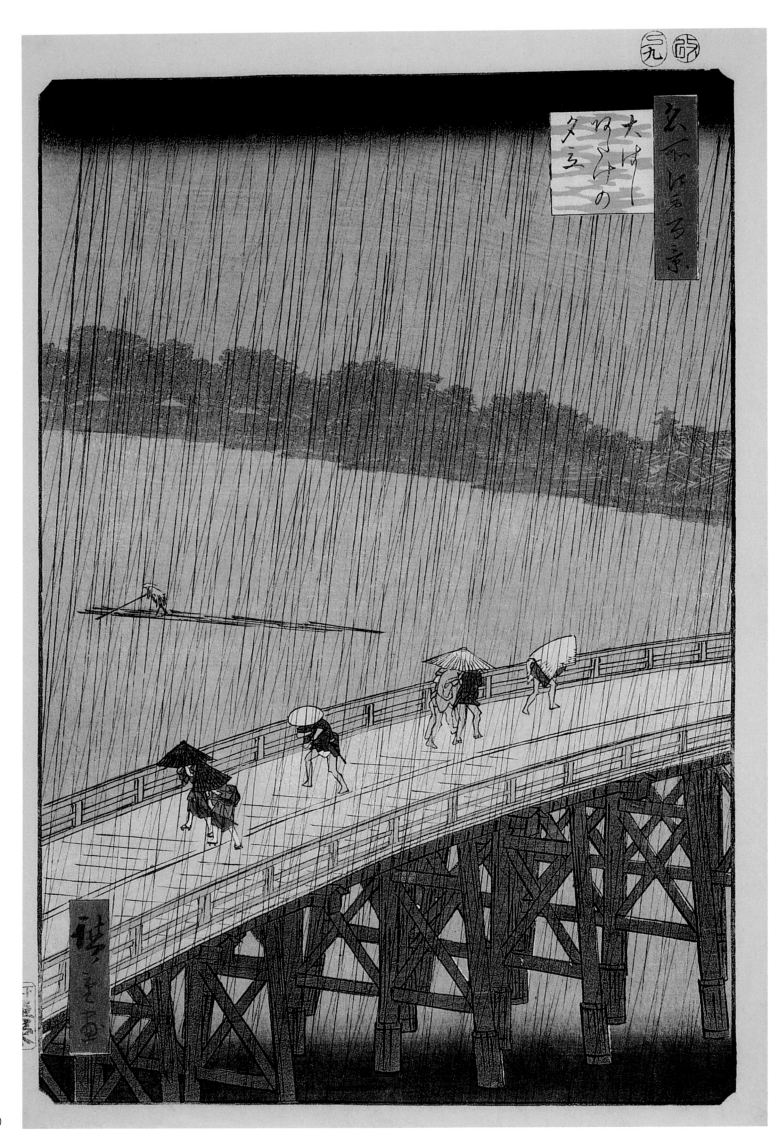

does, the date of his death and proving that the *Meisho Edo hyakkei*, the vertical set of Edo views, so often ascribed to his successor, were by the master.

The inscription is thus quaintly interpreted by a Japanese student:

"Ryusai Hiroshige is a distinguished follower of Toyohiro, who was a follower of Toyoharu, the founder of the Utagawa School. At the present time, Hiroshige, Toyokuni and Kuniyoshi are considered the three great masters of Ukiyo-e no others equal them. Hiroshige was especially noted for landscape. In the Ansei era, 1854-1859, he published the *Meisho Edo hyakkei* ('Hundred Views of Edo'), which vividly present the scenery of Edo to the multitude of admirers.

"About this time also appeared a magazine entitled *Meisho Zuye* ('Sonnets on Edo Scenes'), a monthly, illustrated by Hiroshige, and displaying his wonderful skill with the brush, to the admiration of the world. He passed away, to the world beyond, on the sixth day of the ninth month of this year, 1858, at the ripe age of sixty-two (sixty-one by our count). He left behind a last testament, or farewell sonnet, '*Azuma ji ni fude wo no-koshite tabi no sora; Nishi no mi kuni no Meisho wo Mimu.*' (Dropping the brush at Azuma, Eastern Capital. I go the long journey to the Western Country, Buddhist Heaven is in the West, to view the wonderful sceneries there.)

"This by Temmei Rojin, picture by Toyokuni.

"Dated Ansei 5, ninth month (October, 1858)."

The best known prints by Hiroshige are the "Fifty-three Stations between Edo and Kyoto." This Tōkaidō series was at first beautifully printed, but the later impressions show a sad decay in the colouring. The *Meisho Edo hyakkei* or "Hundred Views of Edo" give a panoramic vista of the Shoguns' capital. The pictorial description of Edo, in black and pale blue, is a lovely series. In many of these landscapes the Dutch influence is very marked, for the master of Hiroshige, Toyohiro, from whom he derived the first syllable of his *nom-de-pinceau*, had experimented in landscape painting after the Dutch woodcuts which were scattered throughout the country. Although Hiroshige is best known through his landscapes, he, like most Japanese painters, was too universal an artist to confine himself solely to one branch. He loved every phase of nature, and in one of his well-known prints, *The Eagle*, his skill in the delineation of birds is best shown. In the later impressions a pale yellowish tone takes the place of the beautiful steel-blue

Utagawa Hiroshige,
A Sudden Shower on the Ōhashi Bridge and Atake, from the series *One Hundred Famous Views of Edo,* 1857.
Colour woodblock print, 36 x 23.7 cm.
Brooklyn Museum of Art, New York.

Utagawa Hiroshige,
Fireworks by the Ryogokubashi Bridge, August 1858.
Colour woodblock print, 33.7 x 22 cm.
Cleveland Museum of Art, Cleveland.

Utagawa Hiroshige,
In the Precincts of the Tenjin Shrine at Kameido,
July 1856.
Colour woodblock print, 36 x 24 cm.
Brooklyn Museum of Art, New York.

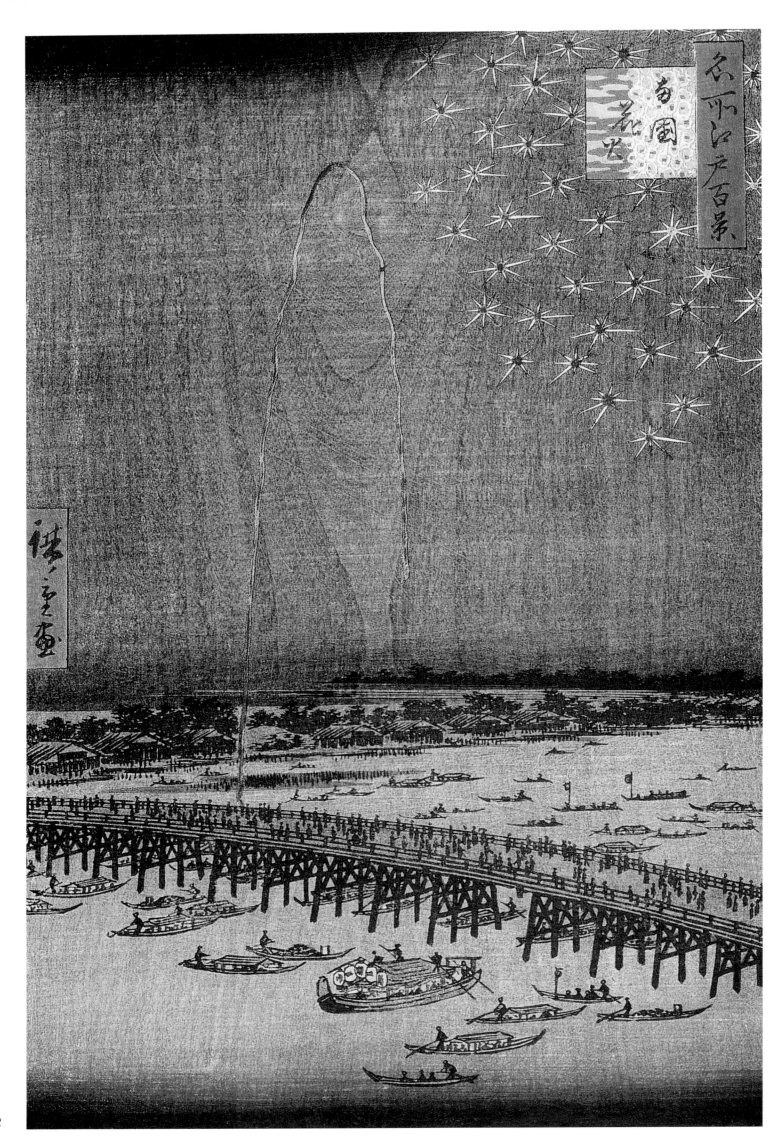

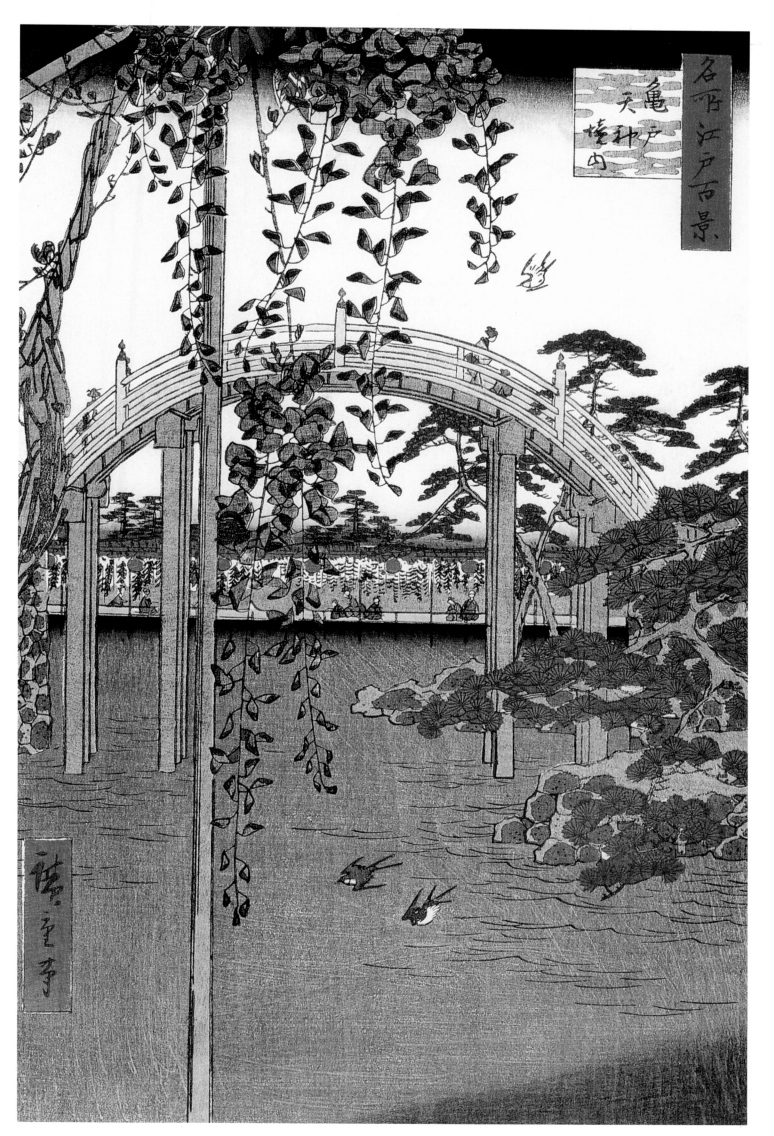

273

background of the earlier prints, miracles of colour printing.

Athwart this background of ineffable blue, which loses itself in the mists that veil the sacred mountain, is seen, sweeping and sailing cruelly alert, the evil eagle of Hiroshige. His wicked gaze is set on nests of murmuring wood-doves, he eyes the callow sea-birds in their bed of rushes. The temple bell rings solemnly; the long vibrations cleave the azure dusk. It is the hour of rest and dreams. Begone, base harbinger of evil!

In the early prints by Hiroshige the colours are most beautiful, one soft tone fading imperceptibly into another, the blues and greens so marvellously blended as to be almost interchangeable. We are told that Michelangelo loved the companionship of the old workman who ground his colours; and of the Japanese, it is said, "this making one family of the greater artist and all who had to do with him has given that peculiar completeness, that sense of peace and absence of struggle which we feel in Japanese art."

In vain Hiroshige fought, towards the middle of the nineteenth century, against introduction of cheap and inferior pigments, which were taking the place of the native dyes – Nature's gifts, distilled by her artist children. Reds, yellows, blues and greens, intense and crude, were now imported, and Western commercialism sapped the virtue of the sincere and devoted artists and artisans of the Orient.

In describing the effect of colour in one of the Nikko temples, W. B. Van Ingen throws a searchlight upon the chemical secrets of this splendour, which he tells us, if asked to describe in one word, that word would be "golden." "These colours," he says, "are not imitations of colours. If vermilion is used, it is cinnabar and not commercialised vermilion which is employed, nor is something substituted for cobalt because it is cheaper and will 'do just as well.' Each colour is used because it is beautiful and frank as a colour, not because some other colour is beautiful. If lacquer is the best medium to display the beauty of the pigment, lacquer is used, and if water is better, lacquer is discarded, and if these colours are not imitations of colours, neither are they suggestions of colours. Pink is not used for red; if it is used at all, it is used for its own beauty, and feeble bluish washes are not made to do service for blue. The Oriental has not yet learned the doctrine of substitution; he knows that substitution is transformation."

The secrets of colouring of the early prints, the joy of Parisian studios and which inspired Whistler, are lost. The delicious

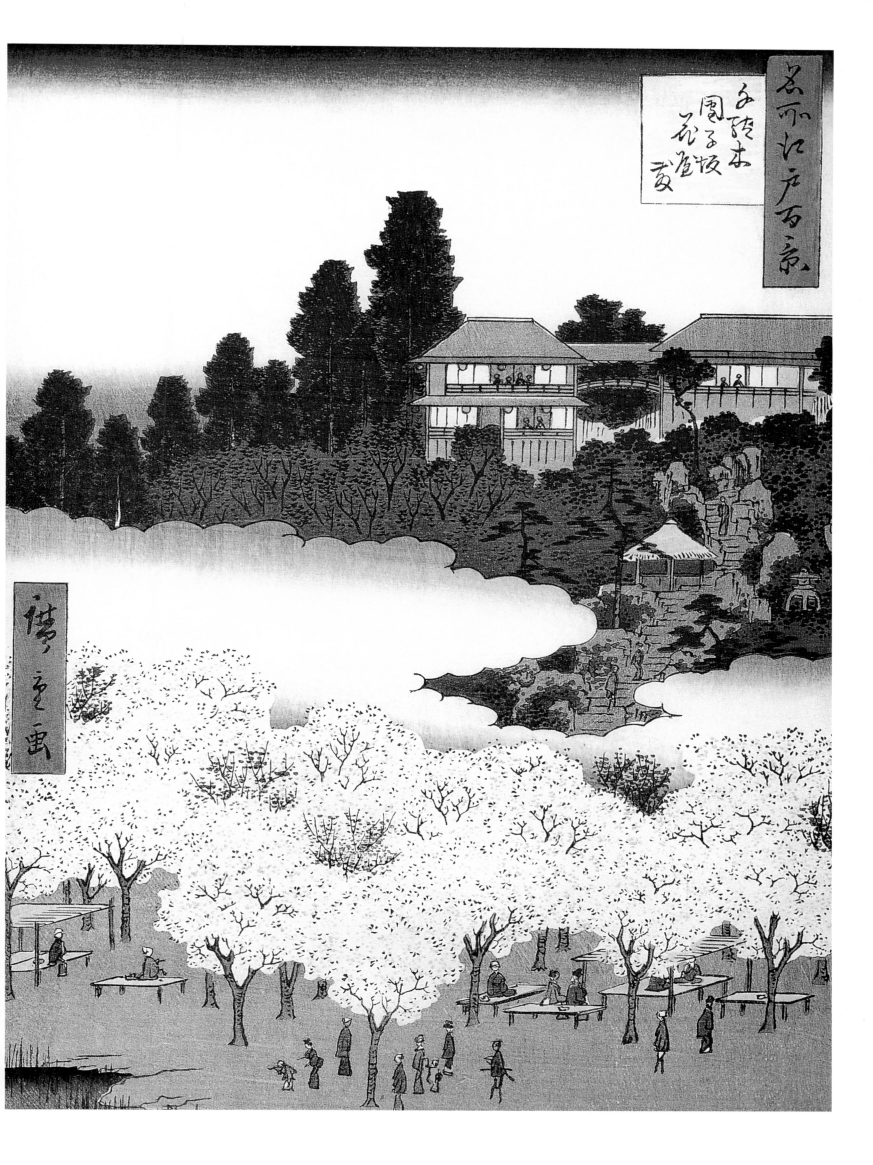

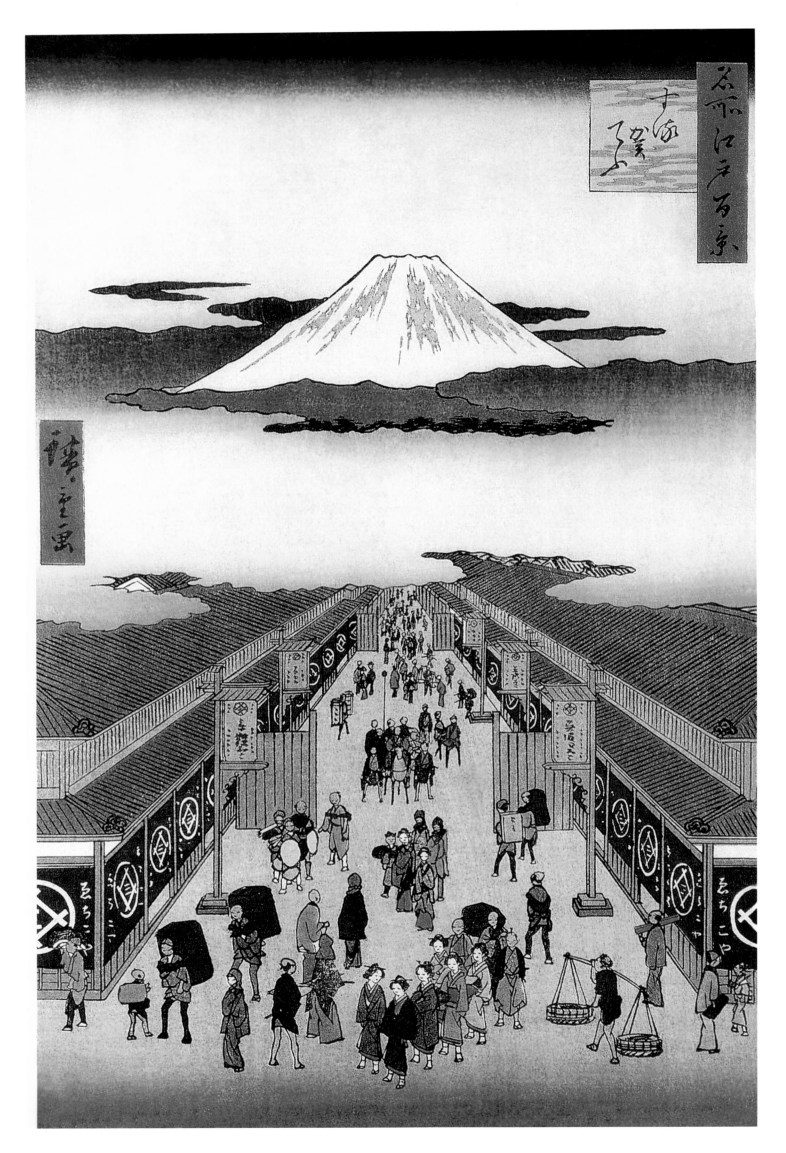

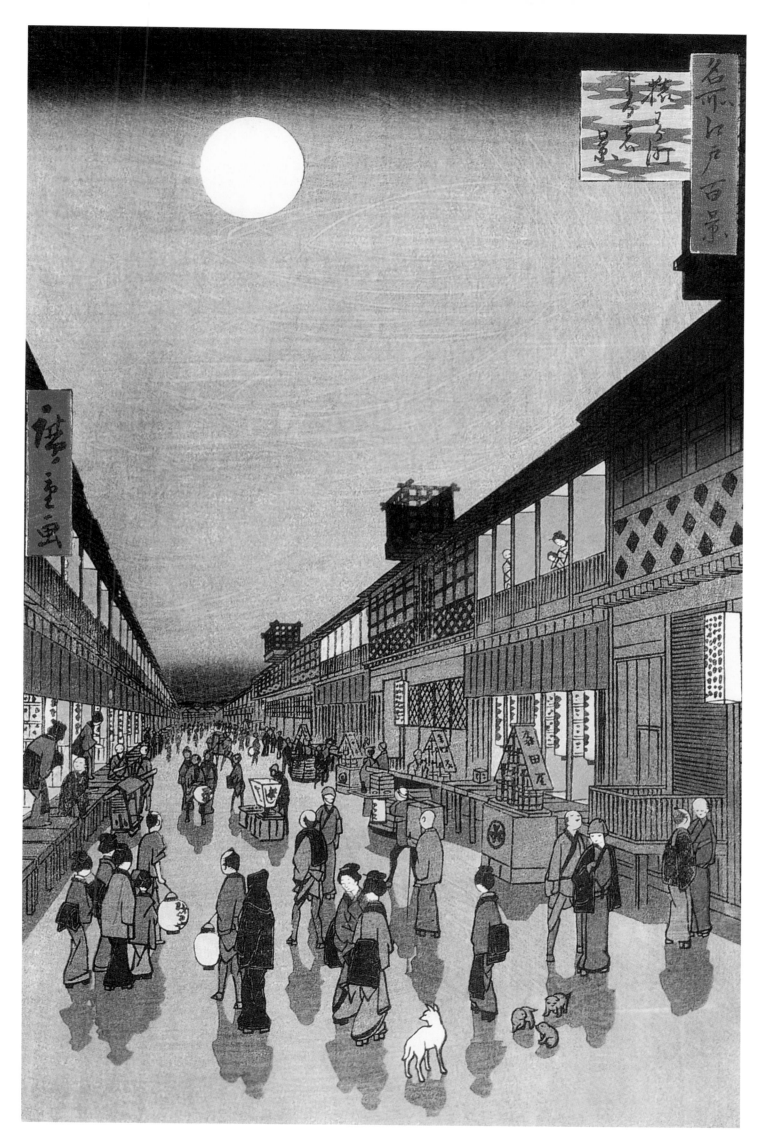

277

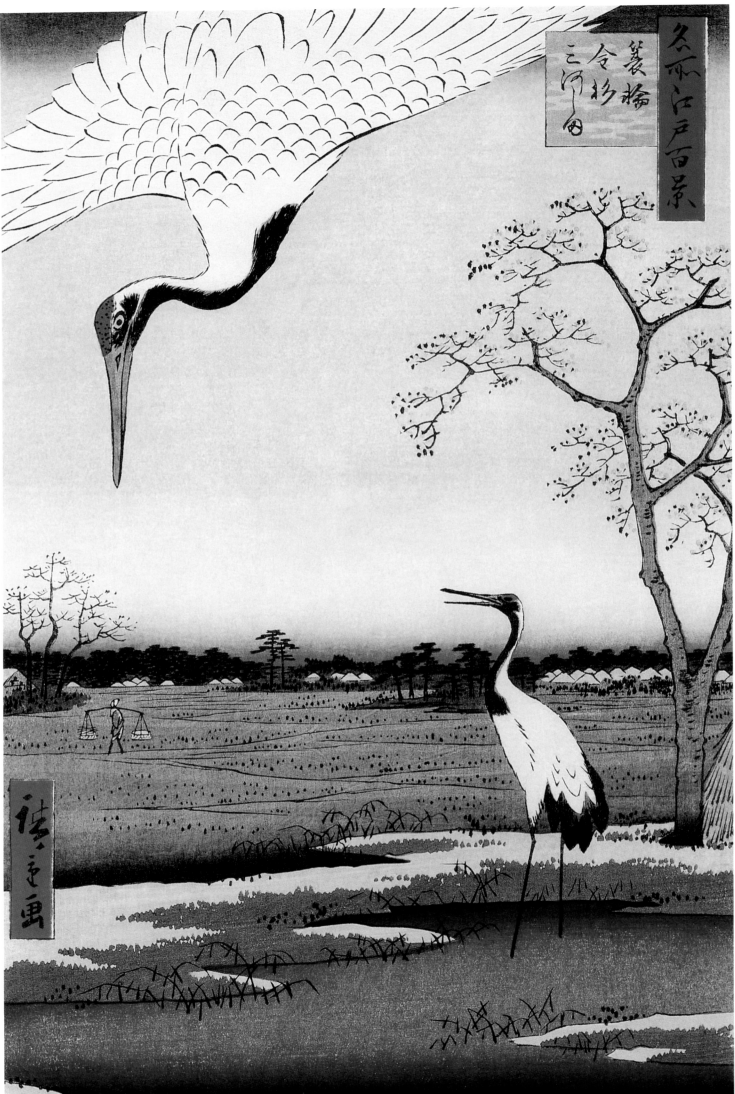

greens of old mosses, the pale rose tints, the veinings and marblings, the iridescent tints of ocean shells, the luminous colours of the anemone, the *bleus malades des mauves* – that divine violet, a benison of the palette handed down by those old Buddhist monks, the earliest painters of India and China.

These visions of colour are taking the place of obscurity and gloom, for the great impressionists, Claude Monet, Manet, the Barbizon school also and its disciples, have abjured the old dark shadows and substituted violet washes, seeming to share the privilege with the saints and sages of "seeing blue everywhere". All true artists live "within the sphere of the infinite images of the soul". These seers are their own masters, and, as Theodore Child says so exquisitely: "They are of rare and special temperaments, and through their temperament they look at nature and see beautiful personal visions. They fix their visions in colour or marble and then disappear forever, carrying with them the secrets of their mysterious intellectual processes." Such a special temperament was bequeathed to Whistler. He submitted himself to the Japanese influence, not imitating but imbibing oriental methods, and following them, notwithstanding Philistine clamour, for the English art doctrines of the time were diametrically opposed to these innovations. Regardless of sneers, he followed the bent of his genius, which led him into Oriental fields. He felt the sweet influence of such artists as Hokusai and Hiroshige. He took advantage of the centuries of thought given to drapery, in the land where, as with Greece, dress is a national problem; where no fads and follies of fashion fostered by commercialism are allowed; where the artists design dress, and the people gratefully and sincerely adopt their ideas.

When we can follow them and allow art to rule, then hideous vagaries and vulgarities, distortions of the figure by hoops and wires, and monstrosities in sleeves will cease. Then may we hope to be an æsthetic nation. We need our American Moronobus to design and embroider and paint dresses for their beautiful and intuitively tasteful countrywomen.

The colour vision of the Oriental far surpasses our own. His eyes are sensitive to colour harmonies which, applied to landscape, at first seem unreal, impossible, until we realise that though they present objects in hues intrinsically foreign to them, yet the result justifies this arrangement, and its integrity is recognised, for the impression we receive is the true one. And

Utagawa Hiroshige,
Minowa and Kanasugi, Mikawa Islands (Minowa kanasugi mikawajima), May 1857.
Colour woodblock print, 33.8 x 21.8 cm.
Collection Carlotta Mabury, Fine Arts Museums of San Francisco, San Francisco.

Utagawa Hiroshige,
The Suidobashi Bridge and Surugadai, May 1857.
Colour woodblock print, 36 x 24 cm.
Brooklyn Museum of Art, New York.

Utagawa Hiroshige,
The Mannenbashi Bridge in Fukagawa,
November 1857.
Colour woodblock print, 36 x 24 cm.
Brooklyn Museum of Art, New York.

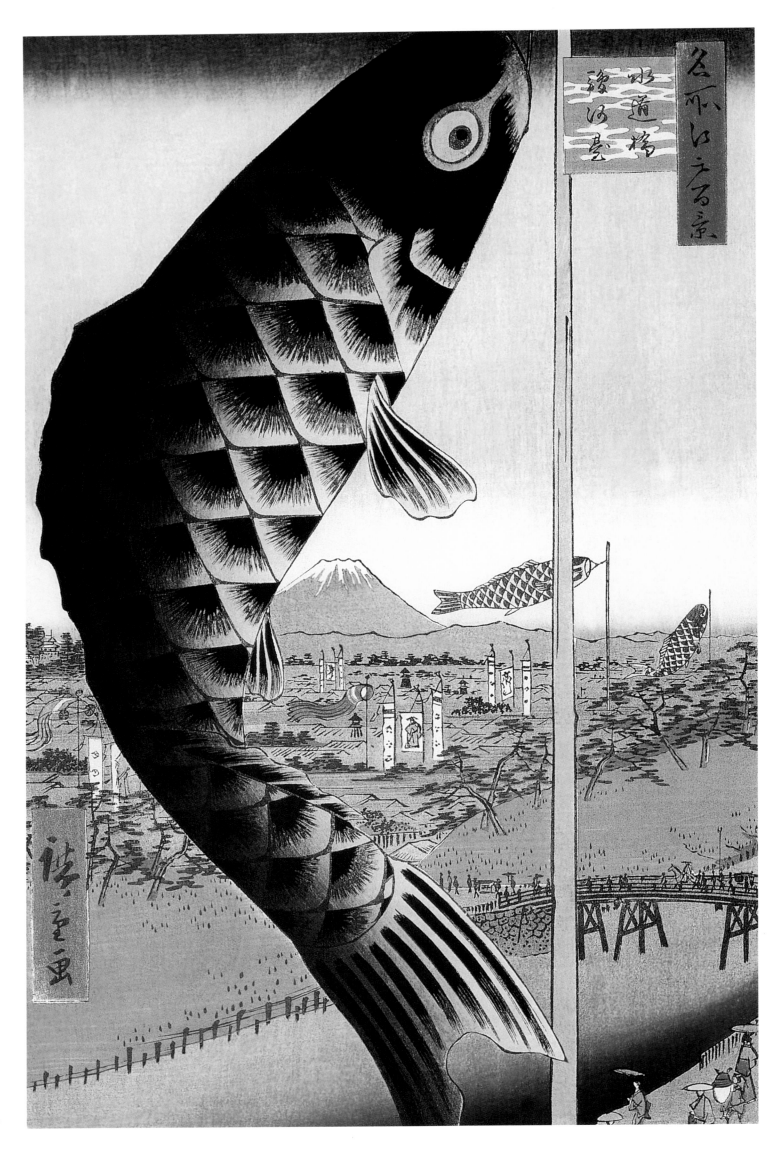

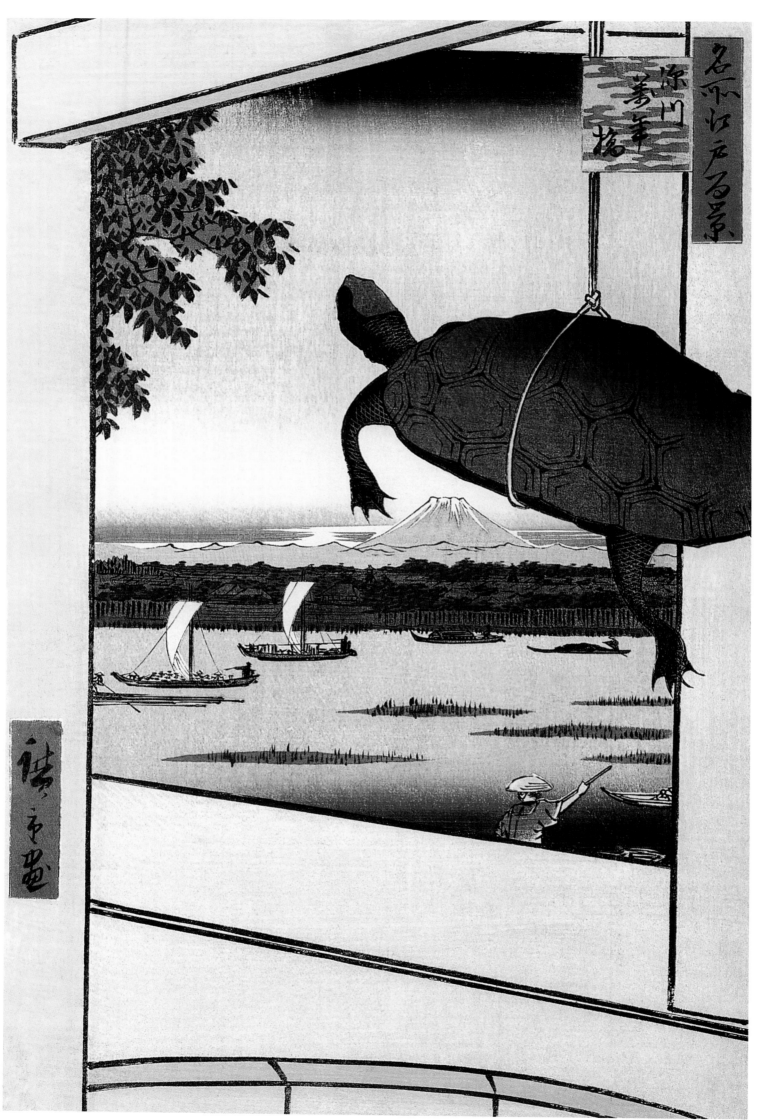

this chaotic massing of colour we notice in a landscape by Hiroshige was employed by many of the old masters. Of the stormy passion of Tintoret, Ruskin says: "He involves his earth in coils of volcanic cloud, and withdraws through circle flaming above circle the distant light of paradise."

There is a keynote to art, as to music, and to genius; through the inner vision this harmony is revealed. It lies within the precincts of the soul, beyond the reach of talented mediocrity, however versed in the canon of art. Nor can this occult gift be handed down. The most ardent disciples of Raphael tried in vain to express themselves after his pattern. The sublime inspiration which found its fullest outward manifestation in the Sistine Madonna rested there. The poets

realised this colour vision, for Dante cried:

"Had I a tongue in eloquence as rich

As is the colouring in Fancy's loom."

Inspiration must be sought by other than mechanical means. Have not the most inspired revelations of colour come to the great master, William Keith, when, invoking the aid of his old temple bell, its lingering vibrations yielded to him rich secrets of colour harmony, as the song of the bell revealed to the soul of Schiller the mystery of life and birth and death, which he crystallised in his immortal poem?

This is the keynote of Impressionism, the touchstone of art. What a fairy wand was wafted by Whistler, standing upon Battersea Bridge!

"The evening mist," he said, "clothes the riverside with poetry, as with a veil, and the poor buildings lose themselves in the dim sky, and the tall chimneys become Campanili, and the warehouses are palaces in the night and the whole city hangs in the heavens, and fairyland is before us!"

Leaning upon the bridge, the sweet influence of Hiroshige permeating his soul, in the crucible of his fancy he blended with the radiant Orient a vision of old London, grimy and age-worn, and realised "a Japanese fancy on the banks of the grey Thames." To this picture he set the seal of his brother artist, and so the two apostles of Impressionism, Occidental and Oriental, in that loveliest nocturne, will together go down to posterity.

Utagawa Hiroshige,
Susaki and Jumantsubo in Fukagawa, May 1857.
Colour woodblock print, 35.8 x 23.5 cm.
Los Angeles County Museum of Art, Los Angeles.

BIBLIOGRAPHY

Anderson, William: *Pictorial Arts of Japan* (London: Sampson Low. 1886.)

Anderson, William: *Japanese Wood Engravings: Their History, Technique and Characteristics* (London: Portfolio, 1895.)

Bing, Samuel: *Artistic Japan:* Compiled by S. Bing, with the assistance of W. Anderson, T. Hayashi, E. de Goncourt, and others (New York: Brentano's, 5 Union Square.)

Fenollosa, Ernest Francisco: *An Outline of the History of Ukiyo-e* (Tokyo: Kobayashi.)

Fenollosa, Mary McNeil: *Hiroshige, the Artist of Mist, Snow, and Rain* (San Francisco, 1901.)

Goncourt, Edmond de: *Outamaro, Le Peintre des Maisons Vertes* (Paris: 11 Rue de Grenelle, 1891.)

Gonse, Louis: *L'Art Japonais* (Paris: A. Quartin, 1883.)

Hartman, Sadakichi: *Japanese Art* (Boston: Page & Co., 1904.)

Hayashi, T.: *Catalogue of the Hayashi Collection, with Illustrations* (Paris, 1902.)

Holmes, C. J.: *Hokusai* (London: Longmans, Green & Co., 1901.)

Huish, Marcus B.: *Japan and Its Art* (London: The Fine Arts Society. 1893.)

Jarves, James Jackson: *A Glimpse of the Art of Japan* (New York. 1875.)

Okakura, Kakuzo: *Essays on Japanese Art*, in "Japan", edited by F. Brinkley. Also: *Japanese Pictorial Art, in Vol. 7, "Japan and China,"* by F. Brinkley (Boston and Tokyo: J. B. Millet Co.)

Pepper, Charles Hovey: *Japanese Prints* (Boston: Walter Kimball & Company.)

Perzynski, Friedrich: *Farbenholzschnitt Der Japanische* (Berlin.)

Revon, Michel: *Etude Sur Hok'sai* (Paris, 1896.)

von Seidlitz, Woldemar: *Geschichte Des Japanischen Farbenholzschnitts* (Dresden: Gerhard Kuhtmann, 1897.)

Strange, Edward F.: *Japanese Illustration* (London: George Bell & Sons, 1904.)

Strange, Edward F.: *Colour Prints of Japan* (Langham Series of Art Monographs. New York: Charles Scribner's Sons, 1904.)

[1] " Here you can observe the Japanese woman in all her poses. You can see her, her head resting on the back of her hand; when she thinks; when she kneels, the palm of her hands pressing her thighs; when she listens, enraptured in words, thrown on the side, her head slightly turned, and which shows her in the fleeting aspect of the lost profile. You can see her beholding with loving contemplation flattened flowers on the floor. You can also see her thrown back or slightly posing, half-sitting on the rail of a balcony. You have seen her reading, where she holds the volume close to her face, both elbows resting on her knees. You have seen her preparing herself, which she does holding a small metal mirror in front of her, while her other hand behind her caresses her neck. You have seen her hand holding a glass of sake, her fingers gracefully and delicately grasping porcelain pieces, the small artistic objects of her country. You have seen her at last, the woman of the Land of the Rising Sun, in her languid grace, stylishly draped over the woven wooden floor."

INDEX